Paul Gauguin
The Breakthrough into Modernity

Paul Gauguin
The Breakthrough into Modernity

Heather Lemonedes, Belinda Thomson, and Agnieszka Juszczak

With contributions by Chris Stolwijk and Moyna Stanton

The Cleveland Museum of Art

Van Gogh Museum, Amsterdam

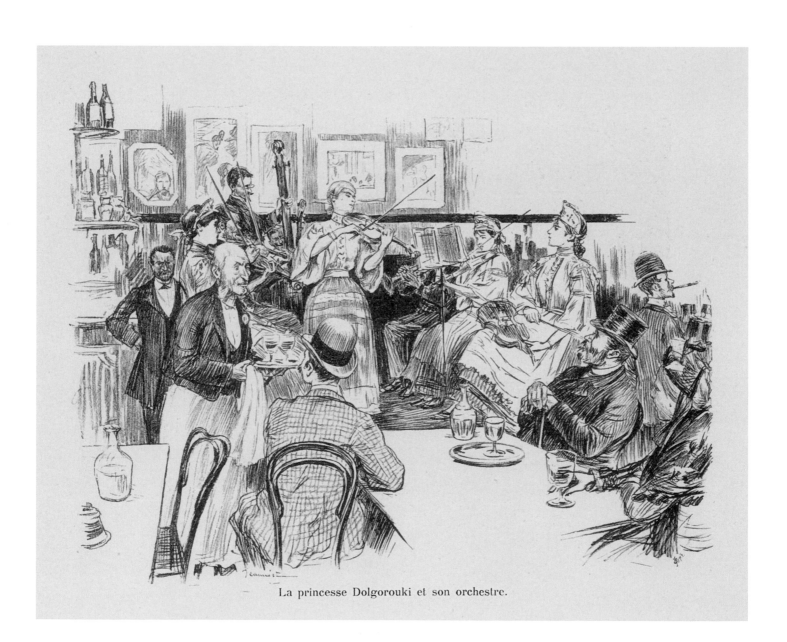

La princesse Dolgorouki et son orchestre.

Contents

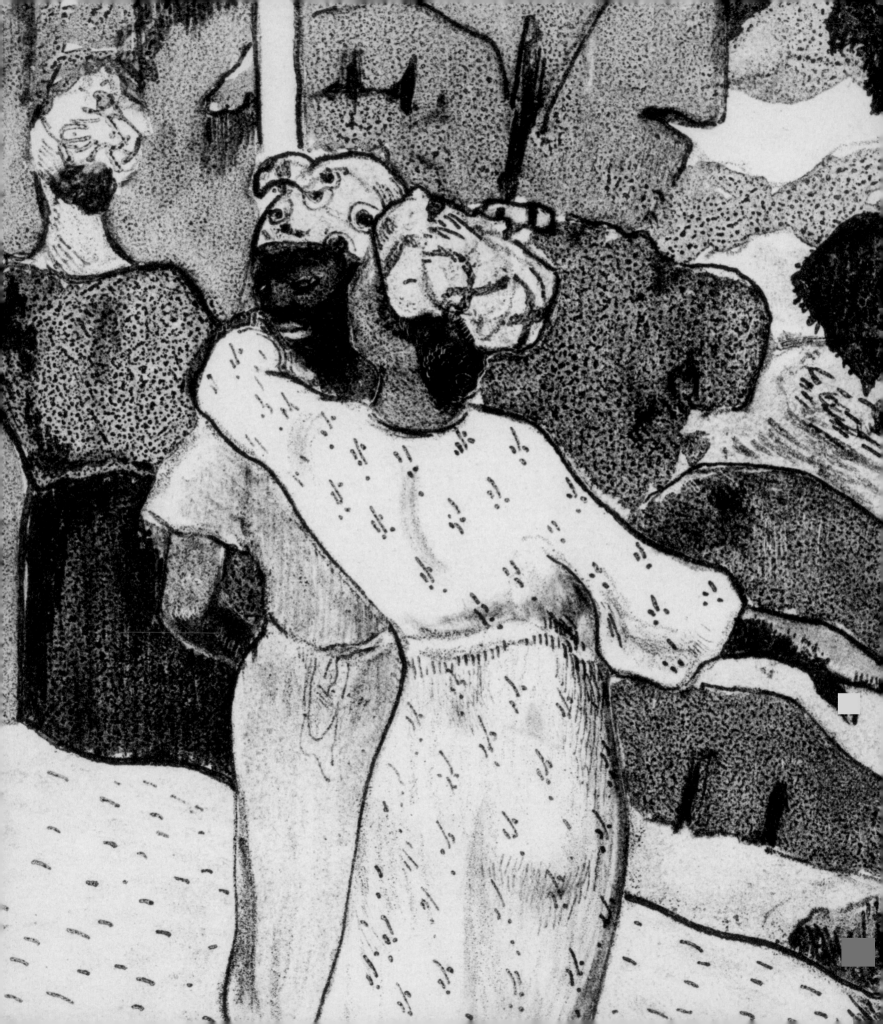

Foreword

This is an exhibition about an exhibition. In the nineteenth century successive expositions universelles—world's fairs—brought celebrity and commerce to Paris, and the exhibits devoted to art represented official taste. Artists deemed unacceptable occasionally mounted their own exhibitions near or within the fair grounds: in 1855 Gustave Courbet built his own pavilion nearby, as did Édouard Manet in 1867. But in 1889 Paul Gauguin required no separate structure; a restauranteur who had established a café within the exposition grounds failed to order décor in time for the opening and was persuaded to display the work of Gauguin and his circle instead. Thus Monsieur Volpini became the host of an epochal event.

In the eleven zincographs Gauguin made for the *Catalogue de L'Exposition de Peintures du Groupe Impressionniste et Synthétiste*—now known as the *Volpini Suite*—we can recognize the style that informed his work for the rest of life. A genuine revolutionary, Gauguin aimed to define a reality beneath appearances, drawing subjects and ideas freely from the Bible to Eastern religions and imagery from the late Middle Ages to Japanese art, while denying all influences and insisting on his absolute originality. Gauguin and his followers abandoned illustration—what Gauguin called a novel in paint—to address subjective experience directly for the first time.

Raised first in luxury in Peru, then in poverty in France, largely alienated from bourgeois society and at home nowhere, Gauguin dropped out of school at seventeen and traveled the world. On his return his guardian installed him on the Paris stock exchange, where he flourished for a time; but he began to paint, and his brief truce with middle-class values came to an end. Commercial success proving elusive, he abandoned his family and scrimped and sponged his way among cheap lodgings on his way from one putative paradise to another, exalting whatever middle-class society condemned in a romantic enthusiasm for primitive culture in a search for a sort of savage sublime. Ruthlessly selfish, he abjured family responsibility, tracing a Pariah's Progress around the world, reveling in his role as a rejected martyr and Peruvian savage.

This bohemian messiah cast a charismatic spell over some younger artists in Brittany, in the summer tourist village of Pont-Aven, and in Paris, to which they returned when the weather turned cold. Many of these disciples were recruited to join him in the exhibition at Volpini's café, and the collection of the Van Gogh Museum has made the presence of their works, crucial to an understanding of Symbolist art, possible in this exhibition.

Despite its seminal role in Gauguin's development, the *Volpini Suite* has received scant attention compared to the woodcuts he made of the South Seas. Now two museums collaborate on the first in depth examination of *Volpini Suite* prints as well as their colorful debut chez Volpini; each museum owns a complete set of the *Volpini Suite* as well as paintings also shown in the café. Our

exhibition was born when Heather Lemonedes, associate curator of drawings at the Cleveland Museum of Art and the general editor of the exhibition catalogue, encountered a pristine set of the prints in the museum's collection. She sought the partnership of the Van Gogh Museum; the distinguished Gauguin scholar Belinda Thomson, who identifies many of the paintings by Gauguin that were also included in the exhibition at the café, was recruited to serve as advisor; she also contributed the catalogue's introductory essay and compiled an appendix of letters and reviews concerning the Volpini exhibition. In his chapter Chris Stolwijk, head of research at the Van Gogh Museum, elucidates the efforts of Theo van Gogh on Gauguin's behalf; it was Theo who suggested that Gauguin make a set of prints. While assistant curator at the Van Gogh Museum, Agnieszka Juszczak helped formulate the exhibition concept in its preliminary stages; as an independent scholar, she contributed a chapter scrutinizing the iconography of the *Volpini Suite*. Moyna Stanton, paper conservator at the Cleveland Museum of Art, sheds new light on Gauguin's use of zincography and provides a technical analysis of his yellow paper.

These scholars have brought us a comprehensive investigation of this pivotal moment in the birth of modern art. We celebrate and thank them for their perspicacity, as well as the creativity of Gauguin and his followers, so crucial to the development of art that speaks to us intimately, at the threshold of an era we can recognize as our own.

C. Griffith Mann
Chief Curator, The Cleveland Museum of Art

Axel Rüger
Director, Van Gogh Museum

Acknowledgments

Bringing together sixty works by Paul Gauguin shown at the so-called Volpini exhibition and related to the *Volpini Suite* has been an ambitious endeavor. The challenge of persuading forty-eight lenders, public and private, in the United States, Europe, and Asia to part with their treasured paintings, drawings, prints, ceramics, and woodcarvings by this protean artist and his colleagues greatly benefited from the efforts of both Timothy Rub, former director of the Cleveland Museum of Art, and Axel Rüger, director of the Van Gogh Museum, who enthusiastically supported this project.

We are profoundly grateful to the private collectors whose willingness to participate in the exhibition has enabled us to tell the story of Gauguin's year of self- discovery in 1889. Samuel Josefowitz graciously agreed to lend one of the key paintings that Gauguin exhibited at the Café des Arts. Mr. and Mrs. Willem Cordia loaned a fascinating self-portrait by the artist, and William Kelly Simpson let us borrow a delightful caricature of Gauguin by Émile Bernard. Our examination of Gauguin's treatment of the theme of the bather was enriched by the loans of works from the collections of Richard Kelton and Mrs. Arthur M. Sackler. We are grateful to Irene and Howard Stein, and Jill and Michael Wilson for loans that helped us unite Gauguin's unique hand-colored impressions of the *Volpini Suite,* one of the major goals of this exhibition.

The following individuals strengthened our liaisons with important collectors: Joseph Baillio and Guy Wildenstein (Wildenstein & Company, New York); David Brenneman (High Museum of Art, Atlanta); Ernst Vegelin van Claerbergen (Courtauld Gallery, Courtauld Institute of Art, London); Charlotte Eyerman (Saint Louis Art Museum); Bruce Guenther (Portland [Oregon] Art Museum); James Berry Hill (Berry-Hill Galleries, New York); Cornelia Homburg; Alison Luchs (National Gallery of Art, Washington); Jonathan Rendell and Alison Whiting (Christie's, New York); and Nina del Rio (Sotheby's, New York). The help of Rachael Arauz, Joy Glass, and Diana Kunkel was also indispensable.

We are also grateful to those directors and curators who made their collections available and were powerful advocates for the project within their institutions: Clifford Ackley, Tom Rassieur, Malcolm Rogers (Museum of Fine Arts, Boston); Lucinda Barnes (University of California, Berkeley Art Museum and Pacific Film Archive); André Cariou (Musée des Beaux-Arts de Quimper); Rhoda Eitel-Porter and Jennifer Tonkovich (The Pierpont Morgan Library, New York); Frédéric Bigo and Marie El Caïdi (Musée Départemental Maurice Denis "Le Prieuré," Saint-Germain-en-Laye); Jean-Marie Bruson and Jean-Marc Léri (Musée Carnavalet–Histoire de Paris); Anne Cahen-Delhaye and Claire Dumortier (Musées Royaux d'Art et d'Histoire, Brussels); Gilles Chazal and Isabelle Collet (Petit Palais, Musée des Beaux-Arts de la Ville de Paris); Holly Hughes

(Albright-Knox Gallery, Buffalo); Colta Ives and Susan Stein (The Metropolitan Museum of Art, New York); Gregory Jecmen and Peter Parshall (National Gallery of Art, Washington); Martin Krause and Ellen Lee (Indianapolis Museum of Art); Ger Luijten and Wim Pijbes (Rijksmuseum Amsterdam), James Mundy (Frances Lehman Loeb Art Center, Vassar College, Poughkepsie); Richard Rand (The Sterling and Francine Clark Art Institute, Williamstown); William Robinson (Fogg Art Museum, Harvard University, Cambridge); Ana Sánchez-Lassa (Museo de Bellas Artes de Bilbao); Sandra Stelts (Pennsylvania State University, State College); and Eric Zafran (Wadsworth Atheneum Museum of Art, Hartford).

Several independent scholars have added immeasurably to the quality of the exhibition and its accompanying publication. Louise d'Argencourt researched the addresses listed by Gauguin in his carnet of 1889, Peter Bower analyzed Gauguin's yellow paper, and Clément Siberchicot generously shared his research on the Volpini exhibition.

Numerous individuals facilitated our research and helped stimulate our thoughts: the staff at the Musée Historique de la Ville de Paris; Karen Beckwith and Margaret Denk-Leigh (The Cleveland Institute of Art); Caroline Boyle-Turner; Eric Carlson; Isabelle Cahn and Sarah Linford (Institut National de l'Histoire de l'Art Paris); Kristi Dahm, and Rachael Freeman (The Art Institute of Chicago); Nanne Dekking (Wildenstein and Company, New York); Marion Dirda, Lisha Glinsman, Michael Palmer, and Kimberly Schenk (National Gallery of Art, Washington); Ségolène Le Men (Université de Paris–X, Nanterre); Dominique Lobstein, Laure de Margery, and Annie Roux-Dessarps (Service de Documentation, Musée d'Orsay, Paris); Patricia Mainardi (The Graduate Center, City University of New York); Monique Nonne; Anne Pingeot (former chief curator of sculpture, Musée d'Orsay); Jonathan Pratt; Rodolphe Rapetti (Deputy Director, Direction des Musées de France); Thalie Rapetti; Valérie Sueur-Hermel (Bibliothèque Nationale de France, Paris); Richard Thomson, Elizabeth Cowling, Frances Fowle, and Vivien Hamilton (Third Republic Seminar, University of Edinburgh); and Judy Walsh (Buffalo State College, New York). Heather Lemonedes's early research was facilitated by a travel grant from the Samuel H. Kress Foundation.

The dedicated staff at the Cleveland Museum of Art gave immeasurable time and energy to realize this exhibition and publication: Katharine Lee Reid, director 2000–2005, championed this project's early development; her successor, Timothy Rub, director 2006–9, was an advocate from the moment of his arrival; and Chief Curator Griffith Mann was a wellspring of ideas and encouragement. Over several years Heidi Strean's skills and dedication helped bring the project to fruition. Betsy Lantz and the staff of Ingalls Library tracked down countless book orders and

interlibrary loans, and special thanks are due Christine Edmonson who was enormously helpful and creative in our investigation into Gauguin's yellow paper. We thank Mary Suzor and the staff of Collections Management for organizing the application for indemnity, coordinating and facilitating the many loans and related logistics, and gathering images for the catalogue. We are grateful to Jeffrey Strean, Jim Engelmann, and Lizzy Lee for their inspired exhibition and graphic design of the installation in Cleveland, and to Marjorie Williams and Caroline Goeser for organizing thought-provoking educational programs. The authors are particularly grateful to Barbara Bradley and Laurence Channing for meticulously editing the English version of the manuscript. We thank curators Jane Glaubinger for feedback on the manuscripts and Constantine Petridis for assistance with translations. In Conservation we acknowledge the assistance of Amy Crist and Henry Travers Newton.

Other staff members from the Cleveland Museum of Art were indispensable to the project: Howard Agriesti, David Brichford, and Adam LaPorta in Photography; Joan Brickley in Prints and Drawings; Marty Ackley, Barry Austin, Arthur Beukemann, John Beukemann, Joseph Blaser, Kim Cook, Todd Hoak, Elizabeth Saluk, and Lauren Turner in Collections Management; Cindy Fink and Marketing and Communications staff members; Susan Stevens Jaros and the Development and External Affairs staff; editors Jane Takac Panza and Amy Sparks; Sheri Walter in the Exhibitions Office; and Bridget Weber in curatorial. Former Deputy Director Charles Venable first encouraged the exhibition concept and supported its development.

We are also deeply indebted to the staff members of the Van Gogh Museum for their assistance preparing this book and the exhibition. We express our gratitude to Edwin Becker, Head of Exhibitions, curator Maartje de Haan and the research staff and curators Nienke Bakker, Leo Jansen, Louis van Tilborgh and Sjraar van Heugten, Head of Collections. A special word of thanks is due Curator of Drawings and Prints Marije Vellekoop for her invaluable advice and help with the manuscripts.

Suzanne Bogman and Geri Klazema dedicated themselves to the publication of this book in collaboration with Marielle Gerritsen.

Regarding the organization of the exhibition at the Van Gogh Museum, we thank Esther Hoofwijk, Fouad Kanaan, and Martine Kilburn and, last but not least, Rianne Norbart, Anita Vriend, and former Director John Leighton who espoused our work from the beginning of this singular project. This catalogue could not have been produced without the wholehearted backing of publisher Annette Kulenkampff of Hatje Cantz Verlag in Ostfildern, Germany. She initiated the collaboration with copublishers and organized the various language editions that will extend the

readership of this book around the world. We thank Simone Albiez and Stefanie Langner for their skillful help at Hatje Cantz Verlag, and Christina Hackenschuh and Markus Braun, for their appealing design. Michael Hoyle and Diane Webb took care of the excellent English translations.

Finally, we thank friends and family Calvin Brown, Richard Thomson, and Renee Bos for their encouragement throughout this endeavor.

The Authors

Lenders to the Exhibition

Private Collections

The Kelton Foundation, Santa Monica
Private collection, courtesy Barbara Divver Fine Art
Private collections: United States, Europe, and Japan
Mrs. Arthur M. Sackler
William Kelly Simpson, New York
Collection of Irene and Howard Stein
The Triton Foundation, The Netherlands
Collection of Jill and Michael Wilson

Public Collections

Albright-Knox Art Gallery, Buffalo
The Art Institute of Chicago
The Cleveland Museum of Art
Fogg Art Museum, Harvard University Art Museums, Cambridge
Frances Lehman Loeb Art Center, Vassar College, Poughkeepsie
Indianapolis Museum of Art
J. F. Willumsens Museum, Frederikssund, Denmark
Kröller-Müller Museum, Otterlo, The Netherlands
Kunsthalle Bremen
McNay Art Museum, San Antonio
The Metropolitan Museum of Art, New York
Musée Carnavalet–Histoire de Paris
Musée Centre-des-Arts, Fécamp
Musée Départemental Maurice Denis "Le Prieuré," Saint-Germain-en-Laye
Musée des Beaux-Arts, Quimper
Musée d'Orsay, Paris
Musées Royaux d'Art et d'Histoire, Brussels
Museo de Bellas Artes, Bilbao
Museum of Fine Arts, Boston
National Gallery of Art, Washington
Nationalmuseum, Stockholm
Ny Carlsberg Glyptotek, Copenhagen
Ordrupgaard, Charlottenlund, Denmark
Pennsylvania State University Libraries
Petit Palais, Musée des Beaux-Arts de la Ville de Paris
The Pierpont Morgan Library, New York
Pushkin State Museum of Fine Arts, Moscow
Rijksmuseum Amsterdam
Staatliche Kunstsammlungen Dresden, Gemäldegalerie Neue Meister
Sterling and Francine Clark Art Institute, Williamstown
Toledo Museum of Art
University of California, Berkeley Art Museum and Pacific Film Archive
Van Gogh Museum, Amsterdam
Wadsworth Atheneum Museum of Art, Hartford

Volpini Suite

The *Volpini Suite* comprises ten zincographs plus a frontispiece. Gauguin assembled the ten prints in a portfolio, with the frontispiece affixed to the cardboard cover. He chose large sheets of canary yellow paper, measuring 50 × 65 cm, with the images printed in the center. These portfolios were for sale at the Café des Arts during the Volpini exhibition.

Cat. 1. *Design for a Plate: Leda and the Swan*, Van Gogh Museum, Amsterdam

Cat. 2. *Breton Bathers*, Van Gogh Museum, Amsterdam

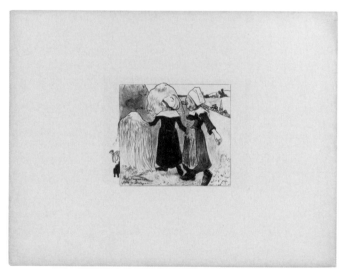

Cat. 3. *Joys of Brittany*, Van Gogh Museum, Amsterdam

Cat. 4. *Dramas of the Sea*, Van Gogh Museum, Amsterdam

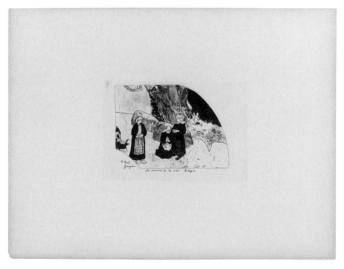

Cat. 5. *Dramas of the Sea: Brittany*, Van Gogh Museum, Amsterdam

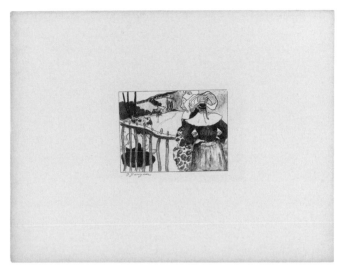

Cat. 6. *Breton Women by a Gate,* Van Gogh Museum, Amsterdam

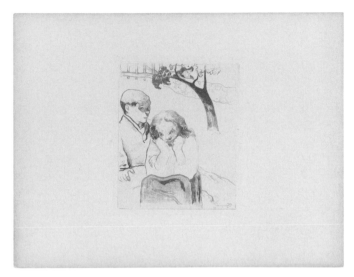

Cat. 7. *Human Misery,* Van Gogh Museum, Amsterdam

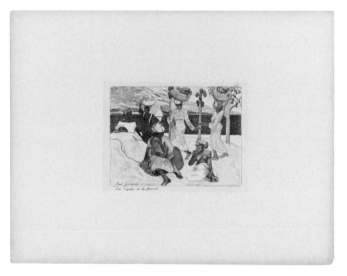

Cat. 8. *The Grasshoppers and the Ants,* Van Gogh Museum, Amsterdam

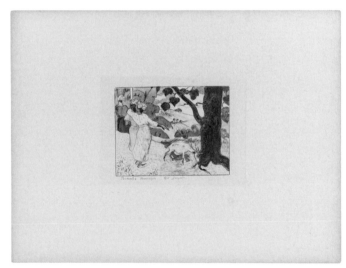

Cat. 9. *Martinique Pastorals,* Van Gogh Museum, Amsterdam

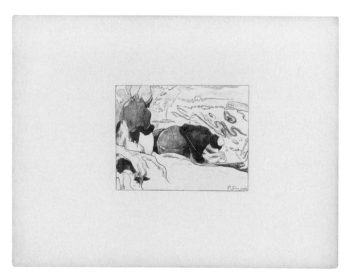

Cat. 10. *The Laundresses,* Van Gogh Museum, Amsterdam

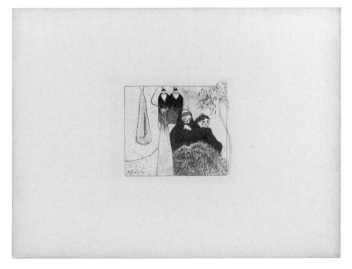

Cat. 11. *Old Women of Arles,* Van Gogh Museum, Amsterdam

Volpini Suite

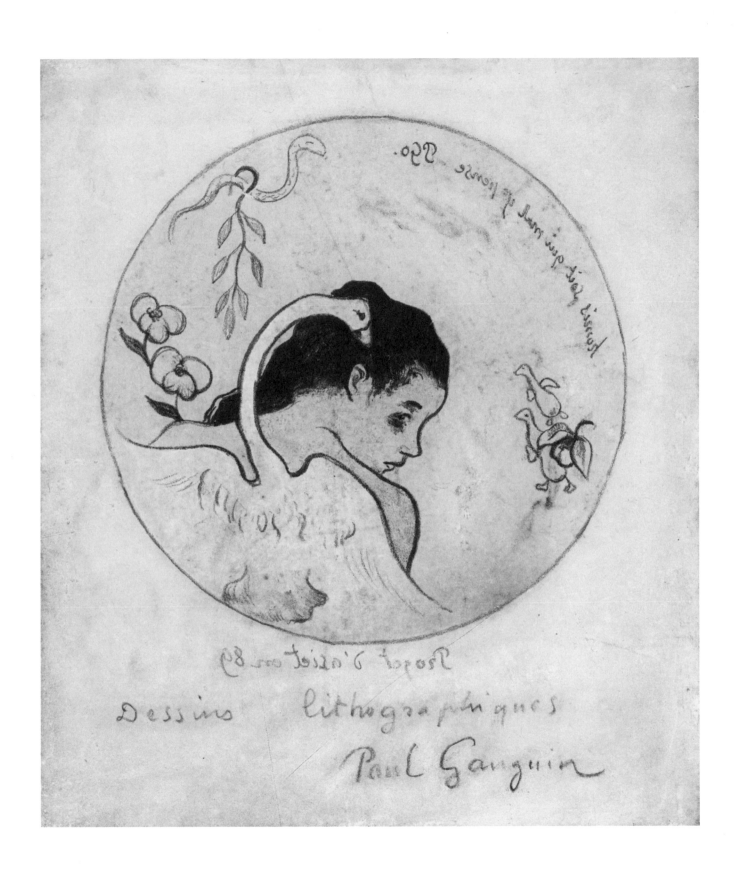

Cat. 12. *Frontispiece, Design for a Plate: Leda and the Swan*, The Cleveland Museum of Art

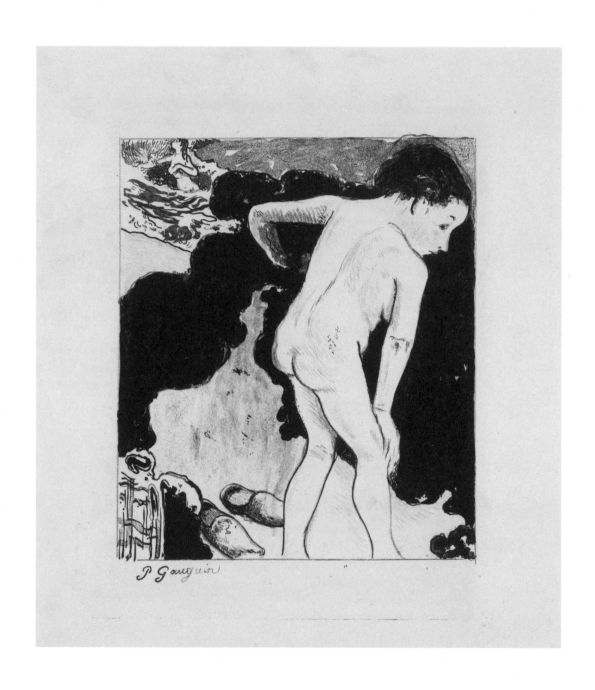

Cat. 13. *Breton Bathers,* The Cleveland Museum of Art

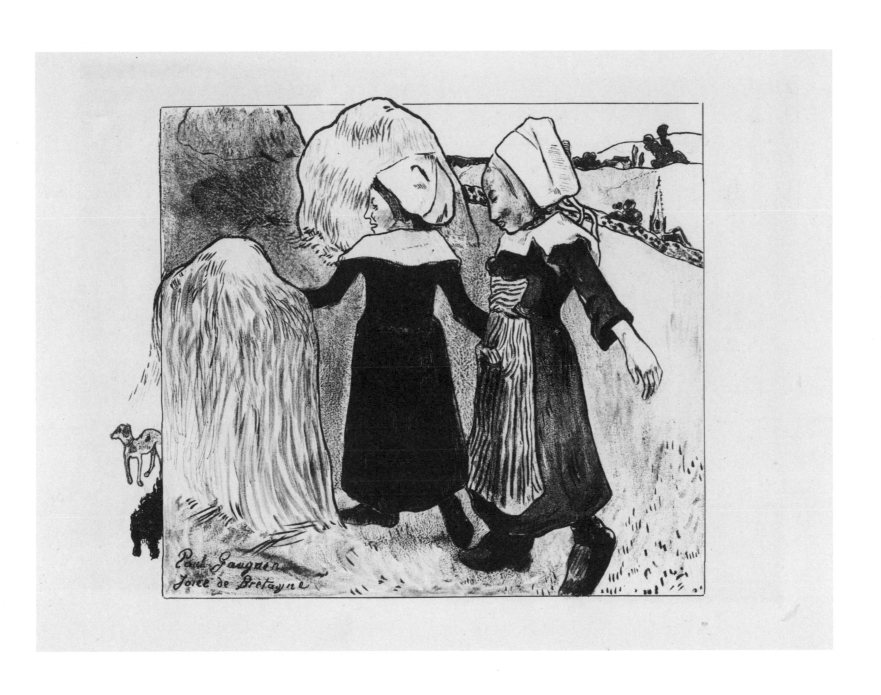

Cat. 14. *Joys of Brittany,* The Cleveland Museum of Art

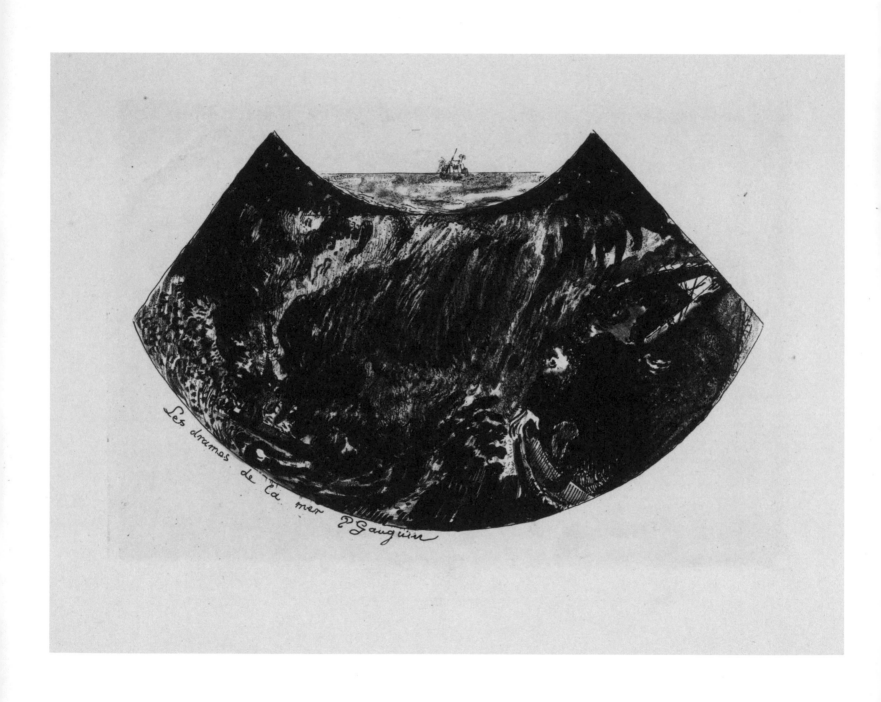

Cat. 15. *Dramas of the Sea,* The Cleveland Museum of Art

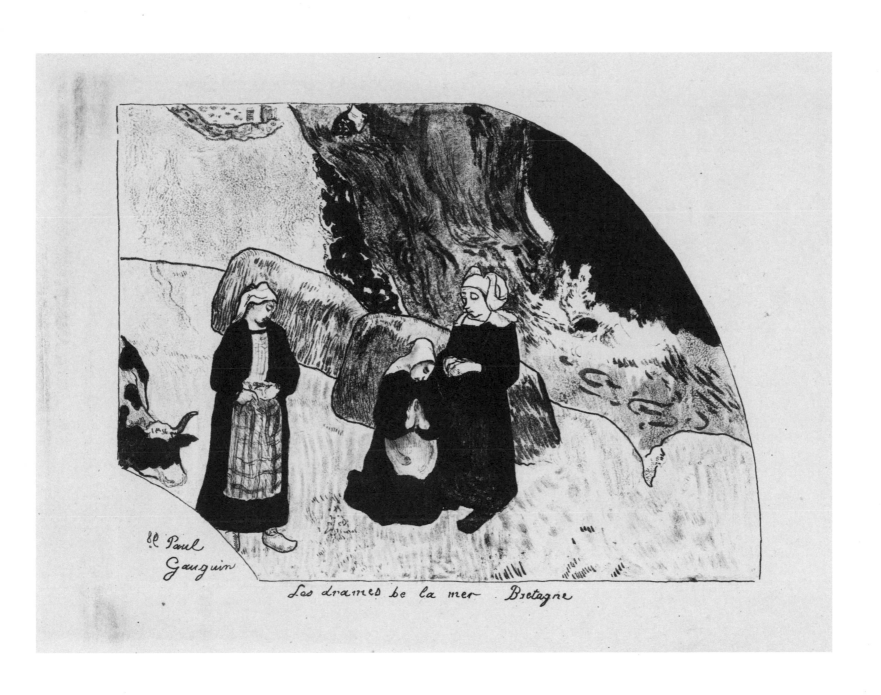

Cat. 16. *Dramas of the Sea: Brittany,* The Cleveland Museum of Art

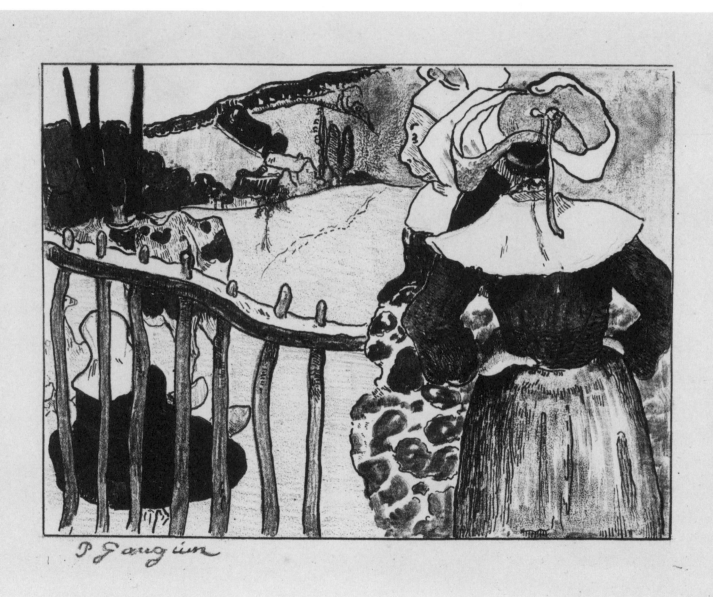

Cat. 17. *Breton Women by a Gate*, The Cleveland Museum of Art

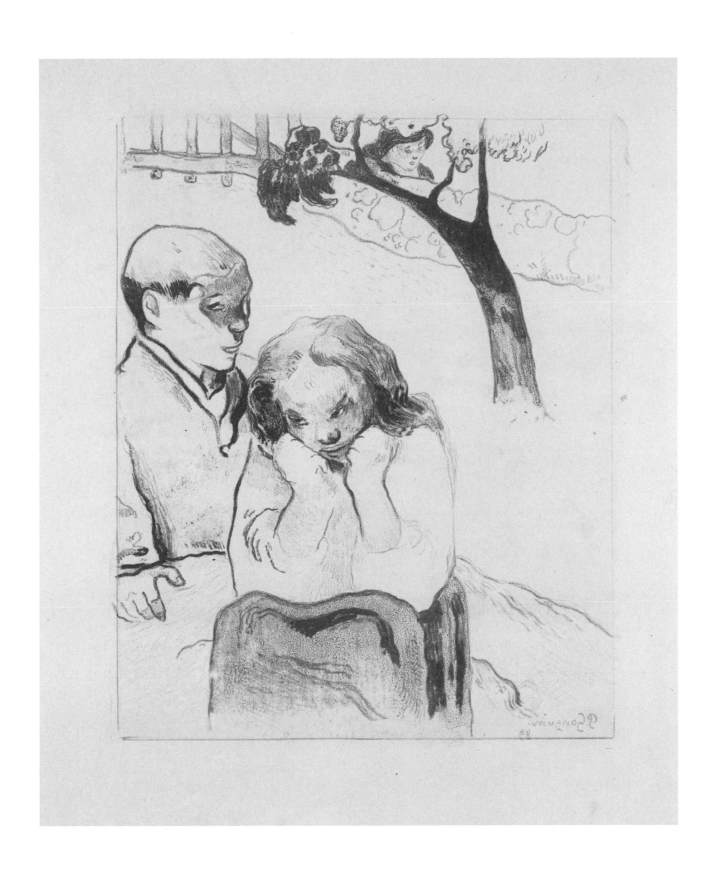

Cat. 18 *Human Misery,* The Cleveland Museum of Art

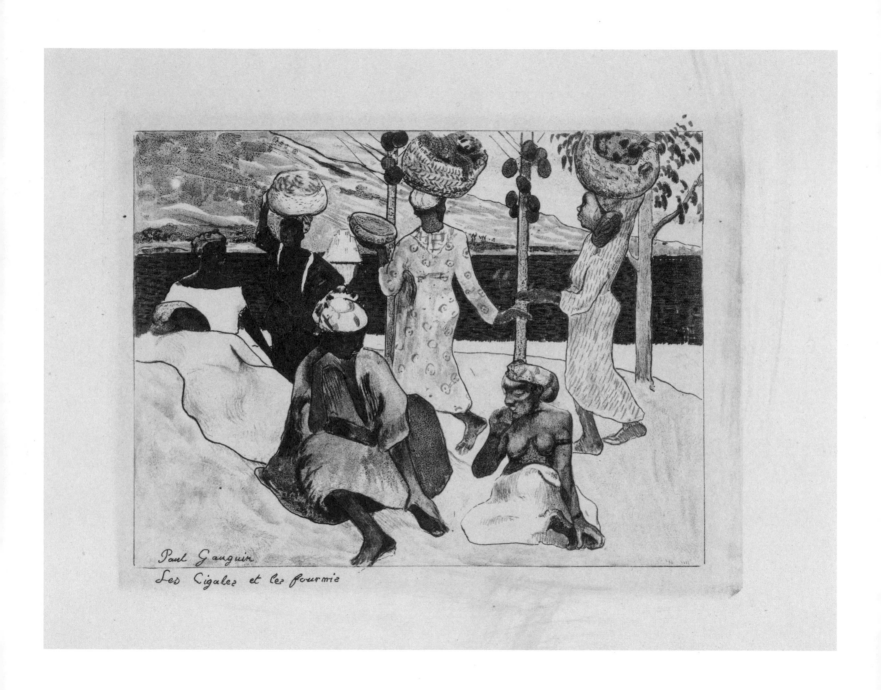

Cat. 19. *The Grasshoppers and the Ants,* The Cleveland Museum of Art

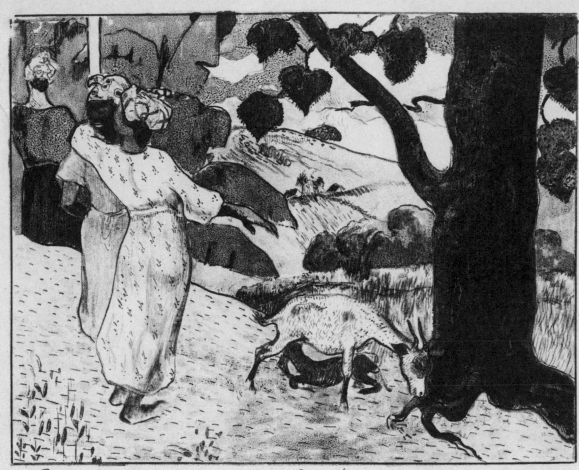

Cat. 20. *Martinique Pastorals,* The Cleveland Museum of Art

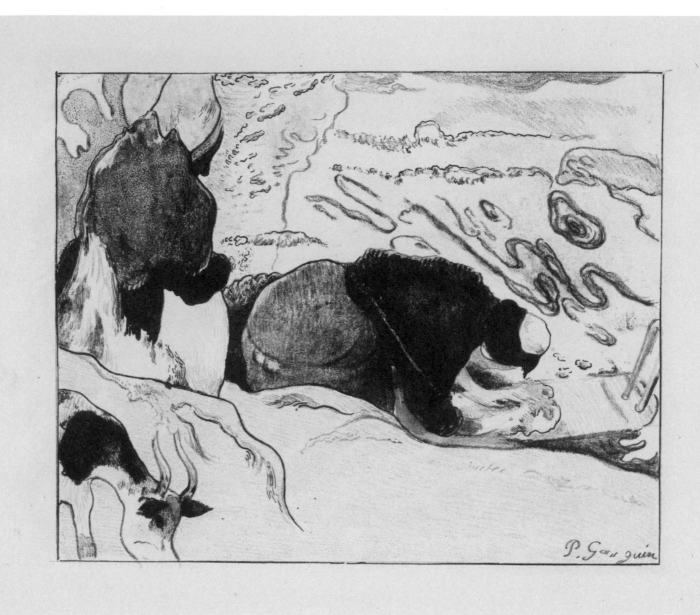

Cat. 21. *The Laundresses,* The Cleveland Museum of Art

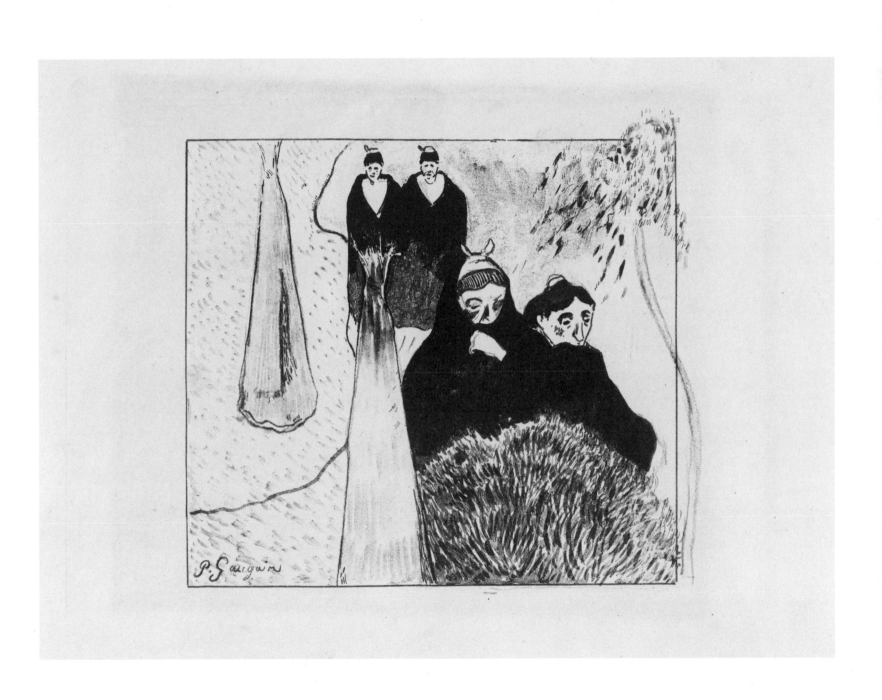

Cat. 22. *Old Women of Arles,* The Cleveland Museum of Art

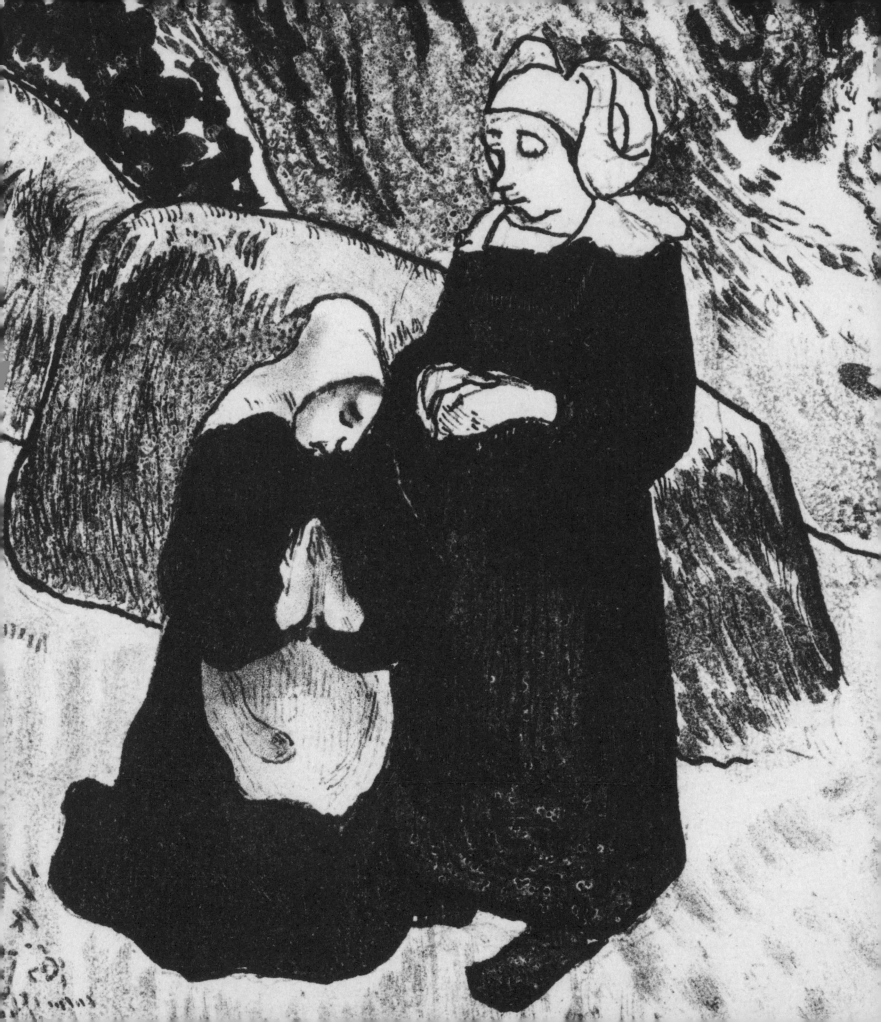

Gauguin Goes Public
Belinda Thomson

The exhibition staged by Paul Gauguin and his comrades within the grounds of the Exposition Universelle of 1889 has long fascinated art historians. Originally billed as an exhibition of the Groupe Impressionniste et Synthétiste, it quickly became known as the Volpini show, taking the name of the proprietor of the café where it was staged. The Volpini show was a bold intervention, almost a guerrilla raid, one of the defining moments in Gauguin's career and a turning point for the artists he influenced. But what do we actually know about it? The Exposition Universelle left a permanent iconic monument, the Eiffel Tower, and a wealth of imagery; it also spawned an enormous literature: ample coverage in the daily press and periodic journals, not to mention weighty and detailed official tomes recording the contents of every section. By contrast, the Volpini show was an ad hoc affair that left scant trace: no installation photographs and just a single sketch by a contemporary illustrator, a rudimentary poster, a cheaply produced catalogue comprising a list of works, and a handful of references in the more ephemeral art journals of the day.[1] Moreover, confusion has surrounded the story of the event's organization thanks to the garbled chronology of the letters and retrospective accounts left by the participants and interested observers.[2] The present exhibition, with its focus on the remarkable suite of prints Gauguin produced and offered for sale in album form at the Volpini show, seemed a valuable opportunity to try to piece together a fuller account of the circumstances that brought the print project into being.

The Exposition Universelle

The 1889 Exposition Universelle was the fourth in a series of such events typically staged in Paris at eleven-year intervals by the French State, the first having been held in 1855 during the Second Empire. Showcases for French industry, with technological progress very much to the fore, these expositions were also extravaganzas for the arts and applied arts, each new one generating more grandiose and comprehensive ambitions. Compared with the 1878 exposition, which took place when France was just recovering from the devastation caused by the Franco-Prussian war and the Commune, visitor numbers almost doubled in 1889, reaching an extraordinary 28 million people. The date was of course significant, and the Republican government of the day made the most of that importance, although celebrating the centenary of the start of the French Revolution was not universally popular, especially among France's neighboring monarchies. Administrative finesse was required to make a success and a unifying experience of the exposition.

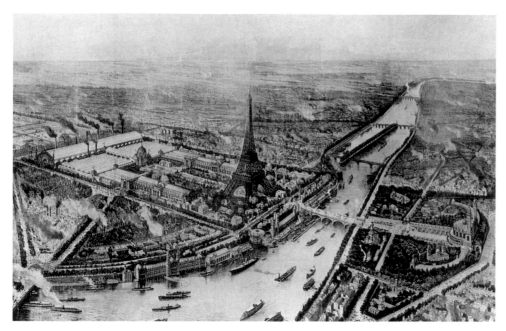

Fig. 1. Bird's-eye view of the 1889 Paris Exposition Universelle, from Brincourt,
L'Exposition Universelle de 1889 (Paris, 1890)

As in earlier years, the exposition centered on the Champ de Mars, the spacious parade ground separating the École Militaire from the river Seine, but extended to incorporate the Invalides esplanade, the stretch of the Seine linking the two, and beyond (fig. 1). Dominated by the spectacular Eiffel Tower (fig. 2), a structure that itself aroused passions for and against, the enormous site comprised elegant ironwork pavilions and a host of colorful temporary structures (cat. 23, p. 32). Ten government ministries ranging from Trade and Industry to Public Education were involved in the organization, showcasing the many facets of the State's public services and their history, each of which was meant to convey positive messages. One political initiative was the Exposition Coloniale, officially reckoned "one of the most curious attractions of the 1889 Exposition" (fig. 3, p. 33).[3] More than 300 *indigènes* from Annam (Vietnam and Tonkin), Senegal, Gabon and Congo, New Caledonia and Tahiti were brought to Paris to live in temporary enclaves for six months under the gaze of the public.[4] Following a period of renewed aggressive colonial expansion, this experiment was intended not only to foster French citizens' curiosity about the new territories annexed by or affiliated with France, but also, arguably, to make a favorable impression on the indigènes who made the journey to Paris. Another popular attraction, partially privately sponsored, was the panorama. No fewer than ten different panoramas offered visitors virtual experiences in painted form: a transatlantic sea voyage, for instance, or oil fields in Pennsylvania and Caucasia, or the history of the century represented by its famous men and women. The scale of the site was a challenge: to help visitors get around, a small railway was installed, and the Tonkinoise *pousse-pousse* (rickshaw) proved particularly popular (figs. 4, 5, p. 34). It is fair to say that no Parisian, and especially no Parisian trader, failed to get involved in the event, whose impact could perhaps be compared to an Olympic Games staged over a six-month period, with a similar emphasis on medals.

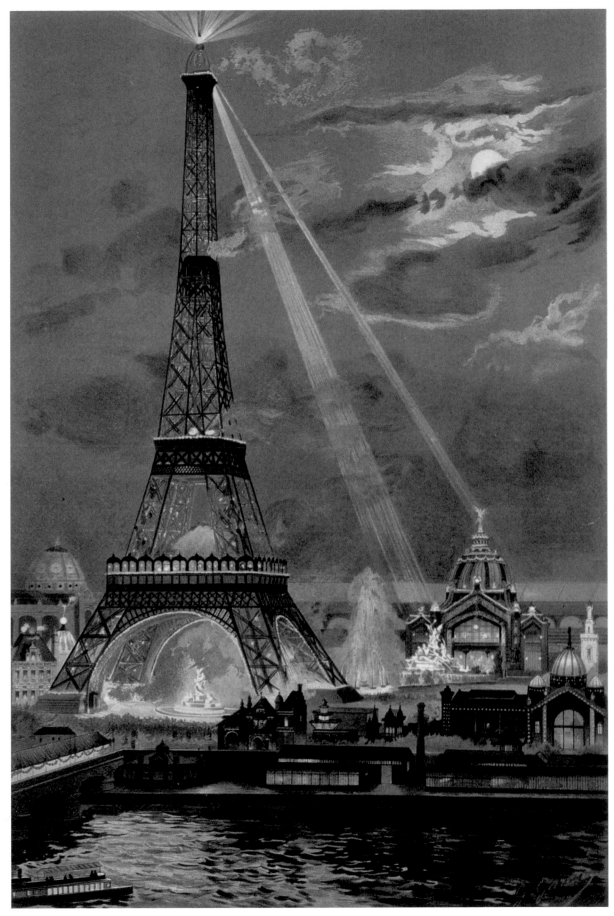

Fig. 2. Georges Garen, *The Lighting of the Eiffel Tower during the Exposition Universelle of 1889,* Musée d'Orsay, Paris

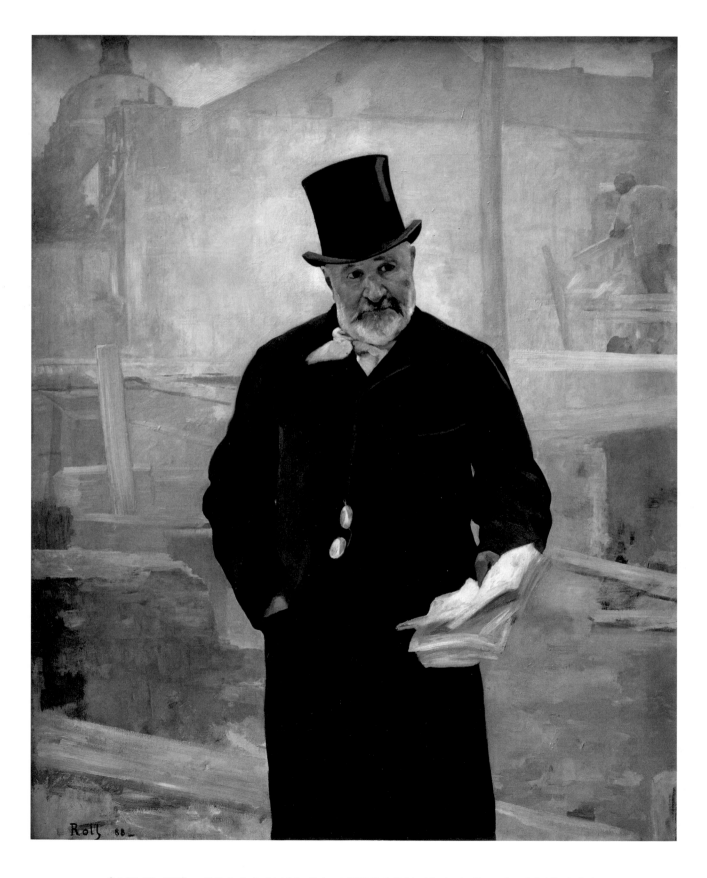

Cat. 23. Alfred-Philippe Roll, *Portrait of Adolphe Alphand,* 1888, Petit Palais, Musée des Beaux-Arts de la Ville de Paris.
Roll's lifesize portrait shows Alphand, the landscape architect of Haussmann's Paris and Directeur Général des Travaux (Chief
Director of Works), at the 1889 Paris Exposition inspecting the progress of the exhibition site. Shown at the Décennale

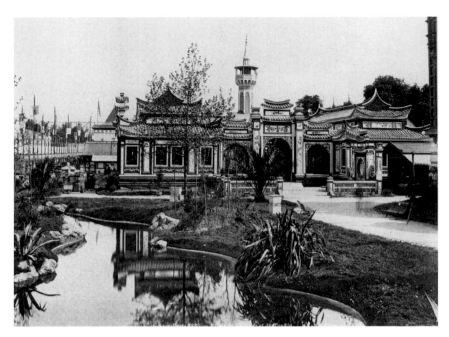

Fig. 3. Pavilion of Annam and Tonkin at the 1889 Paris Exposition Universelle, from *1889, La Tour Eiffel et L'Exposition Universelle* (Paris: Musée d'Orsay, 1989)

As in previous years, the arts played a prominent role. Painting, sculpture, and print exhibitions occupied the Palais des Beaux-Arts on the Champ de Mars (fig. 6, p. 35). The applied arts—ceramics, tapestry, perfumery, fashion, furniture, and the like—were placed in the Palais des Industries Diverses, whose central dome was a riot of color, its ironwork frame studded with polychrome enamel plaques (cat. 24, p. 37). Ethnographic diorama displays in the Palais des Arts Libéraux explored such themes as fresco painting, paper and writing, ceramics, and weaving (fig. 7, p. 36). Complementary exhibitions were organized across the river in the Trocadéro, the Musée du Louvre, and commercial galleries. Over and above the regular Décennale (decade-long survey) exhibition, it was agreed that the historic date demanded a century-long survey. Yet Antonin Proust, former minister of Fine Arts and president of the organizing commission, had to fight to get a representative Centennale exhibition located at the center of the Palais des Beaux-Arts (cat. 25, p. 38). In his report, he described the challenge the Décennale presented, of fitting so many works into a confined space, as repugnant:

I had to make the best of it, and park the works of art like exhibits in an agricultural show. I only just managed, in the rooms reserved for the Centennale Exhibition, to make provision for a little bit of space between the canvases that were crammed onto the walls. . . . In spite of all, the public saw and the public was so thrilled to see that, six months on, they carried away the conviction that rarely had a more extraordinary spectacle been set before it. . . . French art . . . totally triumphed in 1889.[5]

Proust's verdict was echoed by the foreign artists—representing many of the countries of Europe and North and South America—whose jury unanimously voted for a medal of honor to be awarded, collectively, to the artists of the host country. This proposal was deemed unconstitutional, but it did much for French artistic pride.[6]

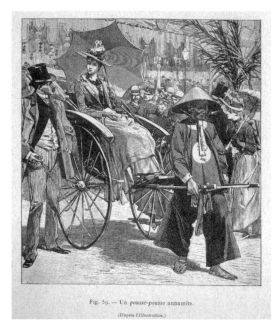

Fig. 4. Tonkinoise pousse-pousse, from Brincourt, *L'Exposition Universelle de 1889* (Paris, 1890)

Fig. 5. La Rue du Caire, 1889, Bibliothèque Nationale de France, Paris

Although one paid for individual attractions, the entrance tickets to the site were priced deliberately low and on a sliding scale, with the intention of making the exposition accessible not just to "the many idlers, sightseers, and rich leisured foreigners," as Proust put it, but also to the artisans and workers of Paris.[7] And early accounts suggest visitors to the exposition enjoyed themselves, making multiple visits to sample the cosmopolitan range of food, music, architecture, and art on offer, to be thrilled by the new technology and inventions, and to discover the rapidly changing world within and without France's borders.[8]

Paul Gauguin at the Exposition

At the time of the exposition's inauguration by President Carnot on 6 May 1889, Gauguin was in Paris; having moved out of Émile Schuffenecker's home, he was living in a rented studio at 25 Avenue Montsouris.[9] We know Gauguin made several visits to the exposition and that the colonial exhibition was decisive in inspiring and informing his future travels.[10] We also know he was enthusiastic about the Javanese dancing, that he made an assignation (possibly arranging a sitting) with a mulatto woman and went twice to Buffalo Bill's rodeo, which staged twice-daily performances out at Neuilly.[11] By the sound of Gauguin's enthusiastic letters to Émile Bernard and in view of the long-term impact the exposition's manifold attractions had on him, one has to assume Gauguin lost no opportunity to spend time there, taking advantage of the cheap entry fee. As far as the fine arts were concerned, the Centennale probably held the strongest interest. If Proust found it a more satisfying exhibition to hang than the overcrowded Décennale, the Centennale almost certainly also offered a more rewarding visitor experience.[12] Proust intended to produce a survey of the key movements in French art of the preceding century, which meant calling upon national museums and private collectors of all political persuasions to rally to "la patrie."[13]

The survey began with popular minor masters of the late eighteenth century, before paying homage to the Neoclassical school of Jacques-Louis David, Jean-Auguste-Dominique Ingres and his pupils, to Eugène Delacroix, to the landscapists of 1830 (not yet designated the Barbizon school), to midcentury realism and to the plein-air movement represented by Édouard Manet and

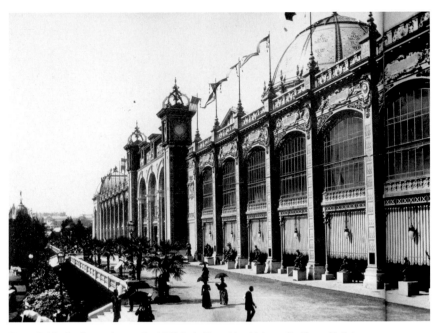

Fig. 6. Palais des Beaux-Arts at the 1889 Paris Exposition Universelle, Roger-Viollet

Jules Bastien-Lepage, respectively, both recently deceased.[14] A number of very large works such as David's *Coronation of Napoléon*, 1807 (Musée du Louvre, Paris), Delacroix's *Battle of Taille-bourg*, 1837 (Louvre), and Thomas Couture's *Romans of the Decadence*, 1847 (Musée d'Orsay, Paris), punctuated the display. Some artists were represented with up to twenty canvases; Camille Corot had a remarkable forty-four in all, matched by the thirteen paintings and more than thirty works on paper by Jean-François Millet. Gustave Courbet and Théodore Rousseau were well represented. Although in this way the Centennale redressed previous injustices, certain visitors (Gauguin among them) were not so ready to forget or forgive the neglect of earlier administrations.[15] Opinions varied as to which reputations had best stood the test of time, but there was a strong feeling, shared by Gauguin, that it was the formerly spurned who had now triumphed, that the few enlightened collectors and critics who had put their faith in Delacroix, Corot, or Manet had been vindicated, and that the aesthetic of the École des Beaux-Arts looked distinctly unsound.[16]

At the Décennale, which purported to demonstrate the trends of the last decade and was well stocked with works by such Salon favorites as William-Adolphe Bouguereau, Carolus-Duran, Henri Gervex, and Jules Lefebvre, there were anomalies and notable absentees. While such popular living artists as Ernest Meissonier, Jules Breton (cat. 27, p. 40), and Alfred-Philippe Roll featured in both exhibitions, there was not a single work by an independent Impressionist artist. Only in the Centennale could Gauguin see a smattering of paintings by his Impressionist colleagues: three by Claude Monet, two by Camille Pissarro, and one by Paul Cézanne.[17] Similarly, works likely to interest him by Pierre Puvis de Chavannes were confined to the Centennale.[18] To add insult to injury, their works went unmentioned in the official report of the Centennale because the author, Armand Dayot, adopted the self-imposed principle of not citing works by living artists.[19] It is hard to explain the omission of these artists from the Décennale, an oversight lamented by a number of contemporary observers. One wonders if political considerations were at work: the fact that it was a State-run exhibition and these independent artists were represented by the dealer Paul Durand-Ruel (whose Catholic monarchist politics were inimical to the Repub-

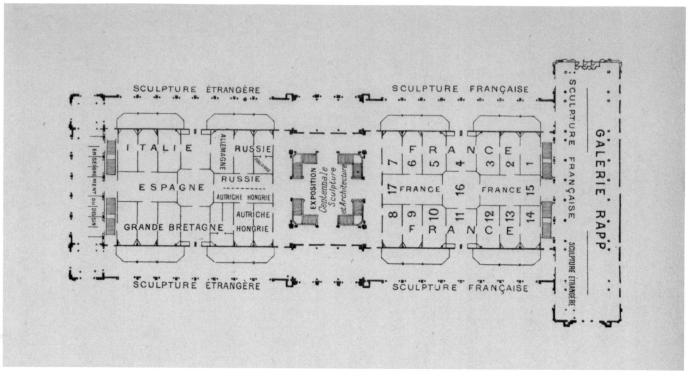

Fig. 7. Ground plan of the Champs de Mars galleries, from François Guillaume Dumas, *Exposition Universelle de 1889: Catalogue Illustré des Beaux-Arts* (Lille, 1889). Volpini's Café des Arts was in the projecting bay immediately outside the Italian sculpture galleries.

lic) was perhaps a factor.[20] Certainly Edgar Degas, entrenched in his opposition to State patronage, had turned down Proust's invitation to hang a group of works at the Centennale.[21]

Nevertheless Gauguin, with his own exhibition plan in mind, would have cast his eye over the Décennale: the foreign sections included individuals he knew such as the Norwegian Fritz Thaulow (until recently his brother-in-law), the Swede August Hagborg, and the Dane Theodor Philipsen. One wonders if he noticed the three works by Jens Ferdinand Willumsen, another Danish artist who would seek him out in the coming months. It cannot have escaped Gauguin's notice that some of the strongest paintings featured peasant subjects set in Brittany: *The Widow of the Island of Sein* (*La veuve du marin*) by Émile Renouf (cats. 29, 30, pp. 42–43) and *The Pardon in Brittany* by Pascal Dagnan-Bouveret (cat. 26, p. 39), both widely reproduced, curiously prefigure Gauguin's fascination with Breton religiosity. But his stock response was one of derision to the naturalist painters who continued to dominate the Décennale, whether it was Roll and Jean-François Raffaëlli, with their democratic parti pris, or those peddlers of modern-life anecdotage Jean Béraud and Ernest Duez. Rare were the works that departed from this naturalist norm and might have interested him more, the imaginative Wagnerian compositions of Henri Fantin-Latour, for instance (cat. 28, p. 41). As a practicing sculptor and ceramist, Gauguin doubtless looked into the sculpture sections, just as he took an interest in the Sèvres porcelain display, writing about this a few weeks later.

Infiltrating the Exposition

With millions of visitors expected in Paris, the year 1889 offered an exhibiting opportunity not to be missed from the ambitious artist's point of view. Monet and Auguste Rodin, for instance, staged a joint show with the dealer Georges Petit, and the annual Salon des Indépendants was rescheduled to September to catch the exposition crowds. Vincent van Gogh was as aware of this pros-

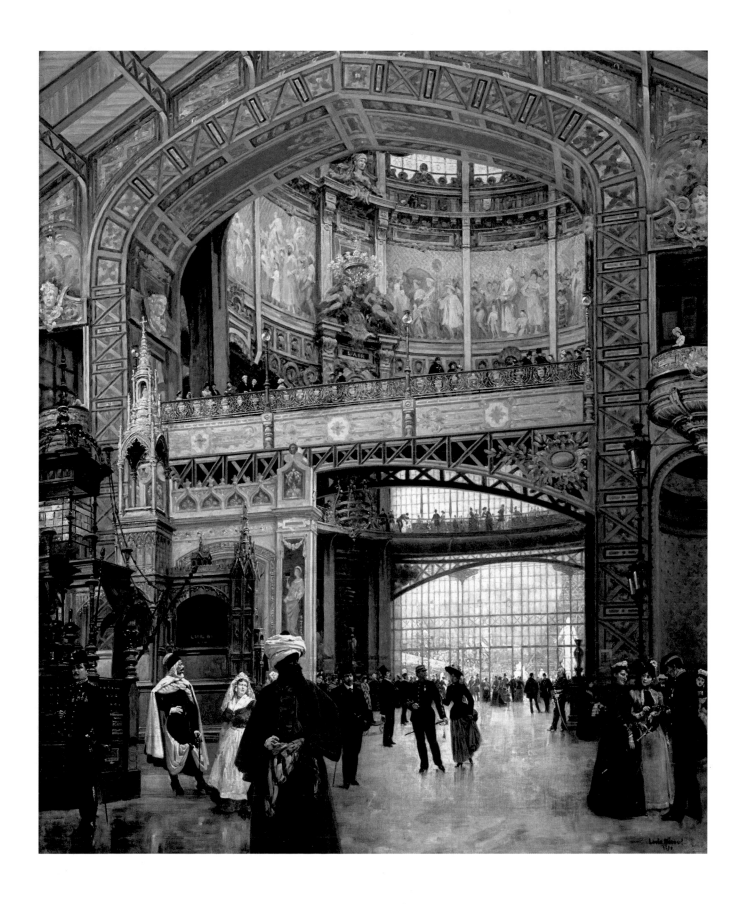

Cat. 24. Louis Béroud, *The Central Dome at the Exposition Universelle of 1889*, 1889, Musée Carnavalet—Histoire de Paris

Cat. 25. Édouard Manet, *Portrait of Antonin Proust,* 1880, Toledo Museum of Art. Shown at the Centennale

Cat. 26. Pascal Dagnan-Bouveret, *The Pardon in Brittany,* 1886, The Metropolitan Museum of Art, New York. Shown at the Décennale

Cat. 27. Jules Breton, *The Shepherd's Star,* 1887, Toledo Museum of Art. Shown at the Décennale

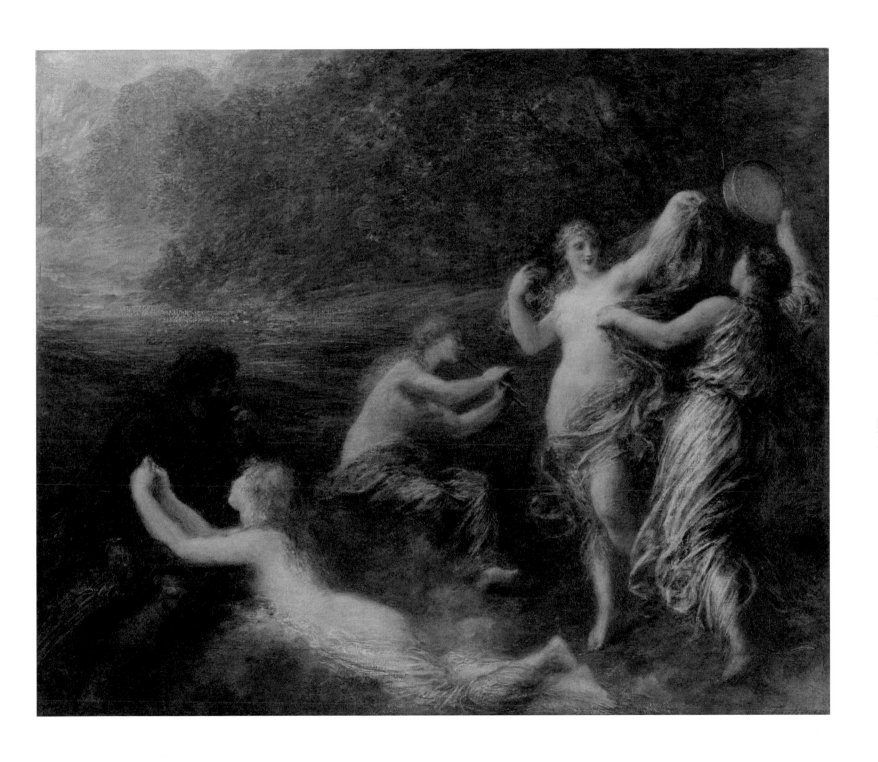

Cat. 28. Henri Fantin-Latour, *Tannhäuser,* 1886, The Cleveland Museum of Art. Shown at the Décennale

Cat. 29. Émile Renouf, *The Widow of the Island of Sein,* 1880, from *L'Exposition de Paris* (Paris, 1889), 2: 185, Van Gogh Museum (Library), Amsterdam

pect as Gauguin; in Arles they had doubtless discussed the ways and means of infiltrating the coming exposition. Indeed Van Gogh had pioneered the idea of showing work in popular eating houses.[22] Gauguin approached the business of exhibiting in strategic, distinctly militaristic terms, regularly speaking of confrontation, rallying, regrouping, and struggle. Tellingly, when Gauguin made his precipitous return north from Arles at the end of 1888, Van Gogh mischievously called him "le petit tigre Bonaparte de l'impressionisme" returning to Paris from exile, determined to impose himself, as had Napoleon returning from Egypt.[23]

Gauguin had a keen sense of timing and strategy, and an impatience with bureaucracy and officialdom. From the outset of his association with the Impressionists, he had actively participated in discussions about exhibition organization. Disappointed by his failure to make a splash at the eighth Impressionist exhibition in 1886 and away from the center of things for much of 1887, during 1888, with Theo van Gogh's support and occasional displays of his work allowing his confidence to grow, Gauguin became ever more alert to getting his work seen at the right time and in the right quarters. When he was invited to show his work in late 1888 by two separate progressive organizations—Les XX, an exhibiting society based in Brussels, and *La Revue Indépendante,* a Paris journal that staged small displays in its offices—he accepted the former with alacrity, since a key part of his strategy was to gain international recognition, but he rudely turned down the latter. Because the journal had consistently supported the Neo-Impressionists grouped around Georges Seurat, Gauguin regarded showing at their miserable "hole" tantamount to entering the enemy's camp.[24] So as far as he was concerned in 1889, the "enemy" (apart from most of the exhibitors at the official exhibitions) was the Neo-Impressionists but also old Impressionists such as Pissarro who, he suspected, looked unfavorably on his latest developments and ambitions as an artist.[25]

Gauguin was not the only artist to have exhibited on site but outside the State-run Palais des Beaux-Arts. The recently constituted private art societies, the Aquarellistes and the Pastellistes, organized exhibitions in their own separate pavilions, which proved meeting points for the beau monde. But the earlier precedents Gauguin had in mind in orchestrating the "avant-garde gambit" of the Volpini show were Courbet, who had staged unofficial solo shows to coincide with the 1855

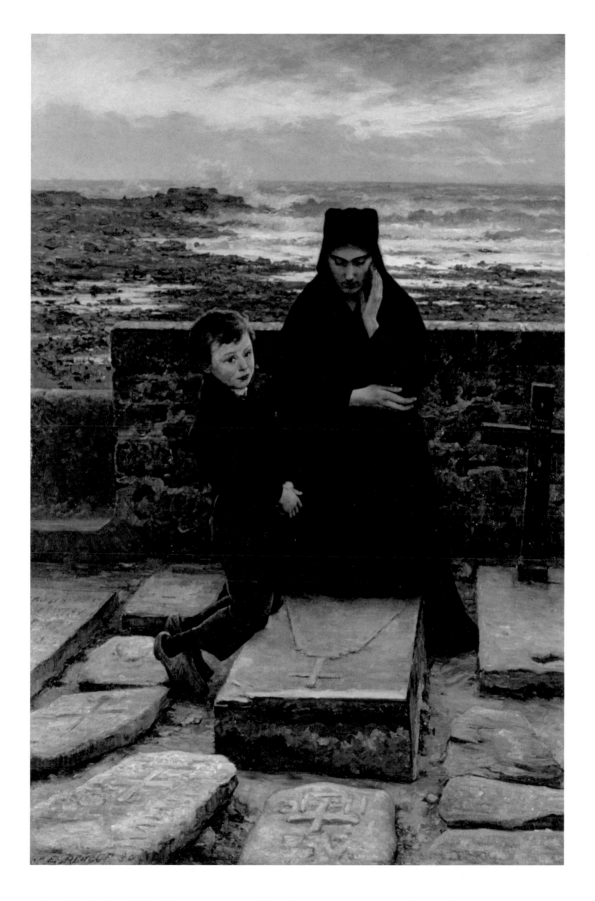

Cat. 30. Émile Renouf, *The Widow of the Island of Sein*, 1880, Musée des Beaux-Arts, Quimper. Shown at the Décennale

Fig. 8. Restaurant row at the 1889 Paris Exposition Universelle, from Brincourt, *L'Exposition Universelle de 1889* (Paris, 1890)

and 1867 expositions, having his own pavilion built at the Place de l'Alma for the latter, and Manet, who had made an equivalent stand in 1867.[26] But the remarkable coup of staging a show within the exposition grounds was a feat that went one better than either Courbet or Manet, Monet or Rodin. The Volpini show was of course a collective undertaking, but the press considered Gauguin the group's undisputed leader. For the most part, he was happy to assume this role, claiming sole rights over the idea of staging the show when he wrote to his dealer Theo van Gogh in early June 1889: "I organized this little exhibition this year at the Universelle to show what should have been done en masse, and to demonstrate how possible it would have been."[27]

However, had Gauguin's desire to seize the day not been backed up by the ambition, contacts, and attention to detail of his fellow exhibitors, the exhibition would not have happened. The bulk of the negotiating and arranging the practicalities seems to have been undertaken by his old friend Schuffenecker, assisted by the much younger and less-experienced Bernard. For whatever part Gauguin took in the initial negotiations, astonishingly, just before the arrangements were settled, he opted to leave Paris; unlike Courbet or Manet, he was absent from his own show. He took himself back to Brittany at least a week before the opening on 10 June (see cat. 113, p. 197); thereafter he sent instructions to his minions and kept a watchful eye from a safe distance.[28] So much so that when he wrote a second time to his dealer, defending the initiative, he could fall back on the line that, had he been in Paris, things would have been handled differently, switching from talking about "my exhibition" to "our exhibition."[29] What happened? Had he, as the weeks of May went by, lost hope of clinching an exhibiting deal? Did he feel he had done all the preparation he could, including the major effort of producing the album of zincographs? Was he simply, after the many distractions of the exposition, in dire financial straits again?

Schuffenecker, a family man like Gauguin but with greater financial security, staked his all on this exhibition. As a founder-member he had shown regularly, since 1884, with the Salon des Indépendants, a forum Gauguin, as a new member of the Impressionists, shunned. Through

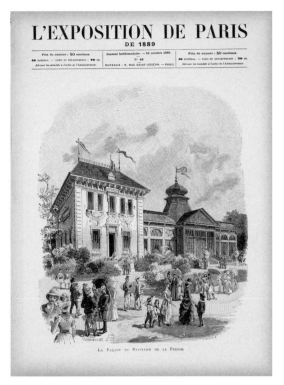

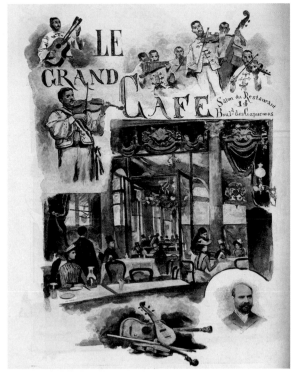

Fig. 9. Maison de la Presse, from *L'Exposition de Paris* (Paris, 1889), 2: 41, Van Gogh Museum (Library), Amsterdam

Fig. 10. Grand Café poster with presumed portrait photograph of Monsieur Volpini, from *L'Armorial de l'industrie* (Saint-Germain-en-Laye: Musée Départemental Maurice Denis "Le Prieuré," 1889)

Gauguin he had exhibited with the Impressionists in 1886. Despite his evident sense of inferiority beside what he saw as Gauguin's towering genius, Schuffenecker was eager to have his work seen in 1889. And he proved an efficient organizer. It was he who clinched a deal that was to the mutual benefit of the artists and the café director, Monsieur Volpini. As far as Volpini himself was concerned, the premises he had secured within the Champ de Mars site for the duration of the exposition must have seemed a promising business venture. His café formed part of the run of restaurants, brasseries, and cafés flanking the main halls (in all, there were fifty such accredited establishments[30]) and was in some ways well located on the northeast corner of the Palais des Beaux-Arts, opposite the Maison de la Presse (figs. 8, 9). A branch of his popular Café Riche on the Boulevard des Italiens and Grand Café on the Boulevard des Capucines (fig. 10), Volpini called the temporary outlet the Café des Arts. His original intention was to decorate the premises with mirrors, but the order he placed failed to arrive in time for the exposition's opening. Prevailed upon by Schuffenecker, at some date in late May Volpini seems to have revised his plans, canceled the order, and acquiesced to the artists' scheme to hang their works on the deep carmine walls of his café.[31]

Although there is conflicting information (notably the retrospective account by Bernard implausibly describing Gauguin taking an active part in the final preparations for the opening), the dates and tenor of Gauguin's various letters to his friends through June make clear that he had already left Paris at the time this deal was struck.[32] His letter of instructions to Schuffenecker of around 1 June with its opening "Bravo!" is both an acknowledgment of his friend's having brought the tricky negotiations to fruition and a delegation of responsibility for the final arrangements.[33] In this letter Gauguin listed the works of his he wanted Schuffenecker to include and also the artists he wanted to show with, a line-up that differs significantly from the eventual shape of the group. For instance, the Impressionist Armand Guillaumin turned down the invitation, a refusal Gauguin treated as a defection (the two artists had been close in the mid 1880s); Vincent van

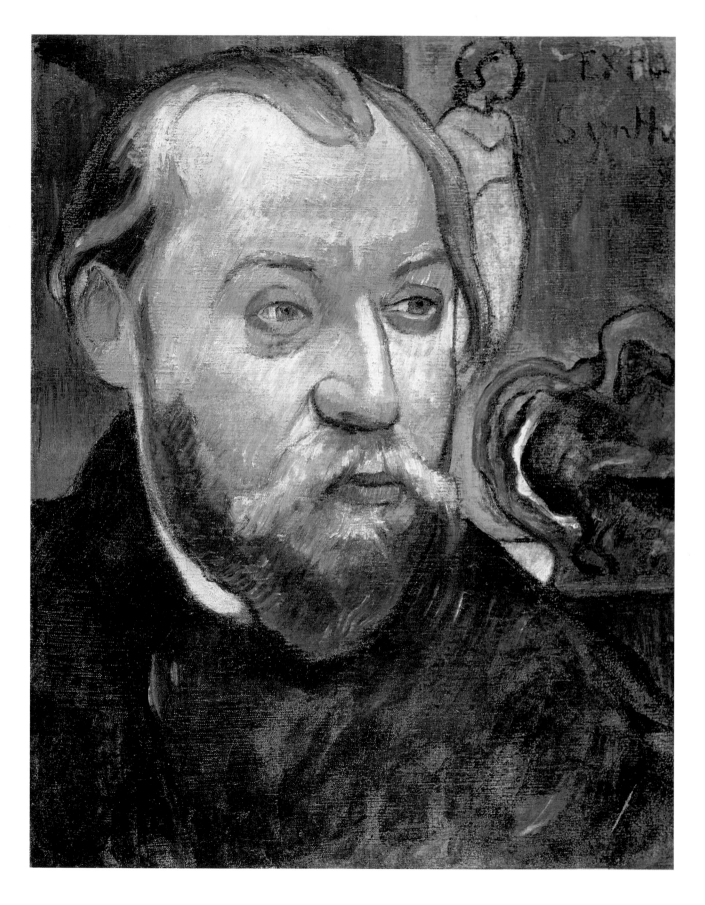

Cat. 31. Paul Gauguin, *Portrait of Louis Roy,* 1893 or earlier, private collection, New York

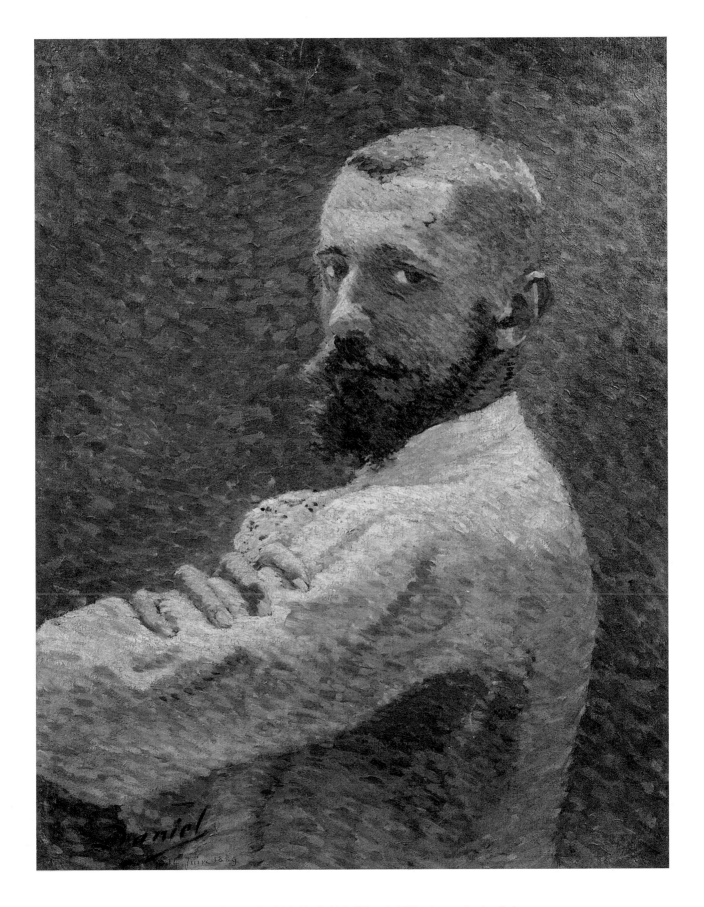

Cat. 32. Georges-Daniel de Monfreid, *Self-Portrait,* 1889, private collection, Paris

Gogh, though supportive and convinced of the importance of this exhibiting opportunity, was held back from involvement by the caveats of his brother, Theo.[34] Henri de Toulouse-Lautrec was mentioned but then dropped, according to Theo, because he was a member of the Cercle Artistique et Littéraire Volney, a private exhibition group centered on high-society connections.

Without this potentially challenging union of established Impressionists and up-and-coming independents, the exhibition was in danger of looking thin, so in early June, with time slipping by (the Exposition Universelle had been open for almost a month), it became urgent to ask new people. A talented unknown, Charles Laval, a close follower of Gauguin and in his debt since their joint trip to Martinique, was now added, although his previous omission from Gauguin's list may have been an oversight.[35] Meanwhile Bernard and Schuffenecker turned to others in Paris, and this last-minute reshaping of the group may have irked Gauguin, to judge from the flurry of correspondence that passed among the three during June and July.[36] Bernard recruited his old student friend from Atelier Cormon, Louis Anquetin: together the two had forged an anti-naturalist cloisonnist style in 1887–88 that, broadly speaking, they continued to practice. Schuffenecker, whose moderate Impressionism retained vestiges of a divisionist touch that Gauguin discouraged, had already put his teaching colleague Louis Roy (cat. 31, p. 46) and young friend Léon Fauché on the list and now extended an invitation to Georges-Daniel de Monfreid.[37] In the event, the contributions of these make-weights attracted little attention and remain obscure, with the notable exception of de Monfreid's strikingly accomplished self-portrait, which must have been added, fresh off the easel, a few days after the opening (cat. 32, p. 47). Yet all three proved loyal servants to Gauguin in years to come.[38]

Schuffenecker promoted the Volpini exhibition with much fanfare by word of mouth and a poster campaign, but his self-importance made an unfavorable impression, particularly on Theo van Gogh to whom he had to turn in order to borrow works by Gauguin. Uneasy all of a sudden about the negative impact this aggrandizing approach was having, Gauguin wrote cautioning

GROUPE IMPRESSIONNISTE ET SYNTHÉTISTE

CAFÉ DES ARTS
VOLPINI, Directeur

EXPOSITION UNIVERSELLE
Champ-de-Mars, en face le Pavillon de la Presse

EXPOSITION DE PEINTURES
DE

Paul Gauguin	Émile Schuffenecker	Émile Bernard
Charles Laval	Louis Anquetin	Louis Roy
Léon Fauché	Daniel	Nemo

Paris. Imp. E. WATELET, 55, Boulevard Edgar Quinet.

Affiche pour l'intérieur

Cat. 33. *Poster for the Exhibition at the Café des Arts*, 1889, Pennsylvania State University Libraries

Schuffenecker and pleading for greater moderation: "It seems to me that you're making a big to-do for this exhibition; I would have preferred it to be done without a lot of noise. There will be plenty of people anyway over 6 months. I've asked Bernard a lot of things, he doesn't reply to any of them.[39] It's true you're all very busy. I've written to [Theo] Van Gog [*sic*] who hasn't replied at all. I'll be in a real pickle if he should drop me because of this exhibition."[40] Bernard must indeed have been busy. Presumably he or Schuffenecker was responsible for producing the poster (cat. 33), and Bernard attempted to bring the press on board, to the limited and marginal extent of appealing to the ambitious young Symbolist poet Albert Aurier, who had recently launched *Le Moderniste,* an opportunistic satirical weekly.[41] It was through this ephemeral organ that the Volpini exhibition received its most direct puffs. In April and May Aurier, under the pseudonym Luc le Flâneur, had written favorably about works by Gauguin and Bernard to be seen in dealers' shops.[42] However, there was a hiatus before he got around to signaling the Volpini show as Bernard had requested. And he did so with exaggerated deprecation, as a "minuscule rivalry to the official exhibition."[43]

There appear to have been no reviews of the show in the mainstream press, although an announcement of its opening was spotted in Saint-Rémy by Vincent van Gogh.[44] Nevertheless, the prominent champion of innovative art, Octave Mirbeau, writing about the exposition in *Le Figaro* on the very day the Volpini show opened (an event of which he was apparently unaware), mentioned Gauguin's name and asked a leading question: "Why, since this Exposition was supposed to embrace the artistic history of the last century and show us its transformations, tendencies, even its abortive efforts, why weren't artists as individual as M. Seurat and M. Gauguin included?"[45] Was this curious and telling conjunction of names a coincidence?

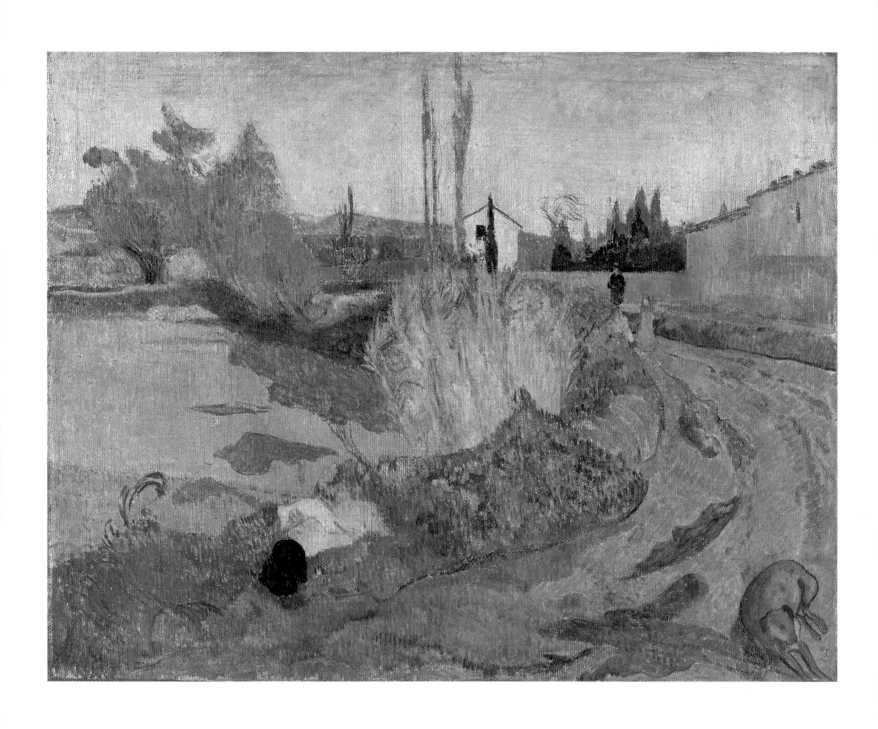

Cat. 34. Paul Gauguin, *Landscape from Arles,* 1888, Nationalmuseum, Stockholm

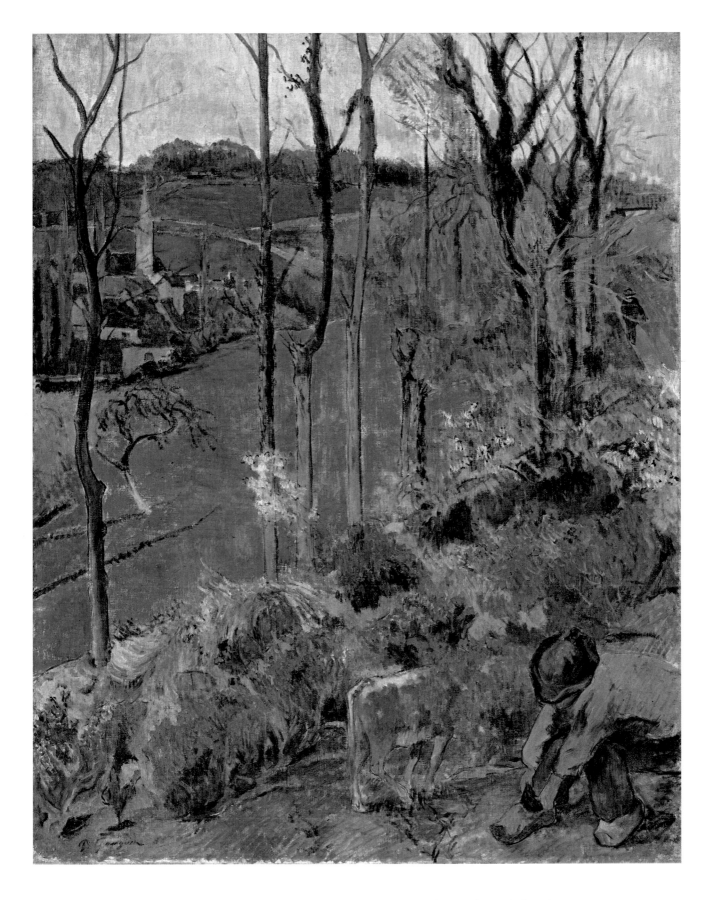

Cat. 35. Paul Gauguin, *Landscape from Pont-Aven, Brittany,* 1888, Ny Carlsberg Glyptotek, Copenhagen

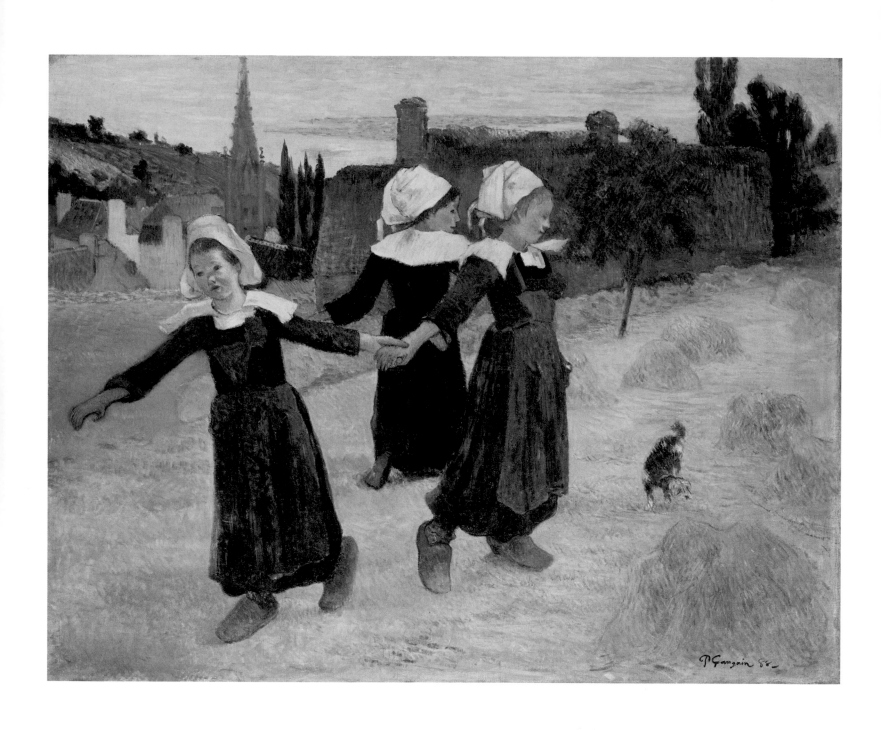

Cat. 36. Paul Gauguin, *Breton Girls Dancing, Pont-Aven*, 1888, National Gallery of Art, Washington

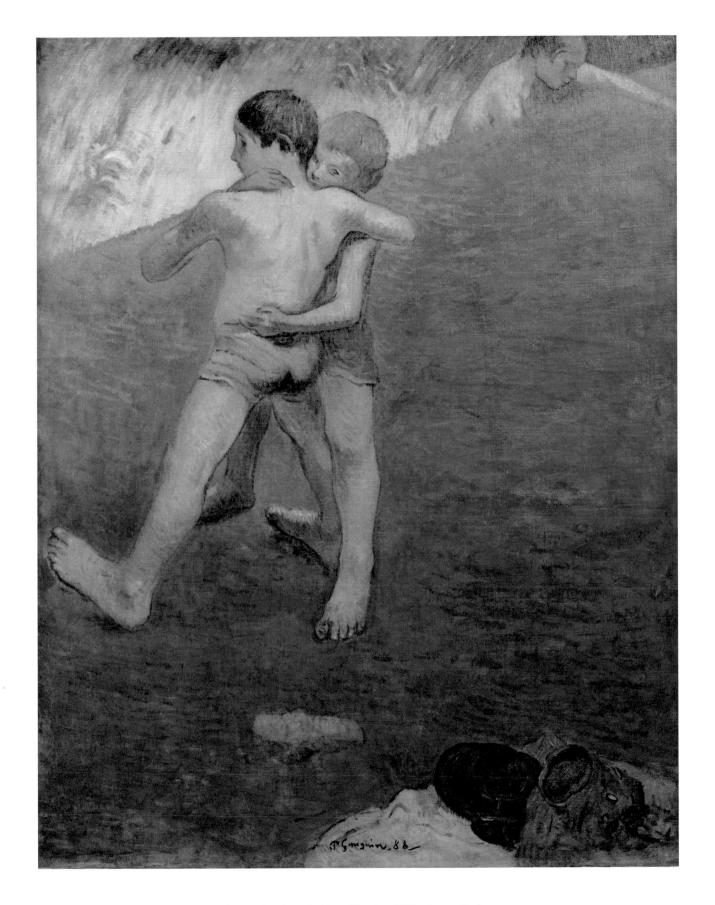

Cat. 37. Paul Gauguin, *Young Wrestlers*, 1888, private collection

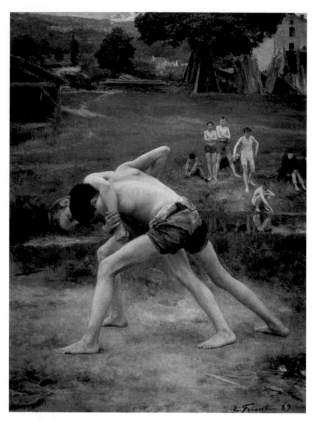

Fig. 11. Émile Friant, *The Wrestlers* (detail), 1889, Musée Fabre, Montpellier

The Shape and Impact of the Volpini Show

Unsurprisingly, the final installation of the show did not stick to the even-handed distribution of ten works apiece recommended in Gauguin's 1 June letter.[46] Probably, more works were needed to fill the spacious café, and Gauguin's entries were bumped up to seventeen; nevertheless he was outnumbered by Schuffenecker's twenty and the twenty-three by Bernard, who added two more under the pseudonym Ludovic Nemo. Only Laval showed the ten works originally agreed upon, Anquetin and Roy had seven apiece, and the other participants fewer still. This indiscipline, together with Bernard's prank of exhibiting under the pseudonym Nemo, most likely caused the acerbic tone of Gauguin's missing letter.[47]

The precise make-up of the show remains elusive given the ambiguity of certain titles. For Gauguin's part we have two lists: the list of paintings he originally drew up in his letter to Schuffenecker, and the longer list of seventeen works printed in the catalogue. Consequently most works can be identified; where doubt might surround the identity of *Paysage d'Arles* (*Landscape at Arles*) from the catalogue, Gauguin's precise "Le paysage d'Arles que vous avez avec buissons" (the landscape at Arles that you have with the bushes) allows a definite identification (cat. 34, p. 50). The fact that Gauguin speaks about "Les Mas d'Arles chez Van Gogh" helps with the identification of *Farmhouse, Near Arles* (fig. 12, p. 58). Similarly where it might be difficult to decide which landscape was meant by the catalogue's *Hiver, Bretagne,* Gauguin's list allows for no ambiguity: "Hiver (petit Breton arrangeant son sabot avec village dans le fond) (Winter [a small Breton man adjusting his clog, with a village in the background]) (cat. 35, p. 51). It seems fair to assume that Schuffenecker followed Gauguin's ten choices to the letter, despite some title discrepancies. But one wonders about the additional works, many of which were of very recent date. Were they specified by Gauguin in a subsequent lost letter or chosen by Schuffenecker?

Gauguin's original choices, broadly reflected in the album of zincographs, range in date from 1886 to 1888 and feature gentle, bucolic themes. It is notable that almost all are landscapes and,

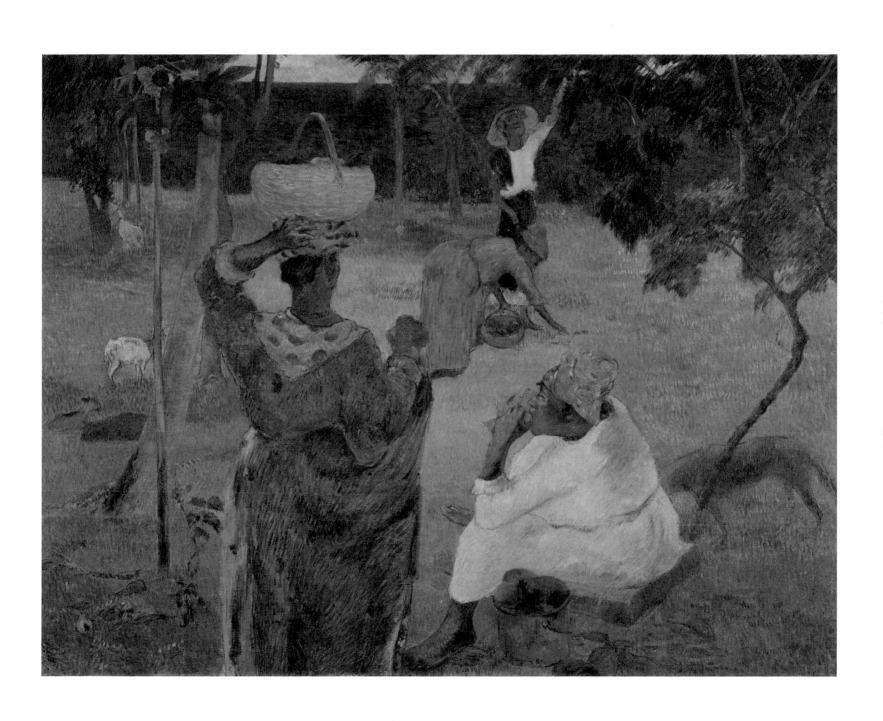

Cat. 38. Paul Gauguin, *Fruit Picking* or *Mangoes*, 1887, Van Gogh Museum, Amsterdam

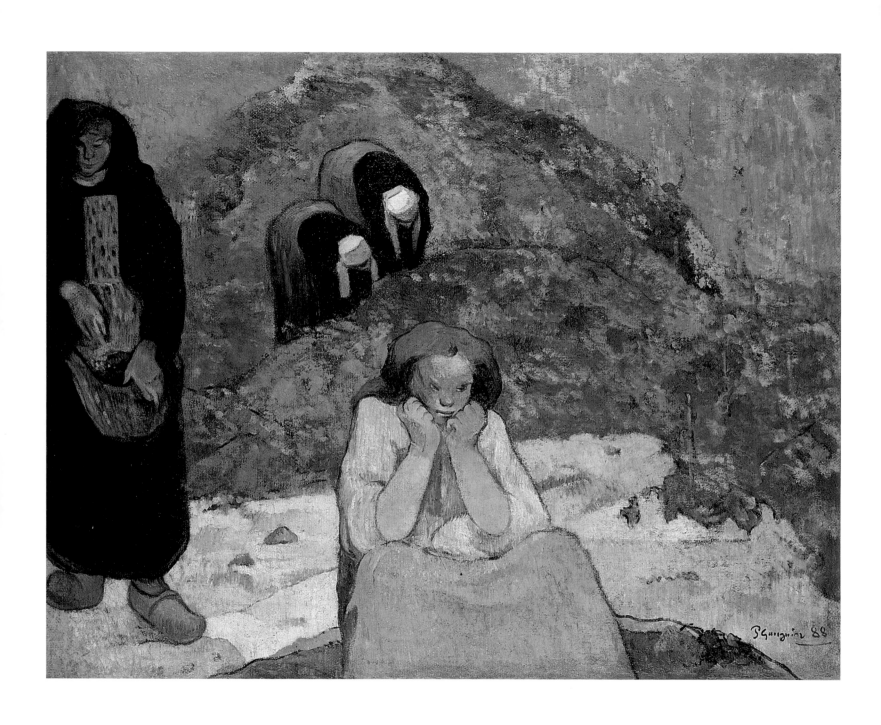

Cat. 39. Paul Gauguin, *Human Misery,* 1888, Ordrupgaard, Charlottenlund, Denmark

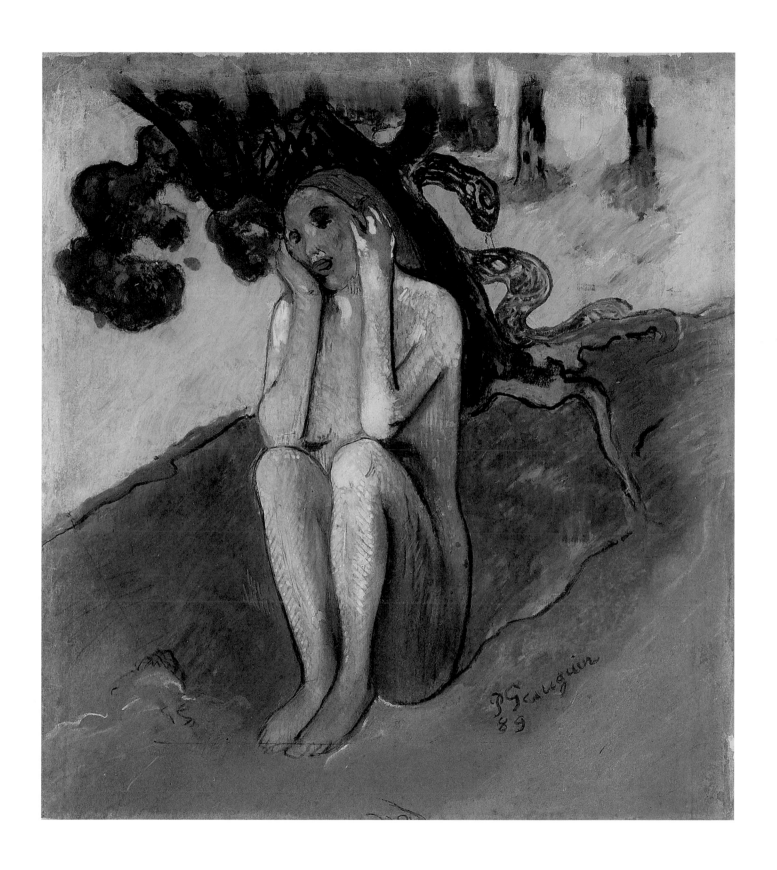

Cat. 40. Paul Gauguin, *Breton Eve*, 1889, McNay Art Museum, San Antonio

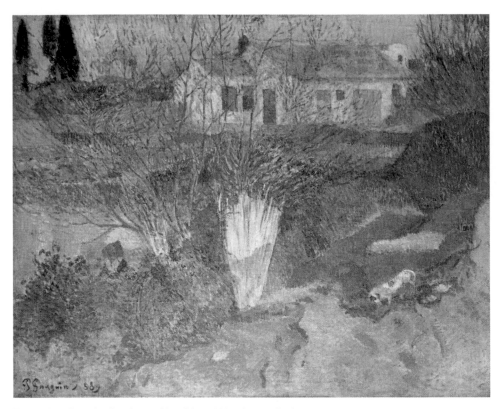

Fig. 12. Paul Gauguin, *Farmhouse, Near Arles,* 1888, private collection

of the ten, four feature children. In his thinking, images of childhood seem to have gone hand in hand with the stylistic simplification he was cultivating. Two of them, specified in Gauguin's list as "Ronde des petites filles" (cat. 36, p. 52) and "Les deux lutteurs enfants" (cat. 37, p. 53), could almost be seen as an informal pair. They show Breton girls and boys rehearsing the gender-specific rituals, associated with dancing and wrestling, of the traditional religious festival called the Pardon.[48] But if his choice of subject here was relatively conventional, his mode of handling was decidedly unconventional. Indeed one wonders if Gauguin took amused pleasure in the contrast between his *Young Wrestlers* (*Les Jeunes Lutteurs*) and Émile Friant's *Wrestlers* (*Les Lutteurs*) (fig. 11, p. 54) hanging, coincidentally, at that year's Salon; the deliberately gauche, synthetic drawing of his painting is all the more apparent in comparison with the meticulous verisimilitude of Friant's. His Martinique painting *Fruit Picking* or *Mangoes* (*La Cueillette des Fruits* or *Aux Les Mangos*) (cat. 38, p. 55) introduces an exotic, decorative note (amplified in the two zincographs, see cat. nos. 19, 20, pp. 24, 25) that was very much in keeping with the exotic internationalism of the exposition. In the sequence of zincographs, the mood darkens somewhat in the two versions of *The Dramas of the Sea* (*Les Drames de la mer*) (see cats. 15, 16, pp. 20, 21) and in *Human Misery* (*Misères humaines*) (see cat. 18, p. 23), which develops the narrative of an earlier Arles painting; but it appears Gauguin originally planned to omit the related painting, with its rough textures and dolorous, loaded imagery (cat. 39, p. 56). Indeed one might posit that he was deliberately withholding his more intransigent works, seeing no point in subjecting them to the ridicule of the heterogeneous crowds and establishment artists liable to frequent the Exposition Universelle.[49] After all, these works had just met a hostile reception in Brussels from the comparatively sophisticated audience of Les XX. It has often been noted that Gauguin opted not to put in his new, ground-breaking work, *Vision of the Sermon* (*Vision du Sermon*) (fig. 13, p. 62), but he also chose to exclude *Woman with Pigs* or *The Heat of the Day* (*La Femme aux Cochons* or *En*

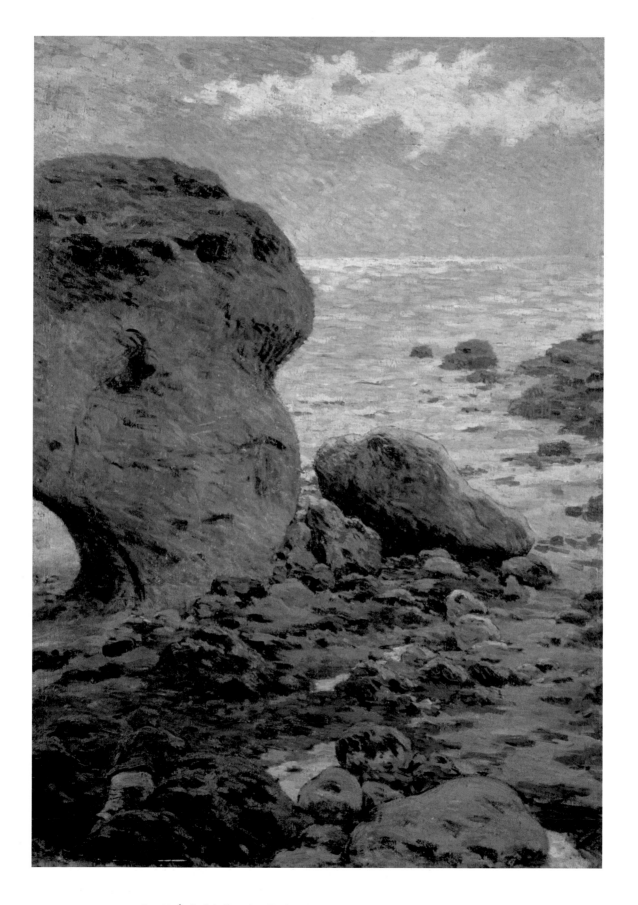

Cat. 41. Émile Schuffenecker, *Rocks at Yport,* 1889, Musée Centre-des-Arts, Fécamp

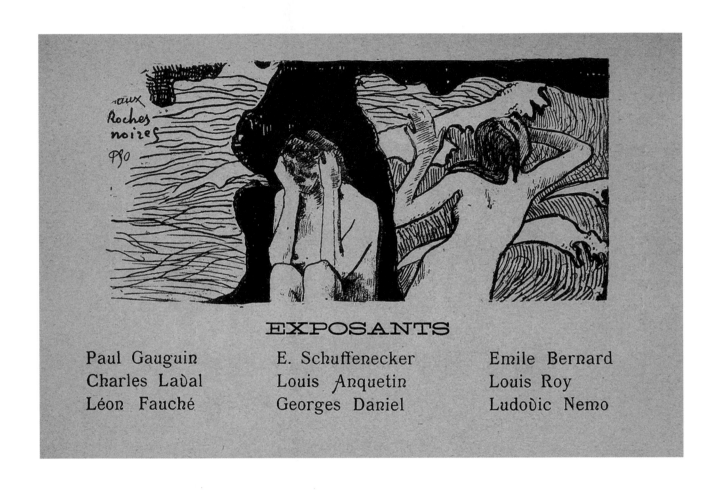

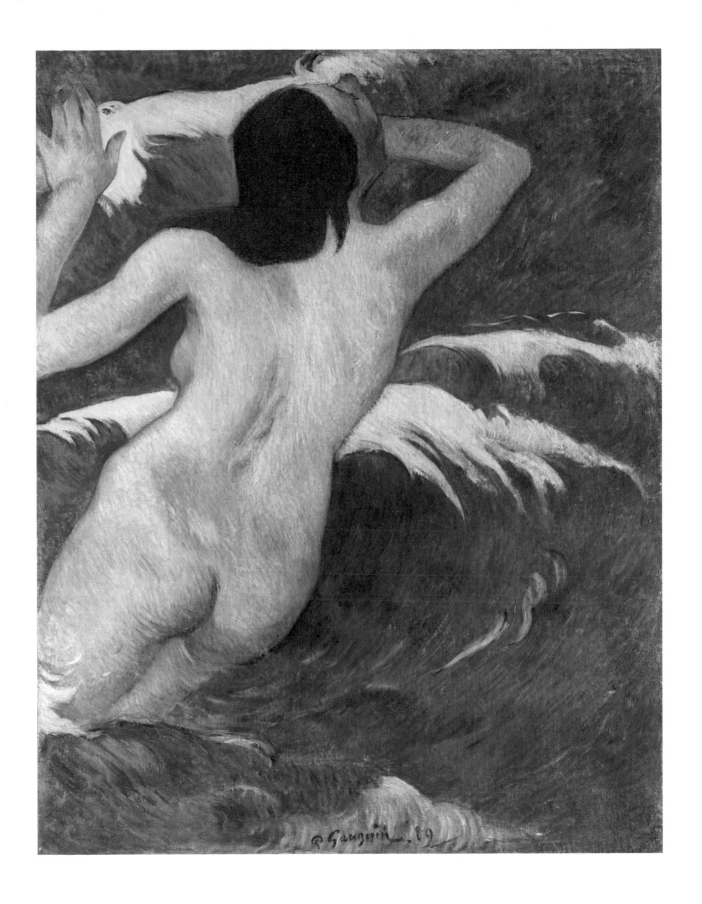

Cat. 43. Paul Gauguin, *In the Waves,* 1889, The Cleveland Museum of Art

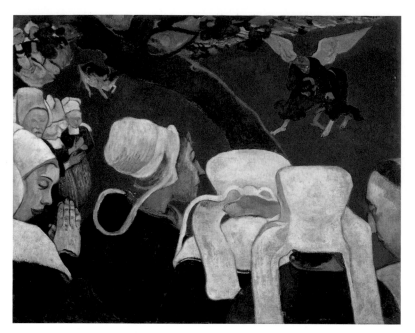

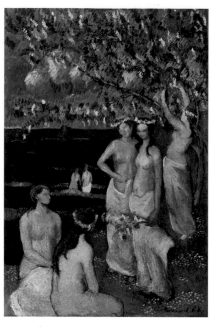

Fig. 13. Paul Gauguin, *Vision of the Sermon,* 1888,
National Gallery of Scotland, Edinburgh

Fig. 14. Émile Bernard, *Female Bathers,* 1888,
private collection

Pleine Chaleur) (W. 301/320; private collection), with its raunchy eroticism, and *Human Misery,*
two works from 1888 that had been ridiculed in Brussels.

Judging from his original list of paintings, Gauguin's aim was to show work at the exposition
that reflected his stylistic evolution but that also stood a chance of pleasing the public and finding
buyers. He probably calculated that if visitors wished to see his more intransigent works, includ-
ing ceramics, they could seek them out at his dealer's. Did Schuffenecker in his admiration and
enthusiasm for Gauguin's work possibly overstep a line by including *Human Misery*? He, after all
(rather than Paul, his son), was the painting's proud new owner. Was Gauguin perhaps annoyed,
sensing that the public needed to be brought round gradually from his Impressionist to his Syn-
thetist style?[50] It is hard to say. In the event though, a number of his more anti-Impressionist figu-
rative compositions went in, as well as *Human Misery,* including *Breton Eve (Ève Bretonne I)*
(cat. 40, p. 57) with its puzzling pidgin French inscription, *In the Waves (Dans les vagues)* (cat. 43,
p. 61),[51] and the still unidentified *Le Modèle–Bretagne.* The hastily produced drawing for the
catalogue that Gauguin supplied from Brittany, at Schuffenecker's request, can be seen as a last-
minute attempt to incorporate these tricky and provocative new works (cat. 42, p. 60).[52]

Apart from a few Parisian subjects and still lifes (cat. 44), Schuffenecker's group was domi-
nated by landscapes and beach scenes, several featuring Concarneau and Yport (cat. 41, p. 59),
painted in an atmospheric Impressionism. Bernard's also included a range of Breton and Paris
subjects painted in a more daringly simplified, flat manner (cat. 45, p. 64). Those that can be de-
finitively identified show the recent experiments he had been making with color and drawing
(cat. 46, p. 65). *Female Bathers (Baigneuses)* (fig. 14) owned by Aurier has a Cézannesque feel,
while strong outlines and simple shapes give *Woman with Geese (Femme avec oies)* (fig. 15, p. 67)
a childlike Synthetist quality. Many are difficult to identify: What did Bernard show under the
rubric "Caricatures bretonnes" for instance? Under the title "Bretonnes" and in the collection of
a Mme Berthe should we identify his important cloisonnist canvas *Breton Women in the Meadow*
(*Bretonnes dans la prairie verte*), 1888 (private collection), which Gauguin had recently taken to
Arles? It is not clear.[53]

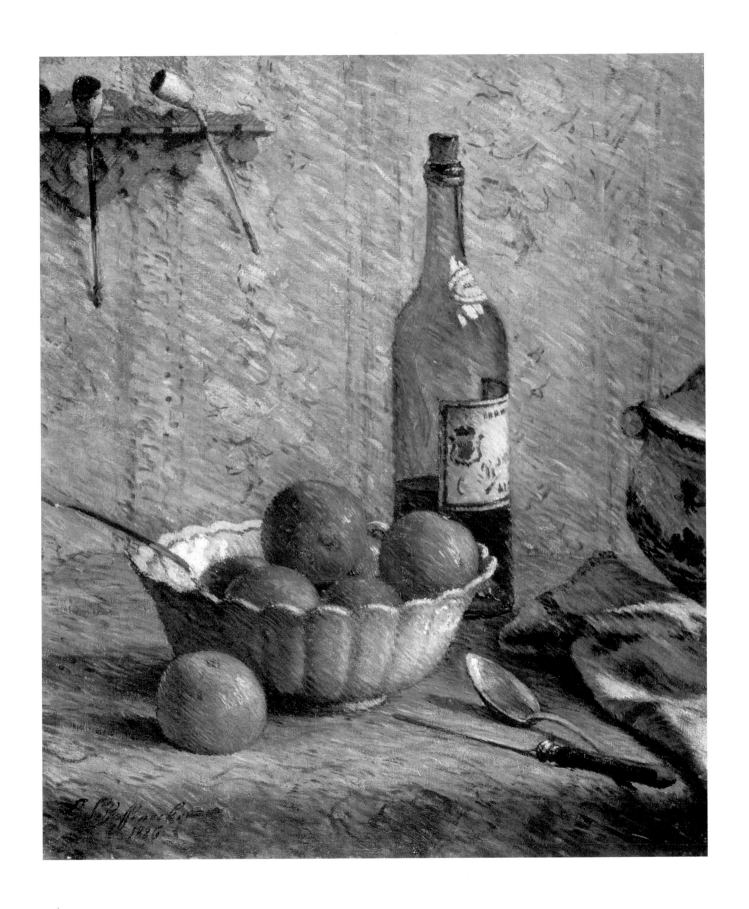

Cat. 44. Émile Schuffenecker, *Still Life with Bowl of Fruit*, 1886, Kröller-Müller Museum, Otterlo

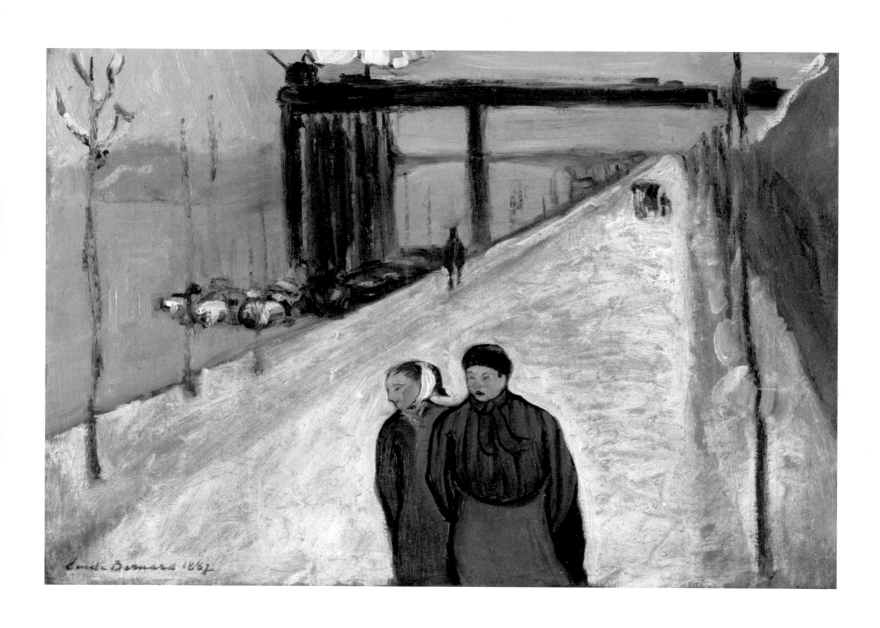

Cat. 45. Émile Bernard, *Quai de Clichy,* 1887, Musée Départemental Maurice Denis "Le Prieuré," Dépôt Musée d'Orsay, Paris

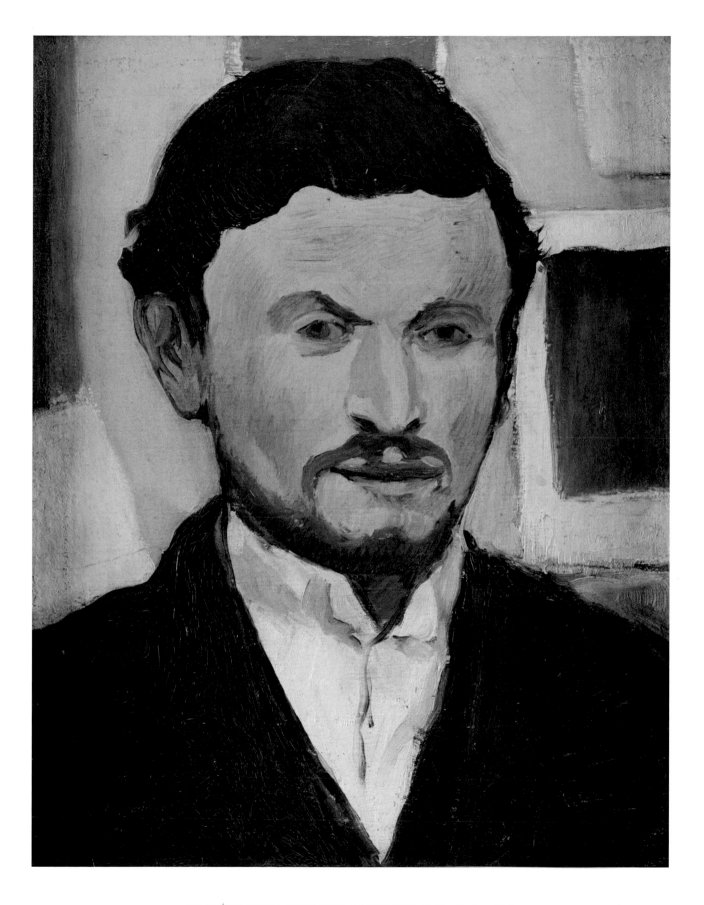

Cat. 46. Émile Bernard, *Portrait of Marcel Amillet*, 1888, private collection, Paris

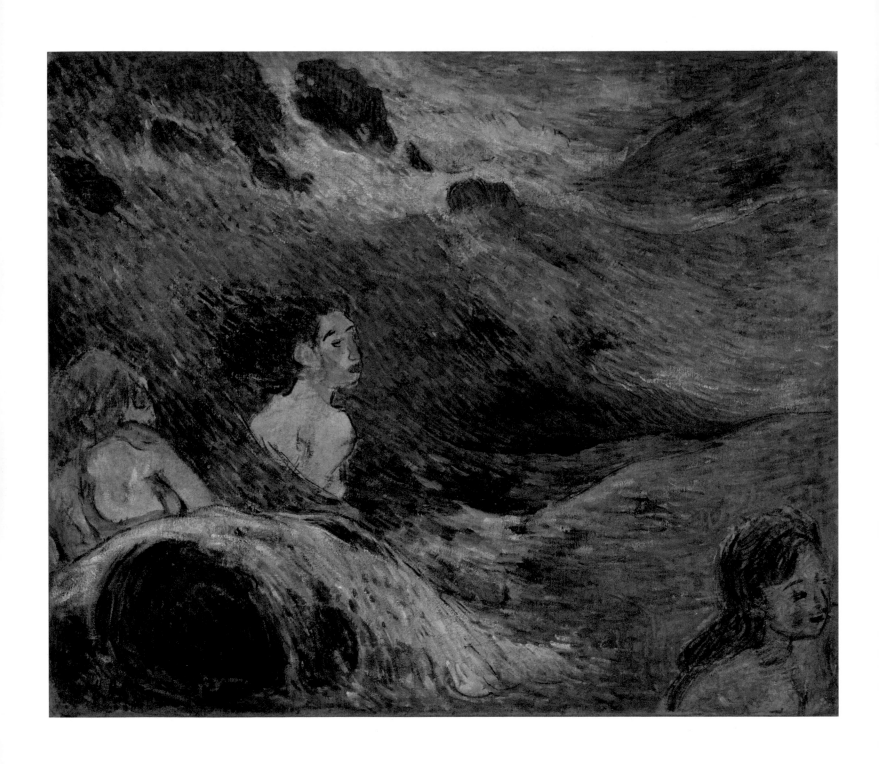

Cat. 47. Charles Laval, *Bathers*, 1888, Kunsthalle Bremen

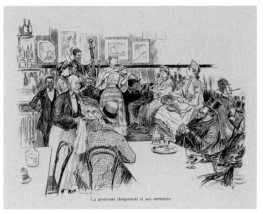

Fig. 15. Émile Bernard, *Woman with Geese*, 1887, private collection

Cat. 48. P.-G. Jeanniot, *Le Cafe Volpini à l'Exposition Universelle*, from *Revue de L'Exposition Universelle de 1889* (1889), Rijksmuseum, Amsterdam

Cat. 49. Émile Schuffenecker, *Seaweed Gatherers, Yport*, 1889, private collection

The one useful visual record of the Volpini exhibition, Pierre-Georges Jeanniot's illustration for the second issue of the *Revue de l'Exposition Universelle de 1889* (cat. 48, see also frontispiece), makes it possible to identify certain canvases by Schuffenecker and Bernard.[54] We can discern the former's *Seaweed Gatherers, Yport* (*Ramasseuses de Varech, Yport*) (cat. 49), and his striking portrait of Bernard (fig. 16, p. 68) thanks to its oddly asymmetric shape.[55] And it confirms an identification of Bernard's title "La Moisson" with the painting *The Harvest* (*La Moisson*) (fig. 17, p. 68). Laval, perhaps because he showed a number of Martinique canvases, tended to be confused with, or dismissed as an imitator of, Gauguin. Yet his submission included some amusing and original works, among them *Bathers* (*Baigneuses*) (cat. 47), *Scene in Martinique (Scène de la Martinique)* (see fig. 19, p. 70), and *Going to Market, Brittany* (*Allant au marché, Bretagne*) (cat. 50, p. 69). Anquetin included a cloisonnist seascape, two horse studies, and a Paris street scene. Critics' comments enable one to identify the painting shown as *Effet du soir* with his boldly innovative *Avenue de Clichy* (cat. 51, p. 73).

A month after the opening of the exhibition the publication of the minimally illustrated catalogue was announced in *Le Moderniste*.[56] Over a series of issues in August the participating artists' simple line illustrations appeared. Both Gauguin and Bernard were able to break into art criticism and more wide-ranging punditry in *Le Moderniste*. Gauguin's views, which ranged from the general to the particular and, for all their quirkiness, were interventions into the key debates of the day, were inspired by the Exposition Universelle.[57] He mounted a robust defense of the Eiffel Tower, thus positioning himself against the artists who had signed a petition protesting it.[58] His forward-looking admiration for cast iron as a new building material was tempered by his scorn for the architects' complete failure to invent for it an appropriate new form of ornamentation. He deplored the state of French ceramic manufacture, an area of keen personal interest, and the idiocy of a Kanak ambassador being expected to take a Sèvres vase home to New Caledonia, before offering a treatise on the importance of firing clay at high temperatures. He lamented the academicism and bad taste of the Décennale and the absence of Manet from the Musée du Luxembourg (the French national collection of contemporary art). While praising his artistic heroes, cannily, without naming names, he slipped in a surreptitious plug for the "independent artists" excluded

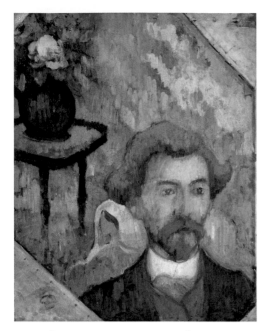

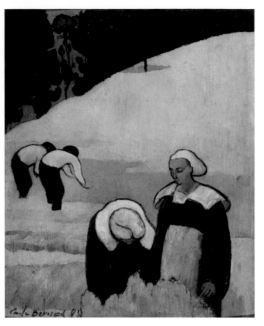

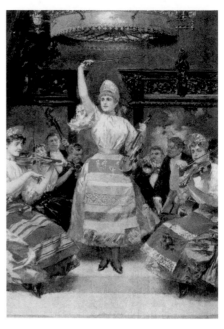

Fig. 16. Émile Schuffenecker, *Portrait of Émile Bernard*, c. 1889, The Museum of Fine Arts, Houston

Fig. 17. Émile Bernard, *The Harvest*, 1888, Musée d'Orsay, Paris

Fig. 18. *Princess Dolgorouky and Her Gypsy Orchestra*, from *Paris, les expositions universelles de 1855 à 1937* (Paris, 2004)

from the official selection who would surely be the "sources of the 20th century." Bernard (possibly with Gauguin's prompting) maintained this ostensibly objective tone in his article on the Centennale, praising the figurative work of Corot and Manet, complaining about the insensitive way Puvis de Chavannes's works were hung.[59] His promised second article was not published, however.

Although *Le Moderniste* continued to appear throughout the run of the exposition, sadly for the artists concerned Aurier's detailed review of the Volpini show, previously announced, never materialized.[60] The physical difficulty of seeing the works in the Café des Arts cannot have helped would-be reviewers, as Jeanniot's illustration makes apparent. Gustave Kahn complained that the café offered the "worst possible conditions" for seeing Gauguin's "interesting, but raucous and heavy-handed painting."[61] Both Adolphe Retté, in *La Vogue,* and Félix Fénéon, in *La Cravache,* began their pieces with amusing accounts of the café orchestra, largely made up of female "Russian" violinists playing Viennese waltzes. Retté expatiates on the garish attire of their leader, Princess Dolgorouky, her presence rivaling and, as it were, symbolizing the "explosive fumisterie [jokes]" of the paintings on the walls (fig. 18). But in praising the works of M. Gauguin that "modulate on the walls some exotic scale not without crepuscular charm" (see cat. 38, p. 55), Retté in fact attributes solely to Gauguin works such as *The Palms* (*Les Palmes*) that were Laval's and *Seaweed Gatherers, Yport* that were Schuffenecker's (cat. 49, p. 67).[62] The most considered, disinterested reviews of the exhibition were Fénéon's in *La Cravache* and Jules Antoine's in *Art et Critique.* Although broadly sympathetic to the venture, Antoine labored under the confusion of the double title "Impressionnistes et Synthétistes" and the blurred distinction between Gauguin's Impressionism and the more blatant Synthetism of Bernard and Anquetin, struggling to define where the synthesis lay. He recognized a Japanese character in Anquetin's "collection of flat tones, all surrounded by a line" and was hostile toward the ingenuous childishness and distortion of the catalogue drawings (fig. 20, p. 71).[63] It can have done nothing for Bernard's or Laval's pride to be accused of "copying" Gauguin. Fénéon meanwhile riled Gauguin by suggesting he had imitated Anquetin, of whose work Gauguin claimed (somewhat disingenuously) no knowledge.[64]

Cat. 50. Charles Laval, *Going to Market, Brittany,* 1888, Indianapolis Museum of Art

Fig. 19. Charles Laval, *Scene in Martinique*, 1889, private collection

Gauguin's principles would not allow him to accept the offer of a promotional article by Félicien Champsaur in partial payment for the Volpini painting he was keen to acquire, *Breton Girls Dancing, Pont-Aven* (*La Ronde des Petites Bretons*) (see cat. 36, p. 52). This kind of back-handed criticism, widely practiced in the Paris art world, disgusted him, for it smacked of the odious practices of Albert Wolff, a prominent critic who had acquired a substantial collection in this way.[65] But from his colleagues' point of view, especially Schuffenecker, who was friendly with Champsaur, it must have appeared a missed opportunity for coverage in a daily newspaper (Champsaur wrote for *L'Événement*).[66] The Dutch artist J.-J. Isaacson, who was in Paris and close to Theo van Gogh in 1889, promised to write about the Volpini show in his weekly column about the Exposition Universelle for the Dutch periodical *De Portefeuille.* But did he do so?[67] A comment made by Gauguin, tipped off by his Dutch friend Jacob Meyer de Haan, suggests he did. Such informed commentary might well have been read by Gauguin's future Dutch disciple Jan Verkade. If in an immediate sense the critical reaction was a disappointment, a move in Gauguin's favor was slowly gathering pace, a buzz was going round the studios that led various artists to vote with their feet, to reject the artistic precepts of their teachers, even to head off to Brittany to join Gauguin as in the case of Paul Sérusier, leader of the newly formed Nabi group. Before long the international group in Pont-Aven that looked to Gauguin for guidance—the École de Pont-Aven as it was soon to be called—was swelled by new dissident recruits: Charles Filiger, Armand Seguin, the Dutchman Verkade, the Danes J. F. Willumsen and Mogens Ballin, and others.

What were the commercial results of the show? The precise terms on which the artists' works were shown are unclear, but Volpini expected to take a percentage of the proceeds of any sales.[68] This made Gauguin anxious that Schuffenecker not upset his dealer Boussod et Valadon (Theo van Gogh) by offering the works at lower prices.[69] Degas apparently expressed interest in buying *Spring at Lézaven (Printemps à Lézaven)*, also known as *The First Flowers (Les Premières fleurs)* (fig. 21, p. 72), and *Breton Girls Dancing, Pont-Aven* was sought after by two rival buyers, Champsaur and Montandon, eventually being bought for 500 francs by the latter. An undated letter from Laval to Bernard written probably toward the end of the Volpini show refers to three other land-scapes, suggesting that further sales were made by Gauguin.[70] But such sales as there were seem

Fig. 20. Paul Gauguin, *The Haymakers*, 1889, from *Catalogue de L'Exposition de Peintures du Groupe Impressionniste et Synthétiste*, Van Gogh Museum, Amsterdam (see also cat. 42, p. 215)

to have been Gauguin's alone, for Bernard later complained that nothing had been sold at this exhibition.

Perhaps because its eventual somewhat chaotic character escaped his full control, the Volpini show was not as commercially successful as Gauguin had hoped, but it was arguably more radical and did more to raise his public profile than he might have predicted. His nonchalance about attending to its details remains puzzling, but in some ways his attitude paid off. Thanks to the Volpini show, Gauguin began to be considered a master to rival Seurat by a small number of critics.[71] For a growing coterie of younger artists, his mystique became all the stronger for standing aloof from the fray.[72] The legend of the Volpini show, which has obscured the more nuanced reality, was well on the way to being established. In early June 1889 Gauguin decided to let events take their course, perhaps because he had already set his sights on higher goals. Clearly, the tumultuous experience of the Exposition Universelle had set in motion many creative ideas and back in Brittany he launched straight into a series of highly charged, inventive works in different media. The second half of 1889 proved one of his most productive periods.[73] As for the implied unity of the Groupe Impressionniste et Synthétiste, it was illusory. Looking back on the Volpini show at the end of the year in a letter to Bernard, Gauguin wrote conspiratorially, "our exhibition, yours and mine, stirred up a few storms," effectively dismissing all the other exhibitors.[74] The Volpini show revealed Gauguin's eye for the main chance, his ability to seize the initiative.[75] It also exposed his domineering tendencies, his divisive relations with younger or lesser artists. The whole episode sowed such seeds of mistrust and resentment that, within a year, Gauguin's close rapport with Laval, Schuffenecker, and Bernard had broken down and he had resolved to follow his artistic path alone.

Exploring in print his ideas about the exposition, whose progress he continued to monitor through the press, was a calculated move on Gauguin's part to keep his name in the public eye.[76] And from this newly authoritative position he made one of his more presumptuous gestures, which reveals the way his mind was then turning. Conveniently forgetting his sustained *impolitesse* toward the establishment in those *Moderniste* articles, he pulled various strings to make a direct appeal to Antonin Proust, requesting preferment for the post of "Vice Resident" in Tonkin,

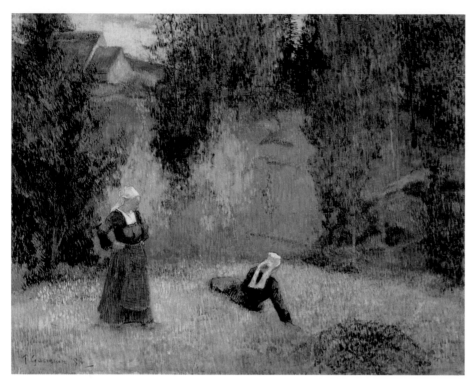

Fig. 21. Paul Gauguin, *Spring at Lézaven*, 1888, private collection

a salaried administrative role in the newly acquired French colony.[77] One wonders what the minister of Fine Arts made of this extraordinary and improbable appeal. Did Gauguin mention his own role as one of the French artists whose "génie," in Proust's words, had added to the "éclat des oeuvres exposées" (brilliance of the works on exhibition) at the Exposition Universelle?[78] All we know is that the request was turned down.

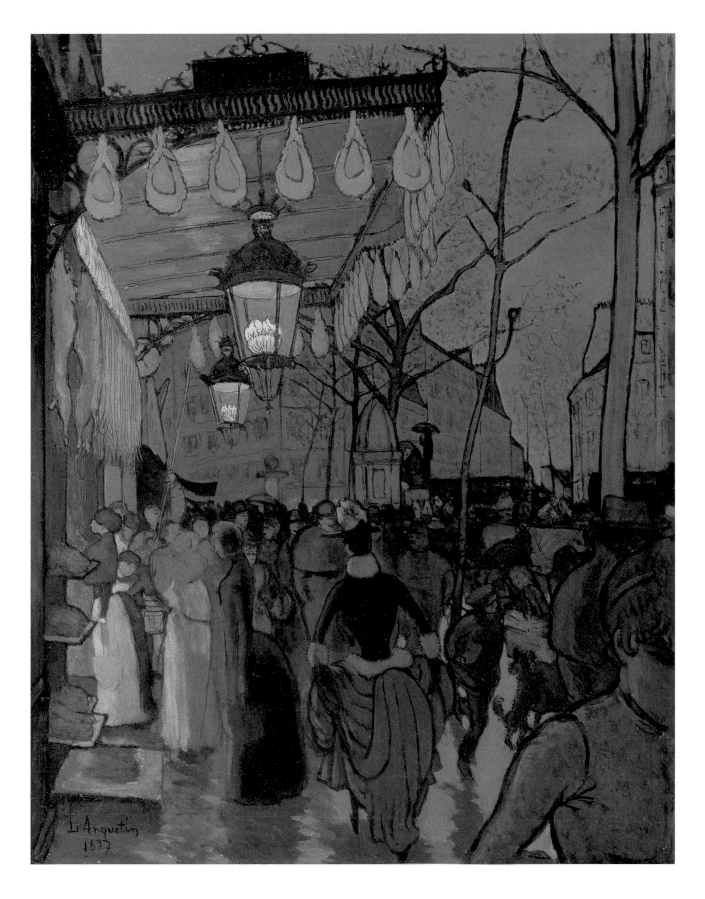

Cat. 51. Louis Anquetin, *Avenue de Clichy*, 1887, Wadsworth Atheneum Museum of Art, Hartford

Devoted to a Good Cause: Theo van Gogh and Paul Gauguin

Chris Stolwijk

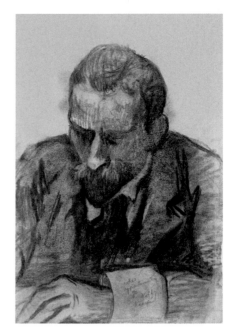

Fig. 22. Jacob Meyer de Haan, *Portrait of Theo van Gogh*, 1889, Van Gogh Museum, Amsterdam

Theo van Gogh—Vincent's younger brother and, until October 1890, the manager (*gérant*) of the Boulevard Montmartre branch of Boussod, Valadon & Cie (formerly Goupil & Cie)—advised Gauguin to produce a series of prints with a view to gaining wider recognition (fig. 22). Theo's insistence led to the famous *Volpini Suite,* a unique display of the motifs Gauguin had taken up in previous years, sometimes at the art dealer's suggestion. This initiative is a good example of the way Theo tried, while adhering to his employer's marketing strategies, to bring Gauguin's progressive art to the attention of the public.

Gauguin was impressed by Theo's efforts, which he described with uncharacteristic generosity in a letter to his wife in November 1892: "Since [Theo] van Gogh's death, [the firm] hasn't sold anything. If you had met Van Gogh, you would have seen a serious man devoted to a good cause. If he hadn't died like his brother, I would not be completely out of business now. And it is thanks to him that the firm of Goupil took us on."[1]

The short period of their collaboration, from December 1887 to October 1890, was of decisive importance to both their careers, the *Volpini Suite* being one obvious result.[2] Gauguin found in Theo van Gogh a dealer who supported him financially and took great pains to build up a clientele for his work, still little appreciated, which included paintings, drawings, sculptures, ceramics, and the *Volpini Suite.* Theo took Gauguin's progressive art on commission and regularly displayed it. According to the company ledgers, Van Gogh managed in just over two years to sell eleven paintings for a total of 4,450 francs, of which 3,315 went to Gauguin. Theo also sold several ceramics and acquired for his own collection a number of drawings as well as several paintings, including *Vincent van Gogh Painting Sunflowers (Van Gogh Peignant des Tournesols)* (fig. 23, p. 76).[3]

At the Forefront of the Avant-Garde

Given the modest returns on Gauguin's work, it could not have been the mainstay of Van Gogh's business. Yet his work and artistic ideas fascinated Theo in the extreme, and he viewed Gauguin as an artist at the forefront of the avant-garde. For him, Gauguin's "strange poetry" was at once

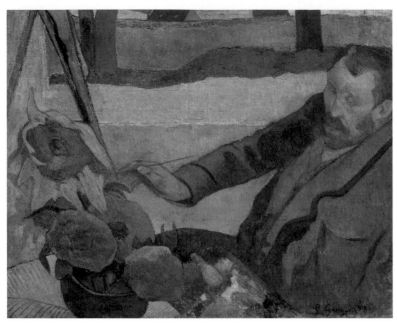

Fig. 23. Paul Gauguin, *Vincent van Gogh Painting Sunflowers*, 1888,
Van Gogh Museum, Amsterdam

moving and comforting; he did not imitate nature but refashioned it—with the help of his exceptional mind (and artistry)—turning it into something that transcended nature and thus attained a more general legitimacy. As Theo wrote, Gauguin could express himself "in many ways" because of the different moods in which he produced his art: "Usually [a] calm nature . . . fills his soul with resignation, but sometimes also the fierce surging of all his pain and strife, which he expresses in the deepest, most powerful tones that resound, above all, when he has seen nature swelling under the salutary and creative force of the sun." According to Theo, a wonderful future was in store for Gauguin: "He appears to be greater than anyone thought." And even though that future seemed a long way off, Gauguin might fare as well as Millet, the artist whom both Vincent and Theo considered one of the absolute beacons of modern art, "who is now understood by everyone, for the poetry he proclaimed is so powerful that old and young alike take pleasure in it."[4]

The decision in December 1887 to stock Gauguin's art testifies to Van Gogh's spirit of adventure and business acumen, for in this way he could acquaint his customers with a wide range of the modern art of his day, namely works produced by both the more established Impressionists of the "Grand Boulevard" (Degas, Monet, Pissarro, Pierre-Auguste Renoir, and Alfred Sisley) and the lesser known of the "Petit Boulevard" (Anquetin, Bernard, Van Gogh, Guillaumin, Seurat, Toulouse-Lautrec, Charles Angrand, and Paul Signac), the latter acknowledging Gauguin as one of their leaders.[5] Theo fully realized that marketing Gauguin's work would require great perseverance for it would be some time before the artist would be accepted and appreciated by a wide public and Boussod, Valadon & Cie would be able to reap the benefits.

Theo van Gogh and Gauguin

When Theo van Gogh decided in December 1887 to buy three works by Gauguin and take several others on commission, he had already been employed by the firm of Boussod, Valadon & Cie for fifteen years. As early as January 1881, he was appointed manager of the branch at 19, Boulevard Montmartre in Paris, where from 1881 to 1886 he dealt mainly in the work of successful artists with "safe" reputations, completely in keeping with the firm's commercial strategy. Of

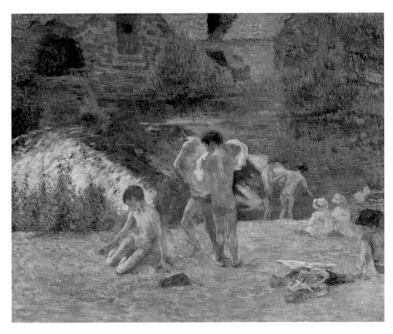

Fig. 24. Paul Gauguin, *The Moulin du Bois d'Amour Bathing Place,* 1886,
Museum of Art, Hiroshima, Japan

paramount importance was the trade in the popular work of a select number of painters of the Barbizon school and contemporary masters of the Salon, including such celebrated academicians as Bouguereau and Jean-Léon Gérôme.[6] Despite this lucrative business, Theo grew increasingly dissatisfied with his prospects, to the extent that in 1886 he made serious plans to set up as an independent art dealer. At this time he was beginning to take more notice of the work of artists who had made a name for themselves at the Impressionists' exhibitions.

Vincent's arrival in Paris gave a boost to Theo's career. Vincent introduced him to a number of young painters, and together they took part in the artistic life of Paris. After a reorganization in the firm, during which old stock was auctioned as a result of disappointing sales and the changing tastes of the art-buying public, in mid 1887 Van Gogh's superiors gave him more autonomy. From that point on, he was able to invest in more progressive, contemporary art, although he was still expected, as in preceding years, to maintain a certain volume of sales. While Theo remained financially dependent on the sale of the successful Barbizon masters and several academicians, he was also able to focus his attention on two Impressionists who since the early 1880s had gradually established their reputations and captured a share of the market, namely Degas and Monet.[7]

In the course of 1887, the mezzanine in Van Gogh's branch gradually evolved into an eye-catching gallery, where visitors could become acquainted with the most recent developments in art. In addition to the Impressionists, from mid 1887 Theo investigated the salability of the work of a few artists whose position in the marketplace was much less secure, such as the young Toulouse-Lautrec.[8] For Pissarro, Theo's promotional efforts were a godsend.[9] Another artist who must have been extremely happy to come into contact with Theo van Gogh was Gauguin.

Since August 1883 Gauguin had been more or less forced to live off the sale of his art. During these years he did all sorts of jobs and was dependent on both the generous help and support of friends and the sale of works from his collection. Not long after his stay with Laval in Martinique (April to November 1887) and his return to Paris, he met Vincent and, probably somewhat later in December, Theo van Gogh.

The meeting with Theo had far-reaching and, from a commercial standpoint, positive consequences for Gauguin. In fact, Theo immediately bought three works for a total of 900 francs and

Cat. 52. Paul Gauguin, *Head of a Woman, Martinique*, 1887, Van Gogh Museum, Amsterdam

Fig. 25. Paul Gauguin, *Vase "Atahualpa,"* 1887–88,
private collection

promised to take more in the near future. This first transaction included *The Moulin du Bois d'Amour Bathing Place (La Baignade au moulin du bois d'amour)* (fig. 24, p. 77), which he managed to sell that same month for 450 francs to the adventurous banker and collector Eugène Dupuis, an important business relation. For his own collection, Van Gogh bought the most ambitious figure painting Gauguin had made in Martinique, *Fruit Picking,* or *Mangoes (La Cueillette des fruits,* or *Aux Mangos)* (see cat. 38, p. 55), for 400 francs. To Gauguin, who was longing for recognition, Theo's purchases and pledges were like manna from heaven, a way out of the financial misery that had long afflicted him. The dealer kept his word and set to work with great energy.

Gradual Progress

As early as December 1887, Theo van Gogh exhibited on the mezzanine of his gallery, next to a painting by Guillaumin and several fans and paintings by Pissarro, four paintings by Gauguin dating from 1885 to 1887 that demonstrated his development in recent years.[10] Among the works exhibited was an early painting of 1885, *The Beach at Dieppe (La Plage à Dieppe)* (W. 166/178; Ny Carlsberg Glyptotek, Copenhagen), which had also been on display at the eighth exhibition of the Impressionists, and a work from Martinique, *Comings and Goings (Allés et Venues),* 1887 (W. 245 [2002 only]; Museo Thyssen-Bornemisza, Madrid). To demonstrate the artist's versatility, Theo also exhibited five ceramics, including *Vase "Atahualpa"* (fig. 25) and *Martinican Woman with Kerchief* (G 52; Ny Carlsberg Glyptotek), both dating from the winter of 1887–88.[11]

An experienced dealer, Van Gogh knew that he had to show Gauguin's work regularly. Scarcely a month after the first presentation, a new show was on view displaying Gauguin's *Two Bathers (Deux Baigneuses)* (fig. 26, p. 80), alongside recent pastels by Degas, an artist Gauguin admired. Theo was also fully aware that he should not spoil the market by lowering the price of Gauguin's work, even though the artist—a former stockbroker who thought he had a keen understanding of the market mechanism—had repeatedly urged him to do so. The already modest prices (400–600 francs) put Gauguin's work at the lower end of the market, approximately on par with the small works of Eugène Carrière, Pissarro, and Jean-François Raffaëlli. A further reduction would bring Gauguin's prices in line with the paintings by Adolphe Monticelli (who had died in 1886 and whose work was not highly esteemed) and further distance him from Impressionists of the Grand Boulevard such as Monet and Degas, whose work Theo sold for about 2,200 and 3,200 francs, respectively.

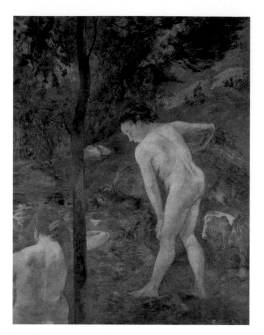

Fig. 26. Paul Gauguin, *Two Bathers,* 1887,
Museo Nacional de Bellas Artes, Buenos Aires

Steady sales were not forthcoming, and when Gauguin again traveled to Brittany in February 1888, he soon found himself in desperate financial straits. On 22 May the destitute artist revealed his awkward situation to Van Gogh, who reacted by sending him 50 francs. Gauguin thanked Theo in December with the gift of two drawings: *Head of a Woman, Martinique* (cat. 52, p. 78) and *Study of "Breton Girls Dancing, Pont-Aven"* (cat. 53). In addition to lending direct financial aid, however modest, Theo tenaciously stuck to the strategy he had mapped out: the gradual marketing and promotion of Gauguin's work. In April he exhibited *Conversation (Tropics)* (fig. 27, p. 82), a work painted in Martinique that, in the critic Félix Fénéon's view, demonstrated what a powerful artist Gauguin was.[12] To promote modern painting beyond the borders of France, in March through April 1888 Theo sent a consignment of Impressionist and Post-Impressionist works on approval to H. G. Tersteeg, his former employer at the Hague branch. The shipment included—in addition to works by Degas, Monet, Pissarro, Sisley, Toulouse-Lautrec, and Van Gogh—Gauguin's *Beach at Dieppe.* While hearing that Theo had been in contact with Tersteeg gave Vincent "a surprising amount of pleasure," the Dutch market—accustomed as it was to the tonal paintings of the Hague school—was not at all ready for such adventurous painting. Its mission unaccomplished, the consignment was returned to Paris in the summer.

This varying success shows that in these months Van Gogh was trying hard, within the bounds set by his employer, to give Gauguin a modest share of the market: he bought works, took others on commission, exhibited them, sent them abroad, but sold only a single painting. Nonetheless, he seemed willing to continue.

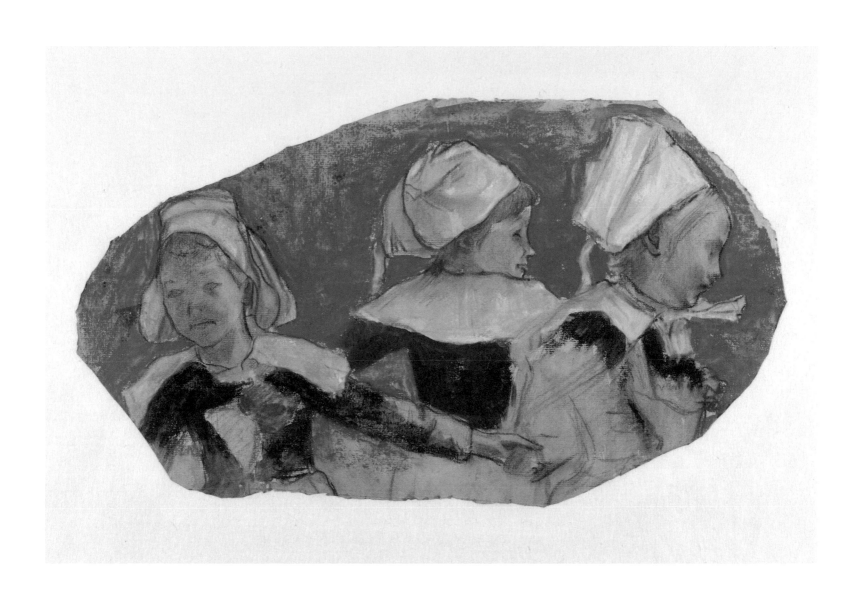

Cat. 53. Paul Gauguin, *Study for "Breton Girls Dancing, Pont-Aven,"* 1888, Van Gogh Museum, Amsterdam

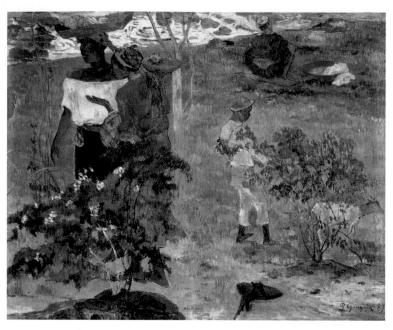

Fig. 27. Paul Gauguin, *Conversation (Tropics)*, 1887, private collection

Studio of the South

After leaving Paris in February 1888 to go to Arles in the south of France, Vincent reminded his brother of the necessity of founding a studio where artists could work together, sharing both living expenses and the profits from sales. In Vincent's view, Gauguin—then in Brittany, and penniless—should be in charge of that studio. Finally, in May–June 1888, Theo decided to ask Gauguin to join his brother in Arles, offering him a monthly allowance of 150 francs in return for a painting every month.[13]

In the early autumn of 1888, Gauguin agreed to the plan. Theo had already sold 300 francs worth of Gauguin's ceramics in September, and on 22 October, the day after Gauguin's arrival in Arles, he sold *Breton Women Chatting* (fig. 28), for 600 francs, 500 of which went to Gauguin.

If Gauguin found these initial sales encouraging, he must have been overjoyed by the huge increase in business that followed. In late October, Gauguin sent a consignment of recent work from Pont-Aven, and in November Theo exhibited a number of these paintings, alongside several pieces of pottery. He was lyrical about the work Gauguin had sent, which in his view contained motifs that lay "more within our reach," thus making them easier to sell than earlier paintings.[14] To his sister Wil he wrote that "it is impossible to describe what is in all those paintings, but he appears to be greater than anyone thought." Gauguin's work literally whispered "words of comfort to those who are not happy or healthy. With him, nature itself speaks, whereas with Monet one hears the maker of the paintings speaking."[15]

The exhibition was very successful. In only a few days Theo sold three works, including *Mount Sainte-Marguerite Seen from Near the Presbytery* (*La Montagne Sainte-Marguerite vue des environs du presbytère*), 1886 (W. 195/227; private collection). In early December he sold *Breton Fishermen* (*Pêcheurs Breton*), 1888 (W. 262/275; private collection). Around the same time, Gauguin sent Theo a roll containing five canvases, most of them recent work from Arles, including the well-known *Human Misery* (see cat. 39, p. 56) and *Night Café, Arles* (*Café de nuit*) (fig. 29, p. 84). But at the same time his collaboration with Theo clearly began to bear fruit, Gauguin's association with Vincent ended with his flight from Arles shortly before Christmas.

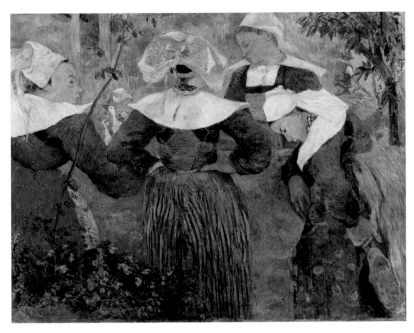

Fig. 28. Paul Gauguin, *Breton Women Chatting,* 1886, Neue Pinakothek, Munich

Volpini Exhibition

Even after Gauguin's hasty departure from Arles, Theo remained devoted to his cause. Only a month later, he urged Gauguin to produce the *Volpini Suite.* In doing so, he reverted to a well-tried marketing strategy used by his employer. For years, Boussod, Valadon & Cie had enjoyed extensive popularity, publishing special artists' albums, prints, photographic reproductions, and other art editions to promote the wide distribution of work by artists they represented.[16] Theo knew the tricks of the trade regarding the combined selling of paintings and prints (whether or not in albums). In his capacity as manager he published in 1889 an album of fifteen lithographs by Georges William Thornley after the work of Degas. Finally, the *Volpini Suite* was followed in 1890 by the Monticelli album, which contained twenty-two lithographs by A. M. Lauzet after the work of this southern French master.[17]

Simultaneously, Theo was trying to introduce Gauguin's work to progressive circles. In February–March 1889, Theo sent twelve paintings by Gauguin, including *Fruit Picking,* or *Mangoes,* from his own collection, to the March 1889 exhibition of the Belgian artists' society Les XX in Brussels, where he succeeded in selling *Shepherd and Shepherdess in a Meadow (Berger et Bergère dans le pré),* 1888 (W. 250/280; private collection), to the Belgian artist Anna Boch. Commercially speaking, however, the year 1889 gave little cause for satisfaction, for Theo did not sell a painting until June, *Conversation (Tropics),* and another in September, *Breton Girls Dancing, Pont-Aven* (see cat. 36, p. 52).

Yet in May and June he did lend, albeit reluctantly, a large number of Gauguin's works from his stock-in-trade to the Volpini exhibition. Theo, who for years had been making cautious attempts to introduce Gauguin's paintings to an audience receptive to modern painting, was not at all pleased with how Émile Schuffenecker organized the exhibition. Theo objected to Schuffenecker's omission of Toulouse-Lautrec's paintings and disapproved of what he perceived as Schuffenecker's pretentious ambitions. Theo voiced his dissatisfaction to Vincent: "However, Schuff. claims that this display will eclipse all the other painters, and if one had let him have his way I think he would have walked through Paris with the flags of all colours to show that he was

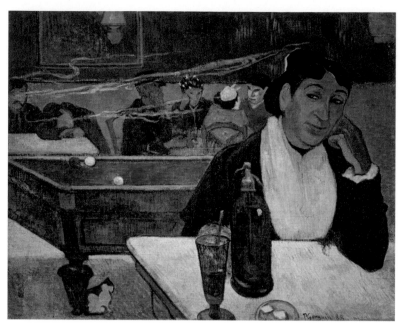

Fig. 29. Paul Gauguin, *Night Café*, 1888, Pushkin State Museum of Fine Art, Moscow

the great conqueror. It was a bit like going to the World Exhibition [Exposition Universelle] by the back stairs."[18]

Theo must have been acutely embarrassed by this state of affairs. Although he was sympathetic to the cause of the avant-garde, he was bound by the interests of his employer, who was well represented at the Exposition Universelle by the work of established masters. In other words, Theo had to avoid being seen as the one who had left that back door open. Moreover, the fact that he would have no control over possible sales of Gauguin's work for the duration of the exhibition was a thorn in his side since he had a clear understanding with the artist that he was his sole dealer. Gauguin was aware of this fact, and wrote to warn Schuffenecker that nothing must be sold at a lower price than Boussod et Valadon were asking or he would have problems with the firm.[19] It is therefore understandable that Theo ultimately viewed the entire enterprise "with regret."[20]

Enduring Collaboration

Although his relations with Gauguin cooled, Theo continued to promote his work, albeit with little success. At the end of the year, he complained to his brother, saying that even though he had a lot of work by Gauguin in stock, it was impossible to find buyers: "The public is most rebellious towards things that aren't done in perfect order. And it's evident that Gauguin, who is half Inca, half European, superstitious like the former and advanced in ideas like certain of the latter, can't work every day in the same way. It's most unfortunate that we can't find something he can live from. These latest paintings are less saleable than last year's."[21]

Throughout 1889 Gauguin had sent him various consignments. In September and October, Theo received at least fifteen works from Brittany, where the artist had been staying since June with Jacob Meyer de Haan, whom he had met through Theo. In contrast to earlier shipments, Theo was none too enthusiastic about these new works, which included *Girl Guarding Cows* (*Vaches dans un Paysage*), 1889 (W. 344; Ny Carlsberg Glypotek) and *Yellow Christ* (*Le Christ Jaune*) (fig. 30). He wrote to Vincent, saying that Gauguin's works "didn't appear as fine to me as the one from last year."[22] According to Theo, Gauguin's striving for extreme stylization in these last

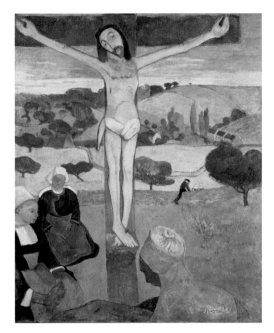

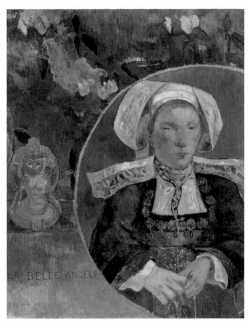

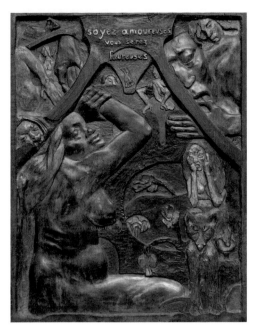

Fig. 30. Paul Gauguin, *Yellow Christ*, 1889, Albright-Knox Art Gallery, Buffalo, New York

Fig. 31. Paul Gauguin, *La Belle Angèle,* 1889, Musée d'Orsay, Paris

Fig. 32. Paul Gauguin, *Be in Love and You Will Be Happy,* 1889, Museum of Fine Arts, Boston

works from Brittany had been at the expense of expressiveness or "sentiment," which he [Theo] took to mean the mood or emotion the artist was attempting to evoke: "I prefer to see a local Breton woman than a Breton woman with the gestures of a Japanese woman."[23]

Theo did, however, see a real Breton woman in *La Belle Angèle* (fig. 31). In this painting, he thought, the pictorial means accorded with the fresh, rustic expression: "It's a portrait arranged on the canvas like the big heads in Japanese prints, there's the bust portrait with its frame, and then the background. It's a Breton woman seated, hands folded, black dress, lilac apron and white collar, the frame is grey and the background a beautiful lilac blue with pink and red flowers. The expression of the head and the posture are very well chosen. The woman looks a little like a young cow, but there's something so fresh and once again so countrified, that it's most agreeable to see."[24]

Van Gogh detected in Gauguin's sculptures, perhaps more so than in his paintings, the artist's exceptional skill and power of expression. In the last months of 1889 he received from Brittany Gauguin's *Black Venus* (*Venus Noire*), 1889 (G 91; Nassau County Museum, Port Washington), and *Be in Love and You Will Be Happy* (*Soyez amoureuses vouz serez heureuses*) (fig. 32). Theo was lyrical about the latter sculpture: "What an excellent *workman* he is, this is worked with a care that must have demanded an enormous amount of work from him. Above all the woman's figure is very beautiful, in waxed wood, while the surrounding figures are in rough wood and coloured. It's obviously bizarre and doesn't express a very clear idea, but it's beautiful like a piece of Japanese work, the significance of which is also hard to grasp, at least for a European, but in which one must admire the combinations of lines and the beautiful parts. The whole has a very sonorous tone."[25] Van Gogh exhibited the relief in February 1890, along with several of Gauguin's ceramics and recent work by Pissarro.

It was to be the last exhibition of Gauguin's work on the mezzanine in the Boulevard Montmartre gallery. In 1890 Theo managed to sell only two paintings for the insignificant sum of 500 francs. There were no more important consignments. The business that had begun so promisingly in late 1887 had practically come to a standstill. In October 1890 the curtain fell for good when Theo lost his mind. A few months later Gauguin left for the South Pacific.

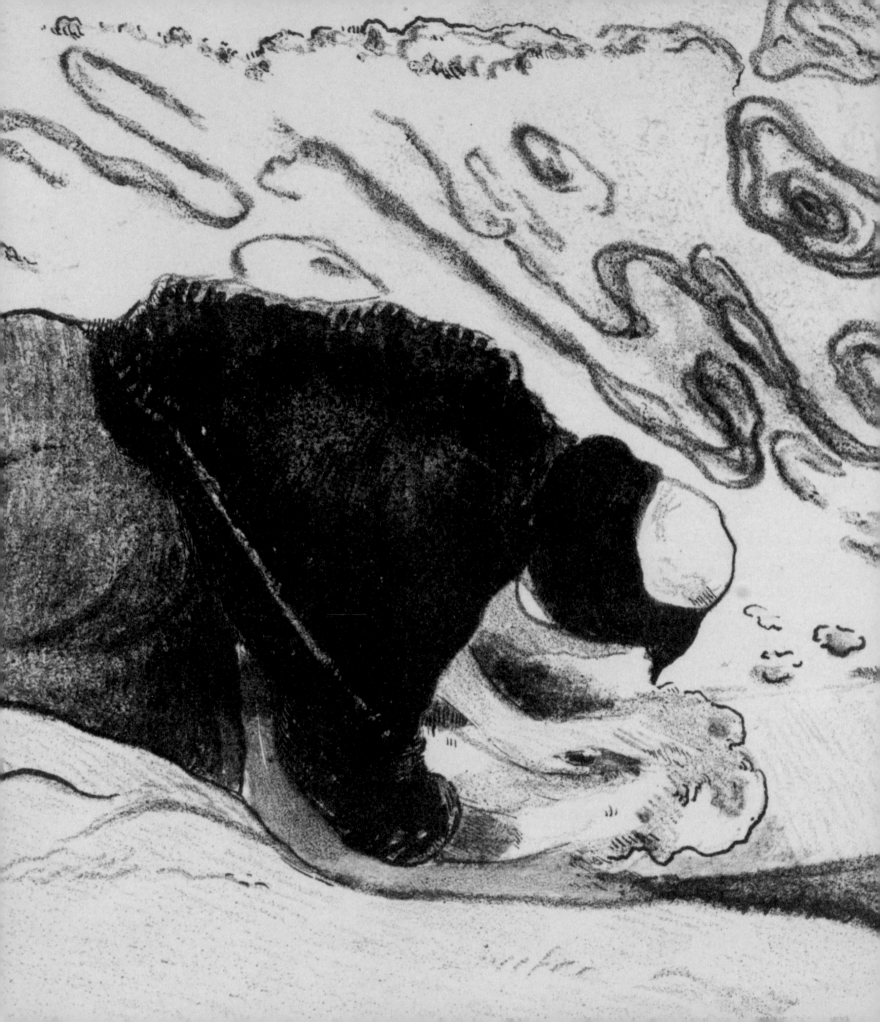

Gauguin Becomes a Printmaker

Heather Lemonedes

During the winter of 1889 in Paris, Gauguin executed a suite of eleven zincographs. First exhibited on the grounds of the Exposition Universelle at the Café des Arts, Monsieur Volpini, proprietor, they became known as the *Volpini Suite*. With these prints Gauguin created a self-portrait, a visual resumé of his professional career as an artist, and an advertisement of his subject matter and style.

In creating a portfolio of original zincographs, Gauguin subscribed to a tradition of printmaking that by 1889 was firmly established in France. In order more clearly to understand Gauguin's goals in making his first album of prints, it is important to acknowledge the artistic tradition out of which the *Volpini Suite* evolved—namely the practice of producing portfolios of limited-edition prints marketed to aspiring art collectors—and to examine the waxing and waning of lithography in France during the nineteenth century.

Alois Senefelder invented lithography in Munich in 1798. Not an artist, Senefelder developed lithography as a way of printing more cheaply than engraving. In intaglio processes such as etching and engraving, copper plates wore down relatively quickly, but the limestone used in the newly invented planographic process could generate many more impressions of consistent quality than could an etched copper plate. Further, the chemical process of etching the stone in lithography made the design extremely durable. Senefelder quickly recognized the medium's artistic potential and went into business with several partners to operate lithographic presses in the capitals of Europe. *The Specimens of Polyautography* ("polyautography" was the first name for lithography), the first portfolio of artistic lithographs, was published in two installments in England in 1803–6. The complete portfolio consisted of twelve pen-and-ink lithographs and included landscapes and figure studies by numerous well-known artists of the day. The expatriate American painter Benjamin West, then president of the Royal Academy, contributed *The Angel of the Resurrection,* 1801, the earliest dated lithograph by an artist. The designs included in *The Specimens* were simple pen-and-ink studies drawn on stone, using the stone as if it were paper. This basic process was soon surpassed as various methods were invented, each achieving strikingly different effects. Artists used lithographic crayons, scratched into the stone to create texture, and eventu-

ally mastered the printing of delicate washes of tusche, a liquid that could create the effect of wash drawings.

Lithography began to be established as a serious medium in Paris in 1817 when the technique made its debut at the Salon with examples by Carle Vernet and Claude Thiénon on view. An examination of the lithographs exhibited in the Paris salons between 1817 and 1824 reveals a rapid progression from the tentative and coarse beginnings of the medium to astonishing works of technical virtuosity.[1] By the 1820s a full-fledged golden age of lithography among the leading French artists had begun. Several great lithographic albums were created by French artists during the period, including Théodore Géricault's *English Suite,* 1821, and Delacroix's lithographic illustrations of *Faust,* 1828, and *Hamlet,* 1835.

Voyages pittoresques et romantiques dans l'ancienne France (Picturesque and Romantic Journeys in Old France), a twenty-volume series of topographical lithographs of France published in Paris from 1820 through 1878, was one of the most ambitious publication ventures of all time.[2] Jointly sponsored by French novelist and poet Charles Nodier, French author Alphonse de Cailleux, and Belgian-born author and theater administrator Isidore-Justin-Séverin Taylor, the series was intended to document a romantic, idealized vision of the architecture and countryside of France that seemed increasingly replaced by industrialization. The choice of lithography probably did as much to ensure the success of the medium as any other single factor. The publication provided work for many lithographers—altogether more than 150 artists contributed to it. The fact that twenty volumes were published over a fifty-eight year period meant that the French were constantly being exposed to lithographs; one might even suggest the topographical views of the provinces conditioned the public to associate lithography with France itself. In 1849 the printer Rosé-Joseph Lemercier began toying with the idea of fixing a photograph image on a lithograph stone, subsequently presenting his experiments at the Great Exhibition in London in 1851. Photo-lithography was used in the last two volumes of the *Voyages pittoresques*. Thus, although its publishers could not have predicted it, in this one publication it is possible to trace the discoveries, progress, and eventual midcentury decline of lithography.

The Decline of Lithography and Attempts to Resuscitate the Medium

By midcentury lithography was increasingly employed for commercial purposes and less often used by artists. The shift was primarily due to technical advances in the medium. Alongside the advent of photolithography, the high Victorian period saw a flood of color lithographs, mainly for book illustrations or collectable portfolios of reproductions of paintings. Known as chromolithographs, these illustrations were printed with immense skill; designs of eight or ten colors required a separate stone for each hue. Artists were put off by the medium's increasing connotations of commercialism, however, and few artistic lithographs were produced at midcentury.[3]

By that time, most critics were in agreement that the essential role of prints was to reproduce works of art, primarily paintings, but that printmaking—particularly lithography—was not a medium for original art.[4] Philippe Burty, the critic and collector of prints was the exception. A great champion of lithography, Burty argued that it had the potential to be the most spontaneous expression of an artist's thoughts and that a lithograph was essentially "a drawing printed in several copies." In a review of the prints exhibited in the Salon of 1861, Burty assessed the midcentury

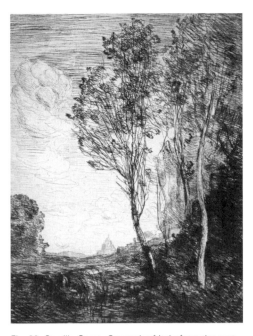

Fig. 33. Camille Corot, *Souvenir of Italy*, from the portfolio *Twelve Sketches*, 1871, The Metropolitan Museum of Art, New York

plight of lithography: "Lithography is also dying through neglect of the great principles that should preside over the making of all art. The painters alone can bring it back to life."[5] During a time when printmaking in general had become synonymous with reproductive etching and engraving, Alfred Cadart established the Société des Aquafortistes (Society of Etchers) in order to promote the concept of the original print, or the "belle épreuve."[6] From 1862 to 1867, with the printer Auguste Delâtre, Cadart published five albums entitled *Eaux-fortes modernes* (Modern Etchings). Each contained approximately sixty original etchings selected by a jury of subscribers. By publishing only "oeuvres originales," Cadart sought to attract established painters to etching and invigorate the concept of the "peintre-graveur" as exemplified by Rembrandt.

Although Cadart succeeded in bringing about an etching revival in France, he was less successful in reviving lithography.[7] He gave lithographic stones to five artists—Édouard Manet, Henri Fantin-Latour, Félix Bracquemond, Alphonse Legros, and Théodule Ribot—but the resulting lithographs were not published, and there was scant public enthusiasm for the medium's artistic capacity primarily because of the stigma attached to its connection with commercial printing. Only a few artists had the foresight to see past the negative connotations that enshrouded lithography in the 1870s and 1880s. A further challenge was overcoming the technical obstacles: lithography was much more complicated than etching and required the close involvement of a professional printer to etch and print the stone. A few courageous artists paved the way for the revival of the medium and the avalanche of color lithography of the 1890s. Gauguin's *Volpini Suite* was made at a pivotal moment in the history of the medium.

Lithography in the 1870s: Camille Corot

French artists began to see past lithography's midcentury commercial connotations and appreciate the medium's artistic potential in the 1870s. Although lithography would not experience its second heyday until the 1890s in Paris, several French artists began experimenting with the medium in the 1870s, and it was their pioneering efforts that helped revive it. Corot's portfolio of transfer lithographs, *Twelve Sketches* (*Douze Croquis*) (fig. 33), was intended to portray lithography

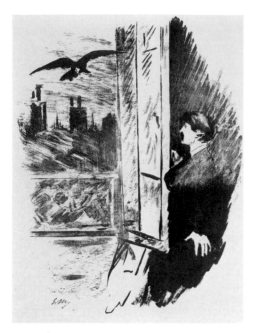

Fig. 34. Édouard Manet, *The Raven: Open Here I Flung the Shutter (The Window),* 1875, The Metropolitan Museum of Art, New York

as a means to multiply original drawings. Much more an enthusiast of etching and clichés-verre, this was Corot's only true foray into lithography. During the Commune of 1871, Corot left the capital and took refuge with friends in northern France. While staying in Douai, his friend the lithographer Alfred Robaut encouraged the artist to make a group of transfer lithographs. An accompanying preface underscored the "authenticity" of the prints, describing the portfolio as "a collection of twelve drawings and compositions drawn on autolithograph paper by [Corot] himself and transferred by us directly to the stone." The preface stressed the spontaneous and frank execution of Corot's lithographs, emphasizing the closeness of the prints to the artist's hand. The prints were published by Robaut and printed by Lemercier et Cie in 1871.

Twelve Sketches was one of the first lithographic publications to be marketed in a limited edition (fifty prints), echoing Cadart's campaign to make etchings exclusive and collectable. A variety of inks and papers was used in the edition, heightening the specialized aspect of the project. Despite disappointing sales, *Twelve Sketches* seems to have generated considerable interest in lithography among a younger generation of artists, including Manet, Fantin-Latour, Camille Pissarro, and Edgar Degas. As well as capturing nature and fleeting atmospheric effects, thus summarizing his essential style, in *Twelve Sketches* Corot also recorded locales of personal significance such as Arras and Douai in the north of France and recollections of the Italian countryside. In serving these dual functions, Corot's album of lithographs fulfilled a similar function to Gauguin's *Volpini Suite* eighteen years later.

Édouard Manet

Perhaps inspired by *Twelve Sketches,* in 1875 Manet made a series of six pen-and-ink lithographs to accompany *Le Corbeau,* Stéphane Mallarmé's translation of Edgar Allan Poe's poem *The Raven* (1845) (fig. 34).[8] Mallarmé, who taught English for a living, began translating works by Poe as early as 1862, but it was not until 1875 that the translations were published. He and Manet met in 1873, and the artist and the Symbolist poet became lifelong friends. Manet's lithographic compositions were entirely original, lacking parallels either to previous artistic endeavors or to any aspect

of Manet's own oeuvre. Rather than make slavish illustrations, he focused on moments in the poem that invited visual interpretation.[9]

Manet was not a newcomer to printmaking in 1875. In 1862 Cadart had published a portfolio of eight Manet etchings plus a title page; the portfolio announced and advertised the artist's paintings on view at Louis Martinet's newly opened gallery on the Boulevard des Italiens and at the Salon des Refusés of 1863. Portfolios like this one were not uncommon even before Cadart founded his business and the Société des Aquafortistes; Théodore Chassériau, Charles-François Daubigny, Paul Huet, and Charles Meryon had all published print portfolios under the guise of self-promotion.

Although Manet's illustrations for Mallarmé's *Raven* were not commercially successful, the publication helped revive lithography among artists. Manet's open-minded approach toward printmaking and its capacity to promote an artist's reputation contributed to redeeming the medium's artistic potential.[10] His use of lithography to illustrate a French Symbolist poet's translation of American poetry was strikingly innovative, as were many aspects of his self-promotion and artistic practice. When Manet died in 1883, Gauguin was still essentially an amateur. Nonetheless, he sought to emulate some of the more audacious aspects of Manet's career, including staging an independent exhibition alongside an exposition universelle and offering for sale prints that reinterpreted his compositions in oil, all of which suggest that Manet's posthumous reputation played an important role in how Gauguin fashioned his own artistic identity. The *Volpini Suite* has been called the most important portfolio of prints of late-nineteenth-century France after Manet's *Raven*.[11] Gauguin likely recognized Manet's use of lithography in *The Raven* as revelatory, and it may have contributed to his desire to begin printmaking.[12] It is noteworthy that Gauguin also chose to refer to Poe in his album of zincography in *Dramas of the Sea* (*Les Drames de la Mer*) (see cat. 15, p. 20).

Henri Fantin-Latour

Following a few early experiments in lithography in 1862, Fantin-Latour began printmaking in earnest in the mid 1870s. Between 1875 and 1903 his work in lithography was virtually uninterrupted, resulting in more than 170 prints. The artist's lithographs—his "projets d'imagination" as he called them—were the realization of his aspiration to produce an art that was inspired by the imagination rather than nature. The lithographs served as the starting points for subsequent works in pastel and oil, which he exhibited at the salons during the 1870s, 1880s, and 1890s alongside his prints. Ultimately, Fantin-Latour's favorable critical reception and his place within the Symbolist movement were founded on his lithographic oeuvre rather than his works in oil or pastel.[13] His work as a printmaker, which began at a time when lithography was totally unfashionable, had, by the end of the 1880s, served to re-establish the creative potential of the medium. In fact, the prints were essential to the rehabilitation of artistic lithography at the close of the nineteenth century.

A turning point in both Fantin's career and the waxing popularity of lithography occurred in 1886 with the publication of Adolphe Jullien's *Richard Wagner, sa vie et ses oeuvres* (Richard Wagner, His Life and Work) to which Fantin contributed fourteen lithographic illustrations that were exhibited in the salons of 1886 and 1887 (fig. 35, p. 93). In the French critical press, Fantin

was compared to Delacroix, who was perceived as the master of original lithography. Fantin's lithographs were praised by the critic Paul Leroi in the influential journal *L'Art*: "There are a number of reproductive lithographers of merit, and there are also some brilliant original lithographers. In first place, without dispute, is M. Fantin-Latour."[14] Fantin's lithograph *Lohengrin* from Jullien's *Richard Wagner* was published alongside Leroi's article. While close to six hundred etchings had been published in *L'Art,* this was the first original lithograph to be included in the periodical since its inception in 1874.

Odilon Redon

Encouraged by Fantin-Latour to use lithography to reproduce his charcoal drawings, Odilon Redon became another pioneer of lithography in late-nineteenth-century Paris.[15] He began making lithographic portfolios in 1878 and worked almost exclusively in the medium until he turned to pastel in 1900. In this twenty-year period, Redon immersed himself in his "noirs," charcoal drawings and lithographs. Rebelling against current artistic trends, he used these black media to give voice to highly personal, idiosyncratic visions. During a time when the avant-garde Impressionists were experimenting with light and color, Redon devoted himself to black. He worked almost exclusively in lithography when it was widely considered unsuitable for artistic expression. Redon's lithographs—like Fantin-Latour's—represent a milestone in the evolution of the technique from a reproductive medium to one with its own distinct artistic possibilities.

Although Redon started out financing and publishing most of his early print projects, by the mid 1880s he had established enough of a reputation that various dealers and publishers began to publish new projects and sell remaining editions.[16] Redon was very much aware of lithography's potential to provide a steady if modest income and to promote his reputation. By 1889, Redon had made eight lithographic portfolios; not merely works of art, the prints were marketing tools. He made sure to give his lithographs to writers who would be willing to mention his prints and exhibitions in their essays or reviews. By the end of the 1880s, Redon was surrounded by a devoted group of Symbolist poets and intellectuals, including J.-K. Huysmans and Mallarmé.

Although not typically associated with Redon, Gauguin approached his first print portfolio with similar goals as had the Symbolist lithographer. Gauguin's zincographs were intended to reinterpret his subject matter in planographic terms and to promote his reputation. The artists' similarities extended to their understanding of the supremacy of the imagination over direct observation of nature. Although a prolific writer, Gauguin was loathe to acknowledge artistic or philosophical influences. He wrote in defense of Redon's intentional use of "ugliness" and praised the Symbolist's art as essentially human:

I do not see why it is said that Odilon Redon paints monsters. . . . He is a dreamer, an imaginative spirit. . . . The artist himself is one of nature's means and, in my opinion, Odilon Redon is one of those it has chosen for this continuation of creation. In his work, dreams become reality because of the believability he gives them. All of his plans, his embryonic and essentially human creatures have lived with us; beyond a doubt, they have their share of suffering. . . . In all his work I see only a language of the heart, altogether human, not monstrous.[17]

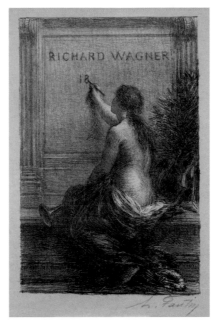

Fig. 35. Henri Fantin-Latour, *Immortalité,* from Adolphe Julien's *Richard Wagner, sa vie et ses oeuvres,* 1886, The Cleveland Museum of Art

Fig. 36. Odilon Redon, *La Mort,* from *À Gustave Flaubert: Tentation de Saint-Antoine,* 1889, Kroller-Müller Museum, Otterlo

Gauguin's validation of Redon's mysterious imagery highlights the similarities between the two artists' creative pursuits. In his own work, Gauguin used ugliness to simultaneously disorient the viewer and suggest the complexity and darkness of his inner vision. Redon's highly personal lithographs of the 1880s paved the way for Gauguin's cryptic print portfolios, which were to follow in 1889, 1893–94, and 1898–99.

In a letter from autumn 1890, Gauguin acknowledged that Redon's lithographs would be part of the visual library that would accompany him to the South Seas:

I take with me in photographs, drawings, a whole little world of friends who will converse with me daily; from you I have a souvenir in my mind of nearly all that you have done, and a star, in seeing her in my house in Tahiti I will not think, I promise you, of death, but on the contrary of eternal life, not death in life but life in death. In Europe this death with its serpent tail is likely, but in Tahiti, one should see her with roots that regenerate with flowers.[18]

Gauguin's description suggests that he brought with him Redon's lithograph *La Mort* (*Death*) from *À Gustave Flaubert: Tentation de Saint-Antoine* (fig. 36).

William Thornley

The 1890s explosion of original color lithographs and the fashion for reprising painted compositions in lithographic form were foreshadowed in 1889 with the publication of Georges William Thornley's *Quinze lithographies d'après Degas* (*Fifteen Lithographs after Degas*) in 1889. The album of prints marked the beginning of Theo van Gogh's endeavors as a publisher of lithographic albums for Boussod, Valadon & Cie.[19] Thornley's lithographs, printed on various colored papers, reproduced paintings of dancers and bathers. Degas, himself an avid printmaker, was close-

ly involved in the project.[20] Before the album's official publication, four of the lithographs were shown at Boussod, Valadon & Cie's Montmartre gallery in 1888. The critic Félix Fénéon commented on the lithographs, particularly struck by their relationship to Degas's paintings: "Four lithographs by Mr. G. W. Thornley, after Degas, through their sparse and essential eloquence, evoke the originals."[21] The success of the album may have prompted Theo van Gogh to urge Gauguin toward printmaking. Of course, in 1889, Gauguin was still forging a style and an identity, so hiring Thornley was not a possibility. Gauguin would have to make his own album of prints to advertise his work and promote his reputation.

By the late 1880s, lithography had been resuscitated from its midcentury decline. Lithographic portfolios by Corot, Manet, Fantin-Latour, Redon, and Thornley helped initiate the change in attitude. Ironically, however, faulty institutional systems for the promotion and support of the arts in France during the last quarter of the nineteenth century also helped encourage the proliferation of lithography at the end of the 1880s. The Third Republic relinquished its authority over the Salon in 1880 and jurisdiction was handed over to the newly founded Société des Artistes Français, which did not welcome modernist art.[22] In the face of this situation, avant-garde artists began looking to nontraditional and nonacademic ways of promoting themselves and their art. This period witnessed the rise of independent art dealers as well as the expanding print market. Single and multi-artist print portfolios that were affordable and accessible became a means through which artists promoted themselves and raised capital. During the 1880s and 1890s, the number of artists' portfolios steadily increased alongside a demand that justified such production.

Exposition des Peintres-Graveurs

In 1888, the Société de l'Estampe Originale (Society of the Original Print) was founded, and the following year the group held its first exhibition of works by peintres-graveurs, as distinguished from reproductive or commercial printers.[23] In 1888 and 1889, Auguste Lepère published two multi-artist albums of ten prints each entitled *L'Estampe Originale* (not to be confused with André Marty's larger and more important print publication of 1893–95 of the same title).[24] While advocating the artistic significance of printmaking in general, Lepère's goal was to promote the "original" limited-edition print, so called because it was based on an original design rather than reproducing a painting. Although Lepère's two albums were neither financially successful nor artistically groundbreaking, conceptually they were important, setting the stage for the 1890s, during which print portfolios increased significantly.[25]

The opening of the first Exposition de Peintres-graveurs at Durand-Ruel's gallery on 23 January 1889 was a milestone in the evolution of nineteenth-century French printmaking. The formation of the Société des Peintres-Graveurs had been influenced by the Société des Aquafortistes of the 1860s; the two groups' aims were similar, although the later society did not limit itself to one technique of printmaking. Bracquemond together with Degas, Pissarro, Redon, Rodin, Sisley, and Mary Cassatt joined the critic Burty and the dealer Durand-Ruel in organizing an exhibition intended to promote printmaking among collectors and elevate the reputations of printmakers.[26] The exhibition signaled a revival not only of lithography, but of all techniques of printmaking in France in the 1890s.

Fig. 37. Edgar Degas, *Nude Woman at the Door of Her Room*, 1879, Rijksmuseum, Amsterdam

The artists who exhibited in the first gathering of the Société des Peintres-Graveurs represented a variety of schools ranging from conservative academic artists to Impressionists. Redon showed a series of six lithographs and a frontispiece entitled *À Gustave Flaubert: Tentation de Saint-Antoine,* and Degas exhibited the lithograph *Femme nue à la porte de sa chambre* (*Nude Woman at the Door of Her Room*) (fig. 37).[27] Degas executed the original design as a monotype but transferred the print to a lithographic stone and reworked the composition, using a crayon and scraper extensively to make the generalized forms of the monotype more specific and detailed in the lithograph. In a review of the exhibition, Fénéon paid particular attention to the lithograph:

Mr. Degas nonchalantly exhibits a small lithograph whose savage artistry is astounding. Her long hair falling down her back, the nude woman, aching all over or half asleep leaves her room. And everything—the woman disappearing, the unmade bed, the downy easy-chair—bears the mysterious imprint of Degas.[28]

Degas's lithographic adaptation of a work initially executed in another medium would have appealed to Gauguin and may have bolstered his confidence as he tried his hand as a peintre-graveur. By the time the Exposition de Peintres-graveurs opened, Gauguin had already begun making his first set of prints.

Gauguin and Bernard in Paris, January–February 1889

Even before he took up printmaking, prints occupied a significant place in Gauguin's artistic consciousness. Although financial straits prevented him from continuing to acquire paintings after 1883, he continued collecting prints. A group of Pissarro's etchings in 1885 was among his final art acquisitions; so eager was he to have them that he asked Pissarro to send the prints to Copenhagen after he had lost his job on the Bourse and was living with his wife's family in Denmark.[29] Back in the French capital in 1886, Gauguin lined the walls of his Paris studio with

Japanese color woodcuts, known as *ukiyo-e;* later he had his Degas prints sent to Arles and eventually brought them to Tahiti.[30] Theo van Gogh, himself an enthusiastic collector of prints, promoted the publication of prints at Boussod, Valadon & Cie. Theo's encouragement was a decisive element in Gauguin's decision to make a portfolio of prints in 1889.[31] A letter from Vincent to Theo van Gogh from October 1888 suggests that Gauguin was musing about the possibility of making a suite of lithographs as early as the autumn of 1888. Responding to a now lost letter from Gauguin, Vincent stated that he would be willing to contribute to a lithographic portfolio by Gauguin and his friends, but warned that publishing lithographs was an expensive venture and would be unlikely to earn money.[32] In the winter of 1889, Gauguin likely felt immersed in a deluge of prints–lithographs in particular. We do not know whether Vincent van Gogh had with him in Arles impressions of the nine transfer lithographs of Dutch peasants he made in Holland between 1882 and 1885, but the two artists likely discussed Vincent's experiments with lithography. In December, Gauguin returned to Paris from Arles. Further, the first Exposition de Peintres-graveurs in January would have underscored the new relevance of printmaking.

The possibility of making lithographs from zinc plates may have been brought to Gauguin's attention by Bernard, who had experimented with the technique as early as 1888 before making *Les Bretonneries* (see cats. 54–63, pp. 99–104), his portfolio of zincographs, in Paris during the winter of 1889. The literature on Bernard has been dominated by arguments supporting Bernard's role in the development of Gauguin's style. Authors have felt compelled to defend Bernard's originality, often relying on his self-aggrandizing memoir, *L'Aventure de ma vie.*[33] The history of modern art and its evolution is full of such pairings at critical junctures; in fact, such dialogues seem to be an essential component of the development of modern art.[34] Gauguin's introduction to Bernard in Pont-Aven in 1886 was unremarkable; neither saw any of the other's works. When they met again in Brittany in 1888, it is clear that Gauguin recognized Bernard's confidence, determination, and precocious nature. In a frequently quoted letter, Gauguin wrote to Schuffenecker of the promising young Bernard: "I have taken on a pupil who will go far: the group is expanding. Young Bernard is here and has brought some interesting things with him from St. Briac. Here is one person who is not afraid to try anything."[35] Letters to Vincent van Gogh from both artists reveal an enthusiastic exchange of ideas and burgeoning mutual respect.

Gauguin and Bernard were each working on their own albums of prints in Paris in January and February 1889. Bernard had begun making preparatory drawings for *Les Bretonneries* at the end of 1888, while Gauguin was still in Arles, and finished working on his zincographs in the early months of 1889.[36] On 17 January 1889 Gauguin indicated in a letter to Vincent van Gogh that he had begun a series of lithographs with the encouragement of Theo.[37] Theo must have been sufficiently involved in the project to keep Vincent informed of its progress. In a letter dated around 25 February 1889, Vincent responded to a now-lost letter from his brother: "It gives me great pleasure that Gauguin has finished some lithographs."[38] It is difficult to determine how much time Bernard and Gauguin spent together during this period or to ascertain whether or how much the two artists witnessed each other's progress on their respective print portfolios. Bernard recalled the winter in his memoirs: "I went to see him often. He had finished his album when I showed him mine. They pleased him so much that he remade two, executing them in the manner which I had discovered."[39] Bernard's claim is suspect as no two prints in the *Volpini Suite* use the much coarser tusche manifest in *Les Bretonneries.*

Fig. 38. Paul Gauguin, *Carnet Huyghe*,
p. 217, The Israel Museum, Jerusalem

Significant differences between the two suites of prints exist. Whereas Gauguin's *Suite* comprises a variety of subjects, some original and some related to paintings, Bernard's series of zincographs is more unified, describing an idealized vision of the daily life of Breton women, unrealistically dressed in traditional festival costume while engaged in the rural work of the locale.[40] Unlike the *Volpini Suite, Les Bretonneries* did not have a fixed number of prints. Within Bernard's graphic oeuvre there are ten zincographs of similar size depicting Breton subject matter, any of which may have been included in the portfolio at various times. Albums of *Les Bretonnneries* have been found in the collections of Bernard's friends such as Filiger, Sérusier, and Andries Bonger, likely gifts of Bernard. Curiously, none of the assembled portfolios contain precisely the same set of images. When giving away his prints, Bernard apparently selected different images according to the occasion. According to Bernard, none of his albums of *Les Bretonneries* was sold at the Volpini exhibition. The "visible sur demande" album was simply printed in black on smooth, thin off-white paper; Bernard later made a habit of hand coloring the zincographs.

Gauguin's Printer

According to the art historian Marcel Guérin, Sérusier remembered that Gauguin's *Volpini Suite* was printed in the atelier of Edward Ancourt in Paris:

Sérusier, who had known Gauguin since 1888, recalled exceedingly well having seen the lithographs in 1889 in Le Pouldu where they adorned the rooms of the Inn of Marie Henry where he was living at the same time as Gauguin; [Sérusier] thought he remembered that they had been pulled in an edition of thirty or fifty proofs at the most by Ancourt, the well-known printer-lithographer who later, with the skillful worker Stern, printed a great number of lithographs of Toulouse-Lautrec.[41]

Based on this recollection, it has always been assumed that Gauguin's zincographs were printed at Ancourt et Cie, located at 83, Faubourg St. Denis.[42] Sérusier was only twenty-five years old when Gauguin made the *Volpini Suite,* however, and Guérin's catalogue raisonné was pub-

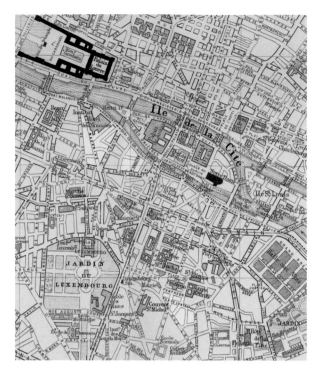

Fig. 39. Detailed map of the Left Bank of Paris showing the addresses mentioned in Gauguin's sketchbook of 1888–89, from W. J. Rolfe, *A Satchel Guide for the Vacation Tourist in Europe* (1901)

lished in 1927, right around the end of Sérusier's life. It is entirely possible that Sérusier misremembered events that had occurred thirty-eight years earlier.

A page from the sketchbook Gauguin was using in Brittany, Arles, and Paris between 1888 and 1889 indicates his involvement with the lithographic process (fig. 38, p. 97).[43] The artist listed three addresses on the Left Bank in Paris, along with materials—grained plates, crayons, and ink—necessary for making zincographs. Next to the address 21, rue de l'Estrapade, Gauguin inscribed the words "grain" and "plaques" (grained plates). In 1889, several artisans' studios were located at this address. In addition to cutlers, grinders, and polishers of steel, several *planeurs de métaux* and *ateliers de planage* (planishers of metal plates used for printing) were in operation there.[44] Gauguin also inscribed the name Cottens, referring to *Cottens, père et fils, planeur pour taille-douce* (planishers of copperplates) who also operated at 21 rue de l'Estrapade. This information suggests that Gauguin obtained the flattened, grained zinc plates for the *Volpini Suite* from Cottens, père et fils on the rue de l'Estrapade.[45] On the same page, Gauguin inscribed the name "Lemercier," referring to the Lemercier et Cie, the firm that was responsible for many important innovations in planographic printing during the period and that championed printing lithographs from zinc plates. Gauguin also inscribed the address 62, rue Mazarine, the home of Rosé-Joseph Lemercier and his son Alfred.[46] At their nearby business address, 57, rue de Seine, Lemercier et Cie sold a variety of printing materials available to artists.[47] Their printing machines were in a large covered space in a courtyard between the rue de Seine and the rue Mazarine. Finally, Gauguin listed the name "Labbé" as responsible for "le tirage" (the printing) and the address 3, rue Séguier. Many artisans rented spaces at this address in 1889. An *imprimeur lithographe* by the name of Labbé is recorded as having worked alone there in a wing to the right of the courtyard.[48]

From the addresses listed in Gauguin's sketchbook, it is obvious that he was purchasing materials and organizing the printing of his zincographs within a small radius of the Left Bank (fig. 39). The addresses at the rue Mazarine and the rue Séguier are within a two-minute walk of each other. It is possible that Labbé was working for his neighbor Lemercier. Gauguin's notes suggest that it may have been Labbé who printed the *Volpini Suite* rather than Ancourt et Cie.[49]

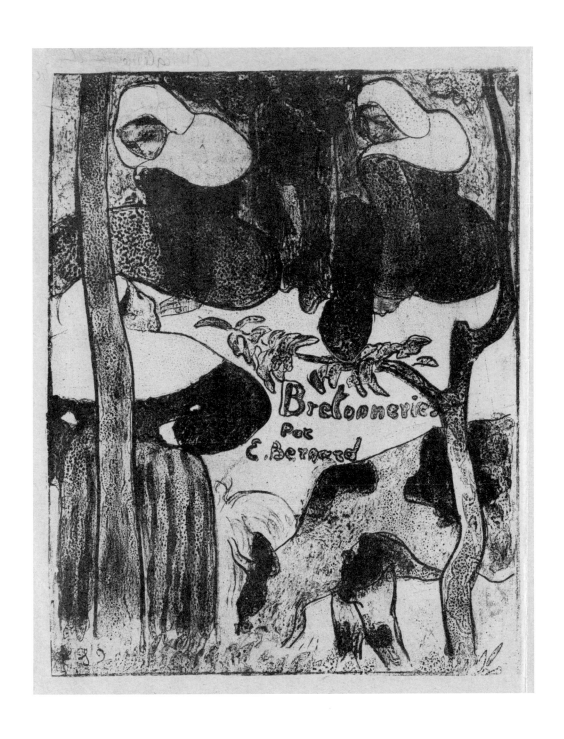

Cat. 54. Émile Bernard, *Les Bretonneries: Title Page,* 1889, The Cleveland Museum of Art

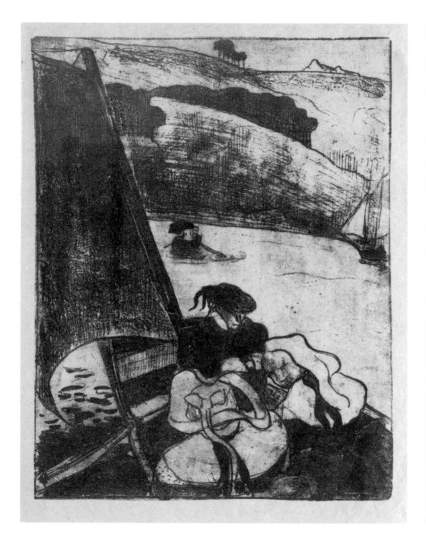

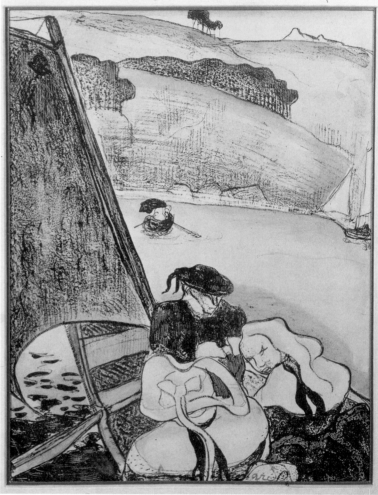

Cat. 55. Émile Bernard, *Les Bretonneries: Return from the Pilgrimage,* 1889, The Cleveland Museum of Art

Cat. 56. Émile Bernard, *Les Bretonneries: Return from the Pilgrimage,* 1889, Van Gogh Museum, Amsterdam

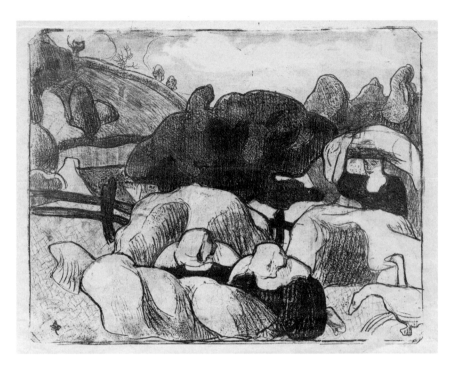

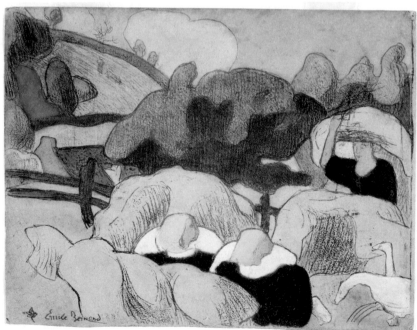

Cat. 57. Émile Bernard, *Les Bretonneries: Women Making Haystacks,* 1889, The Cleveland Museum of Art

Cat. 58. Émile Bernard, *Les Bretonneries: Women Making Haystacks,* 1889, Indianapolis Museum of Art

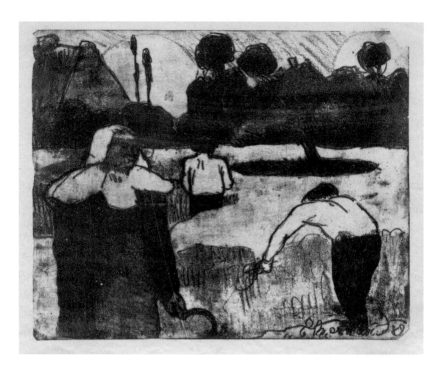

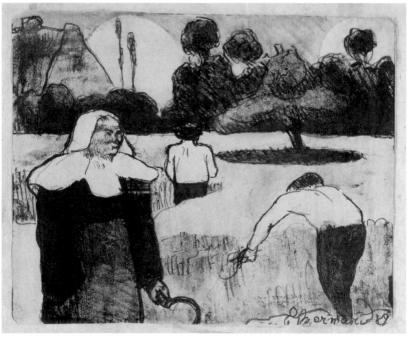

Cat. 59. Émile Bernard, *Les Bretonneries: The Harvesters,* 1889, The Cleveland Museum of Art
Cat. 60. Émile Bernard, *Les Bretonneries: The Harvesters,* 1889, Indianapolis Museum of Art

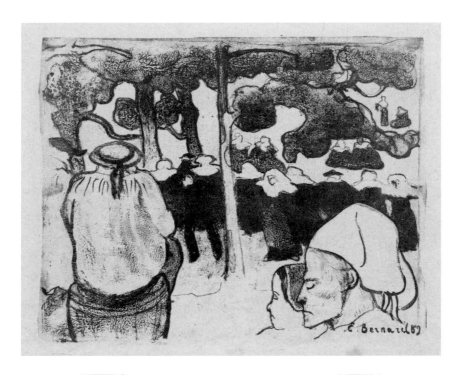

Cat. 61. Émile Bernard, *Les Bretonneries: Wedding in Brittany,* 1889, The Cleveland Museum of Art
Cat. 62. Émile Bernard, *Les Bretonneries: Women Hanging Laundry,* 1889, Indianapolis Museum of Art

Cat. 63. Émile Bernard, *Les Bretonneries: Women with Pigs*, 1889, Indianapolis Museum of Art

The Zincographs—A Technical Examination

Moyna Stanton

For planographic printmaking, Alois Senefelder considered zinc an alternative to limestone as early as 1817, recognizing the advantages a lightweight, portable material offered for developing related processes such as transfer lithography. Zinc-plate lithography was popular in England and Europe by 1840, its use and technical refinements having been spurred on by advancements in commercial printing.[1] Nevertheless, in both commercial and fine art sectors, zinc was disparaged for some time as inferior to stone and suitable only for rough work. Among artist-lithographers of the time, one common working principle for zinc plates was to avoid using tusche (lavis),[2] a black grease-based liquid medium unique to lithography. Designed to be mixed with water[3] to produce a range of wash effects from solid blacks to pale tints,[4] tusche is difficult to control on zinc plates. The *Volpini Suite* was Gauguin's first foray into lithography; apparently undeterred by such warnings, he chose both to use zinc plates and to take advantage of the tusche technique. The result was a suite of zincographs that show accomplished draftsmanship and a pleasing array of texture and tonal range.

Lithography relies on the antipathy of grease and water. Creating an image is possible by simultaneously establishing and maintaining in a controlled manner two diametrically opposite surfaces, one grease-loving (oleophilic) that will accept ink (print), and one water-loving (hydrophilic) that will not accept ink (not print). Metal and stone have different chemical compositions and physical properties, however, and consequently different working properties, each with characteristic advantages and drawbacks. Every aspect of lithography—preparing the surface, making the drawing, processing (chemically fixing the image in place) and proofing, and then printing the edition—is affected by the nature of the printing surface. The initial pessimism and frustration over zinc-plate lithography can be attributed to a difficult learning curve. To make the transition from stone to zinc, numerous technical and practical hurdles had to be overcome.[5]

Lithographic limestone is naturally porous and has equal affinity for grease and water. Zinc plates, however, are essentially nonporous and favor grease. Additionally, limestone undergoes chemical change during processing whereas zinc does not: with stone, the printing and nonprinting areas exist "in" the stone; with zinc, they exist "on" the surface.[6] In practice, these differences mean that images made on zinc are more tenuous and can be more easily disrupted during processing and printing. Specifically, there is a much greater tendency for the grease-loving printing areas to "fill in" (expand and get darker) as prints are pulled and for the water-loving nonprinting areas to "scum" (take up ink).

Zinc plates must be grained for all drawing techniques. Graining produces a roughened surface texture that compensates for the zinc's lack of porosity by providing an increased surface area and foothold for the drawing media, processing chemicals, and printing materials. Graining is accomplished using various abrasives and methods, but the result—a uniform surface of tiny, deep, and sharply angled teeth—provides many minute and protected reservoirs for water retention. Because zinc favors grease, establishing and maintaining the water-loving, nonprinting areas is essential to creating successful zincographs.

Another inherent challenge in making planographic prints from zinc plates is that zinc offers a relatively dark surface on which to draw. Gauging the darkness of a mark or relative values is difficult, as is anticipating the contrast between ink and paper in the final print. For subtle tonal gradations, zinc offers a particularly tricky drawing surface.[7] This inherent property compounds one of the most fundamental rules of lithography: when drawing with a grease-based medium, an artist must be assiduously aware that it is the amount of grease, not the amount of black pigment, that determines the intensity of the printed mark.[8] This rule is not easy to intuit, especially for the novice lithographer, and it underscores the significance of working with lithographic drawing materials of consistent formulation and known performance,[9] and the importance of maintaining seamless communication with the printer, who must also know the artist's methodology and intent as well as how much grease is present.[10]

Zinc's strong affinity for grease necessitates neatness and cleanliness at all times. Seemingly innocuous debris and the lightest fingerprint can form an oleophilic site, and then roll up and print, compromising the final image. Consistent with the overall high level of craft in the *Suite*, Gauguin's zincographs appear free of errant

Fig. 40. Paul Gauguin, *Volpini Suite: Breton Bathers* (cat. 13, detail), showing crayon line underdrawing

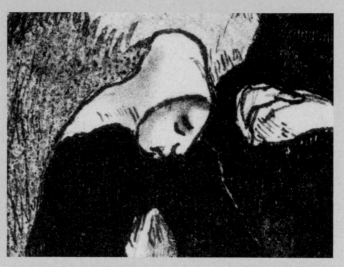

Fig. 41. Paul Gauguin, *Volpini Suite: Dramas of the Sea: Brittany* (cat. 16, detail), showing tusche line, tusche washes (dilute/textured gray and solid black passages), and dry tusche work in the figure's face and cap

smudges and marks; he may have worked with a bridge, sometimes called a hand-board, to help prevent unintentionally marring the plate. The plates were also likely processed shortly after the drawings were completed because zinc plates were prone to corrosion as well as contamination from dust and grease.

The Technique

Drawing directly on professionally grained and degreased zinc plates, Gauguin began his compositions with a loose and delicate outline sketch in lithographic crayon or pencil, a black, grease-based drawing medium specially designed for lithography. It is similar in composition to tusche and comes in several grades of hardness, which correlate to grease content. This underdrawing, which peaks out from under a reinforcing contour line, occurs with reliable strength and frequency throughout the suite (fig. 40). He then worked up the composition in tusche, dry stick, or paste tusche, blended with different proportions of water to achieve a great range of effects.[11] He used a concentrated tusche with a brush- and/or pen-applied line to strengthen and enliven the preliminary crayon contour lines defining the figures and landscapes, to articulate finer details, and to attain rich, solid black washes. Occasionally, to create pattern and highlights in the darkest passages he sparingly scratched away the ink, forming fine white lines. More fluid dilutions of tusche resulted in the distinctively textured and visually commanding tonal passages (fig. 41). And finally, he used dry brushwork—tusche applied in a paste-like consistency—for the very delicate tints that serve to soften and model some of the otherwise starkly "white" negative spaces and for the repetitive marks in patterns (fig. 42).

Gauguin executed the *Volpini Suite* zincographs primarily with tusche wash. The impressive range of textures and values he achieved demonstrates the sensitivity and refinement of his technique. Tusche wash on zinc offers a richness of marks as well as a range and subtlety of tone that is arguably unsurpassed by stone.[12]

Fig. 42. Paul Gauguin, *Volpini Suite: Old Women of Arles* (cat. 22, detail), showing dry brush work with trailing brushstroke and plate grain

Fig. 43. Paul Gauguin, *Volpini Suite: Joys of Brittany* (cat. 14, detail), showing pitted texture called *peau de crapaud*

A key feature of water-based tusche on zinc is that it can create a unique texture called *peau de crapaud* (toad skin), which is unattainable on stone or any other lithographic printing surface. This pitted and sometimes striated texture results when, while the wash dries, the metal oxidizes in the presence of oxygen and water. While the effect was considered uncontrollable and warranted caution against using tusche on zinc, peau de crapaud is now considered one of zinc's most desirable qualities and often what differentiates zincographs from other planographic prints.[13] Gauguin (and his printer) certainly exploited peau de crapaud to great effect in these zincographs (fig. 43).

The choice to make zincographs was a daring one in 1889. Tusche wash offered not only the greatest challenges but the greatest potential for visual expression. Gauguin's exploitation of the technique is a testament to his ambition and desire to realize the expressive potential of the medium. It is also a sign of his bravado, all of which summon further admiration for the *Volpini* zincographs.

Proposed Order of the *Volpini Suite*

Although Gauguin did not number the eleven prints in the *Volpini Suite,* it is possible to suggest a chronology for their production based upon the refinement of technique.[50] Gauguin appears to have worked on the Suite for four to six weeks; in spite of this relatively short time, an increased technical confidence and evolution of style exists among the eleven compositions. Several clues suggest the frontispiece may have been executed first. *Design for a Plate: Leda and the Swan* (*Projet d'assiette: Léda et le cygne*) (see cat. 12, p. 17) is the only one of the eleven prints executed primarily in lithographic crayon, essentially a beginner's tool. Furthermore, the inscription within the image, "homis [*sic*] soit qui mal y pense. P Go," was written on the plate correctly and therefore printed backward; an experienced printmaker would have known that for the inscription to read correctly in a zincograph, it would have to be inscribed on the plate in reverse. [51] Finally, the title of the *Suite,* "Dessins lithographiques," or occasionally "Études lithographiques" and the artist's signature were lavishly inscribed on each impression, which further suggests that the frontispiece was Gauguin's first experiment in printmaking. *Human Misery* (*Misères humaines*) (see cat. 18, p. 23) is the only composition that lacks a four-sided printed border. It was drawn out to the edges of the plate—a fundamental violation of the rules of lithography since it makes printing more difficult. Gauguin added borders by hand in graphite to most impressions of *Human Misery,* a labor intensive endeavor. Finally, *Human Misery* is the only zincograph in the *Suite* to have been printed in an ink other than black, suggesting that Gauguin may have considered experimenting with colored inks but decided against it after seeing the result.

Old Women of Arles (*Les vieilles filles [Arles]*), *Laundresses* (*Les Laveuses*), and *Breton Bathers* (*Baigneuses Bretonnes*) (see cats. 22, 21, 13, pp. 27, 26, 18) may be seen together as constituting a step forward technically. All three compositions are closely based on paintings, and all three rely on solid black washes. Gauguin flattened the background spaces of the three compositions with decorative patterning, creating highly abstracted landscape elements.

The remaining six prints in the *Suite* may be discussed in pairs. Instead of borrowing from previous works, Gauguin created entirely new designs in *The Dramas of the Sea* (*Les drames de la mer*) (see cats. 15, 16, pp. 20, 21), signaling another artistic progression. In this pair, he deviated from a rectangular format, creating fan-shaped, Japanese-inspired compositions. He achieved far greater texture, particularly in the depiction of the sea, and a greater range of tonal values than seen previously. The final four prints—the Martinique pair (see cats. 19, 20, pp. 24, 25) and *Joys of Brittany* (*Joies de Bretagne*) (see cat. 14, p. 19) and *Breton Women by a Gate* (*Bretonnes à la Barrière*) (see cat. 17, p. 22)—reveal the greatest mastery of lithography. In the Martinique pair, only loosely related to the paintings he brought back from the Caribbean, Gauguin achieved a breathtaking array of patterns in the textiles and tropical landscape. *Joys of Brittany* and *Breton Women by a Gate* realize a similar degree of sophistication. Although they allude to previous compositions, they too are essentially new, and like the Martinique images, display a recession of space and perspective. In these two prints, Gauguin mastered the use of tusche, rendering a complex range of textures and shades of gray.

Gauguin's Yellow Paper
Moyna Stanton

Gauguin's "Album de Lithographes" was "visible sur demande" at the Café des Arts. The sheets measure 50 × 65 cm, the traditional French paper size called "raisin," and were housed in oversized boards covered with marbled paper provided by the Parisian stationer and binder C. Guédon. Albums of etchings from the period were occasionally printed on colored papers—often blue or blue-green—and it was not unusual for an artist-designed illustrated cover to be used as a portfolio wrapper and folded around the prints.[1] The paper chosen for the *Volpini Suite* has a vivid saturated yellow color akin to a canary yellow. Gauguin would have been well aware of the tradition of printing on subtly colored papers. In selecting a distinct, not-so-subtle yellow paper for his first album of prints, Gauguin acknowledged tradition while asserting his creativity and radicalism.

Origin of the Paper

For works of art on paper, the paper serves a much greater purpose than mere support: it is physically and visually integral to the image. "The color, tone and texture of any sheet of paper used in a work of art are crucial to the understanding and appreciation of both the work itself and the artist's intentions regarding that work."[2] The study of the *Volpini Suite* naturally led to an investigation of Gauguin's yellow paper.[3] The Cleveland Museum of Art commissioned Peter Bower, paper historian and analyst in London, to analyze the paper and compare it to archived records and known samples from numerous nineteenth-century paper mills.[4] Bower investigated properties of color, fiber composition, and wire profile (visible evidence of the paper machine's forming wire construction impressed in the sheet) at considerable length in an attempt to identify the mill that manufactured the paper, but this research failed to find an exact match.

Gauguin's zincographs are printed on a wove paper with a uniform and fairly dense formation, finely textured surface, and distinct wireside and feltside.[5] The paper is not watermarked and can be characterized as medium weight with a moderately stiff hand.[6] It has the overall look and feel of a machine-made paper. The vivid yellow color penetrates the thickness of the sheet and shows equal intensity on both sides. The wire profile visible in the surface texture shows a generic wove pattern made from a fine-gauge wire, a configuration typical of French-made forming wires (made by the same wire weaver) between 1880 and 1910. A beta radiograph of the paper's internal structure supports this assessment.[7]

Polarized light microscopy of fiber samples from the edges of two prints revealed a blend of fibers, primarily linen and cotton rag, with a soda-cooked softwood pulp added. This fiber composition is also typical of late nineteenth-century machine-made papers. Not unique to France, the fiber blend can be found in other European papers.

Extensive comparisons between this distinctively colored paper and the small range of yellow wove papers produced by the primary French papermakers at the time—Canson Montgolfier, Arches, Johannot, and Rives—showed that none of them made this paper. Other important French makers, Michallet and Barjon, for example, produced no yellow papers during this period. The comparison was extended to imported papers used by Parisian printers from the Dutch maker Van Gelder Zonen and the German mill Hahnemühle; both produced a range of colored papers, but no matches were found. Guédon, the Parisian stationer who provided the portfolios in which the *Volpini Suite* was presented, stocked papers from many of the above-mentioned French paper mills as well as imported papers from English makers such as Whatman, Saunders, and Arnold & Foster, but comparisons confirmed that the yellow paper was not produced by an English maker. There is also no evidence that other artists used this paper. Therefore, at this time we can at best theorize that Gauguin's yellow paper was made in a limited production, possibly by a small mill.

The Coloring of Paper

When the raw papermaking materials produce the color, a paper is said to be "self-colored"—blue paper from blue rags is a classic example of a self-colored paper.[8] Paper can also be colored with natural additives: mineral (inorganic) pigments obtained by grinding and washing clays and minerals taken directly from the earth, and organic dyes of vegetable and animal origin. Since the nineteenth century, papers are more commonly colored with chemically made inorganic pigments (produced commercially since the beginning of the nineteenth century) or organic pigments, which are often referred to

Fig. 44. Inside the Essonnes paper mill, c. 1888–90, Île de France, near Paris, showing the pulp in a Hollander beater

as dyes.[9] Paper can be colored after formation by soaking "white" sheets in a solution of suspended pigments or liquid dye, or by applying washes of color.[10] The coloring method of greatest versatility and importance to the colored-paper industry since the nineteenth century involves coloring the paper pulp in the beater before the sheets are formed (fig. 44).[11] This technology relies heavily on the use of color-fixing agents called mordants. These chemical compounds possess a strong affinity for papermaking fibers and many types of coloring agents, organic dyes in particular. Mordants combine with soluble coloring agents to form insoluble ones, thereby fixing the color to the paper fiber; this is called precipitation.[12]

The yellow paper's unusual color prompted elemental analysis using energy dispersive x-ray fluorescence spectrometry (XRF)[13] to look for elements of a yellow mineral-based pigment. This analysis showed chromium and lead to be present in the paper, suggesting lead chromate, and specifically the popular nineteenth-century synthetic inorganic pigment chrome yellow as the coloring agent.[14] Subsequent analysis with scanning electron microscopy (SEM) and elemental dispersive spectrometry (EDS) has confirmed this initial finding (fig. 45).[15]

The presence of the synthetic inorganic pigment chrome yellow in the yellow paper is entirely appropriate for the time period and artist in question. The pigment was commercially available by 1818; its mass production was important to nineteenth-century paint man-

ufacturers and artists because it provided a relatively stable opaque yellow with excellent clarity and intensity of hue. The Impressionists and Post-Impressionists frequently used chrome yellow in their oil paintings, but recognized its chief failing—a tendency to darken over time.[16] Chrome yellows were eventually replaced on the Impressionists' palette by more stable—and more expensive—cadmium yellows. Regardless of durability, numerous artists continued to use the cheaper chromes. Chrome yellow was favored by Gauguin; the color appears in numerous paintings by the artist dating from late 1888 onward.[17]

As with the painter's palette, chrome yellow provided the papermaker with a pure, intense, and stable color. Julius Erfurt states: "Chrome yellow is perfectly light fast . . . all the various shades of yellow from a pure canary yellow to a light sulfur yellow may be obtained."[18] Two procedures for coloring paper with chrome yellow are documented in early treatises on paper dyeing. The manufactured finely divided pigment could be added to the paper pulp (in the beater) in the form of a paste called "canary paste."[19] In this manner the pigment could be well distributed in the pulp and would adhere to the fibers by mechanical means. Alternatively, the pigment could actually be made in the pulp. In this process one of the two chemical reagents responsible for pigment formation also functioned as the mordant. "Chrome yellow is a compound of chromic acid and oxide of lead, in which the lead oxide plays the *rôle* of a mordant, the chro-

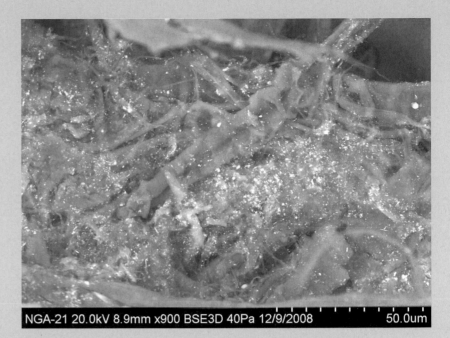

NGA-21 20.0kV 8.9mm x900 BSE3D 40Pa 12/9/2008　　50.0um

Fig. 45. In this image captured with scanning electron microscopy, the bright white spots represent submicron particles composed of lead chromate. Complementary analysis with elemental dispersive spectrometry, spectrum illustrated below, shows the correlating peaks for lead and chromium and confirms the presence of chrome yellow.

mic acid that of a colour."[20] This method of making the pigment in the pulp seems to explain best the color observed in Gauguin's yellow paper—both the richness of hue and the uniform distribution of the color through the sheet.[21] "The fixing of the color on the fibers and the evenness of the shade will be improved if the chrome yellow has been produced in the pulp."[22]

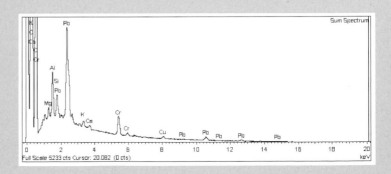

Fig. 46. Félix Buhot, *Japonisme: Dix Eaux-Fortes, Title Page*, 1885, Spencer Museum of Art, University of Kansas

Fig. 47. Émile Lévy, *Mes Transformations*, 1873, Bibliothèque Nationale de France, Paris

Yellow Paper—Possible Influences

Gauguin's choice of large sheets of canary yellow paper is one of the most remarkable aspects of the *Volpini Suite*. He gave no explanation for the paper, but the unconventional use of yellow by the avant-garde was not a new phenomenon. In 1883, James McNeill Whistler titled his exhibition of Venetian etchings at the Fine Art Society in London "Arrangement in Yellow and White." In a letter to the young American sculptor Waldo Story, Whistler described the gallery:

I can't tell you how perfect it all is—there isn't a detail forgotten—there are yellow *painted* moldings—not *gilded*, yellow velvet curtains—pale yellow matting—yellow sofas and chairs—a lovely little yellow table, of my own design—with a yellow pot and tiger lily! Large white butterflies on yellow curtains—and yellow butterflies on white curtains—and finally a servant in yellow livery (!) handing out catalogues.[52]

At a private viewing, guests received yellow silk butterflies to pin to their clothes and Whistler wore yellow socks. Although the effect was as outrageous as Whistler could have desired, the idea was not entirely original. Lucien Pissarro provided an account of Whistler's exhibition to his father, Camille Pissarro, who responded to his son with a recollection of the first Impressionist exhibition of 1874:

How I regret not to have seen the Whistler show; I would have liked to have been there as much for the fine drypoints as for the setting, which for Whistler has so much importance; he is even a little bit too *pretentious* for me, aside from this I should say that for the room white and yellow is a charming combination. The fact is that we ourselves made the first experiments with colors; the room in which I showed was lilac, bordered with canary yellow, but with no butterfly.[53]

Japanese Prints

Several explanations have been offered regarding Gauguin's yellow paper. It has been suggested that the saffron yellow paper reflected the artist's appreciation of ukiyo-e and that the vibrant hue rivaled the bright colored wrappings of Japanese albums as well as in French publications of the 1880s on Japanese art.[54]

Gauguin's interest in Japanese art—ukiyo-e in particular—was persistent. According to the artist Armand Seguin, the walls of Gauguin's studio in Le Pouldu were decorated with ukiyo-e by Utamaro.[55] Jean de Rontonchamp, Gauguin's first biographer, related that Gauguin hung a frieze of prints by Hokusai and Utamaro in Schuffenecker's studio, which Gauguin used in 1890.[56] According to the critic Julien Leclercq, between trips to the South Seas, Gauguin decorated his Pont-Aven studio in 1894 with Japanese prints.[57] Gauguin also decorated his own manuscripts with ukiyo-e. For example, two prints by Hokusai—*Warriors in Combat* from *Ehon Wakan no Homare*, 1837, and *Fujiwara Sane* from *Manga*, 1816—are pasted inside the covers of the manuscript of *Noa Noa*. Gauguin added three ukiyo-e woodcuts by Kunitsuna II to the inside covers and back flyleaf of the manuscript copy of *Avant et Après* (Before and After) (1903). Ukiyo-e prints were a part of the visual reference collection that Gauguin brought on his final journey to the South Seas. He recorded his abiding interest in Japanese art in numerous passages of *Avant et Après*. The inventory of Gauguin's possessions left in his hut in the Marquesas following his death in 1903 listed a Japanese sword, a Japanese book, and forty-five Japanese prints tacked to the walls of his dwelling.[58]

Japonisme, 1885, a suite of ten etchings by Félix Buhot, underscores the French association of Japanese art with the color yellow (fig. 46). Buhot's *Japonisme* was printed on sheets of canary yellow paper, similar to the color of the paper used in Gauguin's *Volpini Suite*.[59] In *Japonisme*, Buhot depicted Japanese objects from Burty's collection of Asian artifacts. In several of the etchings, Buhot intensified the parallels with ukiyo-e by superimposing Japanese characters printed in red ink—both real and of his own invention—over his primary subject. These abstract, calligraphic designs mimic the appearance of Japanese collectors' marks on ukiyo-e prints.[60] Flecks of gold irregularly distributed throughout Buhot's paper heightened the brilliance of the yellow sheets and helped convey the preciousness of Burty's collection.

Popular Posters and French "Yellow-Backs"

By printing on oversized sheets (50 × 65 cm) of bright machine-made paper rather than fine, handmade papers selected by such artists as Rembrandt or Whistler, Gauguin may have intended to evoke the appearance of popular posters of the period, for example, those of Émile Lévy from the 1870s and 1880s that used garish yellow papers.[61] Gauguin's choice of large sheets suggests that he intended the prints to be viewed without cover mats, so that his design would float on a field of vibrating yellow. Such an effect would have been more suggestive of posters of the period than of the rarified *épreuve d'artiste* (artist's proof). The 1860s brought the phenomenon of the entertainment poster to Paris as the number of dance halls and cafés-concerts in the city's capital began to increase exponentially. The earliest posters were dominated by text emphasizing the details of venue and time rather than images of the performer. Jules Chéret, known as the "father of the poster," opened his first printing house in Paris in 1866. His imaginative designs and in-

novations in color lithography revolutionized the entertainment poster and made colorful *affiches* a fixture of late-nineteenth-century Parisian life. By the early 1880s copious lithographic posters advertised the nightlife of Paris. The censorship laws that had kept newspapers and journals in strict control during the first decade of the Third Republic were relaxed in July 1881 after the Republicans achieved a majority in the Senate. Publishing of all kinds escalated dramatically, including journals and posters advertising everything from luxurious café-concerts in central Paris to seedy cabarets in Montmartre.

Lévy was both a lithographic artist and one of the most important professional printers of lithographic posters working in Paris from 1875 to 1895. The son of the lithographer and printer Charles Lévy, Émile Lévy produced a wide range of posters advertising everything from the circus, café-concert, theatrical, and musical performances to contemporary French novels (fig. 47, p. 112).[62] A number of Lévy's posters are printed on large sheets of bright canary yellow paper measuring approximately 80 × 60 cm. Although the paper used in these posters is lighter weight than the paper Gauguin used in the *Volpini Suite,* there are similarities between the sheets; both are wove and apparently machine made. The paper used for the posters has a smoother finish, however, and the fibers are visible only under magnification. The color of the paper used for the posters and the *Volpini Suite* is remarkably similar, as is the effect of printing black ink on a brilliant ground.

Gauguin lived in Paris for much of the 1870s and sporadically during the 1880s, and would have been familiar with such advertisements. An essential aspect of his artistic practice was to assimilate a variety of sources into his art, and the style of the popular posters of the period very likely found their way into his first set of prints. Certainly the large format of the sheets used in the *Volpini Suite* suggests the format of the posters, although his compositions are primarily horizontal while posters are almost always vertical.

Along with popular posters of the period, "yellow-backs" would have been recognizable by contemporary Frenchmen. In 1871 Georges Charpentier inherited a successful publishing house and enhanced its reputation by issuing affordable editions of contemporary naturalist novels by Émile Zola, Flaubert, Guy de Maupassant, and Edmond and Jules de Goncourt bound in bright yellow paper covers (cat. 64). Charpentier's publications became ubiquitous in 1880s France. In *Still Life with Bible and "Joie de Vivre"* (*Nature Morte avec la Bible*), 1885 (Van Gogh Museum, Amsterdam), Van Gogh juxtaposed a Bible and a Charpentier edition of Zola's novel with a bright yellow paper cover, the Bible exemplifying tradition and Zola's novel signifying contemporaneity. Van Gogh carried the association of contemporaneity with yellow-backs further in numerous still-life paintings of the 1880s such as *Parisian Novels* (*Romans Parisiens*), 1887 (private collection); *Oleanders and Zola's "Joie de Vivre"* (*Les Oléandres et Zola's "Joie de Vivre"*), 1888 (Metropolitan Museum of Art, New York); and *A Novel Reader* (*Une Liseuse de Romans*), 1888 (Sagawa Express Co., Ltd., Kyoto). Gauguin would have been aware of Charpentier's yellow-backs and Vincent's appropriation of the books in his paintings.

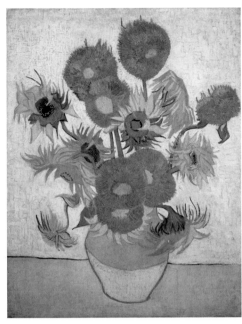

Cat. 64. Yellow paper cover of Émile Zola,
Les Romanciers Naturalistes (Paris: Charpentier,
1881), private collection, Cleveland

Fig. 48. Vincent van Gogh, *Sunflowers*, 1888,
Van Gogh Museum, Amsterdam

Chromatic Allusion to Vincent van Gogh

Gauguin embarked on the *Volpini Suite* immediately following his departure from Arles, and it has been suggested that the colors he chose relate to those of Vincent van Gogh.[63] Douglas Druick and Peter Zegers have argued that, while working side by side, covert emulation and resistance characterized the relationship of the two artists.[64] Although Gauguin denied it in his later writings, his manner of painting—and particularly his palette—was permanently influenced by his collaboration with and observation of Vincent van Gogh. Shortly before Gauguin arrived in Arles in the autumn of 1888, yellow had become a vital element in Van Gogh's personal symbolism. From the winter of 1888, yellow appeared in Gauguin's work in a new way; after his departure from Arles it continued to play an important role in his art, in the *Volpini Suite* as well as in other works of the period.

Van Gogh's sunflowers played an essential role in the evolving rapport between the two artists in 1888. Before Gauguin joined Van Gogh in Arles, they exchanged paintings.[65] Van Gogh sent Gauguin two studies of cut sunflowers painted during the summer of 1887.[66] Anticipation of Gauguin's imminent arrival to Arles inspired Van Gogh's more ambitious series of sunflowers (fig. 48). He intended the sunflower paintings to decorate Gauguin's room, immersing his visitor in the ocher palette that he associated with Arles:

The colour here is actually very fine; when the vegetation is fresh it's a rich green the like of which we seldom see in the north, calm. When it gets scorched and dusty it doesn't become ugly, but then a landscape takes on tones of gold of every shade, green-gold, yellow-gold, red-gold, ditto bronze, copper, in short from lemon yellow to the dull yellow colour of, say, a pile of threshed grain.[67]

Following the December rupture, Gauguin was eager to appease the Van Gogh brothers. In a mollifying letter to Vincent he praised several of Vincent's paintings, reiterating his esteem for the yellow-on-yellow sunflowers:

Fig. 49. Paul Gauguin, *Carnet Huyghe*, p. 223,
The Israel Museum, Jerusalem

Your sunflowers on a yellow background which I regard as a perfect page of an essential 'Vincent' style. At your brother's home I saw your Sower, which is very good, as well as a yellow still life, apples and lemons.[68]

In the same letter, Gauguin intimated that he would like to have the sunflower painting against a yellow ground as a gift.[69] He perceived the personal significance of yellow in Vincent's oeuvre, and when Gauguin made use of it in the *Volpini Suite* and in future works he did so knowingly. In 1894 Gauguin recalled the sunflower paintings:

In my yellow room,—sunflowers with purple eyes stood out on a yellow background, the ends of their stalks bathe in a yellow pot on a yellow table. In one corner of the painting, the painter's signature: Vincent. And yellow light coming through the yellow curtains of my room, and floods all this flowering with gold.[70]

With the passage of years Gauguin began to describe himself as a guide and mentor to the younger artist. Although by the time he arrived in Arles the color yellow was a firmly established fixture in Van Gogh's visual language, Gauguin later suggested that it was through his guidance that Van Gogh had executed his powerful yellow-on-yellow works. In *Avant et Après* Gauguin re-evaluated his relationship with Van Gogh, characterizing him as a fledgling artist to whom he had offered aid in a time of need:

Vincent, at the time when I arrived in Arles, was in the full current of the Neo-impressionist school, and was floundering about a good deal and suffering as a result of it. . . . I undertook the task of enlightening him—an easy matter, for I found a rich and fertile soil. Like all original natures that are marked with the stamp of personality, Vincent had no fear of the other man and was not stubborn. From that day on my Van Gogh made astonishing progress; he seemed to divine all that he had in him, and the result was that whole series of sun-effects over sun-effects in full sunlight.

Have you seen the portrait of the poet?

The face and hair are chrome yellow (1).

The clothes are chrome yellow (2).

The necktie is chrome yellow (3) with an emerald scarf pin, on a background of chrome-yellow (4). . . . This is only to let you know that Van Gogh, without losing an ounce of his originality, learned a fruitful lesson from me. And every day he thanked me for it. That is what he means when he writes to M. Aurier that he owes much to Paul Gauguin.

When I arrived at Arles, Vincent was trying to find himself, while I, who was a good deal older, was a mature man. But I owe something to Vincent, and that is, in the consciousness of having been useful to him, the confirmation of my own original ideas about painting. . . . When I read the remark, "Gauguin's drawing somewhat recalls that of Van Gogh," I smile.[71]

Actually, the color yellow became a central feature in Gauguin's art as a direct result of his proximity to Van Gogh's paintings. By printing on oversized sheets of canary yellow paper, Gauguin created a work of art that vibrated with energy akin to the younger artist's yellow-on-yellow compositions. The size and intensity of the yellow paper lent the *Suite* a presence it would not have had if he had used a more subdued paper. Gauguin's use of a garishly colored paper helped call attention to his work; after all, he intended the *Suite* to advertise his painting style and promote his reputation.

Afterward: Sales and Posthumous Edition of the *Volpini Suite*

There are no records that Gauguin or Bernard sold their zincographs at the Volpini exhibition. However, in his sketchbook from 1888–89, Gauguin recorded sales of five portfolios for between twenty-five and forty francs each (fig. 49).[72] Three albums were listed as given to artists Schuffenecker, Filiger, and "Delaherche."[73] Further sales and gifts undoubtedly took place after the 1889 date of the sketchbook. Vollard recalled seeing a number of albums offered for sale by the "little picture dealer"[74] Alphonse Portier.[75] Portier was a supporter of the Indépendants, to whom Gauguin had entrusted the sale of a Manet painting from his personal collection in 1884.[76] In 1886, Portier and Theo and Vincent van Gogh were living in the same block on the rue Lepic in Montmartre.

The prints eventually came into the possession of Gauguin's artist-friends. An inscription on a hand-colored impression of *Joys of Brittany* (see cat. 72, p. 132) asserts that Seguin purchased one of the zincographs at the auction of Gauguin's work at the Hôtel Drouot in February 1891.[77] Sérusier's *Landscape* (*Paysage*), 1893, a lithograph depicting a Breton hillside printed on bright yellow paper, clearly references Gauguin's zincographs. Whether or not Sérusier owned any of Gauguin's prints, he was very much aware of them.

Later, Ambroise Vollard printed a second edition of the *Volpini Suite* on simile-Japan off-white paper, perhaps intending a deluxe publication. The second edition was vastly inferior to the first edition on yellow paper, in part because the zinc plates had been irreversibly scratched. Perhaps Vollard was disappointed by the results and decided against a full-blown publication. Scholars have always assumed that this second edition was printed between 1894 and 1900, during Gauguin's lifetime, however, a receipt dated 29 May 1911 shows that Amédée Schuffenecker sold Vollard eleven zinc plates along with the reproduction rights, seven ceramics by Gauguin, and eighteen portfolios of the *Volpini Suite*, which confirms that Vollard's edition was printed after 1911.[78]

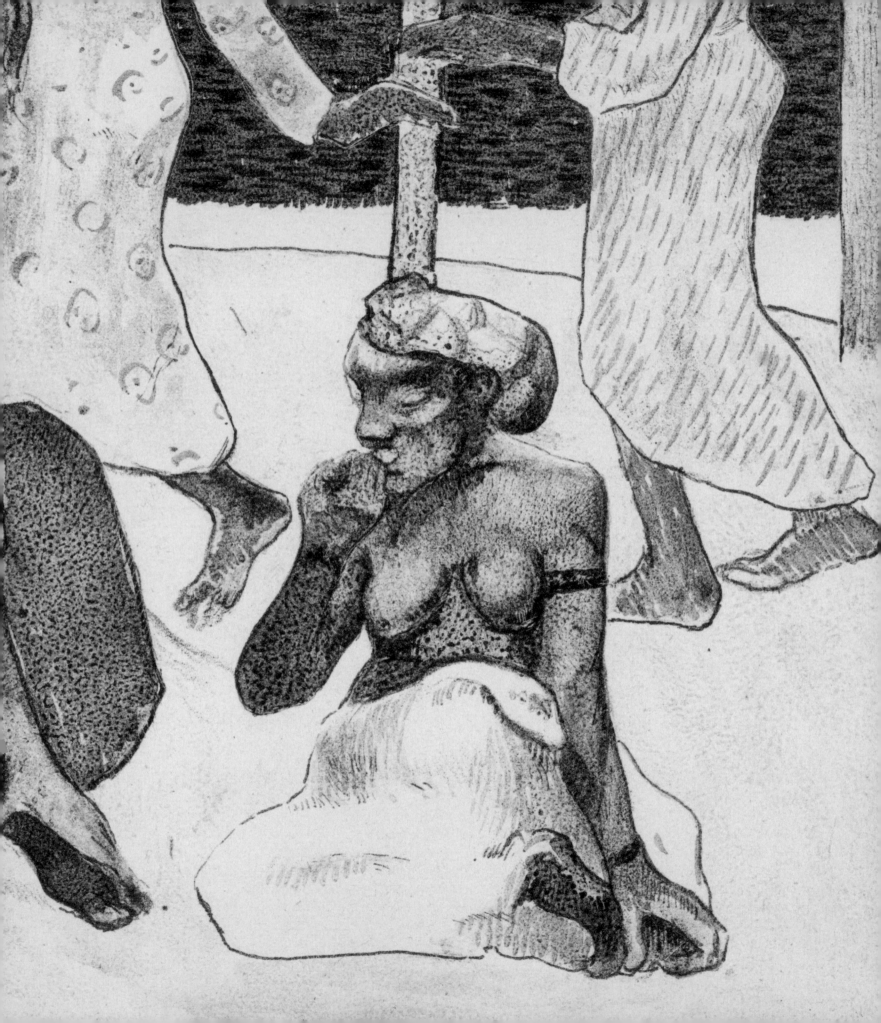

The Iconography of the *Volpini Suite*

Agnieszka Juszczak

Between 1886 and 1888 Gauguin traveled to Brittany, Martinique, and Arles. The impressions those places made on him were a powerful artistic stimulus that usually signaled a change of direction in his work. The subjects of the *Volpini Suite,* which dates from 1889, are based on paintings, drawings, and ceramics Gauguin made in each setting. What is most remarkable about the eleven prints, however, is that the scenes are not copies of existing works but translations and reinterpretations in a graphic technique. The main source of inspiration is people in their daily surroundings: Breton peasant women chatting, Martinican women carrying baskets of fruit, or Arlésiennes out walking. The images of the *Volpini Suite* will be discussed in terms of location, and therefore chronologically.

No fewer than five of the eleven prints are of Breton subjects. Gauguin first went to Brittany in 1886. Short of money and disappointed by his lack of success at the eighth Impressionist exhibition, he hoped to find cheap lodgings and new inspiration in the remote artists' colony of Pont-Aven. Scenic rural life, traditional customs, and picturesque costumes indeed provided him with new subjects. His method also changed, for instead of painting directly from life outdoors he increasingly worked from preliminary studies in his studio.

Gauguin left for the Caribbean island of Martinique in June 1887, again driven by a lack of money but also by a desire to flee Paris, which he found stifling and a blind alley. He hoped to overcome his depression on the tropical island by "living like a savage."[1] He was accompanied by an artist friend, Charles Laval, with whom he had become acquainted in Brittany. Shortly after their arrival, a relieved Gauguin wrote to his wife, Mette: "I cannot tell you how enthusiastic I am about life in the French colonies and I am sure you would feel the same. Nature at its lushest, the climate warm but with cool intervals."[2] During his stay, Gauguin developed a style marked by varied, vibrating brushwork and intense color patterns. The period culminated with *Fruit Picking,* or *Mangoes* (see cat. 38, p. 55), a canvas Van Gogh described as "high poetry."[3]

An intense exchange with artist Émile Bernard characterized Gauguin's second stay in Brittany (January to October 1888). Working increasingly from his imagination rather than from life, on 8 October 1888 he wrote to his friend Émile Schuffenecker: "This year I have sacrificed everything, execution and color, for style, wishing to make myself undertake something different from what I know how to do. It is, I believe, a transformation that has yet not borne fruit but it will."[4] During this period, Gauguin painted *Self-Portrait* (*Les Misérables*) (cat. 65, p. 121), a canvas he sent as a gift to Vincent van Gogh in Arles shortly before leaving Pont-Aven. In this somber self-portrait Gauguin portrayed himself in the guise of Jean Valjean from Victor Hugo's *Les Misérables* (1862). Gauguin identified with Valjean who, although rejected by society, continues to love his

Fig. 50. Paul Gauguin, *Leda and the Swan,*
1887–88, private collection

fellow human beings. Gauguin described the enigmatic character of the painting in a letter to
Schuffenecker: "I believe it is one of my best efforts: absolutely incomprehensible . . . so abstract
it is. . . . The color is a color remote from nature; imagine a confused collection of pottery all
twisted by the furnace! All the reds and violets streaked by flames, like a furnace burning fiercely,
the seat of the painter's mental struggles."[5] With its forceful contour lines and flat passages of vi-
brant color, the painting anticipated Gauguin's Symbolist and Synthetist style, which evolved in
Arles where he worked alongside Vincent van Gogh from 23 October to 24 December 1888.

Frontispiece, *Design for a Plate: Leda and the Swan (Projet d'assiette: Léda et le cygne)*
The frontispiece of the *Volpini Suite* (cat. 1, pp. 14, 122) is decorated with an elegant scene of a
girl with long black hair looking over her shoulder. A swan's outstretched wings envelop her bare
back. The snake and the apple allude to the biblical story of the Fall of Man, in which Eve was
seduced by a snake into eating an apple from the Tree of the Knowledge. The bird references the
Greek myth "Leda and the Swan" in which the god Zeus fell in love with Leda, the wife of King
Tyndareus of Sparta; when she rejected his advances Zeus turned himself into a swan and over-
powered her. Here Gauguin has ingeniously combined Christian and classical symbolism. The
story of Adam and Eve, like the myth, is about deception in pursuit of a goal.

The figure of Leda was borrowed from Gauguin's ceramic vase *Leda and the Swan* (fig. 50).
The figure in the zincograph is also related to a preparatory drawing for the vase, *Jugs in Stone-
ware (Pots en grès)* (cat. 66, p. 123). In the print, ceramic, and drawing, Leda is consistently por-
trayed as a young girl with an innocent, quizzical gaze who avoids confrontation with the swan.
In essence, she is a symbol of awakening sexuality. The two flowers within the design may be in-
terpreted as decorative elements or as symbols of beauty and transience. Gauguin may have been
aware of Émile Bernard's *Woman with Geese,* c. 1886 (cat. 73, p. 133) in which a Breton woman
looks over her shoulder at two birds. Whereas Gauguin's *Design for a Plate* is laced with sinister
eroticism, the pairing of Bernard's lusty figure and quacking geese strikes a lighter note.

The inscription written in mirror image at the top reads, "homis [*sic*] soit qui mal y pense"
(Shame on him who thinks evil of it), the motto of the oldest and most prestigious English order

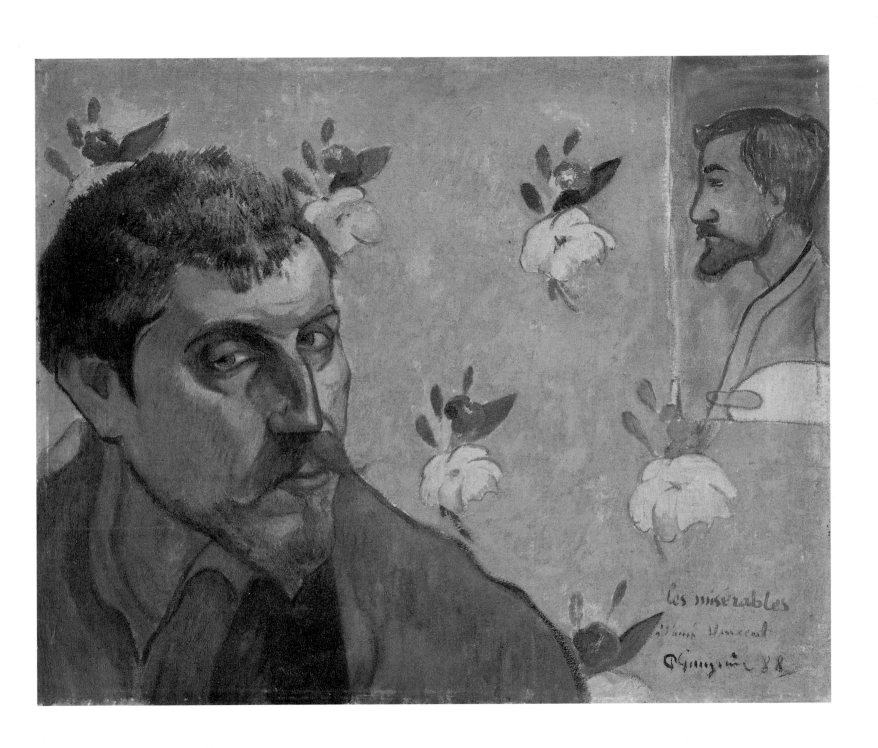

Cat. 65. Paul Gauguin, *Self-Portrait (Les Misérables)*, 1888, Van Gogh Museum, Amsterdam

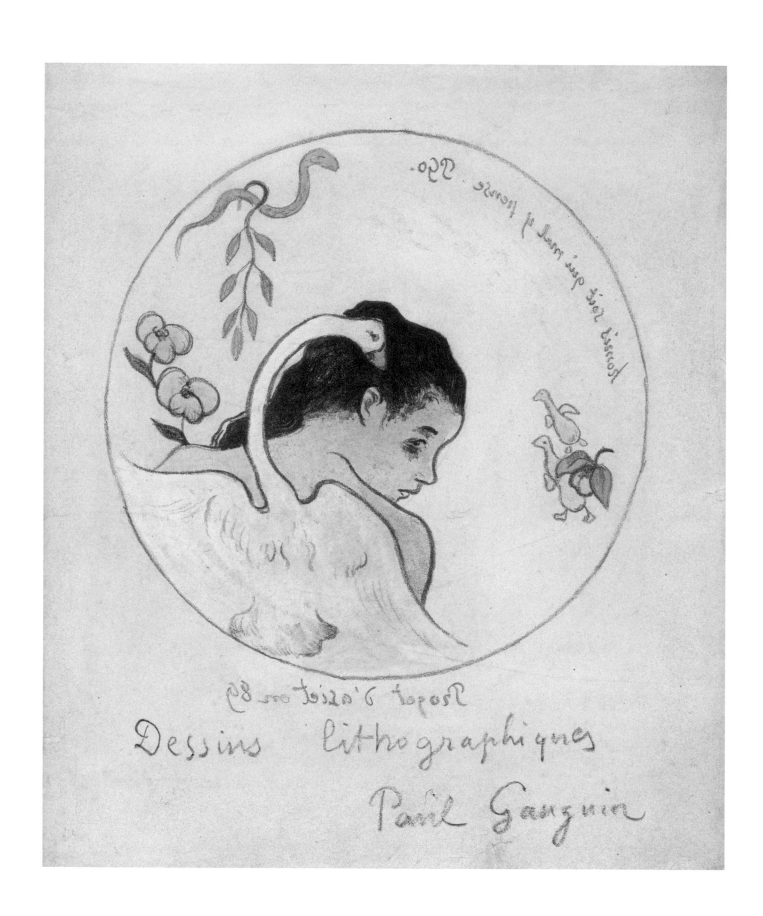

Cat. 1. Paul Gauguin, *Volpini Suite: Design for a Plate: Leda and the Swan*, Van Gogh Museum, Amsterdam

Cat. 66. Paul Gauguin, *Jugs in Stoneware,* c. 1888, Frances Lehman Loeb Art Center, Vassar College, Poughkeepsie

of chivalry, the Order of the Garter.[6] Precisely what Gauguin was trying to say with this motto is not known. He may have been using it in the usual sense, wanting to warn the viewer not to make a quick moral judgment of another person without knowing the facts, but perhaps he also wanted to ward off hasty criticism of his work.

This print is one of the three known designs for plates by Gauguin. The other two date from 1890, and their symbolism also refers to love.[7] The decision to place a design for a decorative utilitarian object on the cover of a suite of prints was far from traditional.[8] Gauguin's choice of this design seems to have been prompted by his great passion for ceramics and his recent experiences creating applied art. As a child he had become familiar with ceramics from different parts of the world in the collection of his mother, who died young, and in the lavish art collection of his guardian Gustave Arosa, which contained objects with fanciful figurative scenes from diverse cultures and periods.[9] In Brittany Gauguin had discovered the colorful peasant faience of Quimper. He had begun making ceramics in Paris in the fall of 1886 following the advice of the artist and writer Félix Bracquemond and under the supervision of the ceramist Ernest Chaplet. The decoration of these ceramics was inspired by subjects he had recently drawn and painted in Brittany.

For Gauguin, making ceramics was an important step toward freeing himself of Impressionism and establishing a personal style. Ceramics gave him the opportunity to revise in a new medium subjects he had already depicted. To prevent the different colored glazes from mixing during firing, he simplified his compositions and placed more emphasis on contours and uniform areas of color—a method he also applied in the *Volpini Suite*. Thus his decision to introduce the series with a design for a ceramic object can be seen as clear evidence of his desire to present himself as a versatile artist who had mastered different techniques, with the suite serving as a representative sample of his oeuvre.

Brittany

Breton Bathers (*Baigneuses Bretonnes*)

Comparable to the frontispiece, *Breton Bathers* (cat. 67) shows a nude woman, her back to the viewer, cautiously approaching the water. The scene is derived from the painting *Two Bathers* (see fig. 26, p. 80), in which two nude women bathe in a woodland brook. The vibrating brushwork in the painting reveals the influence of Gauguin's early mentor, Camille Pissarro. However, the subject and the contorted poses of the bathers display an obvious debt to the work of Edgar Degas, who was hailed by the Impressionists as the undisputed master of the human figure. Gauguin followed Degas' example in *Two Bathers* by opting for complex poses and a contemporary, unidealized appearance for the figures.

Gauguin made significant revisions to the composition of *Two Bathers* in his translation of the subject into a graphic format. In the zincograph *Breton Bathers,* the woman on the left has disappeared, as have the vertical tree trunk and the pig. He replaced the wooded background of the painting with a decorative pattern of flowing shapes suggesting sand and possibly rocks. These surroundings in the zincograph are reminiscent of the rugged coastline of Le Pouldu, a small fishing village near Pont-Aven that Gauguin had visited during his first trip to Brittany and where he was to stay for the better part of a year and a half in 1889–90. The clogs discarded by the bather on the sand also suggest a Breton setting.

Cat. 67. Paul Gauguin, *Volpini Suite: Breton Bathers,* Museum of Fine Arts, Boston

Cat. 68. Paul Gauguin, *Bowl with a Bathing Girl*, 1887–88, Mrs. Arthur M. Sackler

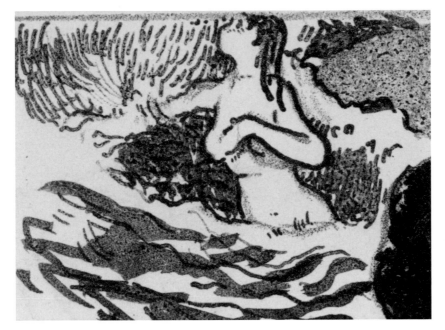

Fig. 51. Paul Gauguin, *Volpini Suite: Breton Bathers* (cat. 13, detail)

Fig. 52. Paul Gauguin, *Woman Bathing,* 1886–87, The Art Institute of Chicago

The woman approaching the water in both painting and zincograph is based on a full-scale preparatory charcoal and pastel study, *Woman Bathing (Baigneuse)* (fig. 52). A similar bather also appeared in two ceramics from the same period: *Bowl with a Bathing Girl (Compotier à la Baigneuse)* (cat. 68) and *Vase with the Figure of a Girl Bathing under Trees (Vase Décoré d'une Baigneuse)* (cat. 69, p. 128). In *Bowl with a Bathing Girl,* a nude figure leans toward the water, closely approximating the tentative bather who approaches the water in the painting. The form of the ceramic echoes elements in the painting; instead of leaning on rocks as the figure does in the painting, the bather in the ceramic holds onto the handle of the vessel. If the ceramic bowl were full of water, the bather would be wading into a shallow pool. *Vase with Bather* is decorated with a nude woman in profile nearly identical to the figure in *Two Bathers.* The trees and foliage that surround the figure on the ceramic, however, more closely resemble the lush tropical vegetation of Gauguin's Martinican landscapes than that of his Breton scenes.

Gauguin repeated the figure of a similar bather in a drawing, *Bather Fan (Baignade [II])* (cat. 70, p. 129). Following in the footsteps of Degas and Pissarro, in the late 1880s Gauguin made about twenty-five fan-shaped drawings. Their imagery was primarily based on his own work or on works in his collection by other artists. The figure in *Bather Fan* has a girlish physique and long hair, but in the painting and the Volpini print her body is more androgynous. In both painting and print, her hair is cropped, her shoulders broad and her hips narrow, and yet her right arm appears to be covering a breast. Gauguin deliberately sought such enigma and ambiguity in his work. A similar tension infuses the composition *Young Wrestlers* (see cat. 37, p. 53) in which two slender boys practice traditional Breton *gouren,* a type of wrestling native to the region. And yet the pose of the wrestlers, with their intertwined arms, legs, and feet, is very much like an embrace.[10]

A second bather can be seen in the background of the zincograph *Breton Bathers* (fig. 51), but she does not resemble the second bather in the painting. Facing the viewer, arms folded and gazing proudly upward, she uninhibitedly surrenders to the waves in the graphic version of the composition. Her sensual body and rounded forms make her a symbol of feminine vitality, sexuality, and power, in contrast with the angular build and uncertain pose of the bather in the foreground.

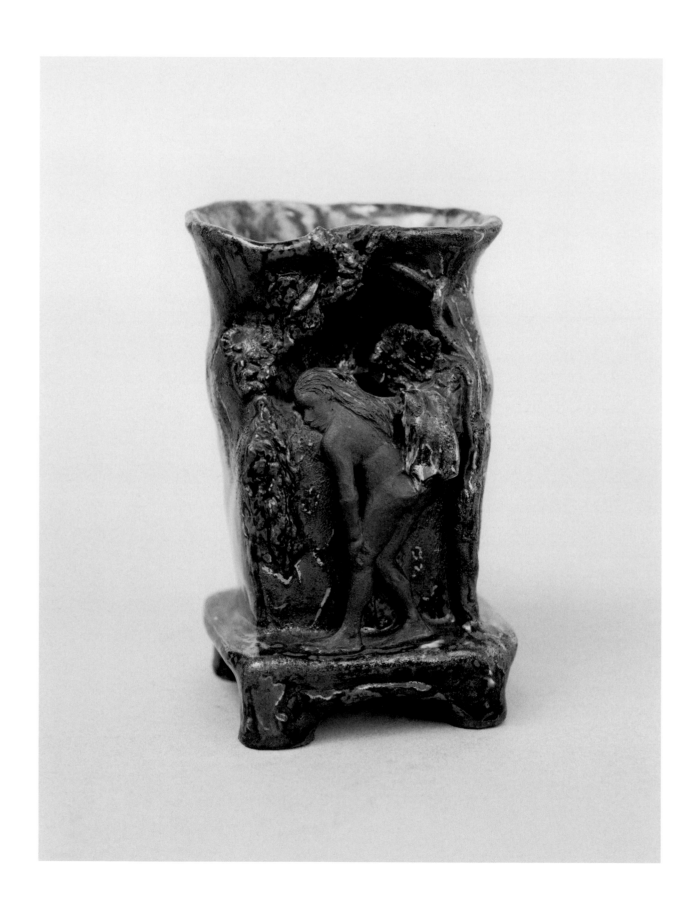

Cat. 69. Paul Gauguin, *Vase with the Figure of a Girl Bathing under Trees,* c. 1887–88, The Kelton Foundation, Santa Monica

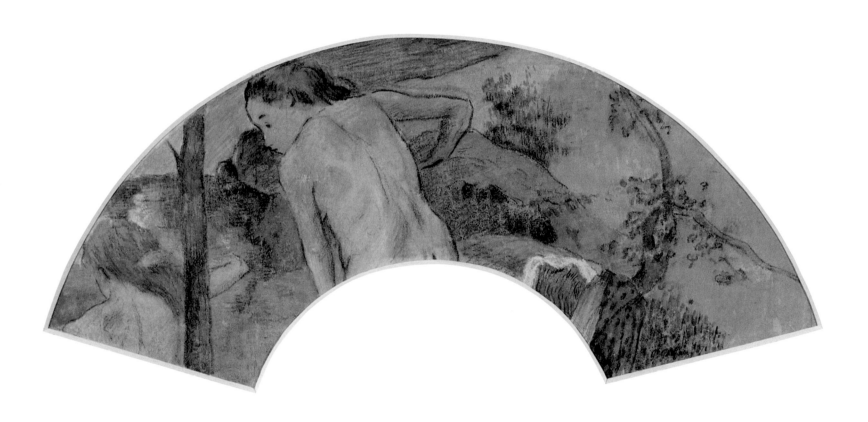

Cat. 70. Paul Gauguin, *Bather Fan (Baignade [II])*, 1887, The Kelton Foundation, Santa Monica

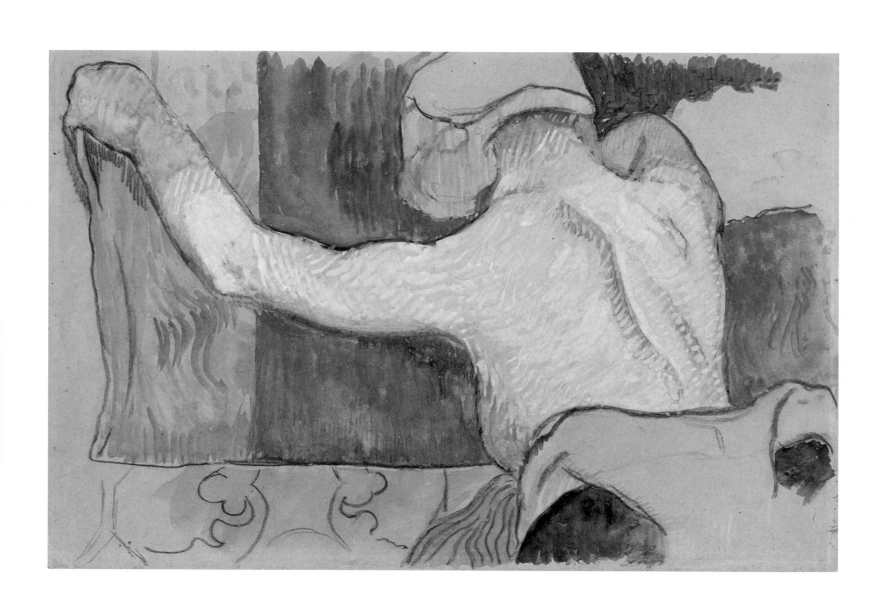

Cat. 71. Paul Gauguin, *Study for "Woman with Pigs,"* or *The Heat of the Day,* 1888, Van Gogh Museum, Amsterdam

The theme of the bather was to recur many times in Gauguin's work from 1889 onward, each time charged with a different symbolic meaning.

In another work of the same period with intensely erotic overtones, *Woman with Pigs* or *The Heat of the Day* (*La Femme aux Cochons* or *En Pleine Chaleur*), 1888 (W. 301/320; private collection), Gauguin painted a partially nude figure seen from behind. In this peculiar composition, a woman with a Breton *coiffe* (headdress) works in the hay. A pig can be glimpsed in the background. A comparison of this work with *Two Bathers,* which also features a nude figure seen from behind with a pig in the background, is irresistible. In a preparatory watercolor, *Study for "Woman with Pigs"* or *The Heat of the Day* (cat. 71), Gauguin focused on the figure's back and upraised arms. The drawing is a veritable symphony of white, blue, and gray dashes of pigment, highlighting the musculature of the woman's body. The care Gauguin lavished on rendering the figure's back would be repeated in future renditions of bathers.

Joys of Brittany (*Joies de Bretagne*)

Joys of Brittany (cat. 72, p. 132) is closely related to *Breton Girls Dancing, Pont-Aven* (see cat. 36, p. 52), a figural composition painted in Pont-Aven in 1888 that Gauguin was very happy with and soon sold.[11] The canvas shows three young girls in Breton dress dancing a traditional gavotte with their backs to one another.[12] Although the background is recognizable as the hills around Pont-Aven, the action is more difficult to decipher since the usual features in conventional scenes of festive peasants—such as dancing couples or musicians—are absent. Instead of moving in a closed circle, two of the girls do not hold hands, which makes the circle ambiguously open. The lack of eye contact among the figures further contributes to the abstracted, static look of the composition as a whole.

Although Gauguin was satisfied with the originality of the painting, which he included in the Volpini exhibition, the zincograph is only loosely based on it. The girl on the left has been eliminated altogether, and the stacks of hay are much larger and partly cut off by the framing lines, as are the playful dogs. The main difference, though, is that the two girls' faces are far more abstract, almost mask-like. Two preparatory drawings for *Breton Girls Dancing, Pont-Aven* are known. *Study for "Breton Girls Dancing"* (*Study for "La Ronde des petites Bretonnes"*) (cat. 74, p. 134), a work in pastel and charcoal with watercolor and gouache, appears to have been the model for the zincograph, for the girls' profiles and coifs are almost identical. The other, *Study for "Breton Girls Dancing"* (*Study for "La Ronde des petites Bretonnes"*) (see cat. 53, p. 81), depicts all three dancers and is more closely related to the painted composition. By the time Gauguin was making the zincograph in Paris during the winter of 1889, this drawing had already been sent as a gift to Theo van Gogh and therefore could not have been a model for the print.[13]

The title of the print evokes the atmosphere of the carefree rural life Gauguin had discovered in Pont-Aven, which he increasingly came to cherish. The girls' coarse facial features tie in with his views about the "primitive" nature of Brittany: "I love Brittany; I find the savage there, the primitive. When my clogs resonate on the granite soil I hear the dull, thudding, powerful sound that I look for in painting."[14] *Joys of Brittany* can therefore be seen as an act of homage to the unspoiled, robust nature for which the western province was renowned.

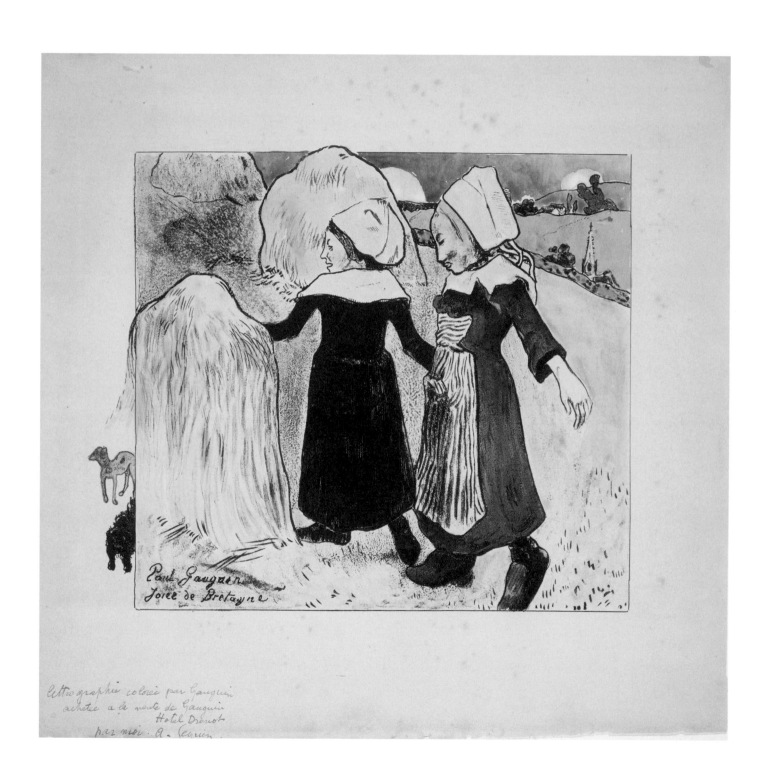

Cat. 72. Paul Gauguin, *Volpini Suite: Joys of Brittany*, 1889, Museum of Fine Arts, Boston

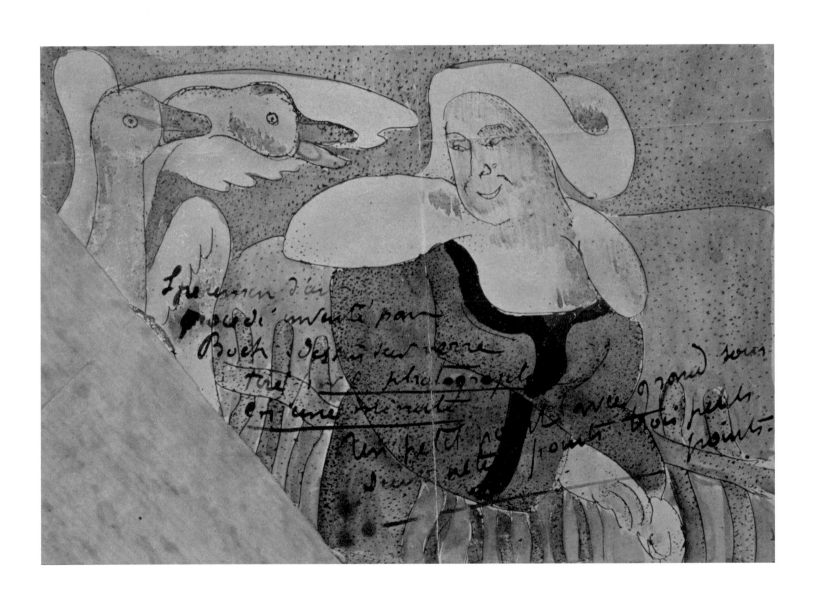

Cat. 73. Émile Bernard, *Woman with Geese*, c. 1886, Musée Départemental Maurice Denis "Le Prieuré," Saint-Germain-en-Laye

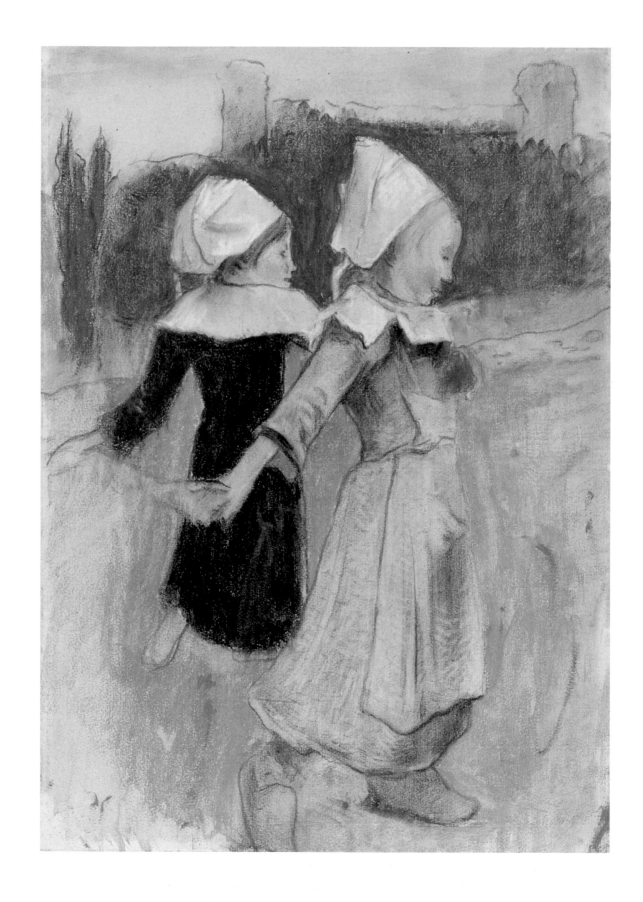

Cat. 74. Paul Gauguin, *Study for "Breton Girls Dancing, Pont-Aven,"* 1888, Thaw Collection, The Pierpont Morgan Library, New York

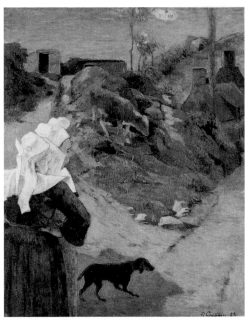

Fig. 53. Paul Gauguin, *Breton Girl*, 1886, Glasgow Museums, The Burrell Collection

Fig. 54. Paul Gauguin, *Breton Women at the Turn*, 1888, Ny Carlsberg Glyptothek, Copenhagen

Breton Women by a Gate (*Bretonnes à la barrière*)

In *Breton Women by a Gate* (cat. 75, p. 136) Gauguin returned to the subject of *Breton Women Chatting* (see fig. 28, p. 83), a painting he had completed in Paris in 1886 after returning from his first trip to Pont-Aven. The canvas depicts a group of four women talking by a low wall and is usually regarded as a breakthrough in Gauguin's development because it is more monumental and decorative than his earlier Impressionistic work.

Although *Breton Women Chatting* had been sold in October 1888, Gauguin was aided by preparatory studies such as *Breton Girl* (*Jeune fille bretonne*) (fig. 53) when rethinking the subject for the zincograph in early 1889. During the winter of 1886–87, he had already reused the subject of women chatting as the basis for a ceramic, *Vase Decorated with Breton Scenes* (*Vase Décoré de Scènes Bretonnes*) (cat. 77, p. 138). In both ceramic and zincograph Gauguin simultaneously simplified the original oil composition while also introducing new elements. The central figure in the painting with her arms akimbo is featured in the print and the ceramic, but Gauguin reduced the original group of four women to two in subsequent treatments of the theme. The face of the figure in profile in both zincograph and ceramic is expressionless and mask-like. This figure in profile in the zincograph serves as an intermediary between the viewer and the unfolding scene; her gaze leads the eye to the seated woman beyond the fence who has her back to the viewer and looks out to the distant hills. The gate underscores the viewer's distance from the landscape. We can catch a glimpse of this closed Breton world, but are not admitted to it. Bernard's watercolor *Lane in Brittany* (cat. 76, p. 137) presents a similar scene with a Breton figure with her arms bent at the elbow. Bernard may have sent the sheet to his friend Vincent van Gogh during the summer of 1888, and it is possible that Gauguin saw it in Arles later that autumn.

Breton Women at the Turn (*Bretonnes au Tournant d'une Route*) (fig. 54) is another canvas with a composition to which *Breton Women by a Gate* is heavily indebted. As in the zincograph, two figures are pressed together into a corner of the scene, looking at something invisible to the viewer. *Women Hanging Laundry* (*Bretonnes étendant du linge*) (see cat. 62, p. 103), from Bernard's suite of zincographs *Les Bretonneries,* has a similar composition and features a figure with her hands on her hips.

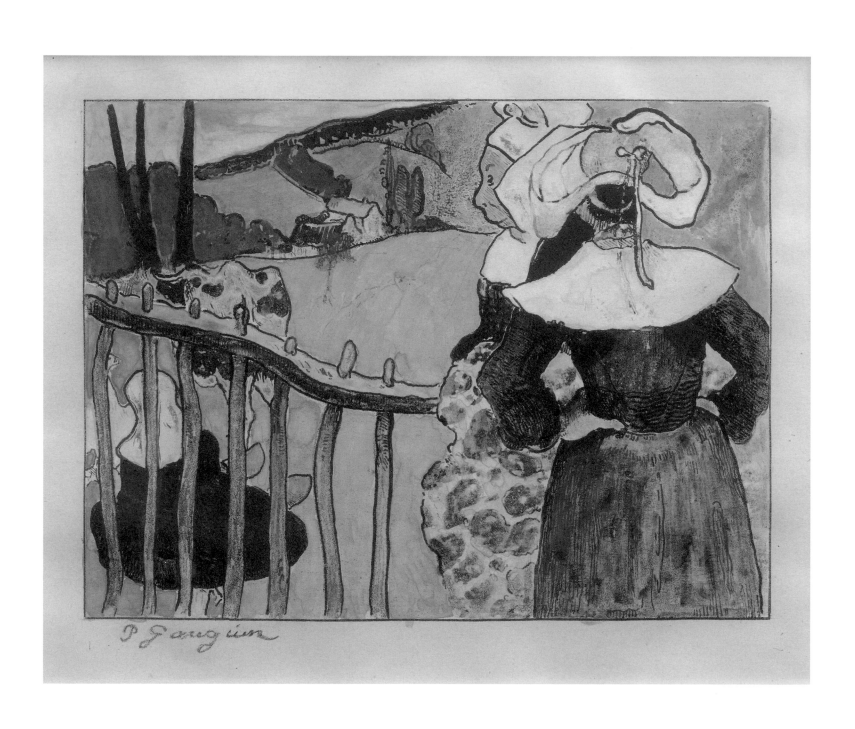

Cat. 75. Paul Gauguin, *Volpini Suite: Breton Women by a Gate*, 1889, private collection, New York

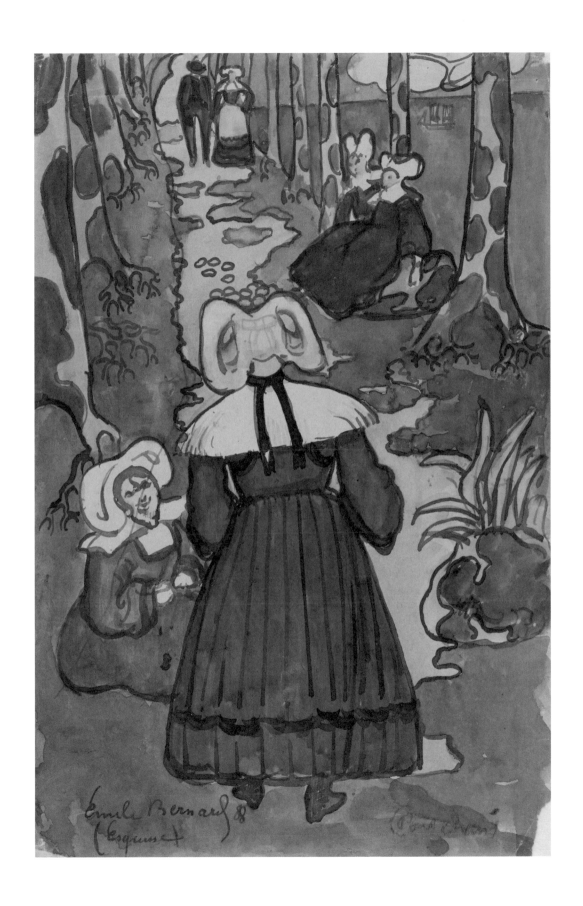

Cat. 76. Émile Bernard, *Lane in Brittany*, 1888, Van Gogh Museum, Amsterdam

Cat. 77. Paul Gauguin, *Vase Decorated with Breton Scenes*, 1886–87, Musées Royaux d'Art et d'Histoire, Brussels

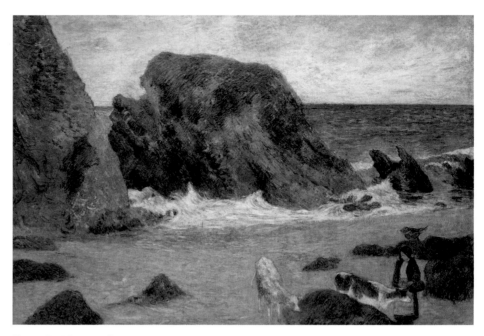

Fig. 55. Paul Gauguin, *Cowherd, Bellangenet Beach,* 1886, private collection

Dramas of the Sea: Brittany (*Les Drames de la Mer: Bretagne*)
Dramas of the Sea (*Les Drames de la Mer*)

Three Breton women pray on a rocky shore in *Dramas of the Sea: Brittany* (cat. 78, p. 140), while a mariner is caught in a storm at sea in *Dramas of the Sea* (cat. 78a, p. 141). The titles are not the only element to suggest a pairing of the two prints; both compositions are variations on the shape of Japanese fans. One is half a fan, the other an inverted fan. In addition, both compositions are dominated by a pattern of dynamic lines and irregular forms depicting steep cliffs and raging seas. Gauguin likely borrowed his decorative treatment of water from Japanese prints, such as Kuniyoshi's *The Sacrifice of Yojibei* (cat. 80, p. 143). Like many artists of his day, Gauguin was a great admirer and collector of Japanese prints. He took them with him on his travels, decorated his studio with them, and even depicted them in some of his paintings.[15]

Unlike most of the Volpini prints, these two cannot unequivocally be traced back to existing works. *Dramas of the Sea: Brittany* is loosely related to *Cowherd, Bellangenet Beach* (*Gardeuse de Vaches sur la Plage de Bellangenet*) (fig. 55), a painting of Breton woman with cows on a beach that Gauguin made on his first visit to the rugged coastal region around Le Pouldu, near Pont-Aven. The praying figures in the zincograph are related to the women praying in *Vision of the Sermon* (*Vision du Sermon*) (see fig. 13, p. 62), the symbolic scene of Jacob wrestling with an angel that takes place in the minds of Breton women sunk in prayer. The green hillside in the hand-colored version of the print suggests that the women are standing on a grassy cliff like those found at Le Pouldu. The two mounded forms immediately behind the women are heaps of sea-weed, which Bretons gathered and used to fertilize their fields. Bernard also addressed the theme of Breton women waiting on shore for the safe return of local fisherman in his watercolor *Breton Women with Seaweed* (*Bretonnes au goémon*) (cat. 79, p. 142).

Gauguin may have witnessed such shore-side vigils in Brittany, for the region was famed for the profound religiosity of its inhabitants. He had already demonstrated in *Vision of the Sermon* how deeply affected he was by scenes of this kind—a sentiment he shared with Bernard. The subject could have been taken from the 1886 novel *Pêcheur d'Islande* (Icelandic Fisherman) by the popular writer Pierre Loti, whose stories were among the favorite reading material of both Gauguin

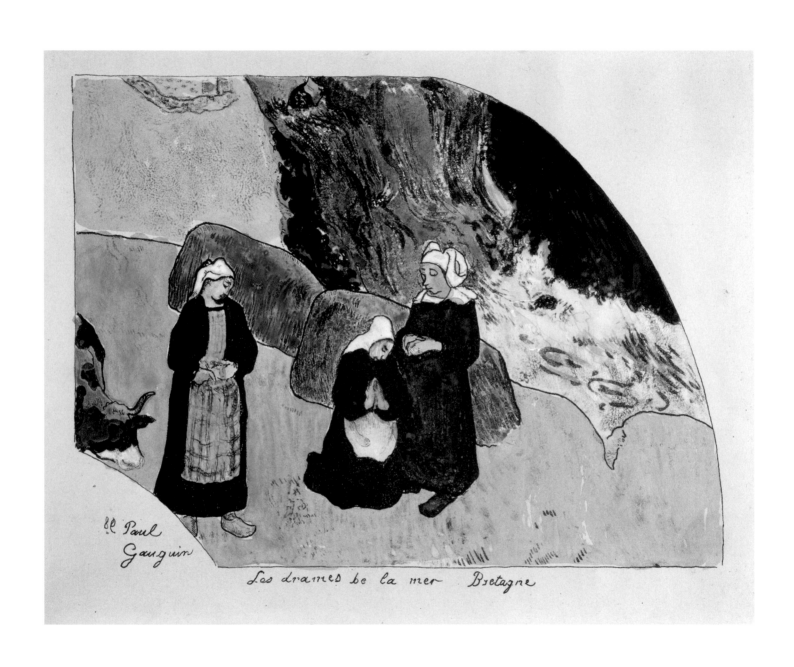

Cat. 78. Paul Gauguin, *Volpini Suite: The Dramas of the Sea: Brittany,* 1889, Albright-Knox Art Gallery, Buffalo

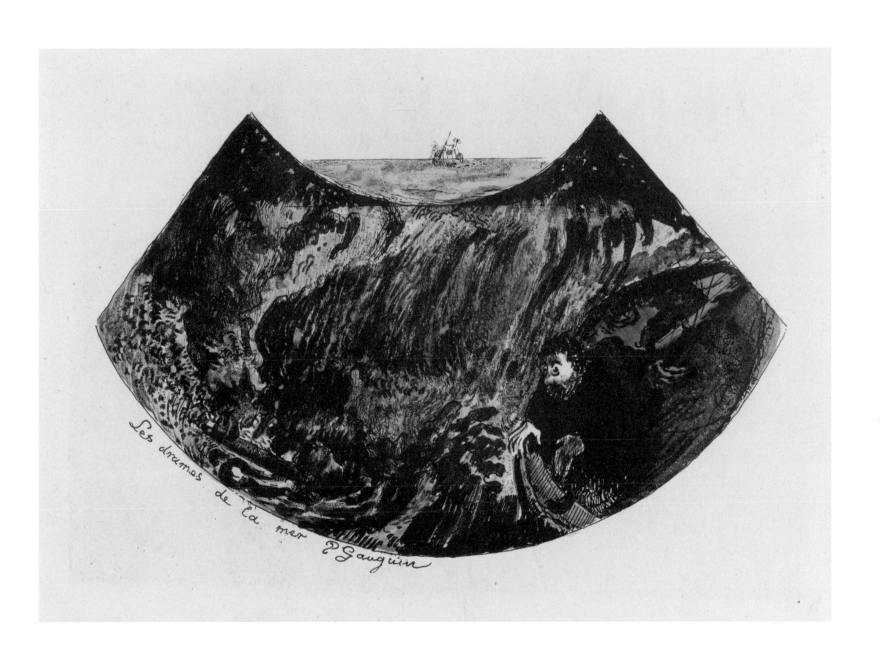

Cat. 78a. Paul Gauguin, *Volpini Suite: Dramas of the Sea*, 1889, Van Gogh Museum, Amsterdam

Cat. 79. Émile Bernard, *Breton Women with Seaweed*, 1888, Musée Départemental Maurice Denis "Le Prieuré," Saint-Germain-en-Laye

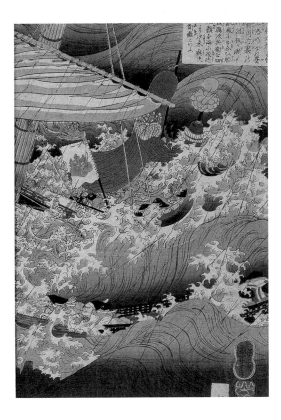

Cat. 80. Kuniyoshi Utagawa, *The Sacrifice of Yojibei*, 1849–53, Van Gogh Museum, Amsterdam

and Van Gogh.[16] During their time together in Arles, the two artists had often spoken about the dangerous life of Bretons who fished off the coast of Iceland, in which intense religious faith was intricately bound up with the uncertain life of the seafarer.[17] The lonely existence of fishermen at the mercy of the elements could also serve as a good metaphor for Gauguin's own uncompromising existence, his financial dependence on others, and the fickle favor of the public.

Dramas of the Sea presents the catastrophe so dreaded by the women unfolding in two stages. At the top of the inverted fan a boat sails on a calm sea; below a storm is blowing, with a terrified seaman on the right in a boat on the point of capsizing. This scene is often associated with a literary source: Edgar Allen Poe's short story "A Descent into the Maelström" (1841), in which two fisherman are sucked into a whirlpool off the coast of Norway. They go through various stages of fear and despair, and ultimately only one survives to tell the tale. Although it is not certain that Gauguin, who was an admirer of Poe's work, was thinking of this specific story, it certainly seems likely, for even the division of the composition into two parts corresponds to a passage describing the weather taking a sudden turn for the worse. "In less than a minute the storm was upon us—in less than two the sky was entirely overcast—and what with this and the driving spray, it became suddenly so dark that we could not see each other in the smack. . . . Our boat was the lightest feather of a thing that ever set upon water."[18] In both dramatic scenes Gauguin examines man's reliance on the whims of nature, alluding at the same time to the consoling power of religion. The fisherman who survives the storm emerges stronger and gains more respect for the forces of nature.

In addition to the literary connotations, the contrast between calm water and a roiling sea could also be a subtle comment on the aftermath of Van Gogh's nervous breakdown in Arles and Gauguin's role in it. Gauguin's sudden departure from Arles after the two artist's famous argument and Van Gogh's self-mutilation can be seen as a shipwreck. The Dutch artist's dream of a communal "Studio of the South" had been dashed; he accused Gauguin of quitting the studio prematurely, leaving him isolated and alone "on board my little yellow house." In a letter Van Gogh said that during his collapse he had hallucinations about sea voyages and at the same time consoled himself with simple lullabies.[19] The rough water in *Dramas of the Sea* could suggest Van Gogh's confused state of mind at that time, but it could also subtly refer to his untidy brushwork, which had been one of the main points of contention between the two artists in Arles and which Gauguin repeatedly condemned.[20] Were this supposition true, this zincograph would be one of the first of Gauguin's works to allude directly to that tempestuous period.

Martinique

Martinique Pastorals (Pastorales Martinique)

Gauguin portrayed the local people going about their daily business in all the paintings he made on Martinique. He was struck by the elegant gestures of the exotic women. "Their gestures are very distinctive and the hands play an important part in harmony with the swaying of the hips."[21] Something of this admiration can be seen in the poses of the women in the two tropical scenes in the *Volpini Suite*.

Martinique Pastorals (see cat. 20, p. 25), a landscape with two women standing in the foreground beside a large tree with heart-shaped leaves, exudes the atmosphere of a tropical idyll. The two figures are a distant echo of those in the painting *Conversation (Tropics)* (*Conversation*

Cat. 81. Paul Gauguin, *Riverside,* 1887, Van Gogh Museum, Amsterdam

[Tropiques]) (see fig. 27, p. 82). The two women in the painting are simply talking to each other, but their meeting in the Volpini print is more intimate as the figure with her back to the viewer seems to be kissing her companion. A third figure in the background contributes to the puzzling nature of the scene. The grouping of the three women—two close together and one set apart—resembles the composition of *Breton Women by a Gate* and also recalls the *Young Wrestlers,* with the two young boys in the foreground and the third looking on from a distance. The tree with the large leaves in the zincograph calls to mind the tree in *Riverside (Au Bord de la Rivière)* (cat. 81, p. 145), although the trunk is more prominent in the Volpini print and forms a compositional counterpart to the figures on the left.

The title Gauguin gave the print evokes the rich tradition of the pastoral genre in European painting. The topos of the paradisiacal Arcadia from classical bucolic poetry was very popular in French painting, the simple life of the land highly idealized.[22] Gauguin transported the pastoral scene to the tropics, reinforcing his own idealized view of life far removed from Western civilization.[23] *Martinique Pastorals* also foreshadows the works he would produce in Tahiti. Martinique was his first sampling of life in the tropics since he had declared himself an artist. The impressions he brought back from that journey strengthened his desire for a life outside Europe, a wish that came to fruition with his first departure for Polynesia in 1891.

The Grasshoppers and the Ants (Les Cigales et les Fourmis)

The Grasshoppers and the Ants (cat. 82) shows a colorful gathering of seven women. Four figures walk along a path, carrying fruit in large baskets on their heads, while three figures recline in various poses on the sand. However, they are grouped in such a way that it is difficult to determine the precise reason for this meeting. The two women in the foreground, for example, face each other but there is no contact between them. Neither of the Martinique prints in the *Volpini Suite* directly echo Gauguin's Caribbean paintings. Drawings he brought back from Martinique, such as *Head of a Woman, Martinique* (see cat. 52, p. 78), may have been helpful in suggesting figure types in the prints. Laval, who accompanied Gauguin to the Caribbean, also portrayed women transporting fruit on the island paradise. The figure balancing a basket on her head in Laval's *Landscape, Martinique (Paysage, Martinique)* (cat. 83, p. 148) is similar to the figures in Gauguin's *The Grasshoppers and the Ants.*

As in *Martinique Pastorals, The Grasshoppers and the Ants* testifies to Gauguin's fascination with the elegant gestures of the local women. "The thing that makes me smile the most are the figures, and each day it's a continual coming and going of negresses dressed up in colored garments with graceful movements infinitely varied."[24] The poses of the women balancing large baskets of fruit on their heads do indeed look more like steps in a dance than hard physical labor. They are very different from the static Breton peasant women in their stiff costumes. These slender Martinican women in their flowing dresses suggest a classical beauty.

The title of the print refers to the well-known fable of the same name by Jean de la Fontaine. According to the fable, an artistic grasshopper entertains a hard-working ant throughout the summer, but the ant refuses to reward the singer by supplying it with food during the bitter winter. The ant is an industrious worker whose only concern is to ensure its own material existence—a bourgeois, in other words. The grasshopper, however, is an artist, a bohemian who does not care about the next day but lives for his calling. Gauguin referred to this fable in *Noa Noa* (1893–94), the

Cat. 82. Paul Gauguin, *Volpini Suite: The Grasshoppers and the Ants,* 1889, Collection of Irene and Howard Stein

Cat. 83. Charles Laval, *Landscape, Martinique*, 1887, Van Gogh Museum, Amsterdam

Fig. 56. Paul Gauguin, *Young Boy,* date unknown, location unknown

account of his experience in the South Seas. A Maori princess supposedly recited the story for him; he used her voice to critique the fable as she emphatically expressed her preference for the grasshopper.[25] In his interpretation of the tale, Gauguin cultivated his own image as an outcast, as he had previously done in his *Self-Portrait (Les Misérables)* (see cat. 65, p. 121). Although La Fontaine was ironically criticizing the lack of appreciation for artists, the fable was later mainly used to illustrate the saying "Those who won't work won't eat." The title suggests that the women transporting fruit represent ants and the three seated women are grasshoppers. The addition of a suggestive title to an everyday encounter and the linking of a European fable with a tropical scene are typical of Gauguin, who sought to give his works several symbolic layers of meaning.

Arles

Human Misery (Misères humaines)

In the zincograph *Human Misery* (cat. 84, p. 151), Gauguin alluded to the grape harvest in Arles, a subject that both he and Van Gogh had painted during the autumn of 1888. Van Gogh's canvas was titled *The Red Vineyard* (State Pushkin Museum of Fine Arts, Moscow), while Gauguin first titled his version of the subject *Poor Woman* or *Splendor and Misery* (*Une Pauvresse* or *Splendeur et misère*), but early in 1889 he changed the title to *Human Misery* (see cat. 39, p. 56).[26] Gauguin's painting is dominated by the figure of a melancholy woman with red hair who sits in the fore-ground. Around her are black-clad figures harvesting grapes in a red field. The two artists had spotted the scene while walking in the countryside around Arles,[27] although Gauguin claimed he had painted his canvas from his imagination rather than from life, and boasted that it portrayed women in Breton costume in a Provençal vineyard.

In his graphic interpretation of *Human Misery,* a similar tousle-haired, despairing woman dominates the composition. However, in the zincograph, a young man is her close companion. Gauguin included one of the black-clad figures from the painting in the background of the zinco-graph; she observes the couple from the far side of a stone wall. The melancholy figure's male companion is based on the drawing *Young Boy* (*Jeune Garçon*) (fig. 56). The slanting tree is an obvious quotation from *Vision of the Sermon* (see fig. 13, p. 62). Although Gauguin was keen to

stress the originality of his subject, the pensive young woman in particular has many predecessors in both his oeuvre and that of other artists.[28] In the nineteenth century a seated figure with elbows on knees and head in hands was often used to depict melancholy, desire, and suffering. Gauguin may have known Van Gogh's similar depiction of deep sorrow and loneliness in the Dutch artist's lithograph *Sorrow* (cat. 85, p. 152). The melancholy figure's pose in Gauguin's zincograph was an elaboration of his portrait of Marie Ginoux in *The Night Café, Arles* (see fig. 29, p. 84), a painting he was working on at the same time as the canvas *Human Misery*. It has often been pointed out that the pose of the figure in *Human Misery* is reminiscent of the Peruvian mummy at the Musée Ethnographique des Missions Scientifiques in Paris, which Gauguin is known to have visited on several occasions.[29]

Immediately after he had finished the canvas Gauguin wrote to Bernard: "It is an impression of vineyards that I saw in Arles. I put Breton women in it—too bad about accuracy." He added that *Human Misery* was his best work of 1888.[30] Gauguin regarded this canvas as a milestone in his development. He was trying to create a nondescriptive form of art that would encourage the viewer to imagine something beyond what was shown. Such a work had to be more a parable than a "painted novel"—easy reading. Given the ambiguous symbolism and suggestive title, he succeeded in making Symbolist art from his imagination, as he had done earlier with *Vision of the Sermon*.[31]

The woman, with her uncovered, unbound red hair, has often been interpreted as a symbol of sexual awakening. It is precisely this sexual awareness and implied refusal to conform to the prevailing norms of morality that caused her to be rejected by French society.[32] According to Gauguin, though, she was a broken, beaten-down woman who nonetheless retained her dignity:

Do you see a poor desolate woman in the grape harvest? Do not think her devoid of intelligence, grace, and every gift of nature. She's a woman. Her chin resting on her hands, she's not thinking of very much, but feels consolation on this earth (nothing but earth) where the sun floods the vineyards with its red triangle. And a woman dressed in black passes, who looks at her as a sister.[33]

There is hope for her because she has the earth, or nature, to console her. Such an idea was likely influenced by Van Gogh, who regarded nature as the ultimate consolation for humankind. The passerby dressed in black is supposedly her opposite, her elder sister, who already knows life's temptations and sorrows.[34]

The addition of the male companion in the zincograph makes the association with sexual awakening more explicit. The melancholy mood of the painting has been replaced by a more ominous one in the print. The implication is that the relationship between the two figures has caused the woman's rejection from society. The figure observing the couple beyond the low stone wall can have the same meaning as in the painting, but she could also represent society passing judgment. The zincograph is the only one in the suite for which Gauguin used brick-red rather than black ink, echoing the dominant color in the painting.

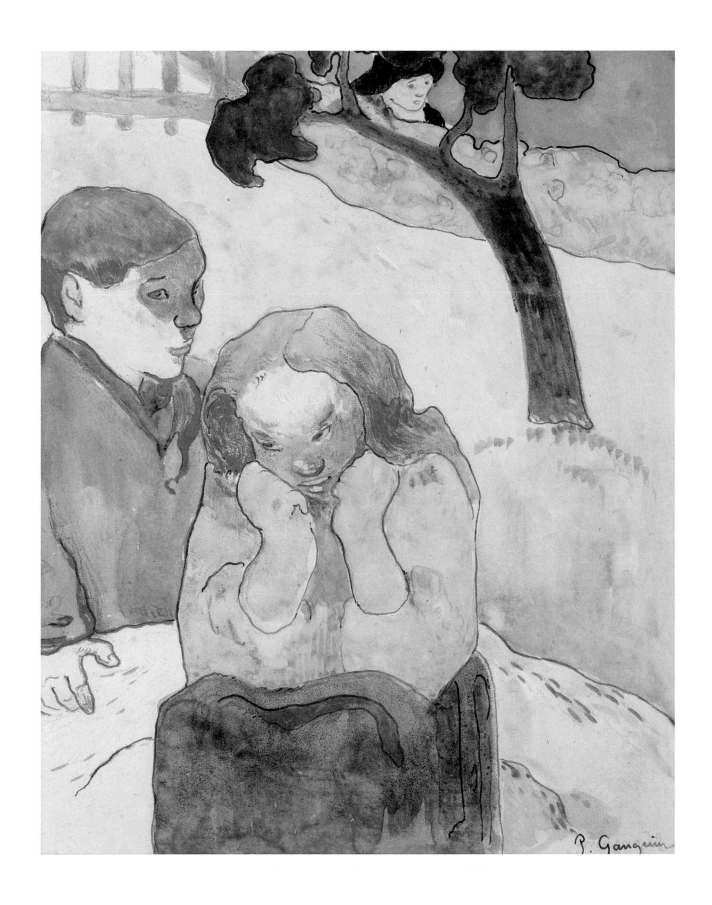

Cat. 84. Paul Gauguin, *Volpini Suite: Human Misery*, 1889, Collection of Jill and Michael Wilson

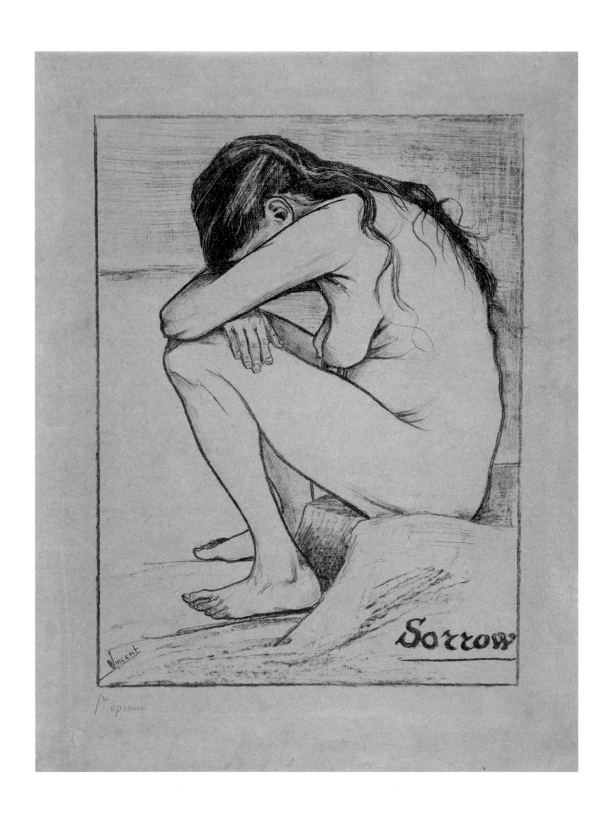

Cat. 85. Vincent van Gogh, *Sorrow*, 1882, Van Gogh Museum, Amsterdam

The Laundresses (Les Laveuses)

The Laundresses (cat. 86, p. 154) almost precisely replicates the composition of *The Laundresses* (*Les Lavandières*) (cat. 87, p. 155), one of two canvases of the subject that Gauguin painted in Arles in November 1888.[35] A popular subject with Gauguin's contemporaries, laundresses also appeared in paintings and drawings by Van Gogh from the same period, including *Washstands at the Canal "La Roubine du Roi"* (cat. 88, p. 156). Breton women hanging laundry to dry was the subject of one of Bernard's earliest prints, *The Washing (La Lessive)* (cat. 89, p. 157).[36] Whereas Van Gogh and Bernard depicted the task of doing laundry more or less realistically, Gauguin's version transformed the everyday activity into a scene laden with symbolic content. His canvas depicting two women and a goat by the water's edge is diagonally divided into two halves, one describing earth, the other water. The painting is striking for its use of brilliant color and dynamic brushwork. Swirling blue-green brushstrokes suggest water at the top of the composition. The water is flanked by a passage of fiery orange-red brushstrokes that are difficult to explain in terms of the suggested landscape. Gauguin repeated these adjacent passages of blue and red in the hand-colored impression of the zincographs. The foreground of the painting is a configuration of muted colors that may represent wash laid out on the grass to dry. The original scene is essentially copied in the zincograph, but made even more abstract by the strong contrast between the black ink and the yellow background and the emphasis on pattern. The water, above all, has become a varied arrangement of billowing lines and forms.

Although all the paintings Gauguin made in Arles were based on his experience of Provence, the bending laundress in both painting and zincograph wears a Breton *coiffe de basin* (mourning headdress). The washboard, too, is typically Breton.[37] These elements suggest that the scene is actually set in Brittany.[38] The green shadow on the right in the oil on canvas version of the composition looks like a specter, and, in combination with the luminous green-blue shawls and the women's headwear, the painting recalls a Celtic legend that was popular in Brittany in the nineteenth century, "The Washerwomen of the Night." In this tale three women wash the clothes of the dying at midnight. Because they dress in green and have webbed feet, the Bretons call them "cannard noz" (night ducks). Gauguin may have heard the story in Brittany or have learned about it from literary or artistic sources.[39] He would certainly have been interested in the "primitive," heathen aura of the legend and the seemingly innocent subject of washerwomen who were nevertheless the harbingers of death. The canvas and the zincograph thus flowed naturally from his endeavor to give his works, wherever possible, a symbolic charge that was open to several interpretations.

Old Women of Arles (Les vieilles filles [Arles])

The zincograph *Old Women of Arles* (cat. 90, p. 158) is an almost literal translation of *The Arlésiennes (Mistral)* (*Arlésiennes [Mistral]*) (cat. 91, p. 159), one of the last canvases that Gauguin finished in the south of France. In the choice of subject and composition he responded to Van Gogh's *Memory of the Garden in Etten*, 1888 (State Hermitage Museum, St. Petersburg), which Vincent had painted upon Gauguin's urging to paint from memory rather than from life. Van Gogh described the experimental painting in a letter to his brother, Theo, and included a schematic drawing (cat. 92, p. 160). In the composition, Van Gogh portrayed his mother and sister

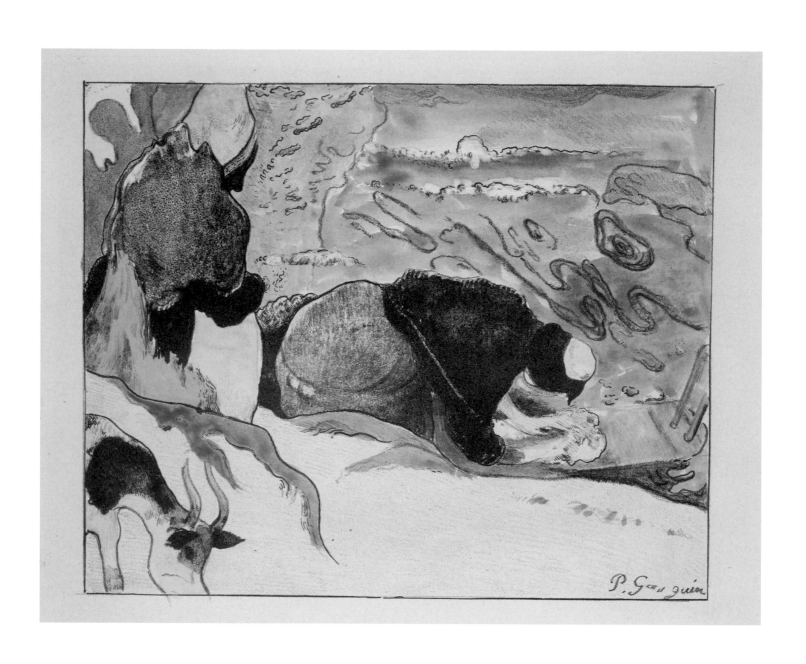

Cat. 86. Paul Gauguin, *Volpini Suite: The Laundresses,* 1889, Museum of Fine Arts, Boston

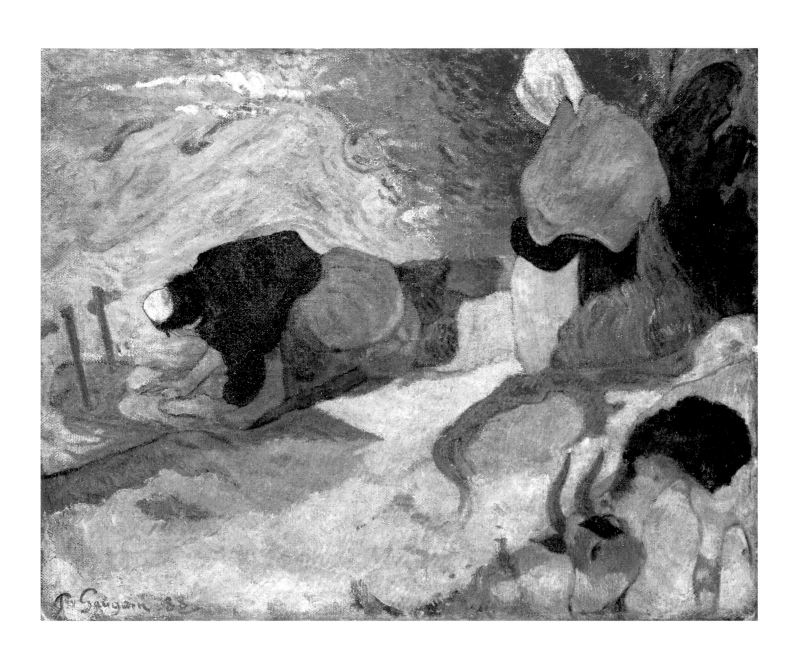

Cat. 87. Paul Gauguin, *The Laundresses*, 1888, Museo de Bellas Artes, Bilbao

Cat. 88. Vincent van Gogh, *Washstands at the Canal "La Roubine du Roi,"* 1888, Kröller-Müller Museum, Otterlo

Cat. 89. Émile Bernard, *The Washing*, 1888, Van Gogh Museum, Amsterdam

Cat. 90. Paul Gauguin, *Volpini Suite: Old Women of Arles*, 1889, Collection of Jill and Michael Wilson

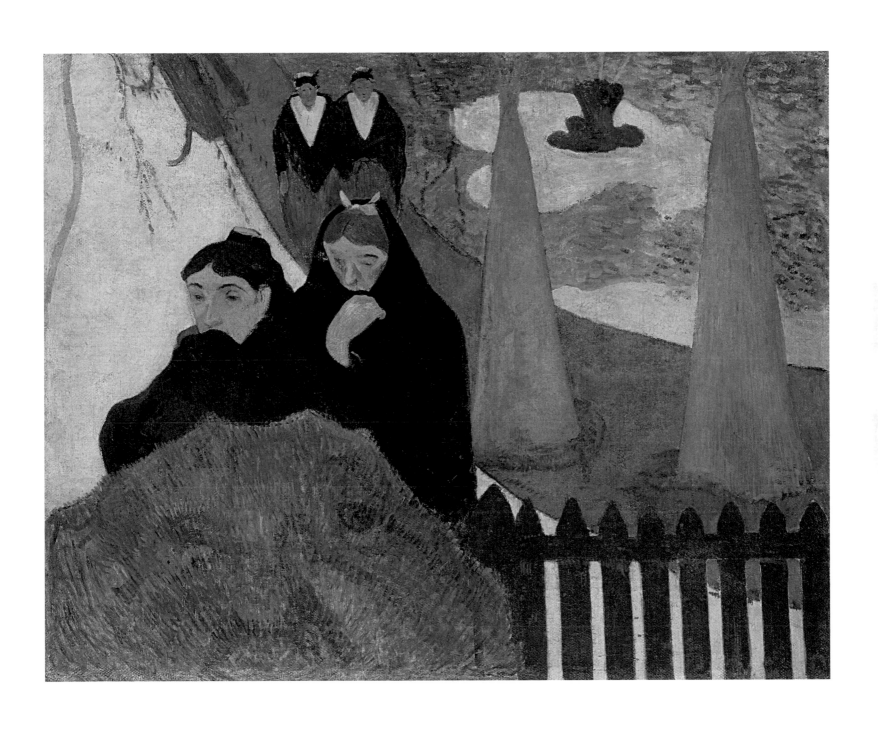

Cat. 91. Paul Gauguin, *The Arlésiennes (Mistral)*, 1888, The Art Institute of Chicago

Ma chère Soeur, une chôse qui m'a fait bien 9
plaisir c'est que j'ai reçu enfin une réponse
de Mme Mauve qui a
Désirant lui écrire de ces jours ci je le prierai
de m'envoyer de suite et sans faute son
adresse actuelle. Sa lettre était datée
de la Haye mais elle ne dit pas si elle
y restera moi je croyais qu'elle avait continué
à rester à Laren.
Elle dit avoir eu aussi une bonne lettre
de toi
J'ai reçu la lettre datée de Mlle Delharris
et t'en remercie bien. Tu fais bien
d'avoir enfin commencé à lire
au bonheur des dames se.
Il y a tant de chôses là dedans comme
dans Guy de maupassant aussi
Je t'ai déjà répondu que je n'aimais
pas énormément le portrait de la mère
Je viens maintenant de peindre pour le
mettre dans ma chambre à coucher
un souvenir du jardin à Etten et en voici
un croquis – C'est une toile assez grande.

Fig. 57. Paul Gauguin, *Les Alyscamps,* 1888, Musée d'Orsay, Paris

walking in the garden of his parental home. Gauguin's interpretation of the subject of women in a garden portrays a group of Arlésiennes in local costume walking along a garden path in winter, the trees wrapped to protect them against the *mistral,* the cold Provençal wind to which Gauguin refers in the title of the painting. A comparison of Van Gogh's treatment of the subject and Gauguin's re-interpretation reveals the intense, rapid-fire exchange that was taking place between the two artists in the autumn of 1888.

As in Brittany and Martinique, Gauguin was attracted to the women of Arles, with their distinctive dress, striking shawls, and hair ornaments. Accordingly, the painting and the zincograph can be seen not only as a tribute to the collaboration with Van Gogh but also as an act of homage to the Arlésiennes, about whom Gauguin wrote to Bernard: "The women here, with their elegant coiffure, their Grecian beauty, their shawls falling in folds like the primitives, are, I say, like Greek processions."[40] The women in the painting walk through a garden, likely inspired by the public garden on the Place Lamartine, directly in front of Van Gogh's yellow house. Distinctive features of the garden—the curving path and weeping willow—are also found in many of Van Gogh's drawings and paintings of the period. One of them, *The Poet's Garden,* 1888 (The Art Institute of Chicago) was part of the decoration of Gauguin's room in the yellow house.

The woman in the right foreground of the zincograph resembles Mme Ginoux, the owner of a café in Arles whose portrait Gauguin had already painted in *Night Café* (see fig. 29, p. 84).[41] The two women in the background relate to the figures in *The Alyscamps* (*Les Alyscamps*) (fig. 57), a painting Gauguin also ironically called *Landscape* or *The Three Graces at the Temple of Venus* (*Paysage* or *Les Trois Grâces au Temple de Vénus*).[42] Although *Arlésiennes, Mistral* and the zincograph portray a commonplace walk in the park, the gestures and facial expressions of the figures are static and mysterious, as if the women are part of a procession. As in *Breton Women by a Gate,* the viewer is kept at a distance from a local scene; the rotund hedge, wrapped tree, and voluminous cloaks all serve to isolate the figures in a hermetic, other worldly atmosphere. Bernard also depicted women walking through a winter garden in a zincograph, albeit not one of the images from his portfolio *Les Bretonneries.* In *The Promenade (La Promenade),* 1888 (cat. 93, p. 163), Bernard depicted city women, who may or may not be prostitutes, bundled in fur-trimmed

coats and fur muffs, walking through a sparse landscape. The zinocograph's curved format is evocative of a Japanese fan, conjuring associations with Gauguin's zincograph *The Dramas of the Sea: Brittany* (see cat. 78a, p. 141).

A Calling Card and Harbinger

Gauguin was forty-one years old when he made the *Volpini Suite*. It was made at a crucial moment in his career—he had been a full-time artist for only six years. From the moment he began to paint, he continuously reformulated subjects he had conceived, exploring them in new contexts using different media. As the basis for these eleven prints on canary-yellow paper, he borrowed from what he considered his most important and avant-garde paintings, drawings, and ceramics. He did not copy them, but paraphrased and quoted them, creating new scenes invested with symbolism that invited various levels of interpretation. By 1889 he had left Impressionism behind; monumental figures and symbolic subjects took its place and he began to transform everyday scenes into subjects shrouded in ambiguity. The *Volpini Suite* can thus be regarded on one hand as the calling card of a mature artist and on the other as a harbinger of the style that would characterize his oeuvre of the 1890s.

Cat. 93. Émile Bernard, *La Promenade*, 1888, Van Gogh Museum, Amsterdam

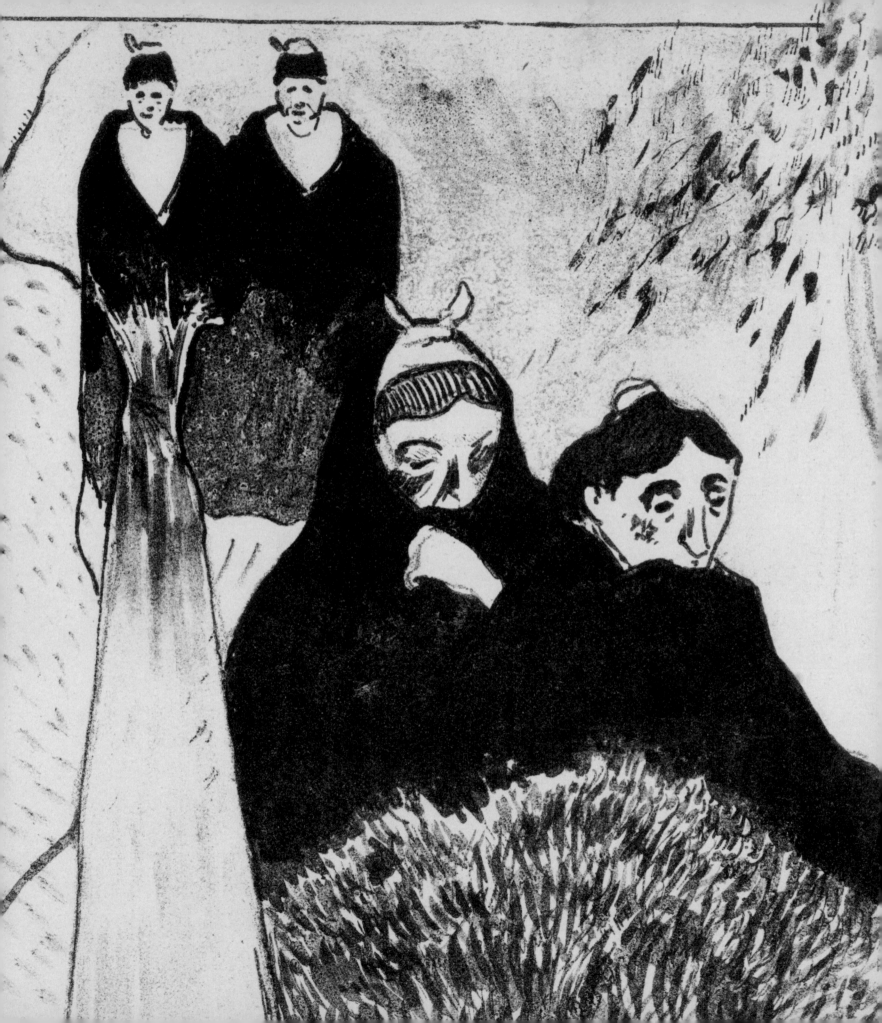

The Legacy of the *Volpini Suite*

Heather Lemonedes

The exercise of making a set of prints to promote himself and his subject matter in 1889 encouraged Gauguin to identify his most essential themes and determine how he wished to be perceived by a wide audience. On a formal level, the zincographs inspired numerous subsequent images of the bather. But the *Volpini Suite* not only predicted what Gauguin would paint in the future; it also foreshadowed how he would paint. The prints, as well as some of his most daring paintings from 1888–89, encouraged an economy of means and an insistently radiant palette. The lithographs were an early manifestation of Gauguin's increasingly elaborate program of mythmaking, an endeavor that ultimately took on monumental proportions and encompassed not only paintings, drawings, sculpture, and prints, but a rich body of writing as well. He continued to define and elaborate his artistic persona in a corpus of Tahitian work that included two additional print portfolios in which he assessed himself and his fundamental subjects as he had done in 1889. Ultimately, making the *Volpini Suite* launched Gauguin on a path of self-discovery and helped him create a unique style.

Recurrences of the Bather

The theme of a woman at her toilette has been central to Western art for centuries. Gauguin made his own particular engagement with the subject evident in his display, at the Café des Arts, of *In the Waves* (see cat. 43, p. 61) and the zincograph *Breton Bathers* in the *Volpini Suite* (see cat. 13, p. 18). In the seventeen paintings and works on paper he exhibited at the Volpini show, Gauguin addressed several themes of such personal significance that they became staples of his growing symbolic repertoire.[1] The theme of the bather was such a subject, its importance so significant that Gauguin continued to use it throughout 1889–90 and his first Tahitian sojourn. The bather appears in virtually every medium in which Gauguin worked: drawing, printmaking, woodcarving, and ceramics.

 In the Waves had its origins in two earlier works: *Two Bathers* (*Deux Baigneuses*) (see fig. 26, p. 80) and, perhaps even more significant, the zincograph *Breton Bathers*. In the oil painting, a curiously awkward female nude approaches a shallow pool, balancing on a grassy bank by resting a hand on a rock. Meanwhile, her more voluptuous companion is already wading, arms upraised

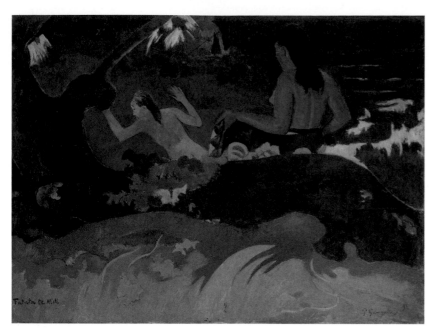

Fig. 58. Paul Gauguin, *By the Sea*, 1892, National Gallery of Art, Washington

to long red hair. Two years later Gauguin reprised the subject in the *Volpini Suite;* the calm pool has been replaced by a churning ocean, and the hesitant bather has become monumental, her physique extending beyond the confines of the image. Her companion has metamorphosed into a full-fledged swimmer, now seen from the front. The abandon with which the bather throws herself into the waves foreshadows the way in which the figure in *In the Waves* experiences the sea.[2] In this radical composition, the nude figure seen from behind diagonally bisects a decorative pattern of churning green waves. Her arms are raised and orange-red hair falls over one shoulder. Gauguin has eliminated horizon, earth, and sky, destabilizing both the subject and the viewer.

Gauguin repeated the dramatic figure in numerous works made after *In the Waves*. She was closely emulated in two drawings of the same period: *Ondine II*, 1889 (W. 337; private collection), and *Ondine III*, 1889 (W. 338; private collection). The bather floats like a siren in the background of *Nirvana: Portrait of Meyer de Haan*, 1889–90 (W. 320; Wadsworth Atheneum Museum of Art, Hartford). A nearly identical bather with red hair and upraised arms is the central figure in Gauguin's magnificent polychrome wood relief *Be Mysterious* (*Soyez mystérieuses*) (cat. 94). Working in the autumn of 1890, Gauguin described his progress in a letter to Bernard: "I have been in labor lately, and am delivered of a woodcarving, a counterpart of the first, *Be Mysterious*, with which I am pleased, and in fact I do not think I have done anything approaching it."[3] He favorably compared *Be Mysterious* to his earlier woodcarving *Be in Love and You Will Be Happy* (see fig. 32, p. 85) in a letter to Theo van Gogh: "I'm just finishing a woodcarving that I think is much better than the first."[4] *Be Mysterious* successfully translates the emotional power of *In the Waves* into a three-dimensional format. The body of the bather in the woodcarving creates a similar dramatic diagonal bisecting a decorative pattern of swirling waves. The sculpture, perhaps even more than the painting, foreshadowed Gauguin's monumental Tahitian nudes. The addition of two mask-like visages flanking the bather added to the enigmatic symbolism of the woodcarving.

Gauguin continued to imagine the bather in varying guises. She is featured in the intimately sized woodcarving *The Ondines* (cat. 95, p. 168), but on this occasion Gauguin paired her with a companion seen from the front. A similar composition of two bathers formed the background of the painting *Still Life with Quimper Pitcher* (*Nature morte avec une cruche de Quimper*) (cat. 96,

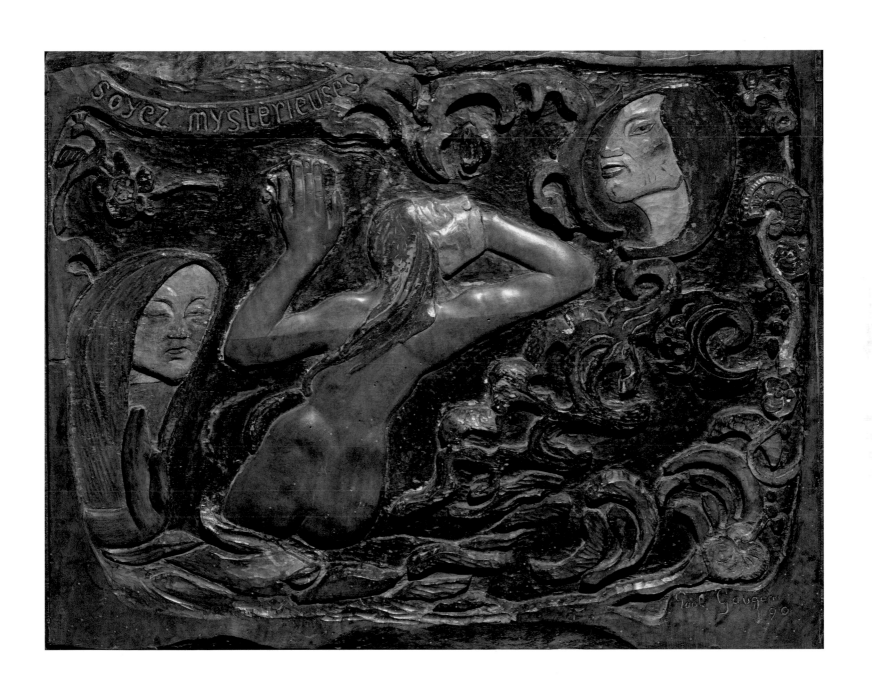

Cat. 94. Paul Gauguin, *Be Mysterious,* 1890, Musée d'Orsay, Paris

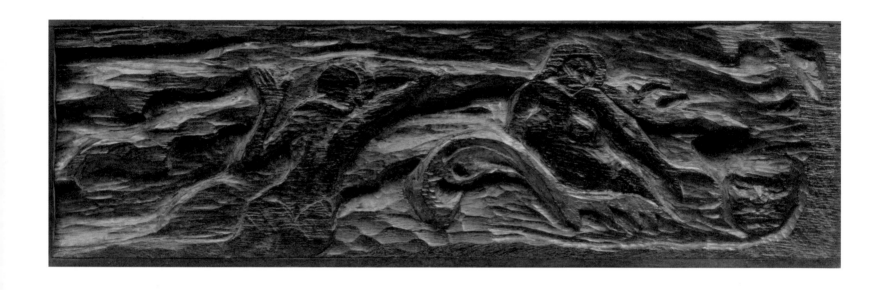

Cat. 95. Paul Gauguin, *The Ondines,* c. 1890, private collection, courtesy Barbara Divver Fine Art

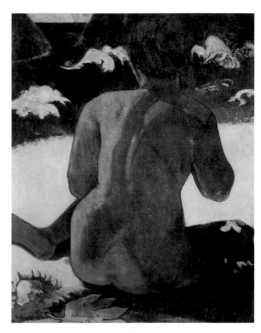

Fig. 59. Paul Gauguin, *Woman at the Sea*, 1892, Museo Nacional de Bellas Artes, Buenos Aires

p. 170).[5] Could Gauguin also have executed a version of these two bathers on canvas or paper that he then included in the background of *Still Life with Quimper Pitcher*? The palette and scale of the background design do not invoke the woodcarving, although the compositions are similar. Or might Gauguin simply have imagined the woodcarving in color to animate the still life? In a watercolor, gouache, and pastel drawing that has recently come to light, *The Bathing Place* (*La Baignade*) (cat. 97, p. 171), Gauguin once again addressed the subject of two women bathing en plein air.[6] The highly worked drawing is a curious blend of old and new; Gauguin relegated the bather with upraised arms to the background, while the red-haired bather of the 1887 canvas *Two Bathers* reappears in the foreground. A dramatically cropped tree divides the composition in a manner similar to the tree in *Two Bathers,* but here the similarities between the two compositions end. Diverging from the Impressionist palette and feathery brushwork of *Two Bathers,* Gauguin eliminated perspective in *The Bathing Place,* instead describing the landscape in a decorative pattern of brilliant hues. Gauguin also included the bather in *Self-Portrait* (*Autoportrait*) (cat. 98, p. 172). Behind the artist, the red-haired bather is depicted in reverse, reflected in a mirror. She hovers like a muse, glimpses of elbow and back just visible. The inclusion of a detail of *In the Waves* in a self-portrait confirms the significance that the painting—and the motif—held for him.

The theme of the bather continued in Gauguin's Polynesian work of 1891–93. A woman with upraised arms throws herself into the sea in *By the Sea* (*Fatata te Miti*) (fig. 58, p. 166). As in several works from 1889, she is accompanied by another bather who more circumspectly approaches the water. *Woman at the Sea* (*Vahine no te miti*) (fig. 59) is a Tahitian reinvention of *In the Waves*. Once again, Gauguin depicted a monumental nude female figure seen from behind. The waves in the Tahitian canvas create a decorative pattern of blue and white swirls, similar to Gauguin's articulation of the sea in *In the Waves*. An expanse of golden sand blazes across the center of the canvas, perhaps an echo of the canary yellow paper of the *Volpini Suite*.

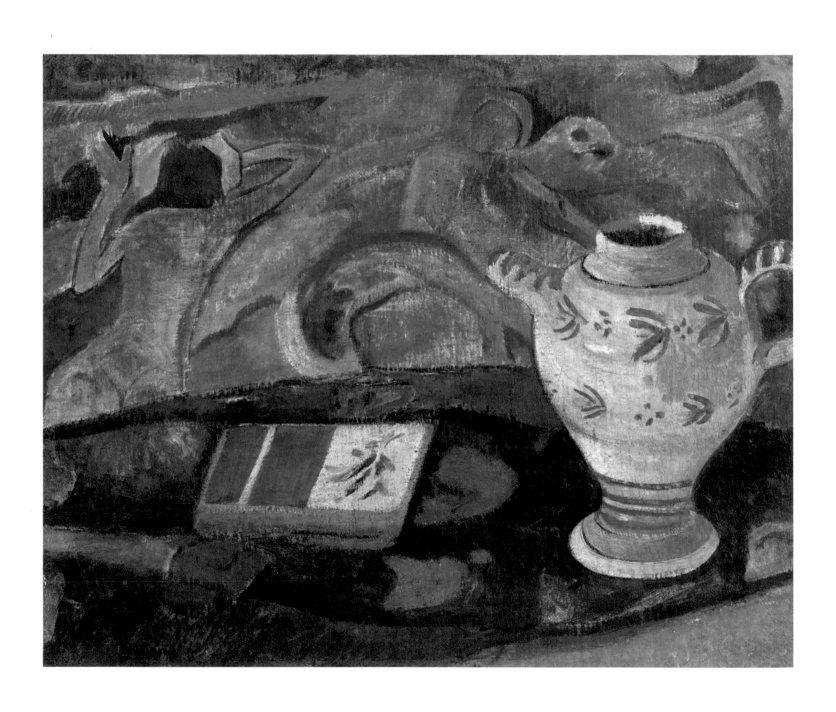

Cat. 96. Paul Gauguin, *Still Life with Quimper Pitcher*, 1889, University of California, Berkeley Art Museum and Pacific Film Archive

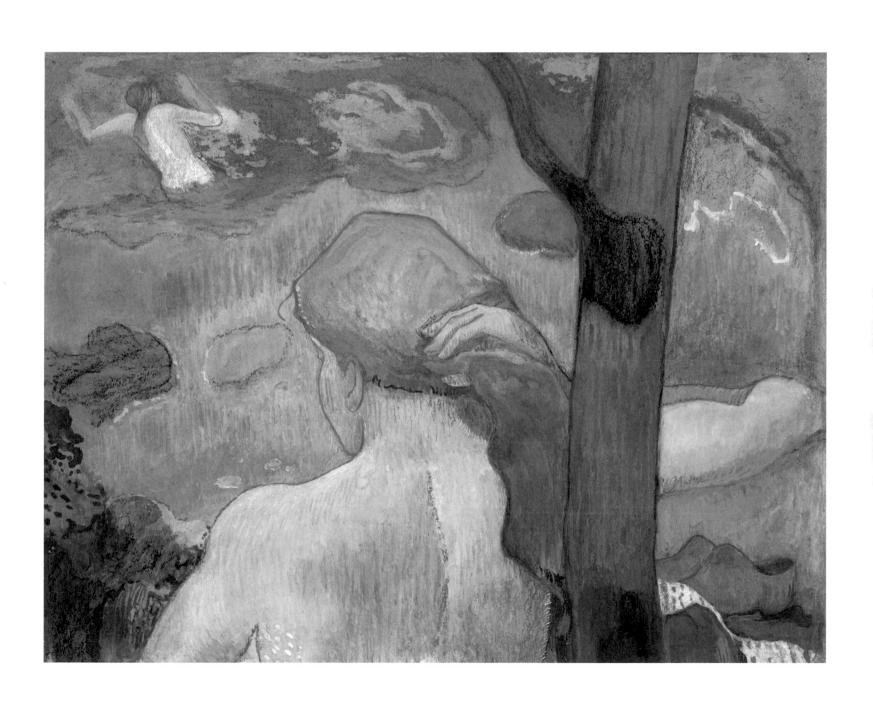

Cat. 97. Paul Gauguin, *The Bathing Place*, 1889, private collection

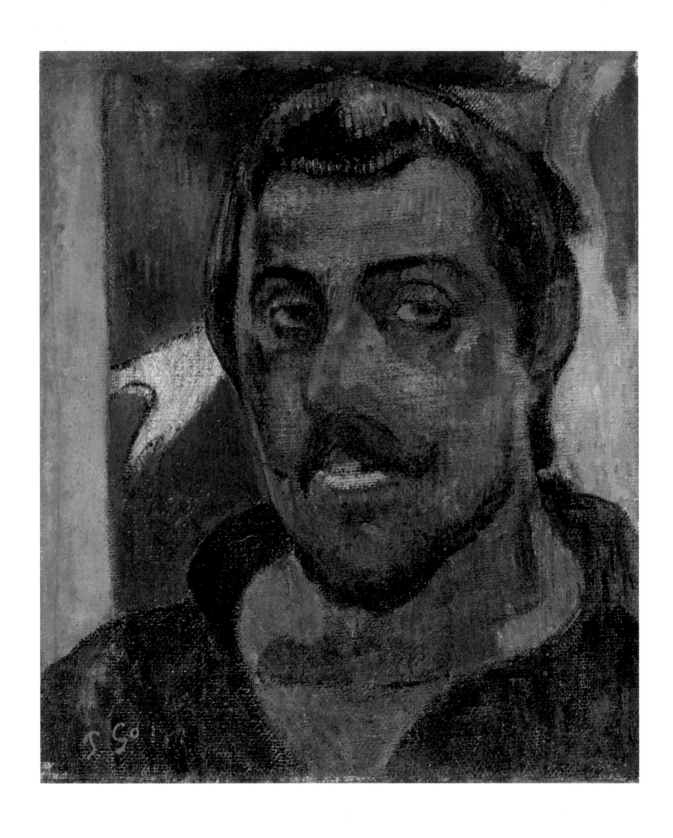

Cat. 98. Paul Gauguin, *Self-Portrait,* 1889–90, Pushkin State Museum of Fine Arts, Moscow

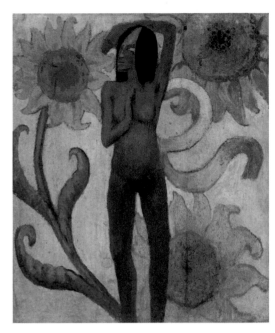

Fig. 60. Paul Gauguin, *The Caribbean Woman*, 1889, private collection

The Evolution of Style and the Persistence of Yellow

The significance of the *Volpini Suite* goes beyond the fact that it synthesized Gauguin's most essential themes. Confronting the technical challenges of making lithographs on zinc plates encouraged radical stylistic innovations that were to impact Gauguin's painting style for the remainder of his career. *Breton Girl Spinning* (*Jeune Bretonne au rouet*) (cat. 99, p. 174), which was made as part of the decorative ensemble for the dining room at the Inn of Marie Henry at Le Pouldu,[7] is evidence of the simplified forms, flattened space, and monumentalized figures that became typical of Gauguin's work from 1889. The painting's hilly coastal setting relates to the terrain of *Dramas of the Sea: Brittany* (see cat. 16, p. 21) from the *Volpini Suite,* and one might even argue that the spinner's canine companion recalls the *remarques* of the dogs in the zincograph *Joys of Brittany* (see cat. 14, p. 19). Sérusier, who lived with Gauguin in Le Pouldu and executed a panel painting for Marie Henry's dining room, remembered that Gauguin's zincographs decorated the walls of the seaside inn,[8] so Gauguin would have literally been surrounded by the suite while living there. Links between the *Volpini Suite* and the inn are underscored by the inscription "ONI SOIE ki male panse" Gauguin painted above the entrance to the dining room door, a variation on the inscription on the frontispiece of the suite of prints. Parallels between the dining room paintings and the *Volpini Suite* continued in the sinuous pose of the figure in *The Caribbean Woman* (*Femme Caraïbe*) (fig. 60); the figure recalls the swaying, musical forms of the Martinique fruit bearers in the zincographs *Martinique Pastoral* (see cat. 20, p. 25) and *The Grasshoppers and the Ants* (see cat. 19, p. 24). Even the background color of the painting—a deep yellow with outsized sunflowers—evokes the *Volpini Suite*. Gauguin made two sculptures during this period that relate to *Caribbean Woman* and the Martinique prints: *Martinican Woman* (*Femme Martinique*), c. 1889 (G. 61; Henry and Rose Pearlman Foundation), and *Lust* (*Luxure*) (cat. 100, p. 175). The graceful forms of these two figures simultaneously underscore his continued fascination with the exotic women of Martinique while foreshadowing the Tahitian subjects that would follow. He also made a woodcarving in relief, *The Grasshoppers and the Ants* (G. 72; location unknown), which reproduces the composition of the zincograph of the same title. Although the woodcarving is presum-

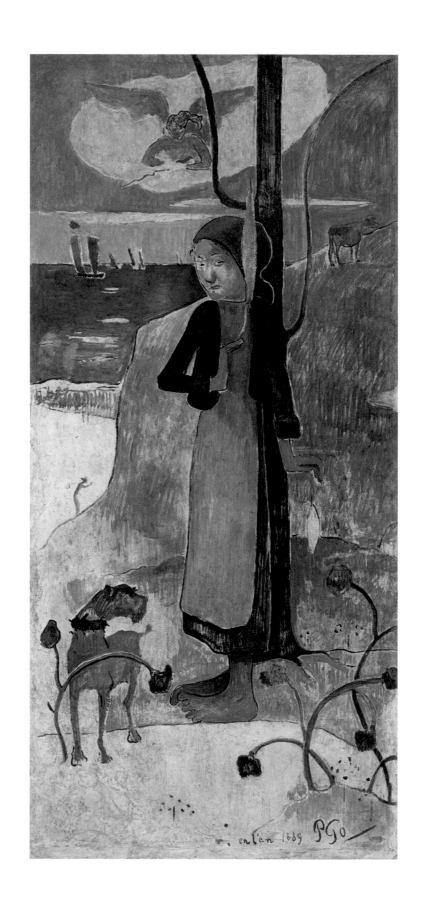

Cat. 99. Paul Gauguin, *Breton Girl Spinning,* 1889, Van Gogh Museum, Amsterdam

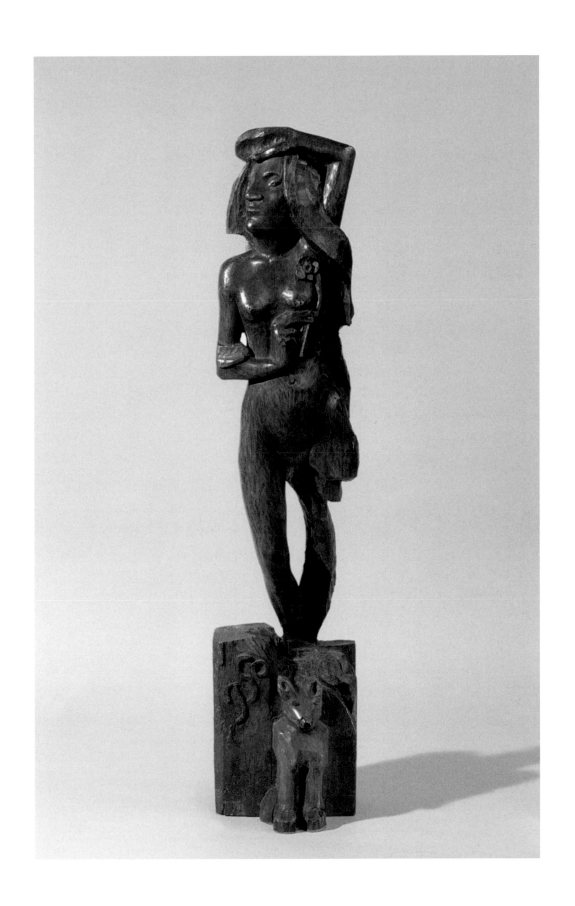

Cat. 100. Paul Gauguin, *Lust,* 1890, J. F. Willumsens Museum, Frederikssund

Cat. 101. Paul Gauguin, *There Is the Temple,* 1892, Fogg Art Museum, Harvard University Art Museums, Cambridge

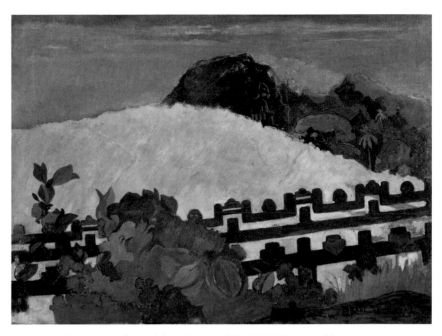

Fig. 61. Paul Gauguin, *The Sacred Mountain*, 1892, Philadelphia Museum of Art

ably lost, it is known from a photograph pasted into Gauguin's so-called *Album Schuffenecker* in the Cabinet des Dessins at the Musée du Louvre.

Two portraits of Gauguin from the period of 1889–90 reveal the association of the artist with the color yellow. In Bernard's watercolor *Caricature of Paul Gauguin* (*Caricature de Paul Gauguin*) (cat. 102, p. 178), the artist is seated in an armchair, wearing a chrome yellow traditional Breton shirt. Bernard portrays Gauguin enthroned as the leader of a new school of painting in Pont-Aven, wearing what had become his signature color. In another watercolor, *Self-Portrait* (cat. 103, p. 179), previously thought to be a portrait of Meyer de Haan, yellow once again figures prominently. In this drawing, Gauguin's disembodied face is schematized, rendered with a cloisonnist blue outline and yellow highlights. The drawing underscores Gauguin's understanding of the law of simultaneous contrast of complementary colors. He would continue to juxtapose blue and yellow in subsequent paintings and drawings.

Parallels with the *Volpini Suite* continued in Gauguin's work from his first journey to the South Seas. *The Sacred Mountain* (*Parahi te marae*) (fig. 61), and the preparatory drawing, which has a different title, (cat. 101) are closely related to the zincograph *Breton Women by a Gate* (see cat. 17, p. 22). In the Tahitian landscape Gauguin repeated the compositional structure of a golden expanse of hilly terrain enclosed by a fence. *The Sacred Mountain* was intended to invoke an imaginary "marae," a sacred enclosure intended for ritual sacrifice as described in his text *Ancien Culte mahorie* (Ancient Rites of the Maori).[9] The schematized forms of the landscape, the undulating rhythm of the fence in the watercolor, the predominance of the color yellow, and even the dark mountains in the distance all call to mind the sloping hills of Pont-Aven and black rocks of Le Pouldu depicted in the *Volpini Suite*.

Gauguin continued the stylistic innovations begun in 1889 in other works from the South Seas. *What News?* (*Parau Api*) (cat. 104, p. 180), is a quintessential example of his mature Tahitian style.[10] This painting, as well as numerous works from his first Tahitian journey, features the pairing of two female figures, perhaps echoing the Volpini zincographs *Joys of Brittany, Breton Women by a Gate,* and *Laundresses* (see cats. 14, 17, 21, pp. 19, 22, 26), whose central motifs consist of two women. The striking immediacy of *What News?* is heightened by the monumentality of the

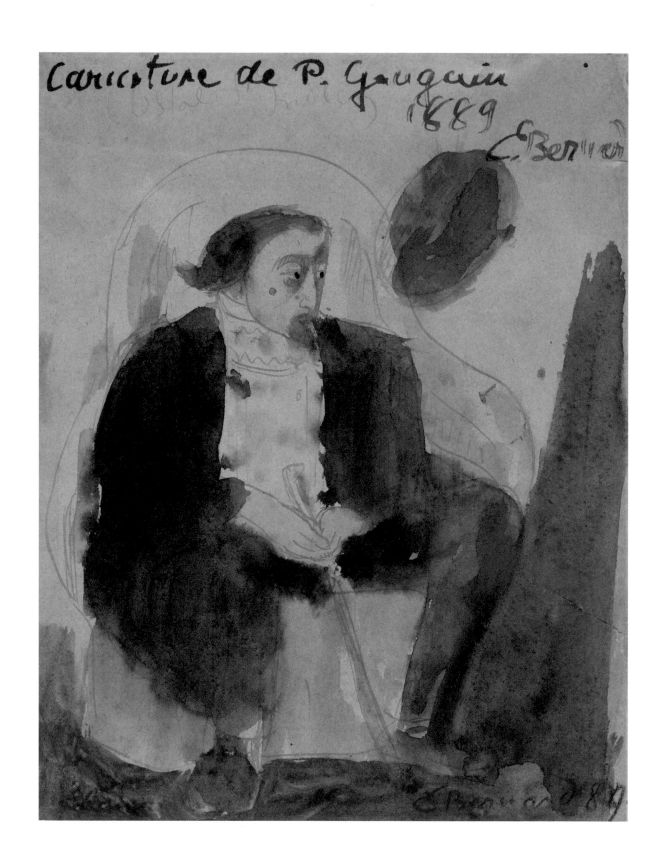

Cat. 102. Émile Bernard, *Caricature of Paul Gauguin,* 1889, William Kelly Simpson, New York

Cat. 103. Paul Gauguin, *Self-Portrait*, 1889–90, The Triton Foundation, The Netherlands

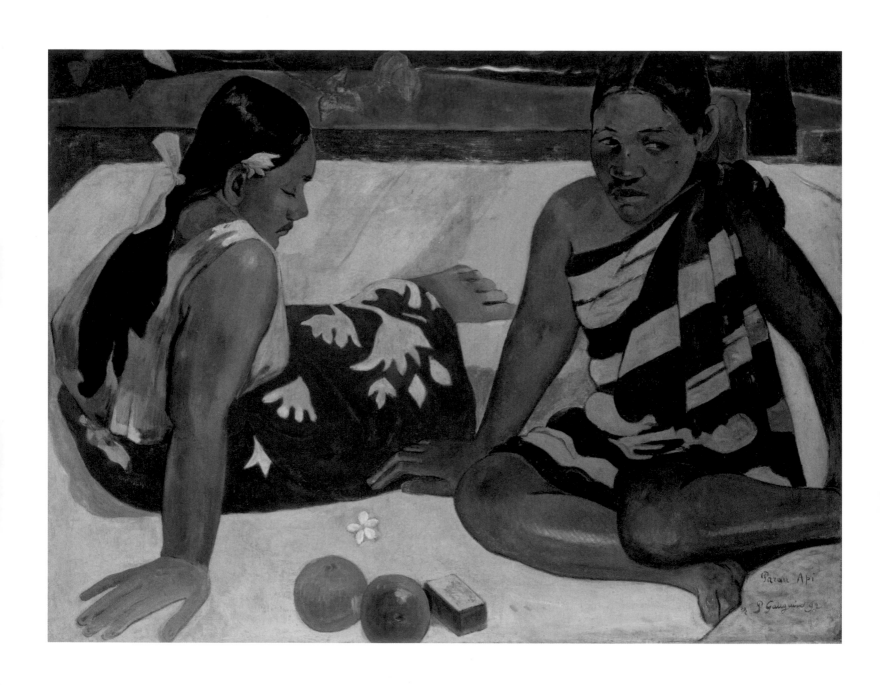

Cat. 104. Paul Gauguin, *What News?*, 1892, Staatliche Kunstsammlungen Dresden, Gemäldegalerie Neue Meister

figures framed against a flat plane of canary yellow. The figures' poses recall those of the Martinique women resting on the path in the zincograph *The Grasshoppers and the Ants*. The figures in *What News?* are rendered as types, interacting only as compositional elements. The seated figures in *The Grasshoppers and the Ants* convey a similar psychological distance; they too seem to be endlessly waiting. Both images suggest a paradisical existence, while the titles introduce elements of psychological uncertainty.

The color yellow continued to play a significant role in Gauguin's work after 1888–89. The predominantly yellow palette throughout *Still Life with Fruit and Spices* (*Nature morte aux fruits et piments*) (cat. 105, p. 182), and the subjugation of volume to flat, decorative pattern is reminiscent of the stylistic changes that were taking place in Gauguin's oeuvre around the time of the creation of the *Volpini Suite*. *Young Christian Girl* (*Bretonne en prière*) (cat. 106, p. 183), is considered the finest canvas from Gauguin's last trip to Brittany.[11] In this canvas, he blended the Breton landscape of his past with the monumental figures of Tahiti. The canary yellow missionary dress, likely brought back from Tahiti, is the true subject of the painting.[12] Back in Paris in 1893–95, chrome yellow was still a color of great significance for Gauguin. Following the exhibition of his paintings at the Durand-Ruel Gallery in 1893, the Hungarian artist Jozef Rippl-Rónai recalled that Gauguin "could not understand the reason for his lack of success, but sought to account for it by the white frames: so that as soon as the exhibition was over he painted them yellow, before hanging them up in his own studio."[13] The walls of that same studio on the rue Vercingétorix were painted olive green and brilliant yellow. In *Self-Portrait with a Palette* (*Autoportrait à la palette*), c. 1894 (W. 410; private collection), yellow is the pigment that covers his palette.

Parallels between the *Volpini Suite* and *Noa Noa*

Upon his return to Paris from Tahiti in August of 1893, Gauguin conceived of an illustrated book that would describe his life among the natives and place his South Seas paintings within a context. He elicited the assistance of his friend Charles Morice, Symbolist poet and critic, to help compile the text of *Noa Noa,* which was drawn from Gauguin's manuscript notes. In the vast body of literature on the artist, the *Volpini Suite* has generally been discussed as a preamble to *Noa Noa,* but perhaps because the two suites of prints use different techniques, little consideration has been given to their similarities.[14] Gauguin's experience with lithography on zinc plates may have encouraged him to be more experimental in his woodcut technique, and he may have discovered innovative ways to use planographic skills while working in relief. The wide range of effects that lithography offered likely raised his expectations of the variety of effects possible with woodcut.

Just as the *Volpini Suite* was made to summarize the subject matter and exotic travels of the first decade of Gauguin's career, *Noa Noa* was conceived to convey his interest in the exoticism and symbolism that he perceived in Polynesian culture. Above all, the book was made to explain—albeit in a highly personal and oblique manner typical of the artist—the Tahitian works of art that he had brought back to Paris. Just as the *Volpini Suite* was available at the Café des Arts exhibition in which Gauguin symbolically proclaimed himself the leader of an avant-garde group of artists, the *Noa Noa* woodcuts were initially intended for an exhibition at the Durand-Ruel Gallery held in November 1893. With the woodcuts, Gauguin sought to herald his artistic development in a medium that could reach a wider audience of collectors than would his paintings. He began working on the woodcuts in September 1893, soon after Durand-Ruel had agreed to rent the artist his

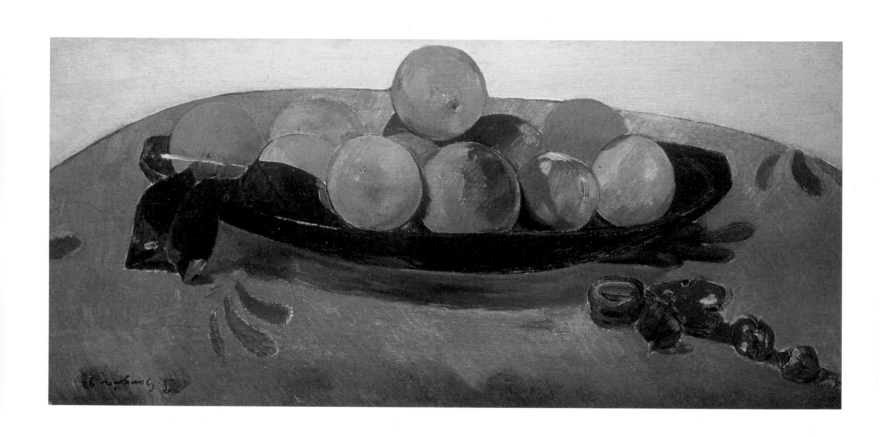

Cat. 105. Paul Gauguin, *Still Life with Fruit and Spices,* 1892, private collection, Japan

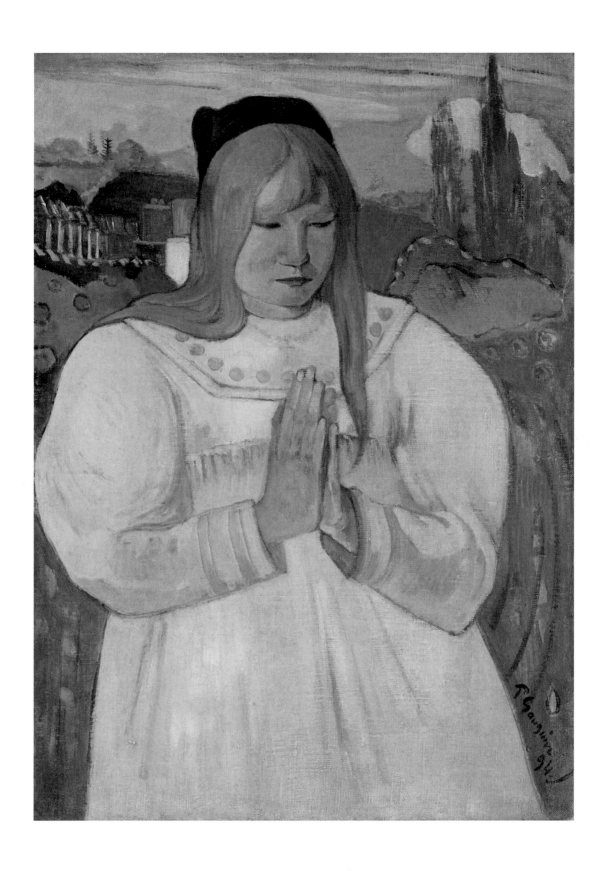

Cat. 106. Paul Gauguin, *Young Christian Girl,* 1894, Sterling and Francine Clark Art Institute, Williamstown

gallery. Gauguin wrote to Mette, "I am preparing a book on Tahiti, which will facilitate the understanding of my painting. What work! I shall soon know whether it was an act of lunacy to go to Tahiti."[15]

To Gauguin's profound frustration, the collaboration with Morice was not completed in time for the exhibition. The collaborative text was still unfinished by the time of the artist's return to Tahiti in July 1895, and, in fact, many years passed before an edition of *Noa Noa* was published with anything resembling the text that Gauguin had written.[16] In spite of the fact that his collaboration with Morice had reached an impasse, Gauguin exhibited his own impressions of the ten woodcuts without text in his Paris studio on the rue Vercingétorix in December 1894.[17]

According to eyewitnesses, Gauguin did his own printing, rubbing the blocks by hand, or using the foot of his bed as a press.[18] An examination of the surviving first-state impressions of *Noa Noa* reveals that Gauguin may have initially considered printing the woodcuts on colored paper, for six of the ten woodcuts were printed on pink paper in the first state. First-state impressions such as *Offerings of Gratitude* (*Maruru*) (cat. 107), set forth mysterious images; unevenly inked and obviously printed by hand, they are difficult to decipher, intentionally arcane. Printing indistinctly on rose paper created a vibrating effect related to the elaborate textures achieved with layers of tusche wash in the *Volpini Suite*. As Gauguin further worked the blocks and printed the second state, he used off-white paper, possibly because it was cheaper, and introduced color by adding touches of watercolor by hand or by printing in colored inks.

Reinforcing the important connections between the two print projects, three extant impressions of *Noa Noa* woodcuts were printed on yellow paper on the verso of his zincographs. Twice Gauguin printed an impression of *The Devil Speaks* (*Mahna No Varua Ino*) (cat. 108, p. 186) on the other side of a trimmed impression of *The Laundresses* from the *Volpini Suite*. He printed another woodblock—*Watched by Spirits of the Dead* (*Manao Tupapau*) on the other side of another impression of *The Laundresses*. It was this impression that Rippl-Rónai witnessed Gauguin printing: "He gave me another print too, showing a milk cow on yellow paper made during his Breton period. But on its verso there was a hardly recognizable female nude from his Tahitian period."[19] This experimental exercise may suggest that Gauguin considered using yellow paper for *Noa Noa*. Whatever his intention—whether he was prompted by artistic curiosity, seriously considered printing on yellow paper again, or simply used it because the paper was at hand—it is clear that the *Volpini Suite* had remained with Gauguin both literally and figuratively.

As in the suite of zincographs, Gauguin reformulated ideas he had explored in paintings and sculpture in *Noa Noa*. Once again, he was working in a graphic format that forced him to simplify motifs and distill compositions to essentials. Of the ten woodcuts in *Noa Noa,* six closely relate to oil paintings or sculptures that Gauguin executed in Tahiti. Similarly, most of the lithographs in the *Volpini Suite,* even if they cannot be directly linked to works in other media, at least reprise themes addressed in earlier works. Not only did the foliage, figures, and decorative elements in the prints stem from imagery in paintings, the *Noa Noa* woodcuts summarized his personal Tahitian mythology just as the *Volpini Suite* encapsulated Gauguin's Martinique, Breton, and Arlesienne themes.

At times in *Noa Noa* Gauguin reviewed motifs and compositional devices that appeared in the *Volpini Suite*. The woodcut *Women at the River* (*Auti Te Pape*) (cat. 109, p. 187) reprised the painting *By the Sea* (see fig. 58, p. 166), reinventing the theme of two bathers also addressed in

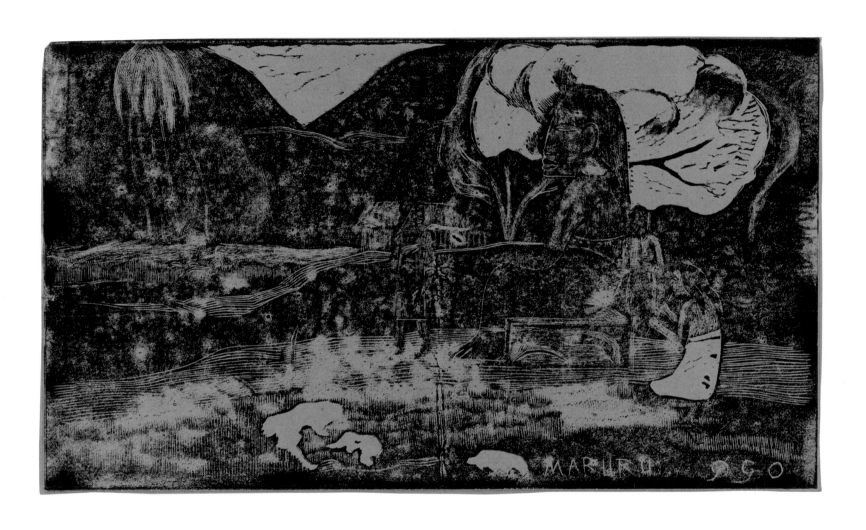

Cat. 107. Paul Gauguin, *Noa Noa: Offerings of Gratitude*, 1893–94, The Cleveland Museum of Art

Cat. 108. Paul Gauguin, *Noa Noa: The Devil Speaks* (recto) (top), *Volpini Suite: The Laundresses* (verso) (bottom),
1893–94, The Cleveland Museum of Art

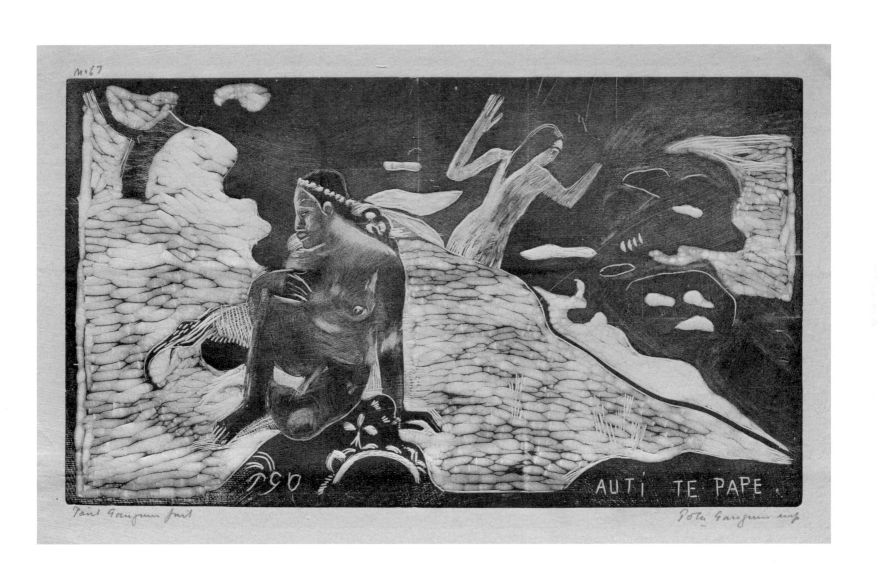

Cat. 109. Paul Gauguin, *Noa Noa: Women at the River,* 1893–94, The Cleveland Museum of Art

the zincograph *Breton Bathers*. In the woodcut, one figure sits on a riverbank while another throws herself into the sea, arms upraised, the face turned in profile. The woodcut also incorporates fragments of another composition: the seated figure is a mirror image of the foreground figure in the painting *What! Are You Jealous?* (*Aha oe feii?*), 1892 (W. 461; Pushkin State Museum of Fine Art, Moscow). Similar figures seated on a warm stretch of sand appear in the *Volpini Suite;* two such figures are poised in the foreground of *The Grasshoppers and the Ants*. The arching form of a tree is just visible in the upper left corner of *Women at the River*. Gauguin used similar curving trees, so Japanese in their stylization, in the zincograph *Human Misery*. Dissecting the imagery in *Noa Noa* and the *Volpini Suite* reveals extraordinary parallels in style, subject matter, and motif. The beginnings of his mature style—the themes, myths, symbols and abstract patterning—were all evident in 1889 in the *Volpini Suite*.

By the time Gauguin set about making *Noa Noa,* enigma had become central to his art. The artist's impressions of his woodcuts are infused with mystery, the compositions populated by non-crystallized, Symbolist forms that seem to be in the process of evolving.[20] Such deliberate ambiguity has numerous parallels with the *Volpini Suite*. For example, it is difficult to grasp the space in *Dramas of the Sea: Brittany*. Where are the boundaries of cliff, water, rock, and distant land? Uncertainty heightens the tension that the viewer experiences in perceiving the figures at the edge of a precipice; not only is it unclear what lies beyond the cliff's edge, the edge itself is indeterminate. Similarly, an amorphous black form dominates the composition of *Breton Bathers*. Does the shape refer to water, foam, seaweed, wet sand, or the famous black rocks of Le Pouldu? This swath of black ink provides a dark background for the luminous bather, but how is the viewer to interpret the form itself? This deliberate uncertainty was heightened in Gauguin's impressions of *Noa Noa*.

Echoes of the *Volpini Suite* in the *Suite Vollard*

Gauguin left Paris for the last time in 1895, arriving in Papeete, Tahiti, in early September. Prints were an important aspect of his output during his final years. Among his graphic work was a group of woodcuts that has become known as the *Suite Vollard,* named for the Paris dealer Ambroise Vollard.[21] In January 1900 Gauguin wrote to Vollard about the imminent arrival of a group of woodcuts:

Next month I shall send, by someone traveling to France, about 475 wood engravings—25 or 30 numbered prints have been made from each block, and the blocks then destroyed. Half of the blocks have been used twice, and I am the only person who can make prints that way. I shall give Daniel instructions concerning them. They should be profitable to a dealer, I think, because there are so few prints of each. I am asking 2500 francs for the lot, or else 4000 francs if sold by the piece. Half the money at once and the balance in three months.[22]

As with *Noa Noa,* Gauguin printed this suite of woodcuts himself in an edition of about thirty, all on tissue-thin Japan paper and numbered by hand.

The late group of prints can be interpreted as a third series, summarizing the artistic and intellectual preoccupations of Gauguin's second stay in Tahiti (1895–1901). As he intended with the *Volpini Suite* and *Noa Noa,* Gauguin hoped these woodcuts would simultaneously raise revenue

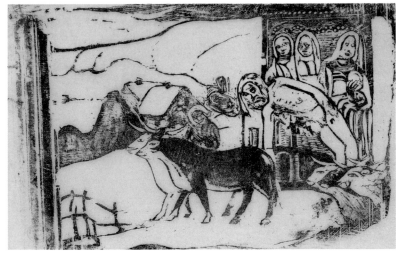

Fig. 62. Paul Gauguin, *The Ox Cart,* 1898–99, Museum of Fine Arts, Boston

Fig. 63. Paul Gauguin, *Wayside Shrine in Brittany,* 1898–99, The Metropolitan Museum of Art, New York

and perpetuate his reputation back in Paris. The woodcuts reference a diverse body of subject matter, not only quoting Tahitian paintings from Gauguin's second sojourn, but also citing French subjects from the artist's past. Specifically, three woodcuts, *Human Misery–Souvenir of Brittany* (*Misères humaines*) (cat. 110, p. 190), *The Ox Cart* (*Le Char à bœufs*) (fig. 62), and *Wayside Shrine in Brittany* (*Le Calvaire Breton*) (fig. 63), look back to Arles and Brittany.

Human Misery refers to the melancholy figure that had so preoccupied Gauguin during the period 1888–89, dominating the painting *Human Misery* (see cat. 39, p. 56), executed in Arles (but populated with Breton figures), and the zincograph of the same title from the *Volpini Suite* (see cat. 18, p. 23). A similar figure appeared in the guise of a "mourning Eve" in two drawings from 1889 both entitled *Breton Eve* (see cat. 40, p. 57, and W. 334; New Orleans Museum of Art), as well as the oil *Life and Death* (*La vie et la mort*), 1889 (W. 335; Mahmoud Khalil Museum, Cairo). In the late woodcut variation on the theme, the brooding young woman appears once again, but here she is more Polynesian than Breton or Arlesienne and is seated beneath a tree heavily laden with fruit rather than the spindly tree of the zincograph. She had migrated with Gauguin to the South Seas, perhaps a substitute for the artist himself, continuously ruminating, linking the beginning and end of his career. The two Breton woodcuts in the *Suite Vollard, Wayside Shrine in Brittany* and *The Ox Cart,* reference *Christmas Night* (*Nuit de Noël*) (W. 519; Josefowitz Collection, Lausanne) and *Village in the Snow (II)* (*Village sous la neige*) (W. 525; Musée d'Orsay, Paris), paintings that have long puzzled scholars. Neither is dated, and it is unclear whether they were produced in Pont-Aven during Gauguin's twenty-two month return to France in 1893–95 or whether they were painted from memory in Tahiti. Even if they were made in Brittany, artistic license played a significant role for Gauguin was in Pont-Aven during the summer and autumn when there was no snow.[23] Wildenstein assigned the date 1894 to the two canvases.[24] *Village in the Snow (II)* was found in Gauguin's studio in the Marquesas at the time of his death. The lack of evidence that he brought any canvases from France to the South Seas suggests that both pictures were made from memory in Tahiti. The two woodcuts are Breton souvenirs, recollections of an earlier time. The first alludes to the Breton Calvary in Nizon,[25] the second describes a general-

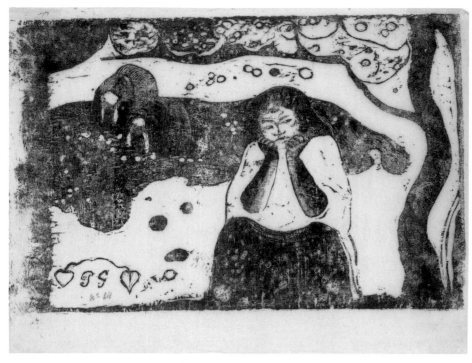

Cat. 110. Paul Gauguin, *Human Misery,* 1898–99, The Metropolitan Museum of Art, New York

ized view of a Breton village under snow. That Gauguin chose to include these two images in what would be his final suite of prints asserts the continued importance of his Breton themes.

Around the same time that he made the *Suite Vollard,* Gauguin executed an additional woodcut invoking his memories of Brittany: *At the Black Rocks* (*Aux Roches noires*) (cat. 111). This print is not generally considered a part of the *Suite Vollard* because it was not printed in an edition of thirty and very few impressions have survived. Gauguin looked back to the drawing that was reproduced in 1889 on the frontispiece of the *Catalogue de L'Exposition de Peintures du groupe Impressionniste et Synthétiste* and reprised it in a woodcut. The composition of two bathers, one seated, the other throwing herself into the waves, conflates the elements in the paintings *In the Waves* and *Life and Death.* Why would Gauguin, in 1898–99, return to this theme of the bather that had virtually obsessed him ten years earlier? The purpose of the print remains, like so many of Gauguin's intentions, unclear. Surviving impressions show that he reworked the block twice after the first proofs were pulled, suggesting a sustained effort. He pasted one impression of the print into the manuscript of *Noa Noa,* asserting his association of the image with his Tahitian period. Like the melancholy thinker in *Human Misery,* the bather remained with Gauguin until the end of his life, a Breton muse or Ondine who continued to haunt the seas of his imagination.

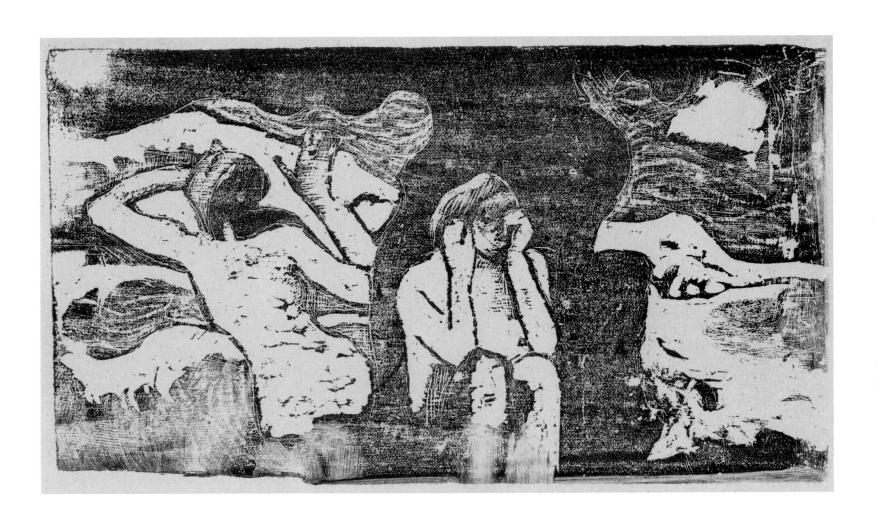

Cat. 111. Paul Gauguin, *At the Black Rocks,* 1898–99, National Gallery of Art, Washington

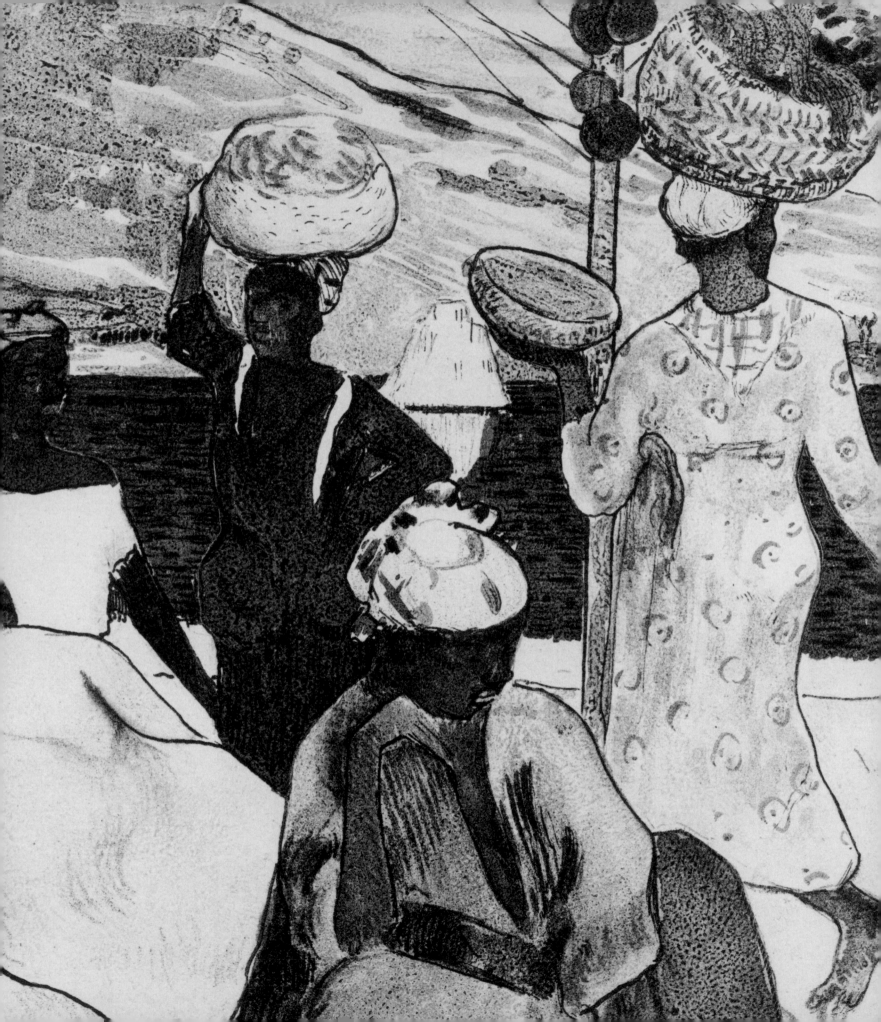

Chronology: Gauguin's Circle and the Exhibition's Reception

Belinda Thomson

This compilation of extracts from the key letters and reviews relating specifically to the Volpini exhibition also includes movements of the main participants in 1889 and key political and Exposition Universelle events. New datings are suggested for several Gauguin letters, reflecting the current state of knowledge. Texts from some letters and reviews appear here in English for the first time.

25 December 1888. Paul Gauguin returns to Paris from Arles, where he had spent the previous two months with Vincent van Gogh. Lodges at first with Émile Schuffenecker, 29 rue Boulard in the 14th arrondissement. By 20 January, Gauguin is renting a studio nearby at 25 Avenue de Montsouris, where he also sleeps. Sends work to be exhibited in Brussels with Les XX. Works on the prints that became the *Volpini Suite*.

17 January 1889. Gauguin to Vincent van Gogh:[1]

> Now that I have a studio in which I sleep, I'm going to put myself to work. I've begun a series of lithographs in order to get myself known. Moreover, it's on your brother's advice and under his auspices.

Gauguin plans display of recent works to be shown the following month in Brussels at the annual exhibition of Les XX:

> I don't know for example if my feeble voice will be heard, in any case the <u>common good</u> is of great concern to me and I shall try to do the right thing.

27 January. Election of General Boulanger, former minister of war, to the Chamber of Deputies provokes severe political instability and fears for the forthcoming Exposition Universelle.

5 February. In *Le Figaro,* Octave Mirbeau predicts that Boulanger will attempt a coup d'état.

c. 25 February. The Van Gogh brothers note that Gauguin has finished work on the *Volpini Suite*. Vincent to Theo van Gogh:[2]

> It gives me great pleasure that Gauguin has finished some lithographs.

31 March. Gustave Eiffel raises the French tricolor at the top of his newly completed tower, which becomes the tallest building in the world (300 m), surpassing the Washington Monument (169 m), completed four years earlier.

1 April. Alarmed by mounting opposition, Boulanger flees to Brussels.

Early April. Gauguin abandons plan for a trip to Copenhagen to visit his familiy, discouraged by caveats of his wife, Mette: he also must be in Paris on 20 April for the firing of a statue.

1 May. Opening of the annual Salon in the Palais de l'Industrie.

6 May. Official inauguration of the Exposition Universelle by President Carnot. Opening ceremony at the Champ de Mars under the Dôme Centrale. The Galerie des Machines (115 × 420 m, 48,300 sq. m) becomes the largest building in the world. The Centennale and Décennale fine art exhibitions in the Palais des Beaux-Arts are not fully installed until later in the month.

c. 13 May. Gauguin to Bernard undated, Paris:[3]

> I don't understand at all, I looked for you in vain at the Exposition—I went to see Buffalo.[4] You absolutely must come to see it. It's of great interest.
> So come for lunch at Schuff's on Wednesday and we'll go in the afternoon.
> If not, let me know.

c. 21 May. Gauguin to Bernard, undated, Paris:[5]

> You made a mistake in not coming the other day. There are Hindu dances in the Java village. All the art of India's there, and the photographs that I have of Cambodia are there, like for like. I'm going again on Thursday because I'm due to meet a mulatto woman. So come on Thursday, but I can't be there too late, so either come for lunch at midday, or at one (at Schuff's). We'll go to Buffalo on Saturday.
> I plan to leave next Tuesday[6] and I have to think about packing up.
> On Saturday, we'll have to be over at Les Ternes at three, otherwise there's no way of getting a place.
> Act accordingly.

c. 28 May. Gauguin leaves Paris for Brittany on his third visit to Pont-Aven, where he joins Charles Laval. Gauguin is based there throughout the summer, staying principally at the Pension Gloanec with side trips to Le Pouldu. In Pont-Aven he works at a studio at Les Avins.

c. 1 June. Gauguin to Schuffenecker, Pont-Aven:[7]

> Bravo! You succeeded. See Van Gogh and arrange the whole thing. But don't forget it's not an exhibition for <u>the others</u>. So let's make it for a small group of pals, and from that point of view I wish to be <u>represented</u> in it as much as possible.
> So act in my best interests, depending on how much space there is.
> 1. The mangoes, Martinique.
> 2. The big Breton [painting?] with the little blue boy (no. 30 canvas).
> 3. The Breton women (1 standing, 1 lying on the ground).

Mon cher Vincent

Ne vous occupez pas des études
que j'ai laissées exprès à Arles
comme ne valant pas la peine
du transport, Par contre les
albums à dessin contiennent des
notes qui me sont utiles et
j'accepte l'offre que vous me
faits de les envoyer. Ainsi que
les 2 masques et gants –
(Chez M^r Schuffenecker
29 Rue Boulard

L'adresse de Milliet est
Sous lieutenant 3^{em} Zouaves
Guelma – Place de Constantine
Algérie

voor emile bernard
Zie brief milliet

Je regrette de l'avoir emportée
par mégarde toutes mes
excuses –) Depuis que je suis
arrivé à Paris j'ai vu Bernard
2 fois . Il a beaucoup de chances
de ne pas être soldat à cause
de son étroitesse de poitrine et
ne connaîtra son sort que fin
février – Il paraît que son
père l'embête de plus en plus
pour la peinture et pour la
malheureuse lettre que j'ai écrite
à sa famille –
Non je n'ai pas encore fait de
portraits ayant passé mon temps
en courses . Maintenant que
j'ai un atelier dans lequel je
couche je vais me mettre au
travail – J'ai commencé une

Cat. 112. Letter from Paul Gauguin to Vincent van Gogh, c. January 20, 1889, Van Gogh Museum, Amsterdam

4. Winter (a small Breton man adjusting his clog, with a village in the background).

5. The presbytery (landscape from 1886).

6. The little girls' dance.

7. The Arles landscape that you have, with bushes?.

8. The Arles farmhouses at Van Gogh's.

9. The ceramic pastel.

10. The two boys wrestling.

Remember it's we who are doing the inviting, therefore:—

Schuffenecker	10 canvases	
Guillaumin	10 canvases	40 canvases
Gauguin	10 canvases	
Bernard	10 canvases	

Roy	2 canvases	
Man from Nancy[8]	2 canvases	10 canvases
Vincent	6 canvases	
		50

That makes enough. I refuse to exhibit with the <u>others</u>, Pissarro, Seurat, etc.

It's our group!

I didn't wish to show a lot, but Laval tells me it's my turn and I would be wrong to work for the others.

Kind regards to your wife, and kiss the children.

Yours, P. Go.

Possibly 4 June. Bernard to Albert Aurier, undated.[9] The notice Bernard urges Aurier to publish here was not published in *Le Moderniste* until 27 June (issue no. 10) but was presumably inserted elsewhere (see Vincent van Gogh's letter below):

As the result of all kinds of efforts we are entering the Exposition Universelle at last. We have a place, it is a café, the best place in the world to see paintings which one should examine at leisure and discuss. This café must be made known, people should learn where it is and what it contains. I appeal to your friendship and especially to your ideas on art, so that you may assist us as much as possible, that is to publish in all the periodicals you know . . . an announcement as follows:

To be seen at the Café des Arts (Fine Arts Pavilion, opposite the Pavilion of the Press) an exhibition of a new group of impressionists. The hall was made available through the enlightenment of Monsieur Volpini, the artistic director of the Grand Café. The exhibitors are: Paul Gauguin, Emile Bernard, Emile Schuffenecker, Charles Laval, Louis Anquetin, Vincent [*sic*] Roy. (We shall publish a detailed review of this exhibition).[10]

9 June. Vincent to Theo van Gogh, saying that he has seen an announcement of the opening of the Volpini show:[11]

> I've seen an advertisement for a forthcoming exhibition of Impressionists called Gauguin, Bernard, Anquetin and other names Am therefore inclined to believe that another new sect has been formed, no less infallible than the others that already exist. Was this the exhibition you were talking to me about? What storms in teacups.

10 June. Volpini show opening

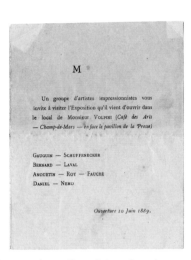

Cat. 113. *Invitation* (to the Volpini exhibition), 1889, Musée Départemental Maurice Denis "Le Prieuré," Saint-Germain-en-Laye

10 June. Octave Mirbeau publishes in *Le Figaro* his "Impressions d'un visiteur" to the Exposition Universelle; the article ends by suggesting space should have been found in the exhibition for two contemporary innovators, Georges Seurat and Paul Gauguin.[12]

10 June. Gauguin to Schuffenecker:[13]

> My dear Schuff
> In all your enthusiasm I recognize my Schuffenecker. Go gently and you won't risk falling—I'm waiting for the final result before getting carried away—Although I see no harm in it and I see good—
> —One thing, though—My paintings must <u>not</u> be sold for less than Goupil [Boussod et Valadon] asks, otherwise I'll be in trouble.
> From 300f to 800 depending on the size of the canvas.
> As soon as you've got through all that, go to Delaherche's to see the crate that's been made. Send me the pot that represents my head; take the owl for yourself and wait as far as the rest's concerned.
> When the statue's been fired let me know.
> Pont-Aven is very beautiful you know and very convenient for working. We're an <u>impressionist</u> family. I'm up to my neck in drawing.
> I've started a Jesus[14] in the Garden of Olives which will be good, I think. Laval and the Dutchman De Hann [*sic*][15] are quite excited about it. It's sad in an abstract way and you know sadness is my key.

All for now.

Good wishes to the family.

Sincerely Paul Gauguin

c. 10 June. Gauguin to Theo van Gogh, Pont-Aven:[16]

Dear Monsieur Van Gogh

Schuff writes that you are sorry to see my exhibition. And I'm amazed at that, you would have been pleased yourself to see an exhibition of the whole group. I tried last year. Nobody wanted etc . . . with all the usual disagreement. Claude Monet is exhibiting at Petit's with some foreigners; at the Centennale this year. Guillaumin has exhibited at the Revue Indépendante, a little hole without merit. He's going to exhibit at the Indépendants, that's to say with 200 nonentities. And this year I've organized this little exhibition at the Universelle to show what needed to be done en masse and to demonstrate what was possible. That's the thing in general. As for the particular what harm can it do me? None, seeing that I'm unknown and nobody shows me to the public — If my paintings are bad that won't change anything and if they're good, as is probably the case, I'll make a name for myself. I'm in as good company as those gentlemen are at Petit's, I mean beside Baudry and the like.

Then there's the question of the premises!!

It seems childish to me and I don't believe (knowing your ideas) you'd have anything to complain about on that score.

Our well-known impressionist friends may for now believe that nothing should be said about the rest of us and it is not in their interest that I, Bernard and others should try to exhibit. My interest is therefore quite different and I am sorry that Guillaumin didn't take part seeing that he's always asking to get known and he's missed an honorable opportunity of doing so. Well that's his business.

I was determined to give you my reasons frankly. There they are.

I've begun a series of drawings here that I believe are interesting. Greetings to Madame.

A warm handshake

P Gauguin

16 June. Theo to Vincent van Gogh:[17]

As you know, there's an exhibition in a café at the exposition, in which Goguin [*sic*] & some others (Schuffenecker) are exhibiting. I said at first that you would be exhibiting there too, but they looked like such rowdies it began to be really bad to be part of it. Meanwhile, Schuff. is claiming that this event will beat all the other painters hollow, and if we had let him, I believe he would have walked across Paris carrying flags of every colour to show he was the great winner. It looked a bit like going to the Exposition Universelle by the back stairs. As usual, there were exclusions. Because Lautrec had exhibited with a circle he shouldn't be included, etc.

c. 18 June. Vincent to Theo van Gogh:[18]

I think you have done well not to show my paintings in the exhibition of Gauguin and the others. That I'm not yet well is a good enough reason for my not doing so without offending them. There's no doubt in my mind that Gauguin and Bernard have great and genuine merit. But that in the case of people like them, alive and young and who *must* live and try to make their way, it should be impossible to turn all their canvases to the wall until it pleased people to admit them into something pickled in officialdom nevertheless seems quite understandable. By exhibiting in cafés we make a noise, which is, I don't say it isn't, in bad taste to do. But I have that crime on my conscience – twice, in fact, having exhibited at the Tambourin and on the avenue de Clichy. . . . So in every case I am worse and more blameworthy than they in that respect (making noise, but quite unintentionally, believe me). – Young Bernard – in my eyes – has already painted some astonishing canvases, in which he has a sweetness and something essentially French and innocent, of rare quality. And neither he nor Gauguin are artists who could look as if they were trying to get into the Exp. univers. by the back stairs.[19] Be assured of that. That they *were unable to keep quiet* is understandable.

That the Impressionist movement did not exhibit as a group is what shows they're less good at fighting their battles than other artists such as Delacroix and Courbet.

June. Gauguin to Schuffenecker, undated, postmarked "juin Quimperlé":[20]

Included herewith drawing done in haste to send off at once. For things like that it would be better to get down to them in advance because you're not always in the right frame of mind and you draw badly when it comes from a commission. Well, then![21] It seems to me that you're making a big to-do for this exhibition; I would have preferred it to be done without a lot of noise. There will be plenty of people anyway over six months. I've asked Bernard a lot of things, he doesn't reply to any of them.[22] It's true you're all very busy. I've written to [Theo] Van Gog [*sic*] who hasn't replied at all. I'll be in a real pickle if he should drop me because of this exhibition. I'm waiting for the pot to arrive from you.

I'm working flat out at the moment. I think I've just done my best thing. A Christ in the Garden of Olives—I still haven't had the copies of Le Fifre.[23]

All for now and give me all the news about the effect of our . . . [exhibition?].

June. Gauguin sends Aurier his first article, "Notes sur l'art à l'Exposition universelle," which appears in two parts in *Le Moderniste* (no. 11, 4 July, and no. 12, 13 July).

June or July. Gauguin in Pont-Aven to Bernard in Paris:[24]

My dear Bernard,

Don't worry: if people have doubts out of self-interest or jealousy, they're not directed at you. And in my recriminations I was referring to Schuff, to whom I had written a letter about that. I should have realized your letter had crossed with that one. . . . You must understand that with all the disappointments I have had at every exhibition, I have some right and duty to take precau-

tions. And my expectations were based to some extent on G[uillaumin]'s behavior. You can see for yourself that he's caving in, surely because of my decision to show with several others. So exhibit all you like, and I'm sure you'll have done what's best.

In all these matters I look as if I'm getting carried away because I go, in telegraphic style, straight to what's most urgent, but fundamentally I know what I'm doing. . . . I have all the old impressionists against me and from this year I've been keeping an eye on G[uillaumin] I know what to expect from that quarter.

So the incident's closed, with no hard feelings, and let's get down to work, making art and struggling nobly.

You know that I very much like both your intentions in art and their results, so I wish you success. I shout from the rooftops: "Pay attention to young Bernard, he's somebody."

Here at Pont-Aven there are lots of changes at the post office. We don't see any more of Chamaillard, he's been hog-tied by the women, who have told him not to trust me.

[Paul] Sérusier's just arrived and talks about nothing but his development. He intends to stand up to Lefebvre and wins the approval of everyone around him—so he tells me.—I've seen nothing of what he. . . ." [the end of the letter is missing]

1 July. Gauguin writes again to Theo van Gogh, defending what he now calls "our" exhibition.[25]

July. On seeing the Volpini exhibition, Paul Sérusier declares his renewed faith in Gauguin and goes to join him in Pont-Aven. Initially Sérusier is disappointed, feeling Gauguin is not, after all, the artist of his dreams. Sérusier in Pont-Aven to Maurice Denis:[26]

> I have seen . . . in his works, a lack of subtlety, an illogical affectation in the drawing that's puerile, a search for originality that reaches the point of fraudulence.

Sérusier resumes his letter three days later from Le Pouldu:

> I arrived yesterday at these magnificent beaches, where I'm going to stay for a fortnight, alone with Gauguin, with no distractions, no cares and no apéritifs.

Mid-July–late August. Gauguin stays at the Auberge Destais, Le Pouldu, at first alone with Sérusier. Jacob Meyer de Haan joins them having visited Paris in early July to view the Exposition Universelle and the Volpini exhibition.

While in Le Pouldu, Gauguin starts writing a second article for *Le Moderniste* concerning the

purchase of paintings for the Louvre and attacking today's art critics.[27]

11 August. Sérusier leaves Le Pouldu to join his parents in Villerville.

Over the summer Schuffenecker abandons the idea of returning to Port Manech on the coast near Pont-Aven and remains in Paris. Bernard tells Laval he has been forbidden by his father to visit Pont-Aven and rejoin Gauguin. He spends August and September in Saint-Briac instead.

c. 22 August. Vincent van Gogh thanks Theo for sending him the catalogue of the Volpini exhibition, which he finds interesting. Gauguin to Theo van Gogh:[28]

> I shall send a new article to Le Moderniste shortly. I believe this one will interest you as well.

August. Bernard writes to Gauguin from Saint-Briac, beginning by expressing his regret that he is not in Pont-Aven, even in the company of the irksome foreigners of whom Gauguin complains, but instead isolated and depressed in Saint-Briac.[29] Moreover he is beset by crippling doubts as far as his talent and painting go, derailed by the visual overload of the Exposition Universelle:

> To tell you all I'm thinking, all these recent exhibitions, Corot, Delacroix, Daumier, Manet, Puvis, Od. Redon, Cézanne, the French primitives recently shown at the Louvre and seen before I left. Cluny—the Ethnographic, the retrospective of French primitive art, I'm exhausted by all these visions of this book read [hastily?] in two months. . . . I've become extremely worried not about my existence but about that of my possible talent, and the present state of affairs seems more apt to make me positively doubt it than to reassure me on that matter. All the artists, except for you, have rejected me, some out of spite, others perhaps after thought, and I suffer greatly as a result, not because I feel a need for admiration, but because if those people in whom I see talent reject me it's because I have none. In short, some clumsy efforts were perhaps the reason for your confidence in me and now all that has probably disappeared.

August. Gauguin writes a sympathetic and encouraging reply to Bernard.[30] Offering his own somewhat different reasons for admiring the masters of the past Bernard cited (Corot and Giotto), Gauguin advises him to take a break from looking at art. His writes confident descriptions of his own recent work, including his work in progress, a modeled version of *Be in Love and You Will Be Happy* that he plans ultimately to carve in wood.

August. Bernard writes to Aurier, accompanying a new article he has written about Vincent van Gogh's work for possible inclusion in *Le Moderniste*. He requests a copy of *La Pléiade*.[31] Bernard also writes to Schuffenecker complaining about their lack of sales and reviews and explaining that before leaving Paris he deposited some remaining (Volpini) catalogues with the color merchant Tanguy.[32]

Gauguin returns to the Pension Gloanec in Pont-Aven where he has credit.

3 September–4 October. Salon des Indépendants held in the premises of the Société de l'Horticulture, 84 rue de Grenelle. Exhibitors include Seurat, Signac, Toulouse-Lautrec, Anquetin.

Gauguin sends repeated requests for a copy of *Le Moderniste* to Bernard, Schuffenecker and Aurier.

21 September. Gauguin's second article, "Qui trompe-t-on ici?" is published in *Le Moderniste* (no. 22).

September. Gauguin in Pont-Aven to Aurier:[33]

> Dear Sir,
> I had asked Bernard to send me the issue of the Pléiade containing your Salon and Le Moderniste,[34] relating to my contribution. It would be kind of you to send it. Some postage stamps enclosed to cover the approximate cost.
> Warmly

September. Gauguin to Schuffenecker:[35]

> My dear Chuff,
> It's a long time since I heard from you. On the other hand I received the pot that you sent and which has turned out very well. I saw Mother Reynier, who gave me your news. It seems you have made sales. Well done and you must be pleased. I know very well you're a pessimist, but after all, everything comes to him who waits. . . .
> And this exhibition! Are people looking at it? Guillaumin wrote saying nobody was paying it any attention. His whole letter is full of a silly sourness; his intelligence is definitely on the way out. In the end I don't give a damn.
> Write me at length everything people are saying and everything they're doing.
> Very little news from here apart from the fact that I'm working.
> The battle at Pont-Aven is over, everyone's been brought to heel and the Julian studio's beginning to change tack and mock the École. Manet's triumph at the [Centennale] is crushing them.

September. Gauguin grudgingly accepts and then fends off an offer from the writer Félicien Champsaur, a friend of Schuffenecker's, to purchase *Breton Girls Dancing, Pont-Aven* from the Volpini show for a low price (200 francs) in partial exchange for writing a laudatory article. Gauguin is embarrassed by these transactions in his dealings with Theo. The latter's client Montandon comes up with a better offer (500 francs) for the picture, which is accepted on 16 September.[36]

19–20 October. Gauguin to Schuffenecker:[37]

It seems you're not speaking to me . . . because I turned Champsor [*sic*] down. First of all, his painting was sold to Montandon for 500 and I couldn't sell it twice over. Besides, he's a common scribbler who isn't worth the rope to hang him with. Two. Besides, articles do nothing. You believe in them, I don't.

Early October. Bernard returns to Paris.[38] Gauguin moves again to the Auberge de la Plage, Marie Henry's inn in Le Pouldu, registering there on 2 October with Sérusier. They are joined by Meyer de Haan on 14 October. Sérusier leaves on 17 October.[39] Gauguin and de Haan remain in Le Pouldu for the winter. Laval returns to Paris from Brittany where, according to Gauguin, he [Laval] had not picked up his brush for the previous six months.[40] In Saint-Rémy, Vincent van Gogh, who had been under the impression that Bernard and Gauguin had spent the summer together in Pont-Aven, learns that they have been apart. Bernard sends photographs of his recent religious works to Gauguin and Vincent van Gogh. In November he receives some guarded praise from Gauguin and a highly critical letter from Van Gogh seeking to steer him back to the way he was working the previous year.[41]

6 November: The Exposition Universelle closes after 185 days. Total number of paying visitors 25,398,506; of them 1,953,122 have made the ascent of the Eiffel Tower. Average number of visitors per day 150,000.[42]

After the Exposition: Reflections on the Volpini Show

Late November 1889. Gauguin to Bernard:[43]

Our exhibition, you and I, has stirred up a few storms. I mentioned it to Van Gogh explaining to him what we both wanted, why we were working, etc. . . .

c. 16 December. Gauguin in Le Pouldu to his wife, Mette:[44]

What I can say, is that I am one of the artists who astonish people the most today. Herewith a few lines giving you information about me. . . .
At the Exposition Universelle this year I held an exhibition at a café-chantant; perhaps some Danes will have seen it and mentioned it to you. In any case almost all the Norwegians see the things I'm doing at Goupil's and Philipsen, whom I met in Paris, has also seen them.

31 January 1891. Gauguin to Schuffenecker, discussing Bernard's idea to establish a Société des Anonymes, an idea Schuffenecker thinks "sublime":[45]

Bernard has already had this Sublime idea by introducing *Nemo* into the Volpini exhibition (without asking my advice) and wanting to do an enormous publicity article promoting it; Fauchet [*sic*] was against it. As you know.

But I would never <u>have dared</u> have this Sublime idea for fear of being treated like an ambitious fraud. And <u>I dare to say, to prove that if</u> anybody has worked on an "Art for Art's sake basis" without any concern for money, sacrificing family and well-being, then it's me—and with never any weakness or <u>concessions</u>.

14 February 1896. Gauguin to Georges-Daniel de Monfreid, talking of Schuffenecker:[46]

That imbecile only dreams of exhibitions, publicity etc. . . . and cannot see what a disastrous effect they have. I have a lot of enemies and am destined always to have, indeed more and more; now every time I have an exhibition it stirs them up and sets them off barking which has an exhausting, off-putting effect on the collector.[47]

April 1900. Gauguin to de Monfreid.[48] Eleven years after the Volpini show, Gauguin wants to learn from the experience of 1889 to manage things better.

If Vollard puts on an exhibition at the same time as the Exposition Universelle, I should like it to be done with great good judgement. That's to say, some good older canvases should be exhibited with some recent ones. Among others the Ia Orana Maria from Manzi's, one or two canvases from Degas'; the large canvas "Où allons-nous." No matter if that's been seen already, because at the moment it's the whole Foreign crowd who're there and who don't know my works.[49]

<div align="center">

Critical Reviews, 1889

</div>

18/25 May. Jaques Le Long/Aurier, review of the Salon, *Le Moderniste* (no. 7, pp. 53–54, and no. 8, p. 63).

Arguably the most significant, albeit tangential, reference to the Volpini show in a mainstream publication is Pierre-Georges Jeanniot's illustration in the *Revue de l'Exposition Universelle de 1889* (2: 225), captioned "La Princesse Dolgourouki et son orchestre." It accompanies an article by Maurice Montégut reviewing the eclectic and colorful range of music to be heard at the Exposition, "La Musique dans les cafés."[50]

Princess Dolgourouki, who is shrouded in a mysterious legend concerning a Cossack love affair, has set up her orchestra at Volpini's, opposite the Press Pavilion; she has for associates three young women, two of whom are pretty.

27 June. Aurier, "Concurrence" (short review of Volpini show), *Le Moderniste* (no. 10, p. 74).

I am happy to learn that individual initiative has attempted what eternally incurable bureaucratic idiocy would never have agreed to do. A small group of independent artists have succeeded in breaking down the doors, not of the Palais des Beaux-Arts, but of the Exposition, and of creating

a minute amount of competition with the official exhibition. Ah, yes, the installation is a little primitive, very strange, and as people will doubtless say, *bohemian!* . . . But what do you expect? If these fine fellows had had a Palais at their disposal, they would certainly not have hung their canvases on the walls of a café.

Whatever the case, this little Exhibition, which I was eager to see, struck me as very curious. I believe I noticed in the majority of the works, and more particularly in those of P. Gauguin, Emile Bernard, Anquetin, etc., a marked tendency toward synthetism in drawing, composition and color, as well as a search for simplification in technique, which seemed to me very interesting in these times of skill and extremes of effect.

Le Moderniste will, by the way, publish a special, longer article on this courageous endeavor.[51]

4 and 13 July. Gauguin, "Notes sur l'art à l'Exposition Universelle," *Le Moderniste* (no. 11, p. 84, and no. 12, p. 90).[52]

6 July. Félix Fénéon, "Autre groupe impressionniste" (review of Volpini show), *La Cravache:*

> Their mysterious, aggressive, crude quality isolated the works of M. Paul Gauguin, painter and sculptor, from their surroundings at the impressionist exhibitions of 1880, 1881, 1882 and 1886; many technical details, and the fact that he carved his bas-reliefs in wood and colored them, showed a distinct tendency toward archaism; the shape of his earthenware vases revealed a taste for the exotic, all characteristics that reach saturation point in his recent canvases.
>
> Around 1886, the methods of the *tachistes,* so suitable for representing fleeting visions, were abandoned by several painters seeking an art of synthesis and premeditation. While M. Seurat, M. Signac, M. Pissarro and M. Dubois-Pillet realized their conception of such an art in paintings in which distinct episodes disappear in a broad orchestration that obeys the laws of optics, and in which the creator's personality remains latent, as does that of someone like Flaubert in his books, M. Paul Gauguin aimed at a similar goal, but by using different means. For him reality was no more than a pretext for exotic creations; he reorganizes the materials with which it provides him, scorns trompe l'oeil, even atmospheric trompe l'oeil, shows his lines, restricts their number, gives them a hieratic quality; and in each of the spacious sections formed by the way in which they interlace, rich, heavy color stands out in a gloomy way, showing no regard for adjacent colors and not harmonious in itself.
>
> It is not unlikely that the style of M. Anquetin, with its unbroken outlines and intense, flat tones, has had some influence on M. Paul Gauguin: an influence that is purely formal, because not the slightest feeling appears to animate these academic, decorative works.
>
> M. Emile Bernard is exhibiting landscapes and scenes of Brittany; M. Charles Laval, scenes and landscapes of Brittany and Martinique: places to which M. Gauguin is attached. Both of them will free themselves from the stamp of that painter, whose work is too arbitrary, or at least springs from too special a state of mind for newcomers to be able usefully to make it their starting point.
>
> The broad lines in which M. Bernard encloses the accidental details of landscape and living things are the lead interstices of a stained-glass window. With their very simple attitudes, his

figures would sometimes seem to recall traditional poses if it were not that some wild gesture immediately disconcerted the memory.

One of M. Laval's main submissions could be described as follows: in the distance a number of women are bathing and frolicking among whirls of green-black water; others are standing still, in the foreground. M. Laval has been careful to make them look ugly; he has even given them the skin of corpses; they resemble the women in M. de Chavannes's *L'Automne* and *Au bord de la mer*, but unhinged by sinister, farcical misfortunes, there they are on this inhospitable shore. . . . Messrs Anquetin, Bernard, Georges Daniel, Fauché, Gauguin, Laval, Nemo, Louis Roy and Schuffenecker, brought together for the first time under the label "impressionist and synthetist group," have tattooed the walls of the Café des Arts, on the Champ de Mars (Exposition Universelle) with some hundred items. They have produced a hand-written catalogue with prices marked, which you will find at the desk. It is impossible to get near these canvases because of the sideboards, beer pumps, tables, M. Volpini's cashier's bosom and an orchestra of young Muscovites whose bows unleash in the vast hall a music that bears no relationship with these polyphonic works.

20 July. Publication of the *Catalogue de L'Exposition de Peintres du Groupe Impressionniste et Synthétiste* announced in *Le Moderniste* (no. 13, p. 102).

27 July. Bernard, "Au Palais des Beaux-Arts" (part one of a review of the Centennale), *Le Moderniste* (no. 14, p. 108). Among the artists he singles out for praise are Corot, Delacroix, Daumier, Manet, and Puvis de Chavannes. He complains that the true Impressionists are poorly represented, whereas their imitators, such as Albert Besnard, are prominent.

3 August. Lithographed sketches by Gauguin and Bernard from the Volpini show catalogue included in *Le Moderniste* (no. 15).

10 August. Lithographed sketches by Nemo, Gauguin (*At the Black Rocks*), and Fauché included in *Le Moderniste* (no. 16).

17 August. Lithographed sketches by Roy and Schuffenecker included in *Le Moderniste* (no. 17).

24 August. Lithographed sketch by Georges-Daniel de Monfreid included in *Le Moderniste* (no. 18).

August. Gustave Kahn, "Chronicle: French Art at the Exposition," *La Vogue* (2, no. 2, pp. 133, 136):[53]

> Manet, who triumphs, now that he is dead, occupies a panel and wins admiration from those who accept only a diluted dose of impressionism. . . . At the center of the panel the portrait of M. Antonin Proust is a beaming presence; it is not one of the best Manets, nor even one of Manet's best portraits. . . .

Not a trace of M. Renoir, not a trace of M. Guillaumin. M. Gauguin is exhibiting in a café, in the worst possible conditions, his interesting, but somewhat raucous and over-emphatic work; around him are paintings of no other interest, with patches of extravagant color, full of unnecessary relief and in no way attractive.

They did not see fit, either, to invite Messrs. Seurat or Signac, in other words, the whole neoimpressionnist group.

August. Adolphe Retté, "Bars et Brasseries à l'Exposition," *La Vogue* (pp. 155–56):

There, next to a brasserie full of lady musicians got up as Hungarian hussars, a café that is utterly out of place in the very *comme il faut* setting of the Exposition.

I confess I am forced to visit this café, where M. Gauguin's paintings play upon the walls some exotic scale that is not without its crepuscular charm: a slender palm tree rises against a horizon of calm water and soft foliage;[54] kelp gatherers hurtle down a pebbly slope, in bright sunshine; cliffs shimmer, waves dazzle; in the deepening blues of invading darkness, negresses squat; there are other, less praiseworthy canvases.

7 September. Osado [pseudonym], untitled article, *De Opmerker:*[55]

After quaffing such draughts of mental delight I began to feel the need for a little physical refreshment. I therefore descended the main staircase of the Palace of Fine Arts, high above which arched the dome, and, having cast a brief glance at the array of sculptures, I entered a spacious hall built against the palace, which beckoned me with the enticing notice: *Café des Arts*. There, Art was celebrated in two fashions. The Muse of Music was fêted by three ladies and four gentlemen who, mounted upon a small platform, executed a selection of pieces taken from dances and operas. The Muse of Painting was commemorated by the most independent of *artistes indépendants,* who had displayed upon the wall a not inconsiderable quantity of their products. Such work is now regarded here as the art of the future; the paintings show people with blue faces, green suns, purple trees, in brief, almost every object that is represented has a different color from the one that mankind has until now been accustomed to see. The brushwork is bold and forthright. I am curious to know whether such work will in time replace the art of the Millets and the Corots.

21 September. Gauguin, "Qui trompe-t-on ici?" *Le Moderniste* (no. 22).[56] He discusses the recent Secrétan sale where an attempt to buy Millet's *Angelus* for the French State failed; instead the painting went for a record sum to the American Art Association.

September. Aurier, "La Peinture à l'Exposition," *La Pléiade* (pp. 102–4). Recently celebrated Salon artists such as Bouguereau, Meissonier, etc. come off worst, he maintains:

This impersonal correctness, this glacial, photographic exactitude, these clever schoolboy formulas, are what we very nearly took for drawing, composition, science! . . . And this dullness, this

lack of substance, this utter absence of deep feeling, this want of ideas, this tremendous banality that we once barely suspected, now appear to us with depressing obviousness.

Aurier praises the art that has stood the test of time, citing Delacroix, Courbet, Manet, Millet, Corot, Daumier, Troyon, Rousseau; among contemporaries, he praises Henner, Gustave Moreau and above all Puvis de Chavannes. He allows some merit to Besnard, Carrière, Dagnan-Bouveret, Bastien-Lepage, Hébert, Cazin, and Roll. But he deplores the paltry representation of contemporary art:

> A handful of Raffaëllis, two Pissaros in the old style and a single Claude Monet, lost in the galleries of the Palais des Beaux-Arts! No Degas, no Gauguin, no Seurat, no Renoir, no Guillaumin![57]

The foreign sections are a severe disappointment. Instead of discovering new art among these ethnographically diverse artists he finds only imitations of the French national school.

> However great my patriotism, that only half satisfies me!

9 November. Jules Antoine, "Impressionnistes et synthétistes," *Art et Critique* (no. 24, pp. 369–71):[58]

> It is so easy to crush the young with the past, and this means has been used so often to block the way to artists today recognized as masters that I avoid letting myself be influenced by the often modest, sometimes ridiculous appearances that the small exhibitions manifest. So, not wishing to emulate the great critics who ignore, or pretend to ignore, any effort that does not emanate from a certain quarter, I have tried to see, as well as the necessarily defective installation permitted me to, the hundred or so works that Messieurs Gauguin, Schuffenecker, Roy, Fauché, Laval, Daniel, Anquetin, Bernard, and Hemo [*sic*] have shown in a restaurant on the Champ de Mars. As its title indicates, this exhibition was put on by artists from two schools, or attempts at schools, because, as far as the synthetists are concerned, I see scarcely more than Messrs. Anquetin, Bernard and Hemo [*sic*] who are going in this direction, and quite frequently they manage to forget themselves and simply paint.
> I confess I have not yet understood what aesthetic they follow.
> Until now I believed that a work of art was necessarily a synthesis, because, in order to execute it, the artist had been obliged to combine various elements, to play up some feature and remove another, until he felt he had achieved his purpose. . . .
> M. Anquetin, who strikes me as the most synthetist of the exhibitors . . . has made, for example, a work that he describes as: *Boat–Setting [sun]*. There's ambiguity in the very title. Of what is he trying to give us a synthesis? Is it of the Boat or is it of the Setting sun? . . . If I look at the canvas now, I see something clearly borrowed from the decorative system of the Japanese, but inferior to them, a collection of flat tones, all surrounded by a line . . . with the best will in the world, I don't understand.

Evening effect . . . represents an outdoor scene on the boulevard, entirely blue, corresponding rather closely to the feeling you have in the street in the evening, when you leave a place that's brightly lit. . . .

I just [wonder] what subtleties of reasoning M. Anquetin is employing when he sees synthetic art here.—I myself see precisely the opposite, art that's excessively specious, the study of very uncommon accidents

Among those exhibiting who are vulgar Impressionists (they are wise men, if we compare them to M. Anquetin), there is one, M. Gauguin, who already enjoys a certain reputation, which I find deserved, with mild reservations.

It is certain that *Dancing a Round in the Hay, The Young Wrestlers—Brittany, The Model—Brittany, The Mangoes—Martinique,* etc. are the works of a painter, even though they include, here and there, deformations of drawing and falsifications of color values that bother me, and that, in other works where these are excessive, manage to damage a great deal M. Gauguin's indisputable talent.

For example, the exhibition catalogue includes a lithograph by him entitled *The Haymakers,* which is a very poor thing. M. Gauguin knows how to draw, and there is no aesthetic that justifies too-long arms, too-narrow torsos, and a woman's head resembling that of a mouse.

A watercolor, called *Eve,* portrays a naked woman crouched at the foot of a tree equipped with a serpent; beneath it, I read: "Don't listen—him—him liar!" What document supports M. Gauguin's assumption that Eve talked pidgin?

Unless I am mistaken, M. Gauguin, too, is a Synthetist!

Among the nine exhibitors, there are two who visibly copy M. Gauguin. One, M. Bernard, is a Synthetist; the other, M. Laval, purely and simply imitates him very closely.

Antoine also roundly criticizes Bernard for his deformed figures, which lack natural proportions.

M. Schuffenecker is not concerned with synthesis, and I congratulate him. He contents himself with being an impressionist, in other words, to look for luminous colorations, and in that he's quite often successful.—His snow scenes, a still life, beach scene, landscape, Paris landscape, and a dancer are works by a talented artist, although his snow scenes are overdelicate and somewhat lacking in virility. In his *Kelp Gatherers,* I would draw attention to the aprons of the women in the background, which are not sufficiently prominent. . . .

I also saw a portrait of M. Daniel by himself, which struck me as a good piece of painting.—This portrait is accompanied only by two still lifes, which I regreted because he seems to promise other interesting works.—Some still lifes and landscapes by M. Roy, not as bad as his drawing for the catalogue might have made one fear.—And lastly, M. Fauché's pastels, nothing out of the ordinary, but adequate.

The Aftermath

1 March 1895. Maurice Denis, "Notes d'art" (review of an exhibition of the work of Armand Seguin), *La Plume* (no. 141, p. 118).

> Those who have followed from the beginning the development of these painters, called in turn "Cloisonnistes" (Dujardin, *Revue indépendante*, 1886[59]), "Synthetists" (1889), "Neotraditionalists" (Pierre Louis, *Art et critique*, 1890), "Idéistes" (Aurier, *Mercure*, 1891), "Symbolists," and "Déformateurs" (A. Germain) will take a special interest in the Seguin exhibition. They will be pleased when it reminds them of some forgotten features of the exhibition at the café Volpini, on the Champ de Mars in 89; they'll see more happy examples of the Pont-Aven school. . . . Who remembers the café Volpini? . . . There was a group of very beautiful things there, of which a few will survive. Since then we have rarely seen an affirmation of methods that are so simple, so primitive, and that have so obviously ingenuous a basis.

15 November 1905. Denis's "De Gauguin, de Whistler et de l'excès des theories" published in *L'Ermitage* (vol. no. 33, pp- 309-10).[60] Written in support of an idea then being mooted of holding a Gauguin exhibition at the École des Beaux-Arts. In Denis's view, Gauguin was as influential for the artists of the 1890 generation as Manet had been for that of 1870, and his work, worthy of comparison with the Old Masters, would be a valuable corrective to the Beaux-Arts students:

> Even if one were to admit, as M. Mirbeau would have it, that Gauguin was no more than the popularizer of Cézanne's art, it must be agreed that the exhibition at the café Volpini in 1889—in which the Synthetists and the whole Pont-Aven School, Bernard, Anquetin, Laval, Schuffenecker, etc., appeared grouped for the first time round Gauguin—it must be agreed that that exhibition marked a turning point, and inaugurated a new era. The appearance in an everyday location of a type of art that had never been seen before marked the beginning of the reaction against Impressionism. The crisis of symbolism, which broke out shortly after, encouraged the spread of Gauguin's ideas, to the point where all the applied arts—decorative painting, ornaments, posters and even caricature—were refreshed by them.

1906. Jean de Rotonchamp's *Paul Gauguin 1848–1903* published in Paris.[61] Witness account of the Volpini exhibition, with detailed description of key paintings and the *Volpini Suite*, of which he owned a complete set. Rotonchamp also acquired Gauguin's painting *The Laundresses:*

> The year 1889 saw the opening on the Champ de Mars of the enormous world's fair. Under the blue domes of a palace now destroyed, in which were amassed the artworks of every school, nothing was given a place that had not previously been awarded an official stamp of approval.

Nevertheless, right on the ground floor of those imposing galleries, in an alcove of an ordinary boulevard bar, visitors were surprised one day to see on the walls, which had hitherto been innocent of any form of decoration, a hundred or so strange canvases, many of which seemed to some people like the creatures of nightmare.

An oblong booklet in a white cover with blue stripes—like the stuff of a marquee—was made available to the public under this surprising title: *Catalogue of the Exhibition of Paintings of the Impressionist and Synthetist Group*. The exhibitors were Paul Gauguin, E. Schuffenecker, Émile Bernard, Charles Laval, Louis Anquetin, Louis Roy, Léon Fauché, Georges Daniel, and Ludovic Nemo. Through the clouds of steam coming from a monumental urn, among the comings and goings of busy waiters, could be glimpsed seventeen canvases by Gauguin, dating from Martinique, Brittany, and Arles. They had the following titles:

Early flowers. —Brittany

The mangoes. —Martinique.

Conversation. —Brittany.

Winter. —Brittany.

Presbytery of Pont-Aven.

Dance in the hayfield.

Arles landscape.

The farmhouses. —Arles.

Decorative pastel.

Young wrestlers. —Brittany.

Decorative Fantasy. —Pastel.

Eve. —Watercolor.

Human Misery.

In the waves.

The model. —Brittany.

Portrait. —Arles.

Landscape. —Pont-Aven.

Two facsimiles of Gauguin's ("P. Go") drawings decorated the pages of the catalogue: two tragic bathers, one seated, her head resting in her hands, the other battling grimly with the waves; and some Breton women haymakers, with brutal profiles.

Émile Bernard had twenty-three canvases there, executed either in Brittany or in the area around Paris. He also exhibited, under the pseudonym Ludovic Nemo, two "petrol paintings." The following note was printed at the end of the catalogue:

May be seen on request

ALBUM OF LITHOGRAPHS

By Paul Gauguin and Émile Bernard.

The lithographs by Gauguin were printed in black on light chrome yellow paper, in the format 0m.50 × 0m.32. They were:

A design for a plate, showing a modern Leda, seen from the back, with a swan pecking her hair. The composition contained these words as an epigraph: "Homis (*sic*) soit qui mal y pense. P. Go."

A *Pastoral in Martinique,* with two negresses chatting, with their heads close together.

Another scene in Martinique, *The grasshoppers and the ants:* busy negresses carrying baskets of fruit, while at their feet other negresses are squatting lazily on the sand.

Old maids crossing a garden in winter, in Arles.

A goat-girl, sitting next to a woman washing clothes in the Rhône.

And several scenes of Brittany: women praying beside the sea; others chatting near a fence; a little bather about to go into the water. . . .

A design for a fan completed the series: an unfortunate man clinging to a boat as it is swept toward the abyss.

Charles Laval, who has since died, was represented by half a dozen canvases brought back from Martinique: *Entrance to a wood; The palms; Under the banana trees; A Martinique dream.* . . . They were barely concealed imitations of the works of his brilliant traveling companion.

And visitors, attracted by the throbbing rhythms of a chamber orchestra, dominated by the strident bowing of "Princess Dolgorouka," contemplated with alarm these unusual compositions, which not even the most malicious could deny, for want of authoritative correction, the merits of originality and boldness.

May 1909. Denis, "De Gauguin et de Van Gogh au classicisme," *L'Occident* (no. 90, p. 188):[62]

To understand our excitement, our sense of dizzying originality, one had to have seen the café Volpini at the 1889 Exposition. There, in a tucked-way corner of the great Fair, far from the official art and the accumulated masterpieces from the Retrospectives, were pitifully hung the first works by Gauguin, Bernard, Anquetin, etc., brought together for the first time. It was certainly one of the most laughter inducing sights of the Exposition. . . .

It was . . . the inevitable outcome—both action and reaction—of the great impressionist movement.

October 1925. Gustave Kahn, "Paul Gauguin," *L'Art et les Artistes* (n.s. 60, pp. 37–65):

At the 1889 Exposition, this [Gauguin's Impressionist-Synthetist] group made its presence felt in a café (artists exhibit where and how they can, and at these grandiose fairs, when art questions are decided by somewhat conservative bureaucrats, any form of protest is valid, and any kind of art installation suffices.) . . . This exhibition represented the full affirmation of Gauguin. For the critics, he stopped being one of those in the background of Impressionism and started to be accepted instead as a leading figure, considered someone who possessed an assured and incontestable originality.

March 1934. Denis, "L'Époque du symbolisme," *Gazette des Beaux-Arts* (6th per., 11, pp. 165–79), evokes certain key youthful recollections concerning the birth of symbolism:

> The first of these images, in a deserted, or almost deserted corner of the great fair of 1889, on the Champ de Mars, in the shadow of the brand new Eiffel Tower, is the café Volpini. There the first works of the new movement in painting were exhibited in white frames. Were they studio satires, of the sort being shown at the time by the *Incohérents*? The distortion in the drawing, the aspect of caricature, the colors laid down flat, it all [caused] a scandal.

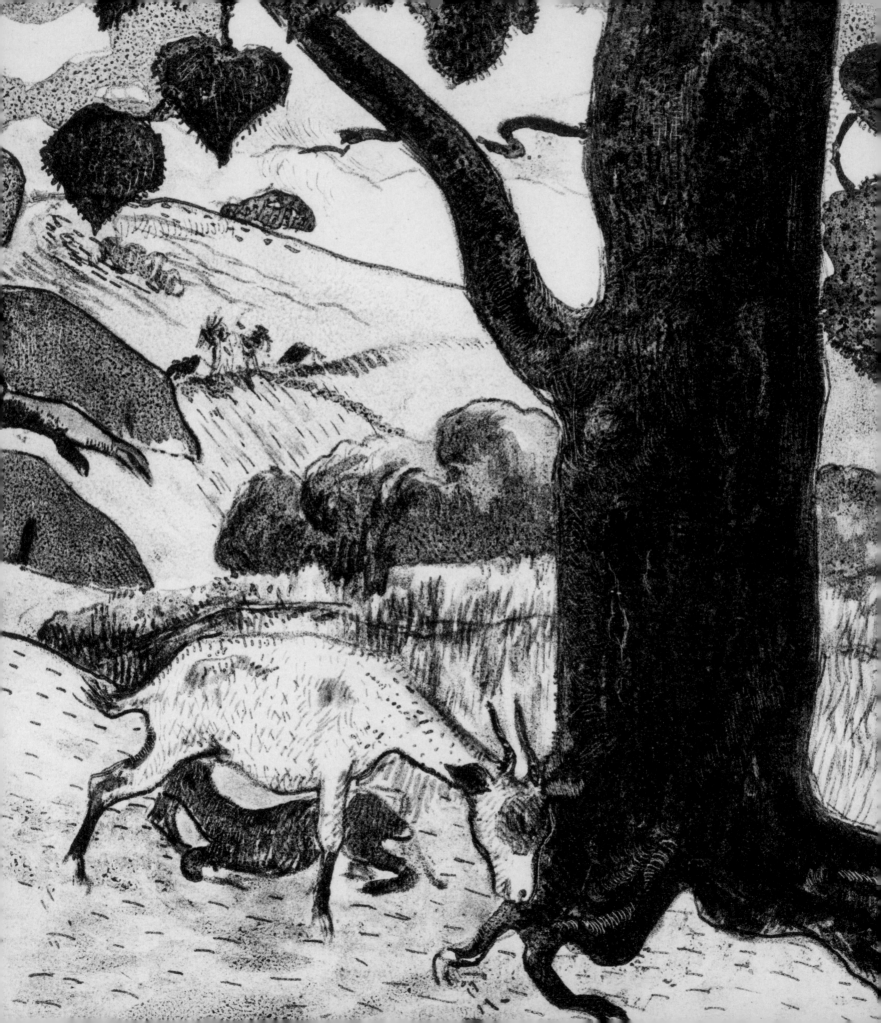

An Exegesis of the Volpini Exhibition

Belinda Thomson

The following table illustrates the pages of the Volpini catalogue. The works that could be identified with reasonable confidence are arranged by artist and numbered (some out of sequence) as they were in the catalogue. These numbers (below each illustration) correspond to the numbers in the Volpini catalogue, but the titles are those used today, which are often different from the titles used in 1889. The process of matching works by subject and date has been double-checked, where possible, against other information such as dimensions, provenance, critical reviews, or artists' correspondence. In cases where two strong contenders for an exhibited work exist, both are illustrated. Where there are several potential candidates, or where, for other reasons, identification has not been possible, no illustration is provided. For sources and details of the arguments behind the new attributions, see the notes.

Cat. 42. *Catalogue de l'Exposition de Peintures du Groupe Impressionniste et Synthétiste* (Paris, 1889), Van Gogh Museum (Library), Amsterdam

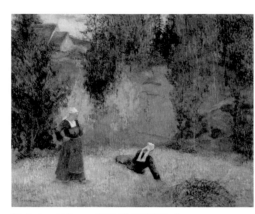

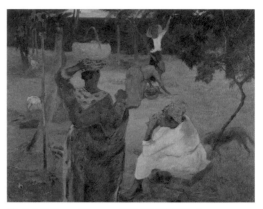

31. *Spring at Lézaven,* 1888 (W. 249/279), oil on canvas, 70 × 92 cm. Private collection (see fig. 21, p. 72).[2]

32. *Fruit Picking* or *Mangoes,* 1887 (W. 224/250), oil on canvas, 89 × 116 cm. Van Gogh Museum, Amsterdam (see cat. 38, p. 55).

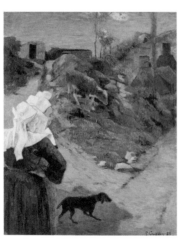

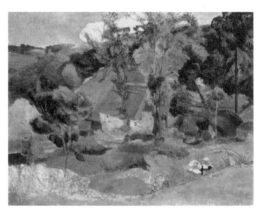

33. *Breton Women at the Turn,* 1888 (W. 252/271), oil on canvas, 91 × 72 cm. Ny Carlsberg Glyptotek, Copenhagen (see fig. 54, p. 135)

OR 33. *Autumn at Pont-Aven,* 1888 (W. 253/313), oil on canvas, 72 × 93 cm. Private collection.

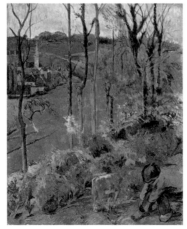

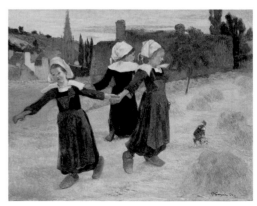

34. *Landscape from Pont-Aven, Brittany,* 1888 (W. 258/273), oil on canvas, 90.5 × 71 cm. Ny Carlsberg Glyptotek (see cat. 35, p. 51).

36. *Breton Girls Dancing, Pont-Aven,* 1888 (W. 251/296), oil on canvas, 73 × 92.7 cm. National Gallery of Art, Washington (see cat. 36, p. 52).

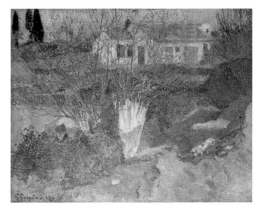

37. *Farmhouse, Near Arles,* 1888 (W. 310/324), oil on canvas, 73 × 92 cm. Private collection (see fig. 12, p. 58).[3]

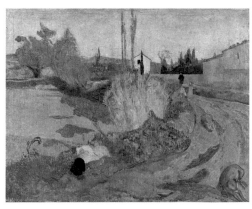

38. *Landscape from Arles,* 1888 (W. 309/323), oil on canvas, 72.5 × 92 cm. Nationalmuseum, Stockholm (see cat. 34, p. 50).

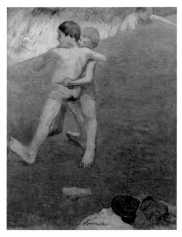

40. *Young Wrestlers,* 1888 (W. 273/298), 93 × 73 cm. Private collection (see cat. 37, p. 53).

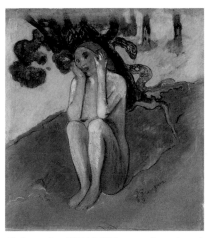

42. *Breton Eve,* 1889 (W. 333), watercolor and pastel, 33.7 × 31.1 cm. McNay Art Museum, San Antonio (see cat. 40, p. 57).

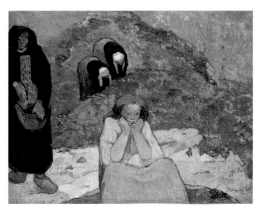

43. *Human Misery,* 1888 (W. 304/317), 73.5 × 92.5 cm. Ordrupgaard, Charlottenlund, Denmark (see cat. 39, p. 56).

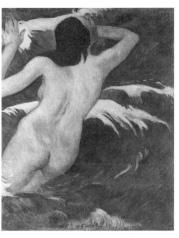

44. *In the Waves,* 1889 (W. 336), oil on canvas, 92 × 72 cm. The Cleveland Museum of Art (see cat. 43, p. 61).

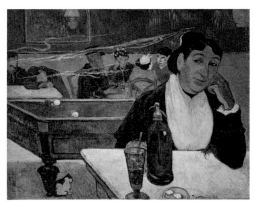

46. *Night Café, Arles,* 1888 (W. 305/318), oil on canvas, 72 × 92 cm. Pushkin State Museum of Fine Arts, Moscow (see fig. 29, p. 84).[4]

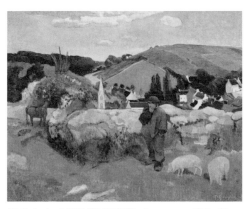

47. *Swineherd,* 1888 (W. 255/302), oil on canvas, 73.5 × 92 cm. Los Angeles County Museum of Art.[5]

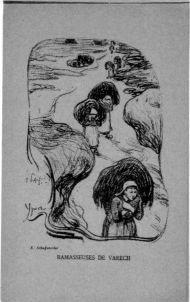

55. *Dancer,* 1887, pastel,
61.5 × 38.2 cm. Private collection.

57. *Notre Dame in the Snow,* 1886, oil on
canvas, 50.1 × 63.5 cm. Wallraf-Richartz
Museum, Cologne.

59. *Rocky Coast in Brittany,* 1886, oil on canvas, 50 × 61 cm.
Musée de Quimper.

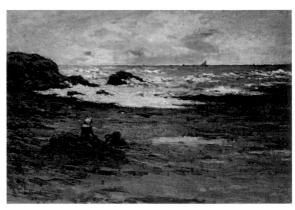

60. *Corner of a Beach at Concarneau,* 1887, oil on canvas, 38.1 × 55.2 cm.
Private collection.

61. *Seaweed Gatherers, Yport.* 1889. Private
collection (see cat. 49, p. 67).[7]

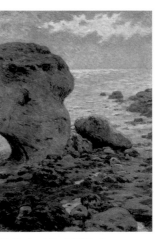

65. *Rocks at Yport,* 1889, oil on canvas,
81.5 × 59.5 cm. Musée Centre-des-Arts,
Fécamp (see cat. 41, p. 59).

66. *In the Park at Montsouris,* 1886, oil on canvas, 65 × 81 cm. Private collection, United Kingdom.

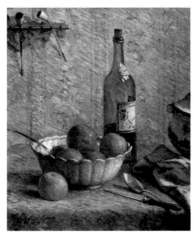

78. *Still Life with Bowl of Fruit,* 1886, oil on canvas, 65 × 54 cm. Kröller-Müller Museum, Otterlo (see cat. 44, p. 63).

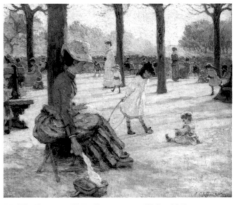

69. *The Square,* 1885, oil on canvas, 80.6 × 99.7 cm. Private collection.

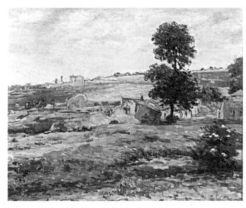

70. *Old Fortifications of Paris,* 1888, oil on canvas, 43 × 53 cm. Collection of Mr. and Mrs. van Duren-van der Leeuw, The Netherlands.

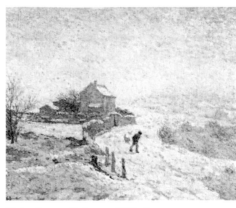

72. *Landscape with Snow,* c. 1886, oil on canvas, 45.7 × 55.8 cm. Private collection.[8]

73. *Snow Scene,* 1887, oil on canvas, 38.1 × 46 cm. Private collection.[9]

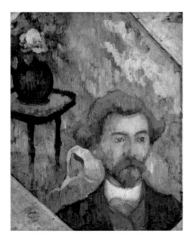

83. *Portrait of Émile Bernard,* c. 1889, oil on wood, 83.3 × 77.5 cm. The Museum of Fine Arts, Houston (see fig. 16, p. 68).[10]

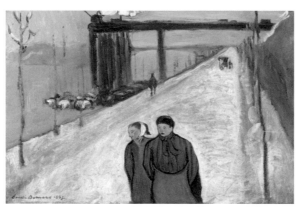

7. *Quai de Clichy,* 1887, oil on canvas, 39 × 59 cm. Musée Départemental Maurice Denis "Le Prieuré," Dépôt Musée d'Orsay, Paris (see cat. 45, p. 64).

8. *Still Life with Flowers,* 1887, oil on canvas, 61 × 50 cm. Norton Simon Museum, Pasadena.

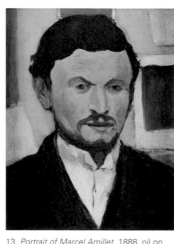

13. *Portrait of Marcel Amillet,* 1888, oil on canvas, 41 × 33 cm. Private collection (see cat. 46, p. 65).

14. *Breton Women in a Meadow,* 1888, oil on canvas, 74 x 90 cm. Private collection.[12]

15. *House at the Far End of a Park,* 1888, oil on canvas, 54.5 × 64.5 cm. Musée Léon Dierx, La Réunion, Saint-Denis, Collection Ambroise Vollard.[13]

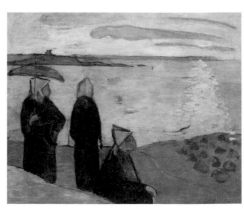

OR 14. *Three Breton Women at the Seashore,* Saint-Briac, 1888, oil on canvas, 53 x 64 cm. Private collection.

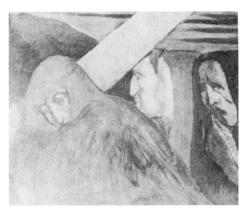

18. *Christ Carrying the Cross*, 1887, oil on canvas, dimensions unknown. Private collection.

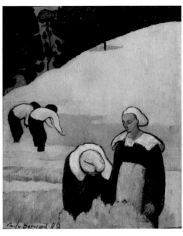

19. *The Harvest*, 1888, oil on canvas, 56.5 × 45 cm. Musée d'Orsay, Paris (see fig. 17, p. 68).[14]

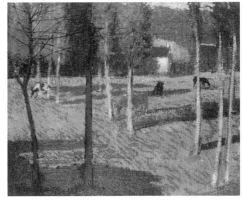

19 bis. or 11. *A Meadow in Saint-Briac*, 1887, oil on canvas, 46 × 55 cm. Private collection.

75. *Female Bathers*, 1888, oil on wood, 57 × 86 cm. Private collection (see fig. 14, p. 62).[15]

76. *The Castle of Kerlaouen*, 1888, oil on canvas, 46 × 33 cm. Private collection.[16]

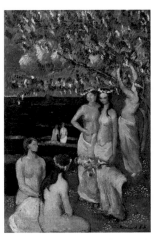

79. *Poplars*, 1887, oil on canvas, 70 × 98 cm. Private collection, France.

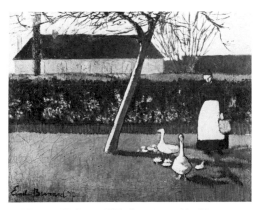

86. *Woman with Geese*, 1887, oil on canvas, 41 × 23 cm. Private collection (see fig. 15, p. 67).

Louis Anquetin at the Café des Arts[17]

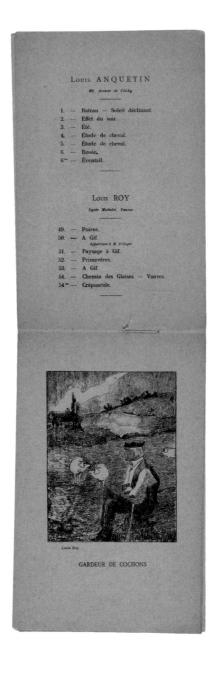

1. *Boat, Setting Sun*. Whereabouts unknown.[18]
No image available

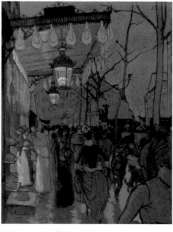

2. *Avenue de Clichy*, 1887, oil on canvas,
69 × 53 cm. Wadsworth Atheneum Museum
of Arts, Hartford (see cat. 51, p. 73).

3. *Mower at Noon*, 1887, oil on canvas,
69.2 × 52.7 cm. Private collection.

4. *Study of a Horse*. Whereabouts unknown.[19]

5. *Study of a Horse*. Whereabouts unknown.

6. *Dew*. Whereabouts unknown.[20]
No image available

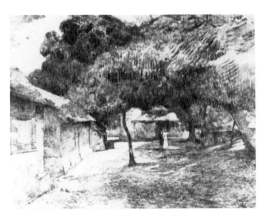

84. *In the Village,* 1887, oil on canvas, 73 × 92 cm. Private collection.[22]

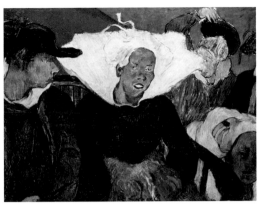

85. *Going to Market, Brittany,* 1888, oil on canvas, 37.5 × 46 cm. Indianapolis Museum of Art (see cat. 50, p. 69).

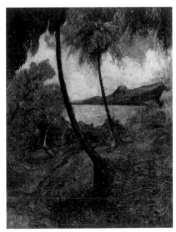

89. *Landscape in Martinique,* 1887, oil on canvas, 91.1 × 71.1 cm. Private collection.

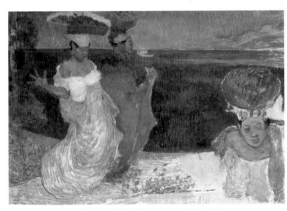

91. *Women by the Shore,* 1887, oil on canvas, 65 × 91.5 cm. Musée d'Orsay, Paris.

92. *Landscape, Martinique,* 1887, oil on canvas, 60 × 73 cm. Van Gogh Museum, Amsterdam (see cat. 84, p. 148).

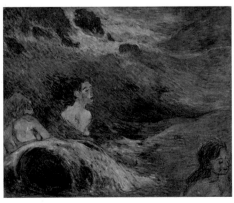

94. *Bathers,* 1887, oil on canvas, 46 × 55 cm. Kunsthalle Bremen (see cat. 47, p. 66).

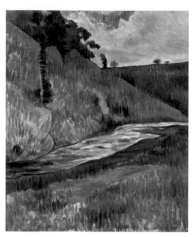

95. *The Aven Stream,* 1889, oil on canvas,
55 × 46 cm. Musée de Strasbourg (Dépôt du
Musée d'Orsay).[23]

96. *Scene in Martinique,* 1889, pen and ink and crayon
heightened with watercolor, affixed to gray-blue paper,
14.5 × 22 cm. Private collection (see fig. 19, p. 70).

Georges-Daniel de Monfreid at the Café des Arts

21 bis. *Self-Portrait,* 1889, oil on canvas,
63 × 48 cm. Private collection, Paris
(see cat. 32, p. 47).[24]

Ludovic Nemo (pseudonym used by Émile Bernard) at the Café des Arts

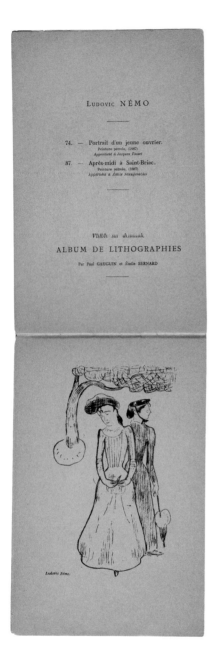

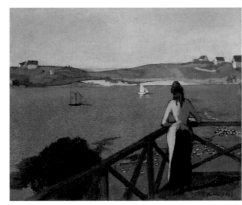

87. *Afternoon in Saint-Briac (Après-Midi à Saint-Briac)*, 1887. oil on canvas, 45.5 × 55.5 cm. Aargauer Kunsthaus, Aarau, Switzerland.

Notes

Gauguin Goes Public (pp. 29–73)
Belinda Thomson

1 Given the lack of reviews and generic character of many of the works' titles, the pictures shown at the exhibition are by no means always easy or even possible to identify. In arriving at these preliminary findings, I acknowledge the help of Clément Siberchicot and his 2008 master's thesis, "L'exposition impressionniste et synthétiste du café Volpini, 1889." Université de Paris X, 2008.

2 John Rewald (Rewald 1978, 288–89) established a considerable body of data, but his account suffered from the uncertain dating of Gauguin's letters at that time. Victor Merlhès published new letters and revised the dating of Gauguin's key letters to Schuffenecker (see Chrononlogy). He also published, unsourced, the Jeanniot illustration of the café interior (see Merlhès 1995). The most coherent chronology of Gauguin's movements is Bogomila Welsh-Ovcharov, "Paul Gauguin's Third Visit to Brittany," in Zafran 2001, 15–59.

3 "Exposition des Colonies," in *L'Exposition universelle de 1889,* 1: 176: "une des attractions les plus curieuses de l'exposition de 1889." All translations from the French are by the author, unless noted otherwise.

4 Of the residents of the colonial village, the Annamites were by far the most numerous, numbering 204 individuals; in addition there were 64 Senegalese, 20 Gabonese and Congolese, 10 Canaques (New Caledonians), and 11 Tahitians. Ibid., 185.

5 "Expositions des Beaux-Arts," in *Exposition universelle de 1889,* 2: 243: "J'ai dû prendre mon parti et parquer les oeuvres d'art comme les produits d'un concours agricole. C'est à peine si, dans les salles réservées à l'Exposition Centennale, il m'a été possible de ménager un peu d'air entre les toiles qui se pressaient sur les murs. . . . Malgré tout, le public a vu et le public a été si ravi de voir que, après six mois, il a emporté cette conviction que rarement un plus extraordinaire spectacle avait été mis sous ses yeux . . . cette grande et admirable cause de l'art français . . . a pleinement triomphé en 1889."

6 As reported by A. Picard in the preface to "Les Beaux-Arts, Exposition Centennale," in *Rapport Général,* 4: part 7, pp. 4–5.

7 Caroline Mathieu, in *1889 La Tour Eiffel,* 13, citing Antonin Proust, "Rapport de la Commission consultative," *Le Génie Civil* 6, no. 21 (21 and 28 March 1885): "grand nombre d'oisifs, de curieux, d'étrangers riches et qui peuvent disposer de leur temps."

8 In front page articles in *Le Figaro,* both Albert Wolff and Octave Mirbeau stated that the exposition surpassed their expectations and remarked upon the joyousness of the throning crowds. *Le Figaro,* 6 and 10 June 1889.

9 The confusion surrounding Gauguin's movements in this year (see note 2 above) has now effectively been resolved. He did not, as was previously thought, visit Pont-Aven in March and April but was in Paris from January to late May, delaying his return to Brittany until the Exposition Universelle was well and truly open.

10 Gauguin's interest in the colonial exhibition has been long established, while his interest in the "Exposition rétrospective du Travail" has been well argued by Merlhès in Zafran 2001, 85–90. It is noteworthy that not all the delegations of indigènes arrived in time for the exposition's opening. The Tahitians only reached Paris on 1 June, possibly too late for Gauguin to have seen them. "Exposition des Colonies," 185.

11 See letters in Chronology, p. 194.

12 There were considerably fewer works to fit into the Centennale, 652 as opposed to 1,481 French paintings alone in the Décennale.

13 Proust 1892, 167.

14 Nineteen paintings by Bastien-Lepage and sixteen by Manet were on view, mostly lent by private collectors. They included Manet's portrait of his old friend Antonin Proust, a fellow student at Couture's studio, and *Le Fifre,* 1866 (Musée d'Orsay, Paris; lent by Faure); *Espagnol jouant de la guitare,* 1861 (The Metropolitan Museum of Art, New York; lent by Faure); *Olympia,* 1863 (Musée d'Orsay; lent by Mme Manet); *Toreador tué,* 1862–64 (National Gallery of Art, Washington; lent by Faure); *Le bon Bock,* 1873 (Philadelphia Museum of Art; lent by Faure); *Argenteuil,* 1874 (Musée des Beaux-Arts, Tournai, Belgium; lent by E. May); *Femme en blanc,* Salon 1879 (unidentified; lent by Mme Manet); *Les asperges,* 1880 (Musée d'Orsay; lent by Ch. Ephrussi); *Mon jardin,* 1881 (Private collection; lent by Clapisson); *Le printemps (Jeanne),* 1881 (Fogg Art Museum, Cambridge, Mass.; lent by A. Proust); *Le Port de Boulogne—effet de nuit,* 1869 (Musée d'Orsay; lent by Faure); *Le Liseur,* 1861 (St. Louis Art Museum; lent by Faure); *Lola de Valence,* 1862 (Musée d'Orsay; lent by Faure); *En bateau,* 1874 (The Metropolitan Museum of Art; lent by V. Desfossés); *La voiture* 1870 (Shelburne Museum, Shelburne, Vermont; lent by Mme Manet). He also showed watercolors and drawings.

15 In the second of his two articles for *Le Moderniste* about the Exposition Universelle (see below), "Qui trompe-t-on ici?," Gauguin fulminates at the folly of the State handing out lavish sums of the taxpayers' money to stop Millet's *Angelus* from being sold to America when it had done nothing to help the artist when he was alive and his works were still affordable. Gauguin was referring to the Secrétan Sale where, on 1 July 1889, Antonin Proust tried to purchased *L'Angélus* for the French State, bidding a record sum of ·563,000 francs, but it went instead to the American Art Association.

16 Certainly this was the message Gauguin took from the exposition. In a letter to Schuffenecker written toward the end of the summer, he crows: "The battle at Pont-Aven is over, everyone's been brought to heel and the Julian studio's beginning to change tack and mock the École. Manet's triumph at the [Centennale] is crushing them." (La lutte à Pont-Aven est terminée, tout le monde est mâté et l'atelier Julian commence à virer de bord pour blaguer l'école. Le triomphe de Manet à la centenale les écrase.) See full text in Chronology, p. 202.

17 The three Monets on view, all lent by private collectors, were *Les Tuileries,* 1876 (Musée Marmottan, Paris; lent by de Bellio); *L'Église de Vernon,* 1883 (Yamagata, Japan; lent by H. Vever); and *Vétheuil,* 1883 (private collection; lent by E. May). The two Pissarro landscapes, hitherto unidentified, were both lent by the collector Ernest May; one had been shown at the Salon of 1864. *Soleil d'hiver* can be probably identified with *Entrée de Voisins,* 1872 (Musée d'Orsay). Victor Chocquet lent Cézanne's Auvers landscape *La Maison du pendu,* 1873 (Musée d'Orsay).

18 The five works by Puvis de Chavannes, all lent from private collections, were *L'Automne,* 1864 (Musée des Beaux-Arts, Lyon), *Décollation de Saint-Jean Baptiste,* 1869 (Barber Institute, Birmingham), *L'Enfant prodigue,* 1879 (E. H. Bührle Foundation, Zurich), *Jeunes filles au bord de la mer,* 1879 (Musée d'Orsay), *Vie de Sainte-Geneviève* (reduced version), c. 1878 (possibly the one in the Norton Simon Art Foundation, Pasadena).

19 Armand Dayot, in *Exposition universelle de 1889,* 246.

20 I owe this suggestion to Richard Thomson. According to Merlhès (Merlhès 1995, 28), Durand-Ruel mounted his own display of the artists he represented within the exhibition grounds, in the Pavillon de la Presse, which was opposite the Volpini café. Further information about the timing and nature of this display is sadly lacking.

21 J.-J. Isaacson (Isaacson 1889, 233) commented on the disagreement between Degas and Proust at the time. G. Jeanniot (Jeanniot 1933) discussed Degas's refusal to exhibit an important group of works at the exposition.

22 In November 1887, while still in Paris, Van Gogh organized an informal exhibition of his friends' works, Anquetin and Bernard among them, at the Grand Bouillon, Restaurant du Chalet. The show occasioned his first meeting with Gauguin. Van Gogh had already hung the Café du Tambourin with Japanese prints that spring, and with his own works in the summer. For a detailed discussion of these avant-garde strategies, including the Café des Arts show, see Homburg 2001.

23 Vincent to Theo van Gogh, 17 January 1889, no. 736 in Gogh 2009.

24 For more on the *Revue indépendante* exhibitions, see Richard Thomson, "The Cultural Geography of the Petit Boulevard," in Homburg 2001, 79–80.

25 According to Gauguin's account, he had argued for an Impressionist group showing at the Exposition Universelle and was disappointed not to have prevailed, although what measures he took to secure his colleagues' agreement is unclear. See Chronology, pp. 194–96. See also Gauguin to Theo van Gogh, Pont-Aven, 10 June 1889, no. GAC 13B in Cooper 1983, 92–99.

26 Gauguin refers admiringly to these initiatives in his first article for *Le Moderniste,* no. 11 (4 July 1889). Griselda Pollock uses the phrase "avant garde gambit" of Gauguin in her Walter Neurath Memorial Lecture. See Pollock 1993.

27 "J'ai organisé cette année à l'Universelle cette petite exposition pour montrer ce qu'il fallait faire en masse et en démontrer la possibilité." See Gauguin to Theo van Gogh, c. 10 June 1889, in Chronology, p. 198.

28 See the three June letters from Gauguin to Schuffenecker in Chronology, pp. 194–96, 197–98, 199. I am grateful to C. Siberchicot for alerting me to the existence of a dated invitation to the vernissage (see cat. 113).

29 Gauguin to Theo van Gogh, Pont-Aven, 1 July 1889, no. GAC 14 in Cooper 1983, 100–7 See also Chronology, p. 200.

30 According to Brincourt 1890, 246.

31 In the letter he wrote to Aurier (see Chronology, p. 196), Bernard was full of praise for Volpini's intelligence. It is worth noting that Volpini went on to have further involvement with innovative artists, commissioning a series of decorations from Jean-Louis Forain for the Café Riche in 1893 and two years later allowing the Lumière brothers to use his premises for the first screenings of cinema in Paris. Whether Gauguin or his co-exhibitors regularly frequented his other establishments is not known.

32 See Bernard 1939, 13–15. Unfortunately, in many respects this account, skewed by the determination to underline his own role in the invention of synthetism, is not to be fully relied upon.

33 See full text of letter in Chronology, pp. 194–96.

34 Vincent is at pains to defend Gauguin and Bernard from Theo's criticism and admits that if it is a somewhat vulgar gesture to display one's work in a public eating place, it is

one of which he is equally guilty. See Vincent to Theo van Gogh, c. 18 June 1889, no. 782 in Gogh 2009.

35 It seems improbable that Laval, who was in Pont-Aven at the time of the opening, was a last-minute addition: his entries included a work lent by an aristocratic collector (unless this "comtesse" was apocryphal).

36 Unfortunately Schuffenecker's letters to Gauguin do not survive, and two key June letters, from Gauguin to Bernard and from Bernard to Gauguin, that might clarify these last-minute maneuvers are missing from the record of the exhibition. We learn of their existence from Gauguin's subsequent letters to Schuffenecker and Bernard.

37 Louis Roy, with Schuffenecker, taught drawing at the Lycée de Vanves. Léon Fauché, from Nancy, the same age as Bernard, exhibited a group of pastels at the Volpini show. Georges-Daniel de Monfreid was an acquaintance of both Schuffenecker and Gauguin from the Académie Colarossi.

38 Following the Volpini show, Louis Roy spent time with Gauguin in Paris in 1890–91 and later executed color impressions of Gauguin's *Noa Noa* woodcuts. In 1890–91 Léon Fauché bought a Gauguin Breton painting, *Breton Shepherdess (Bergère bretonne)*, 1886 (NW. 233; Laing Art Gallery, Newcastle-upon-Tyne, Eng.), and lent Gauguin the press on which he made his only etching, *Portrait of Mallarmé*. De Monfreid lent Gauguin his studio just before he left for Tahiti in 1891 and thereafter became Gauguin's most loyal correspondent and factotum.

39 Neither this recriminatory letter to Bernard with its laconic list of urgent demands nor Bernard's wounded reply are known. However their tone and content can be inferred from the placating letter Gauguin wrote to Bernard shortly after.

40 Translated by Imogen Forster. See the full text of his letter to Schuffenecker of mid June 1889, hitherto unpublished, in Chronology, p. 197.

41 See Bernard's letter to Aurier in Chronology, p. 196. This letter, previously dated c. 20 May, should be put back to early June, given that Bernard confidently anticipates the show will open on the following Thursday (it actually opened on a Monday).

42 Aurier mentions Bernard's work seen at Tanguy's and Gauguin's at Van Gogh's. Flâneur 1889, 55.

43 In the 10th issue of *Le Moderniste*, which appeared later than usual on 27 June 1889: "une minuscule concurrence à l'exhibition officielle."

44 Vincent to Theo van Gogh, 9 June 1889, no. 799 in Gogh 2009. See Chronology, p. 197. In what paper Vincent read this announcement is not known (communication from Leo Jansen, Van Gogh Museum, 6 August 2008).

45 "Pourquoi, puisque cette Exposition devait embrasser l'histoire artistique de ce siècle, nous montrer ses transformations, ses tendances, même ses avortements, pourquoi n'avoir pas compris . . . des artistes aussi particuliers que M. Seurat et M. Gauguin?" Mirbeau 1889, 1. This reference shows that Mirbeau had already become aware of Gauguin's work (presumably at Theo van Gogh's gallery). His first recorded dealings with Gauguin are in early 1891 when he wrote articles championing him for *Le Figaro* and *L'Echo de Paris*. See Mirbeau 2005, 322–47.

46 See Chronology, pp. 194–96.

47 In a letter to Schuffenecker of 31 January 1891 ridiculing Bernard's latest idea of launching a Société des Anonymes, Gauguin refers back to his earlier disapproval of Bernard's

adoption of the name Nemo. The name, as Merlhès (Merlhès 1995, 32, 73) points out, evokes the mysterious art-collecting Captain Nemo of the *Nautilus* from Jules Verne's novel *Twenty Thousand Leagues under the Sea* (1869).

48 For a discussion of the role of wrestling in the *Breton Pardon*, see Thomson 2005, 67–68.

49 Evidence of Gauguin's keen awareness of the need to pitch himself to specific publics is given in his letter of 1900 to de Monfreid. See Chronology, p. 204.

50 Gauguin's placatory letter to Bernard makes clear that he was annoyed with Schuffenecker about some aspect of the organization of the show, and this misjudgment of the audience may have been one of his grouses. See Chronology, pp. 199–200.

51 The painting was listed as "Dans les vagues" in the Volpini exhibition, but in the record of sale at the Hôtel Drouot auction of Gauguin's work in 1891 "Ondine" was placed in parenthesis after "un tableau," perhaps by the auctioneer. Brettell 1988, 146.

52 This is presumably the drawing referred to at the opening of his letter of mid June to Schuffenecker. See Chronology, p. 199.

53 Forty years later Bernard claimed he showed this painting in 1889, but in other respects his 1939 account is questionable.

54 *Revue de l'Exposition Universelle de 1889*, no. 2 (June? 1889).

55 I am grateful to Clément Siberchicot for identifying and locating illustrations of these works.

56 *Le Moderniste*, no. 13 (20 July 1889).

57 Gauguin, "Notes sur l'art à l'Exposition Universelle," *Le Moderniste*, nos. 11 and 12 (4 and 13 July 1889); "Qui trompe-t-on ici?" *Le Moderniste*, no. 22 (21 September 1889). Articles partially reprinted in Guérin 1974, 47–56. Translated by Eleanor Levieux in Guérin 1996, 28–32, 34–36.

58 One wonders if he read Huysmans's scathing attack on the tower, "Promenades à l'Exposition, Les derniers travaux," dated 15 April 1889 and originally published in *Revue de l'Exposition universelle*, no. 1 (May 1889). Huysmans's views were later published in more unbuttoned form in *La Revue Indépendante* (August 1889).

59 Bernard 1889.

60 Juliet Simpson (Simpson 1999, 214–19) explores this failure on Aurier's part to write the expected supportive and theoretical article, despite urging from Bernard and Gauguin. She concludes that Aurier was not yet ready "to make the leap in identifying Synthetism with Symbolism, and produce the manifesto article on which Gauguin's reputation depended." Aurier's lengthy article on Gauguin for the *Mercure de France* of March 1891 was, she believes, in a sense his fulfillment of that promise.

61 Kahn 1889, 36: "M. Gauguin expose, dans un café, dans les plus mauvaises conditions, sa peinture intéressante, mais comme rauque et martelé."

62 "Modulent aux murs quelque gamme exotique non sans un charme de crépuscule," wrote Adolphe Retté (Retté 1889, 155–56). See Chronology, p. 207.

63 Jules Antoine (Antoine 1889, 370) wrote of the "ensemble de teintes plates, toutes cernées par un trait" and complained specifically of Gauguin's lithograph *The Haymakers*:

"there is no aesthetic that justifies too-long arms, too-narrow torsos, and a woman's head resembling that of a mouse" (il n'existe pas d'esthétique justifiant des bras trop longs, des torses trop étroits et une tête de femme ressemblant à une tête de souris).

64 Fénéon 1889.

65 Gauguin directly attacked Wolff in "Qui trompe-t-on ici?"

66 See the entry on *La Ronde des petites bretonnes* in Wildenstein, D. 2001, 2: 416, cat. 296.

67 Isaacson wrote a series of weekly letters about Dutch art at the Exposition Universelle in *De Portefeuille* (3 August–28 September 1889). Thereafter he intended to move on to aspects of Impressionism and French independent art. I am most grateful to Gillian Keay for help translating Isaacson's prose.

68 This is made clear by a note from Gauguin to Theo van Gogh relating to a possible sale late during the exhibition's run, in which he says: "The café proprietor takes so much a % on the deals that go through him; so take that into account" (Le patron de café a tant % sur les affaires qui passent par ses mains; ainsi donc tenez en compte), c. 20 October 1889, no. GAC 21 in Cooper 1983, 146–47.

69 See letter in Chronology, p. 199.

70 Quoted, without source, in Wildenstein 2001, 2: 416.

71 Kahn, for example, although he deplored the viewing conditions, gave Gauguin equivalent prominence to Seurat, in his long and considered review of French Art at the Exposition Universelle. See Kahn's review in Chronology, pp. 206–7.

72 Maurice Denis and other Nabis were clearly deeply affected by the Volpini show. Through his writings Denis was responsible for building the legend of the Volpini show's importance, in articles dating from 1895, 1905, 1909 and 1934. See extracts in Chronology, pp. 210–13.

73 For the many exotic artistic influences absorbed into Gauguin's work from the Exposition Universelle, see in particular Druick and Zegers 1991, 101–42.

74 Gauguin to Émile Bernard, datable to late November 1889, no. XCV in Malingue 1946, 178: "Notre exposition, vous et moi, a soulevé quelques orages."

75 In 1900, Gauguin urged de Monfreid to get some of his works shown at the Exposition Universelle, even works that had been seen before, because they would be new to the cosmopolitan crowds coming to Paris. See Chronology, p. 204.

76 Gauguin had great difficulty getting Aurier to send copies of the issues of *Le Moderniste* containing his articles, although he received issue no. 14 (27 July 1889) with Bernard's article, the content of which was perhaps to some extent a joint effort.

77 This project comes up in several letters written between September and December 1889 and his visit to Paris on 7 February 1890 was occasioned by an appointment with Proust.

78 Proust, "Avant-Propos" in "Expositions des Beaux-Arts," in *L'Exposition universelle de 1889*, 243.

Devoted to a Good Cause: Theo van Gogh and Paul Gauguin (pp. 75–85)
Chris Stolwijk

1 Paul to Mette Gauguin, Tahiti, 5 November 1892, no. CXXXIII in Malingue 1946, 268–69: "Depuis la mort de Van

Gogh il n'a encore rien pu vendre. Si tu avais connu Van Gogh tu aurais vu un homme sérieux et dévoué à la bonne cause. Il ne serait pas mort comme son frère que je serais à l'heure qu'il est tout à fait hors d'affaire. Et c'est grâce à lui que la maison Goupil s'est laissée faire pour nous." All translations from the original French are by the author unless noted otherwise.

2 Regarding their collaboration, see Druick and Zegers 2001, 82–85.

3 For this collection, see Sjraar van Heugten and Chris Stolwijk, "Theo van Gogh: The Collector," in Stolwijk and Thomson 1999, 153–81. Three of the paintings Gauguin gave Theo on commission were sold after the dealer's death.

4 The quotations in this paragraph are taken from the same letter: Theo to Wil van Gogh, Paris, 6 December 1888, no. b 916 in Van Gogh Family Archives, Van Gogh Museum, Amsterdam: "die nu door iedereen begrepen wordt door de poëzie die hij verkondigde zoo machtig is dat van groot tot klein een ieder er voldoening in vind."

5 See Richard Thomson, "The Cultural Geography of the Petit Boulevard," in Homburg 2001, 65–66.

6 On Theo van Gogh as an art dealer, see Rewald 1973; Thomson, "Theo van Gogh: An Honest Broker," in Stolwijk and Thomson 1999, 61–151; and Stolwijk 2000, 18–27.

7 Theo bought his first Monet, Rocks at Port-Coton, the Lion Rock, Belle-Île (Rochers à Port-Coton, Le Lion), 1886 (Fitzwilliam Museum, Cambridge), directly from the studio; this purchase proved the beginning of an intensive and lucrative collaboration, ultimately resulting in the direct purchase of more than 40 paintings. Several months later, in July 1887, Theo bought, directly from Degas, his famous A Woman Seated Beside a Vase of Flowers (Madame Paul Valpinçon?) (Femme accoudée), 1865 (The Metropolitan Museum of Art, New York); in the following years he made 13 more studio purchases.

8 Frey 1994, 231.

9 In August of the same year, Theo bought, for the first time, a work directly from Pissarro's studio: The Hay Harvest, Éragny, 1887; in October he bought a gouache, The Pea Harvest, and in December a market scene. Theo sold a total of 18 paintings by this artist.

10 Félix Fénéon gave a short, precise description of the works in his "Calendrier" in the Revue Indépendante. Fénéon 1970, 90 ("Calendrier de Décembre 1887 V. Vitrines des marchand des tableaux"). See also Merlhès 1984, 478–79 n 247.

11 According to Fénéon, who thought little of Gauguin's paintings from this period, his ceramic work demonstrated that he was "chiefly a potter": "He [Gauguin] cherishes the hard, ill-omened, coarse-grained clay of stoneware, scorned by others: haggard faces with wide glabellae, snub noses and tiny slits for eyes—two vases; a third: the head of an ancient long-lived ruler, some dispossessed Atahualpa, his mouth rent gulfwise; two others of an abnormal, gibbous geometry." Halperin 1988, 214.

12 Theo sold this painting in June 1889 for 300 francs to the collector Henri Lerolle, a good friend of Degas and Renoir. Gauguin received 225 francs. See also no. GAC 3 in Cooper 1983, 45.

13 To underscore the urgency of his request, Van Gogh enclosed 50 francs. See also Vincent van Gogh to Émile Bernard, Arles, c. 22 May 1888, no. 612 in Gogh 2009, and Vincent to Theo van Gogh, Arles, 18 September 1888, no. 682 in Gogh 2009.

14 No. b 4523 in Van Gogh Family Archives: "meer onder ons bereik."

15 Ibid., Theo to Wil van Gogh, Paris, 6 December 1888, no. b 916: "niet te beschrijven is wat er in al die schilderijen is, maar het blijkt dat hij nog grooter is dan wie ook gedacht had . . . troostwoorden . . . tot hen die niet gelukkig of gezond zijn. Bij hem spreekt de natuur zelf terwijl bij Monet men den maker der schilderijen hoort spreken."

16 See Renié 1994, 96–97.

17 On this subject, see also pp. 139, 144. in this catalogue, as well as Sheon 2000, 52–61.

18 Theo to Vincent van Gogh, Paris, 16 June 1889, no. 781 in Gogh 2009. See also Chronology, p. 198.

19 Gauguin to Émile Schuffenecker, June 1889, Chronology, p. 197.

20 Gauguin to Theo van Gogh, 10 June 1889, no. b 858 in Van Gogh Archives: "avec régret."

21 Theo to Vincent van Gogh, Paris, 22 December 1889, no. 830 in Gogh 2009.

22 Ibid., Theo to Vincent van Gogh, Paris, 5 September 1889, no. 799.

23 Ibid., Theo to Vincent van Gogh, Paris, 22 October 1889, no. 813.

24 Ibid., Theo to Vincent van Gogh, Paris, 5 September 1889, no. 799.

25 Ibid., Theo to Vincent van Gogh, Paris, 16 November 1889, no. 819.

Gauguin Becomes a Printmaker (pp. 87–117)
Heather Lemonedes

1 For a discussion of lithography of the period, see Johnson 1977.

2 For a thorough discussion of the Voyages pittoresques, see Twyman 1970.

3 Caricatures such as those of Honoré Daumier and Paul Gavarni, published in journals such as La Caricature and Le Charivari throughout the middle of the 19th century, are exceptions.

4 The midcentury decline of original lithographs is illustrated by the fact that reproductive lithographs made by professional printmakers were shown at the Exposition Universelle of 1855, but no original lithographs were exhibited.

5 Burty 1861, 177: "La lithographie se meurt aussi par l'oubli des grands principes qui doivent présider à toute œuvre d'art. Les peintres seuls pourraient lui rendre la vie." All translations from the French are by the author unless noted otherwise.

6 For the definitive study of the Société des Aquafortistes, see Bailly-Herzberg 1972. See also Weisberg 1971; Melot 1980; and Eugenia Parry Janis, "Setting the Tone—The Revival of Etching, The Importance of Ink," in Painterly Print.

7 For literature on lithographs of this period, see Porzio 1982 and Melot 1996.

8 Manet had long been an admirer of Poe; one of his first prints was an etched portrait of the poet based on a daguerreotype, possibly intended to illustrate an edition of Baudelaire's articles on Poe.

9 For essays on Manet's Le Corbeau, see Jay McKean Fisher, "Manet's Illustrations for 'The Raven': Alternatives to Traditional Lithography," in Gilmour 1988, 91–109; and Melissa De Mederios, " 'A New Order of Beauty'—Manet, Mallarmé, and Poe," in Roos 1999, 61–67.

10 Phillip Dennis Cate points out that by working in almost every genre of printed image that was available to progressive artists of the 1890s—poster, music-sheet cover, multi-artist album, single-artist album, book cover and text illustration—Manet had paved the way for artists of the next generation. Cate 2000, 15.

11 Ibid.

12 Manet was not merely an artistic mentor of Gauguin's youth. During the winter of 1890–91 in Paris, Gauguin painted a copy of Manet's Olympia, which since November 1890 had been installed in the Musée de Luxembourg. Gauguin's copy was purchased by Degas in 1895 in the auction organized to help fund Gauguin's final trip to the South Seas.

13 Druick 1979, pp. i–ii.

14 Leroi 1886, 36: "Si la lithographie compte de nouveau des traducteurs du mérite le plus distingué, elle a ses créateurs que ne sont certes pas moins brillants. A leur tête se place sans discussion possible M. Fantin-Latour."

15 "I had earlier tried, in vain, to show in the official Salons with the numerous drawings I had already completed, which were lying dormant in my folios. Fantin-Latour gave me the excellent advice to reproduce them in lithographic crayon; he gave me, out of kindness, a sheet of transfer paper to make the tracing. I therefore made my first lithographs in order to multiply my drawings." Odilon Redon to André Mellerio, 21 July 1898, in Redon 1923, 30.

16 See Starr Figura, "Redon and the Lithographed Portfolio," in Hauptman 2005, 76–95; and Kevin Sharp, "Redon and the Marketplace before 1900, " in Druick 1994, 237–56.

17 Gauguin, "Huysmans and Redon," translated in Guérin 1996, 39.

18 Redon and Bacou 1960, 193: "J'emporte en photographies, dessins, tout un petit monde de camarades qui me causeront tous les jours; de vous j'ai un souvenir dans ma tête de tout ce que vous avez fait à peu près, et une étoile; en la voyant dans ma case à Taïti, je ne songerai pas, je vous le promets, à la mort, mais au contraire à la vie éternelle, non la mort dans la vie mais la vie dans la mort. En Europe cette mort avec sa queue de serpent est vraisemblable mais à Taïti, il faut la voir avec des racines qui repoussent avec des fleurs."

19 August Lauzet's Adolphe Monticelli: vingt planches d'après les tableaux originaux de Monticelli et deux portraits de l'artiste (Adolphe Monticelli: Twenty Plates after Original Paintings and Two Portraits by the Artist) followed in 1890.

20 Douglas Druick and Peter Zegers, "Degas and the Printed Image, 1856–1914," in Reed and Shapiro 1984, lvii–lviii.

21 Fénéon 1888, 382: "Quatre lithographies de M. G. W. Thornley, d'après Degas, suscitent, d'une éloquence laconique et essentielle, les originaux."

22 For an analysis of the Salon and its eventual demise during the Third Republic, see Mainardi 1993.

23 The Société des Artistes Lithographes Français was founded in 1884. The 30 founding members included mostly professional reproductive printmakers; although the group claimed credit for an increase in the number of lithographs, it accomplished little in the promotion of original lithography.

24 For literature on L'Estampe Originale, see Stein and Karshan 1970; Baas 1983, 12–27; and L'Estampe Originale.

25 *L'Estampe originale*, 11–12.

26 For a discussion of the six exhibitions of the Société des Peintres-graveurs Français held between 1889 and 1897, and the revival or original printmaking in France in the 1890s, see Leard 1992.

27 Reed and Shapiro 1984, 110–13.

28 Fénéon 1948, 165; quoted in its entirety and translated in Reed and Shapiro 1984, 110.

29 Belinda Thomson made this point in the didactic texts for the exhibition *Gauguin's Vision* at the Royal Scottish Academy Building, Edinburgh, 6 July–2 October 2005.

30 Françoise Cachin, "Degas and Gauguin," in Dumas 1998, 232.

31 Gauguin's relationship with Theo van Gogh is the subject of Chris Stolwijk's essay in this catalogue.

32 Vincent to Theo van Gogh, Arles, 10 or 11 October 1888, no. 706/549 in Gogh 2009.

33 For example see Fred Leeman, "Réussite, et destin d'Emile Bernard," in *Emile Bernard 1868–1941*, 9–12; and Rapetti 2002, 135–49. The full text of Bernard's *L'Aventure de ma vie* remains unpublished. The manuscript is in the collection of the Cabinet de Dessins at the Musée du Louvre. Excerpts from *L'Aventure de ma vie* are published as a forward in Cailler 1954, 11–47.

34 Consider the dialogues between Paul Signac and Henri Matisse, as well as between Pablo Picasso and Julio Gonzales.

35 Gauguin to Schuffenecker, 14 August 1888, in Merlhès 1984, 210; translated in Thomson 1993, 89.

36 Morane 2000, 19.

37 Gauguin to Vincent van Gogh, 17 January 1889, no. 737 in Gogh 2009.

38 Vincent to Theo van Gogh, c. 25 February 1889, no. 748 in Gogh 2009.

39 Émile Bernard, *L'Aventure de ma vie,* quoted and translated in Welsh-Ovcharov 1981, 194.

40 For discussions of *Les Bretonneries,* see Boyle-Turner 1986, 57–64; and Stevens 1990, 268–73.

41 Guérin 1927, 1: 5: "M. Sérusier, qui a connu Gauguin dès 1888, se rappelle fort bien avoir vu les zincographies en 1889 au Pouldu où elles ornaient les salles de l'auberge de Mlle Henry, qu'il habitait en même temps que Gauguin; il croit se souvenir qu'elles avaient été tirées à une trentaine ou à une cinquantaine d'épreuves tout au plus par Ancourt, l'imprimeur-lithographie bien connu, qui plus tard fit tirer par son habile ouvrier Stern un grand nombre des lithographies de Toulouse-Lautrec."

42 In addition to printing most of Toulouse-Lautrec's lithographs, Ancourt also printed complex color lithographs for Bonnard, Vuillard, and Denis, as well as being the primary printer for *L'Estampe originale,* André Marty's nine albums of original prints published between 1893 and 1895. Among the 97 prints in *L'Estampe originale* was Gauguin's *The Spirit of the Dead Watches* (*Manao Tupapau*), 1894, a reprise of his oil painting of the same title from 1892, and the artist's only lithograph on stone.

43 Huyghe 1952, 2: 217.

44 *Calepins du Cadastre,* cote D1P4 388, Archives de Paris.

45 Ibid., *Bottin du Commerce,* 1889, cote 2Mi3/95.

46 Ibid., *Calepins du Cadastre,* cote D1P4 714.

47 Ibid., cote D1P4 1092.

48 Ibid., cote D1P4 1089.

49 My sincere thanks to Louise d'Argencourt for her invaluable assistance researching these addresses.

50 This endeavor was greatly facilitated by the commentary of two professional lithographers: Maggie Denk-Leigh, assistant professor and Printmaking Department head, and Karen Beckwith, technical assistant, Printmaking Department, and Tamarind Master Printer, both at the Cleveland (Ohio) Institute of Art. We are grateful for their generosity and expertise.

51 Although Gauguin may have intended the intentionally enigmatic inscription to print backward, it may also be considered a beginner's mistake.

52 Fleming 1991, 228.

53 Pissarro to Lucien Pissarro, 28 February 1883, in Bailly-Herzberg 1980, 1: 177: "Que je regrette de ne pas voir l'exposition de Whistler, tant au point de vue des fines pointes sèches qu'au point de vue de la mise en scène qui, chez Whistler, est d'une grande importance; il y met même un peu trop de *puffisme* selon moi. A part cela, ce me semble que blanc et jaune doivent être d'un effet charmant; nous avons en effet les premiers fait ces essais de couleurs; ma salle était lilas avec bordure jaune serin, sans papillon."

54 Boyle-Turner 1986, 37. For example, in Louis Gonse's *L'Art japonais* (Paris: Maison Quantin, 1886) the endpapers are brilliant canary yellow and the cardboard covers are wrapped with yellow-gold cloth.

55 Seguin 1903, 165.

56 Rotonchamp 1925, 77.

57 Leclercq 1895, 121. Leclercq does not specify any artists in particular.

58 Frébault 1956, 201–4.

59 Although the papers used in Buhot's *Japonisme* and Gauguin's *Volpini Suite* are similarly colored, they are not the same weight or wove.

60 Buhot's stamped monogram with an owl, printed in red at the lower platemark of his prints, also mimicked the appearance of Japanese collectors' stamps.

61 Druick and Zegers 2001, 393; Brettell 1988, 132.

62 Lethève and Gardey 1967, 14: 282–92.

63 Druick and Zegers 2001, 277.

64 Ibid., 3.

65 Gauguin gave Vincent a Martinique painting, *Riverside* (*Au Bord de la rivière*) (see cat. 81, p. 145).

66 The two canvases are *Two Sunflowers* (*Deux Tournesols*) (The Metropolitan Museum of Art, New York), and *Two Sunflowers* (*Deux Tournesols*) (Kunstmuseum Bern).

67 Vincent to Wil van Gogh, Arles, between 16 and 20 June 1888, no. 626 in Gogh 2009.

68 Gauguin to Vincent van Gogh, between 8 and 16 January 1889, no. 734 in Gogh 2009.

69 Ibid. Van Gogh responded by praising Gauguin's choice. Although Vincent refused to give Gauguin the canvas, he offered to paint him another version. Van Gogh did paint two additional versions of the sunflowers, but Gauguin never

70 Gauguin 1894, 273; translated in Guérin 1996, 246–47.

71 Gauguin 1936, 10.

72 Gauguin listed the names "Choquart"; "Jean" [de Rotonchamp]; "Chamaillard," a Pont-Aven artist; "Portier," an art dealer; and "[Theo] van Gog[h]." Huyghe 1952, 2: 223.

73 Ibid.

74 Lecomte 1926, 32; as quoted in Wildenstein 2002, 2: 585.

75 Guérin 1927, XI: "[Vollard] a vu pour la première fois les épreuves sur papier jaune chez Portier auquel Gauguin en avait confié quelques séries pour les vendre."

76 Gauguin to Pissarro, 1884, no. 49 in Merlhès 1984, 64: "Recommandez bien à Portier de s'occuper de la vente mon Manet; j'ai *besoin d'argent*."

77 Inscription: "Lithographie colorée par Gauguin achetée à la vent de Gauguin Hôtel Drouot par moi, A. Seguin."

78 Ms 421 (1–13), Vollard Archives, Bibliothèque Centrale des Musées Nationaux, Paris.

The Zincographs—A Technical Examination (pp. 105–7)
Moyna Stanton

1 Croft 2003, 11–15. Readers interested in metal-plate lithography should consult this volume.

2 Druick, "Forward," in Boyle-Turner 1986, 14.

3 Tusche can also be dissolved with solvents such as turpentine and mineral spirits to create very different wash effects.

4 For a thorough discussion of the ingredients and properties of tusche, see Antreasian and Adams 1971, 256–57.

5 The first zinc plates were too thick and often impregnated with impurities. The artist/draftsman and printer had to contend with the metal's ready tendency to oxidize and adjust the chemistry for all the processing steps because what was suitable for image formation on stone was not suitable on zinc. Further, initial attempts to print from smooth zinc plates were unsuccessful. Goodman 1914, 2–3.

6 For a discussion of the chemistry for both stone and metal-plate lithography, see Antreasian and Adams 1971, 266–68.

7 Ibid., 127, 140.

8 Working in tusche further complicates this difficulty because, when layering with the liquid medium, the proportional build-up of grease and pigment is not always predictable and can lead to misreading the design, incorrect processing, and a flawed final outcome: darks printing too light or lights printing too dark. Ibid., 258–59.

9 Hullmandel 1833, 27.

10 For additional control Gauguin may also have worked with standard tusche solutions pretested by the printer. Antreasian and Adams 1971, 41.

11 Gauguin likely worked entirely or nearly so with water-based tusche, which implies two things: first, that he did not use lithographic ink such as Charbonnel's Encre Zincographique (a grease-rich liquid ink intended for line work and achieving consistently black marks) and, second, that he did not use tusche blended with organic solvents or at least did not use such mixtures to an appreciable degree. Tusche mixed with organic solvents results in washes that are excessively greasy and more difficult to control on zinc. Still, Gauguin

may have occasionally and sparingly used organic solvents or other ingredients such as salt added to the water washes for further textural effects. My thanks to colleagues in the printmaking department at the Cleveland Institute of Art Margaret Denk-Leigh, lithographer and department head, and Karen Beckwith, lithographer and technical assistant, for taking the time to look closely at the *Volpini Suite* with me and for lending their practical and technical expertise toward this assessment.

12 Croft 2003, 34.

13 Contrary to early interpretation, peau de crapaud is controllable to a great extent. The pitfalls of filling in and scumming, however, are most difficult to control when working with tusche and wash effects such as peau de crapaud. Antreasian and Adams 1971, 140–45.

Gauguin's Yellow Paper (pp. 109–11)
Moyna Stanton

1 Fisher 1985, 53.

2 Bower 2002, 42.

3 Initial efforts to identify the paper using the paper data base at the National Gallery of Art (NGA) in Washington were unsuccessful. Marion Dirda, senior paper conservator at the NGA, and Judy Walsh, associate professor of paper conservation with the Art Conservation Department at Buffalo State College and former senior paper conservator at the NGA, helped with this investigation. Walsh also kindly shared her research material on 19th-century French paper.

4 Information in this section regarding wire profile, fiber composition, and review of potential papermakers was drawn directly from Bower's analysis and research, described in a report submitted to the Cleveland Museum of Art on 29 October 2008. The museum provided a beta radiograph of the paper, magnified detailed images showing the wireside and feltside textures in raking light, and several small unprepared paper samples taken from the edges of two of the zincographs. Bower also received a copy of the paper's XRF spectrum showing the presence of lead and chromium.

5 Wireside and feltside as imparted by the forming wire and drying felts, respectively.

6 A water-droplet test was performed to assess paper absorbency. The manner in which the water forms a bead on the surface of the paper and the paper's resistance to wetting over time indicates that it is a moderately hard-sized paper.

7 Beta radiography is an imaging technique whereby radioactive beta particles pass through a material to expose a piece of x-ray film. In this application, the beta particles are supplied by a beta plate and the material being imaged is a sheet of paper. Beta plates are thin plastic (Plexiglas) sheets labeled with the radioactive isotope carbon-14. As this isotope decays, it emits the high-speed but relatively low-energy beta particles capable of penetrating small distances, depending on the obstructing material's physical density. In the case of paper, close contact between the film, paper, and beta plate is needed to minimize air gaps, which deteriorate image quality. In essence, a beta radiograph sees through the sheet and can clearly record, in a (negative) contact print, characteristics such as laid and chain lines, watermarks, and even subtle woven wire profiles. Kushel 1999, 117–23.

8 Bower 2002, 42.

9 Synthetic organic dyes were of great importance to the manufacture of colored paper in the second half of the 19th

century, often supplanting earlier coloring materials because they offered brilliant, pure shades and excellent coloring power, and were readily soluble and simple to apply. Their main drawback was their poor stability to light. Erfurt 1901, 69–70.

10 Bower 2002, 42.

11 The "beater" refers to the Hollander beater, the machine invented by the Dutch in the late 17th century that cuts, crushes, macerates, fibrillates, and hydrates paper fibers, turning them into pulp suitable for paper formation. During this process additives such as pigments or dyes can be most effectively distributed through the pulp.

12 Julius Erfurt's treatise on paper dyeing describes the essential role of the mordant: "The dyeing of paper pulp is not only a question of forming coloured precipitates, but of obtaining as far as possible, a thorough combination of these precipitates with the fibers, by fixing the soluble colouring matter in an insoluble state on the fibers by means of a mordant." Erfurt 1901, 1.

13 The XRF spectrometer in Cleveland allows for nondestructive testing because the entire object can be placed in front of the x-ray tube and detector. The instrument is capable of detecting elements with atomic number 19 (potassium) on up through the entire periodic table; it is not able to detect organic dye molecules. Bruce Christman, former chief conservator at the Cleveland Museum of Art (CMA), carried out this analysis.

14 This initial finding has been reviewed by Lisha Glinsman, conservation scientist in the Scientific Research Department at the NGA. Glinsman kindly offered to review the CMA XRF spectrum and found that it clearly suggested the presence of chrome yellow. Glinsman confirmed this interpretation by conducting XRF on one of the NGA's *Volpini* sheets: this analysis also showed lead and chromium to be present in proportions consistent with the yellow pigment.

15 SEM-EDS analysis was performed on a very small sample taken from the edge of one of the CMA's *Volpini* sheets. These analytical techniques showed that the particulate deposits on the paper fibers, which appear as bright white spots in the SEM image, are composed of lead and chromium. This analysis was carried out by Lisha Glinsman and Michael Palmer (Palmer is also a conservation scientist with the Scientific Research Division at the NGA). Glinsman and Palmer also examined the sample with polarized light microscopy and again were able to detect the submicron chrome yellow pigment particles (at 160× magnification) and undyed paper fibers (at 64× magnification). As Glinsman and Palmer have interpreted the data, this combined analysis not only confirms the presence of the chrome yellow pigment but also strongly indicates that the paper does not contain any organic dye components.

16 "The darkening or browning (of chrome yellow) is a photochemically induced reaction in which an important part is played by visible as well as ultra-violet radiation. . . . The lead chromes also tend to darken upon exposure to hydrogen sulfide." Herman Kühn and Mary Curran, "Chrome Yellow and Other Chromate Pigments," in Feller 1986, 1: 190–91.

17 For a discussion of Gauguin's palette, see Jirat-Wasiutynski and Newton 2000.

18 Erfurt 1901, 37.

19 Roberts 1924, 29.

20 Erfurt 1901, 35.

21 One drawback of making the pigment in the pulp is the difficulty of maintaining a consistent shade from one batch

to the next: shifts in temperature and alkalinity of the water tend to vary the shade. Roberts 1924, 29.

22 Erfurt 1901, 36.

The Iconography of the *Volpini Suite* (pp. 119–63)
Agnieszka Juszczak

1 Paul to Mette Gauguin, March 1887, no. 122 in Merlhès 1984, 147: "Je m'en vais à Panama pour vivre en sauvage." All translations from the French are by the author, unless noted otherwise.

2 Ibid., Paul to Mette Gauguin, c. 20 June 1887, no. 127, 154–55: "Je ne pourrais te dire mon enthousiasme de la vie dans les colonies françaises et je suis sûr que tu serais la même chose. La nature la plus riche, le climat chaud mais avec intermittence de fraîcheur."

3 Gauguin to Schuffenecker, September 1887, in Thomson 1993, 46: "despite my physical weakness my painting has never been so light, so lucid (with plenty of imagination thrown in)."

4 Gauguin to Schuffenecker, 8 October 1888, no. 168 in Merlhès 1984, 248–49: "J'ai cette année tout sacrifié l'exécution la couleur pour le style voulant m'imposer autre chose que ce que je sais faire. C'est je crois une transformation qui n'a pas porté ses fruits mais qui les portera."

5 Gauguin to Schuffenecker, 8 October 1888, no. 71 in Malingue 2003, 105.

6 The correct spelling of the motto is "Honi [or Honni] soit qui mal y pense." It is impossible to tell whether Gauguin's misspelling was deliberate, but one finds similar mistakes in his correspondence.

7 The titles of the other two subjects are *Long Live the Joys of Love* (private collection) and *The Follies of Love* (private collection).

8 The cover of a suite of prints usually had an illustration related to the theme of the series and listed the names of the artist, lithographer, and publisher, as well as the price and year.

9 Brettell and Fonsmark 2005, 289. Arosa's collection is known from Auguste Demmin, *Histoire de la céramique en planches phototypiques inaltérables* (Paris, 1875).

10 The Neo-Platonic concept of androgyny became popular in Symbolist circles in the late 1880s through the works of Honoré de Balzac and Joséphin Péladan. Gauguin was interested in the idea, partly because of his avowedly platonic love for Madeleine Bernard. He advised her to behave above all like an "androgynous being" and not to conform to the expectations and demands made of women by patriarchal society. Gauguin to Madeleine Bernard, 15–20 October 1888, no. 173 in Merlhès 1984, 256; see Jirat-Wasiutynski 1978, 145–50.

11 Gauguin may have returned to the subject of the dancing girls in the *Volpini Suite* because of the recent interest in the painting by a potential buyer. On the sale, see Gauguin to Theo van Gogh, c. 16 November 1888, no. GAC 8, and c. 21 September 1889, no. GAC 20 in Cooper 1983, 66–73 and 138–45.

12 Gauguin to Theo van Gogh, July 1888, in Thomson 1993, 87: "I am in the middle of painting a picture of three girls dancing a Breton gavotte at haymaking time. I think you will be pleased with it. This painting seems to me quite original and I am fairly happy with my draughtsmanship." Scenes of dancing peasant women mainly belonged to the repertoire of naturalist painters such as Jules Breton and Pont-Aven

artists such as Adolphe Leleux, but Pissarro and Bernard were also regularly inspired by the subject.

13 Gauguin to Bernard, December 1888, no. 78 in Malingue 2003, 116. See also Stolwijk and Thomson 1999, 139.

14 Gauguin to Schuffenecker, late February/early March 1888, no. 141 in Merlhès 1984, 172: "J'aime la Bretagne, j'y trouve le sauvage, le primitif. Quand mes sabots résonnent sur ce sol de granit, j'entends le ton sourd, mat et puissant que je cherche en peinture."

15 On Gauguin and Japanese prints, see Wildenstein 2002, 362. Gauguin would have been able to admire the superb collection of Vincent and Theo van Gogh's ukiyo-e in Arles and Paris. For Vincent's collection, see Van Rappard-Boon 2006.

16 Druick and Zegers 2001, 84–85 and 184.

17 Loti had a special significance for Gauguin because Loti was a seaman and his book Le Mariage de Loti (1880) had described the exotic life of the tropics, which Gauguin had experienced in 1887 on Martinique. Van Gogh's series of portraits of Augustine Roulin (La Berceuse, F 508, F 505, F 506, F 507, F 504) had been directly inspired by Loti. See Vincent to Theo van Gogh, 28 January 1889, no. 743 in Gogh 2009: "On the subject of that canvas, I've just said to Gauguin that as he and I talked about the Icelandic fishermen and their melancholy isolation, exposed to all the dangers, alone on the sad sea, . . . following these intimate conversations, the idea came to me to paint such a picture that sailors, at once children and martyrs, seeing it in the cabin of a boat of Icelandic fishermen, would experience a feeling of being rocked, reminding them of their own lullabies." Van Gogh felt these portraits should be flanked by two paintings of sunflowers to form a triptych based on a consoling Stella maris (the Virgin as the protectress of seafarers). In his book Loti had described a similar statuette flanked by artificial flowers in the middle of a boat's saloon.

18 Stories by Edgar Allen Poe had been translated into French under the title Histoires extraordinaires (1856), with an introductory essay by Charles Baudelaire. The quotation is from Poe 1966, 115. On Gauguin's knowledge of Poe's work see Wildenstein 2002, 2: 538.

19 Vincent van Gogh to Gauguin, 21 January 1889, no. 739 in Gogh 2009: "In my mental or nervous fever or madness, I don't know quite what to say or how to name it, my thoughts sailed over many seas. I even dreamed of the Dutch ghost ship and the Horla, and it seems that I sang then, I who can't sing on other occasions, to be precise an old wet-nurse's song while thinking of what the cradle-rocker sang as she rocked the sailors and whom I had sought in an arrangement of colors before falling ill."

20 Gauguin to Bernard, December 1888, no. 78 in Malingue 2003, 116: "When it comes to colour he is interested in the accidents of the pigment, as in Monticelli, whereas I detest this messing about in the medium, etc."

21 Gauguin to Schuffenecker, early July 1887, no. 129 in Merlhès 1984, 157: "Leurs gestes sont très particuliers et les mains jouent un grand rôle en harmonie avec le balancement des hanches."

22 The desire for the carefree enjoyment of the countryside is best expressed in the Fêtes champêtres by Jean Antoine Watteau and Jean-Honoré Fragonard. The pastoral theme was continued in the 19th century by Camille Corot, whose scenes of nymphs playing in sun-drenched woods and rivers Gauguin greatly admired. See Gauguin to Schuffenecker, 20 December 1888, no. 193 in Merlhès 1984, 306.

23 Paul to Mette Gauguin, early May 1887, no. 52 in Malingue 2003, 81: "To go back to Martinique—that would be an enchanting life. If I could only sell 8,000 francs worth of pictures in France we, that is, all the family, could live as happily as possible. . . . The people are so genial and gay."

24 Gauguin to Schuffenecker, early July 1887, no. 129 in Merlhès 1984, 156: "Ce qui me sourit le plus, ce sont les figures, et chaque jour c'est un va-et-vient continuel de négresses accoutrées d'oripeaux de couleur avec des mouvements gracieux variés à l'infini."

25 Gauguin 1919, 16–17: "She began to recite a fable, one of La Fontaine's, 'The Crickets and the Ants'—a memory of her childhood days with the sisters who had taught her. The cigarette was entirely alight.

 'Do you know, Gauguin,' said the princess in rising, 'I do not like your La Fontaine.'

 'What? Our good La Fontaine?'

 'Perhaps, he is good, but his morals are ugly. The ants . . .' (and her mouth expressed disgust). 'Ah, the crickets, yes. To sing, to sing, always to sing!'

 And proudly without looking at me, the shining eyes fixed upon the far distance, she added. 'How beautiful our realm was when nothing was sold there! All the year through the people sang. . . . To sing always, always to give!' " For the original French, see Gauguin 1929, 40.

26 Gauguin to Theo van Gogh, 4 December 1888, no. GAC 9 in Cooper 1983, 75. Un Pauvresse was shown at the beginning of 1889 at the Les XX exhibition in Brussels under the title Misères humaines. It was also included in the Volpini exhibition with that title. Gauguin jotted down the title Splendeur et misère in his notebook when the canvas was sold to Schuffenecker. Huyghe 1952, 2: 223.

27 Vincent to Theo van Gogh, c. 3 November 1888, no. 717 in Gogh 2009: "But if only you'd been with us on Sunday! We saw a red vineyard, completely red like red wine. In the distance it became yellow, and then a green sky with a sun, fields violet and sparkling yellow here and there after the rain in which the setting sun was reflected."

28 Gauguin's Human Misery is in a long tradition that began with Dürer's famous engraving Melancholia (1514). See Clair 2006.

29 Andersen 1967; Zafran 2001, 84 and 104. Gauguin could also have seen illustrations of the objects in popular magazines such as L'Illustration. Dorra 1978, 13.

30 Gauguin to Bernard, early November 1888, no. 179 in Merlhès 1984, 275: "C'est un effet de vignes que j'ai vu à Arles. J'y ai mis des Bretonnes—Tant pis pour l'exactitute. C'est ma meilleure toile de cette année." In the painting Pont-Aven, Winter, with Boy and Firewood-Gatherer, 1888 (W. 265/256; National Museum of Western Art, Tokyo) there is a figure in exactly the same pose as the peasant women in the background of Human Misery.

31 Gauguin to Schuffenecker, 22 December 1888, no. 193 in Merlhès 1984, 306. Gauguin writes about Human Misery: "To explain in painting is not the same thing as to describe. This is why I prefer a suggestive color of forms, and in the composition the parable to the painted novel. For many I am in the wrong and it may be that all this is in my imagination, but nevertheless, if I arouse in you a feeling of the beyond, it is perhaps through this magnetic current of thought, the absolute path of which we do not know but can guess. . . . Never mind those who will not be able to decipher them; we must not explain." "Expliquer en peinture n'est pas la même chose que décrire. C'est pourquoi je préfère une

couleur suggestive des formes, et dans la composition la parabole, qu'un roman peint. Pour beaucoup j'ai tort et peut-être tout cela est dans mon imagination, mais cependant si je suscite chez vous le sentiment du au-delà, c'est peut-être par ce courant magnétique de la pensée dont on ne connaît plus la marche absolue mais qu'on devine. . . . Tant pis pour ceux qui ne les pourront lire : nous ne devons pas leur expliquer."

32 See, for example, Andersen 1967 or Dorra 2007, 77–85.

33 Gauguin to Schuffenecker, 20 December 1888, no. 193 in Merlhès 1984, 306: "A percevez-vous dans les Vendanges une pauvre désolée? Ce n'est pas une nature privée d'intelligence, de grâce et de tous les dons de la nature. C'est une femme. Les deux mains sous le menton elle pense à peu de chose, mais sent la consolation sur cette terre (rien que la terre) que le soleil inonde dans les vignes avec une femme habillée de noir passe, qui la regarde comme une sœur."

34 Boyle-Turner (1986, 44) points out that an unmarried Breton woman always wore a head-covering. Anyone without a headcovering was regarded as sexually provocative. For the symbolism of the figure, see also Dorra 1978, 14–15.

35 Interestingly, neither The Laundresses nor Arlésiennes, Mistral was included in the Volpini exhibition, perhaps because the prints reproduced the compositions almost exactly.

36 Van Gogh portrayed laundresses along the canal in several paintings including The Canal La Roubine du Roi with Washerwomen, 1888 (private collection, New York); The Langlois Bridge at Arles with Women Washing, 1888 (Kröller-Müller Museum); The Langlois Bridge at Arles, 1888 (private collection) and the related drawing The Langlois Bridge, 1888 (private collection). For a discussion of Bernard's The Washing, see Boyle-Turner 1986, 56.

37 Ibid., 44.

38 Ibid., 45.

39 George Sand recounts the legend "Les laveuses de nuit ou lavandières" in Légendes rustiques (1858). The painting Washerwomen of the Night, Breton Ballad by Yan Dargent was exhibited at the Salon in 1861. Delouche 1988, 124, 161.

40 Gauguin to Bernard, October 1888, no. 176 in Merlhès 1984, 270: "Les femmes sont ici avec leur coiffure élégante, leur beauté grecque, leurs châles formant plis comme les primitifs, sont, dis-je, des défilés grecs."

41 For Van Gogh's portraits of Mme Ginoux, see L'Arlésienne: Madame Ginoux with Books, 1888 (The Metropolitan Museum of Art, New York) and L'Arlésienne: Madame Ginoux with Gloves and Umbrella, 1888 (Musée d'Orsay, Paris).

42 Gauguin to Theo van Gogh, 4 December 1888, no. GAC 9.1 in Cooper 1983, 75. The Alyscamps was a cemetery dating back to classical times and a trysting place in Arles. The "Temple of Venus" was in fact the 12th-century church of Saint-Honorat.

The Legacy of the Volpini Suite (pp. 165–91)
Heather Lemonedes

1 Maurer 1998, 125.

2 Bogomilia Welsh-Ovcharov suggests this figure anticipated the figure in In the Waves. See Welsh-Ovcharov, "Paul Gauguin's Third Visit to Brittany," in Zafran 2001, 22.

3 Gauguin to Bernard, September 1890, no. 112 in Malingue 2003, 151.

4 Gauguin to Theo van Gogh, mid-September 1890, no. 27 in Cooper 1983, 195: "Je suis en train de terminer un bois sculpté que je crois plus beau que le premier." All translations from the French are by the author unless noted otherwise.

5 According to a letter from Sylvie Crussard of the Wildenstein Foundation dated 25 May 1990, this painting will be included a forthcoming volume of the catalogue raisonné of the works of Paul Gauguin being prepared by the Wildenstein Institute, Paris.

6 This heretofore unpublished work will be included in a forthcoming volume of the catalogue raisonné of the works of Paul Gauguin being prepared by the Wildenstein Institute, Paris.

7 For a discussion of the Gauguin's and his friends' decorations for the dining room of the Inn of Marie Henry, see Robert Welsh, "Gauguin and the Inn of Marie Henry at Pouldu," in Zafran 2001, 61–71.

8 Guérin 1927, 1: X.

9 Shackelford and Frèches-Thory 2004, 43.

10 Gauguin's first version of this subject, Women on the Beach (Deux Femme sur la Plage), 1891 (W. 434; Musée d'Orsay, Paris), was sold to Charles Arnaud, who was serving in the French Foreign Legion in Tahiti. The artist intended the replica, What News?, to be exhibited in Copenhagen and Paris.

11 Brettell 1988, 349.

12 Ibid., 349.

13 Prather and Stuckey 1987, 230.

14 For discussions of Noa Noa, see Field 1968, 500–511; Kornfeld 1988, 48–115; Brettell 1988, 317–29; Christopher Conrad, "Technique as Stimulus for the Artist's Imagination—Gauguin's Print Oeuvre," in Becker 1998, 107–46; Barbara Stern Shapiro, "Shapes and Harmonies of Another World," 206–21, and Isabelle Cahn, "Noa Noa: The Voyage to Tahiti," 91–113, in Shackelford and Frèches-Thory 2004; and Richard R. Brettell, "Gauguin and Paper. Writing, Copying, Drawing, Painting, Pasting, Cutting, Wetting, Tracing, Inking, Printing," in Eisenman 2007, 59–67.

15 Paul to Mette Gauguin, October 1893, no. 143 in Malingue 2003, 187.

16 Following legal disputes with Mette Gauguin, her sons, and Charles Morice, Georges-Daniel de Monfreid finally succeeded in publishing the book with Editions Crès in 1924, but it was illustrated—ironically—not with Gauguin's 10 woodcuts but with 24 woodcuts created by Monfreid himself. Isabelle Cahn describes the frustrated collaboration between Gauguin and Morice and the tortured history of Gauguin's manuscript in Cahn, "Noa Noa," 92–113.

17 After printing a number of impressions of the woodcuts himself, in 1894 Gauguin envisioned a deluxe edition of Noa Noa and thus commissioned Louis Roy—who had been among the eight exhibitors at the Café des Arts in 1889—to print an edition of about 25 to 30 impressions on heavy Japan paper in black, orange, red, and yellow.

18 Rippl-Rónai recalled: "I went to see him one evening . . . Gauguin himself was busy at the foot of the bed, reproducing one of his typical woodcuts. As soon as he had finished printing the block he was at work on, we shook hands. . . . As a souvenir he gave me three copies of his woodcuts, printed in a primitive way by using the foot of his bedstead as a press." Prather and Stuckey 1987, 229–30.

19 Inscribed on an impression of Fragrant Isle (Nave Nave Fenua) in the National Gallery of Art, Washington. Kornfeld 1988, 56.

20 Field 1968, 504.

21 The number of woodcuts included in the Suite Vollard has been disputed. In the 1988 catalogue raisonné of Gauguin's prints, Kornfeld, Mongan, and Joachim argue that there are 17 in the group. Conrad concurs that there were 17, but Brettell and Shapiro assign 14 to the suite. See Kornfeld 1988, 155; Conrad, "Technique as Stimulus for the Artist's Imagination," 138–45; Brettell 1988, 428–45; and Shapiro, "Shapes and Harmonies of Another World," 206–21.

22 Rewald 1943, 33.

23 Hoog 1987, 231.

24 Wildenstein 1964, 213–15.

25 Gauguin first portrayed the calvary in The Green Christ (Breton Calvary), 1889 (W. 329; Musées Royaux des Beaux-Arts de Belgique).

Chronology (pp. 193–213)
Belinda Thomson

1 No. 35 in Cooper 1983, 262–63.

2 No. 748 in Gogh 2009.

3 No. LXXX in Malingue 1946, 157, misdated to February 1889.

4 "Buffalo Bill" Cody gave twice daily performances at the Neuilly stadium, Avenue des Ternes, of his spectacular Wild West rodeo. The event involved herds of buffalo and a troupe of American Indians.

5 No. LXXXI in Malingue 1946, 157–58, misdated to March 1889. We know from these two short letters to Bernard that in May 1889, before leaving Paris, Gauguin visited the Exposition Universelle several times and went at least twice to see Buffalo Bill's rodeo out at Neuilly.

6 The Tuesday he planned to leave Paris was presumably 28 May (he was already in Brittany by Tuesday, 4 June).

7 This key letter about the organization of the Volpini show was first published in Malingue 1946, no. LXXVII, 152–53, with some errors and misdated to Arles, December 1888. It was corrected, located to Pont-Aven and redated to early June 1889 in Merlhès 1989, 25–27. Given the discrepancy between the list of invited artists and the works Gauguin mentions and the eventual make-up of the exhibition, clearly adjustments and new decisions were made in the interim; some works may have been added after the opening of the exhibition on 10 June.

8 At this date Gauguin seems to be ignorant of the name of Schuffenecker's friend, Léon Fauché.

9 Hitherto dated 20 May 1889, in view of the dating of Gauguin's letter (see above) from Pont-Aven, a later date, c. 4 June 1889, would seem appropriate: the participants have been defined and Bernard anticipates the Volpini exhibition will open the following Thursday (presumably 6 June). The exhibition in fact opened on Monday, 10 June. Partially published in English (Rewald 1978, 260), the full text of the original letter will be published in a forthcoming book, Correspondance d'Emile Bernard, edited by Sarah Linford, Neil McWilliam, and Laure Maire-Harscoët, due out in 2010.

10 Unless Bernard was under the impression that Roy's first name was Vincent, it would appear that he was still expecting Vincent van Gogh to be among the exhibitors. It was presumably only when he and Schuffenecker went to Theo to borrow his pictures and others on behalf of Gauguin, that they would have encountered his refusal. Theo informed Vincent of his decision in a letter of 16 June 1889. Interestingly, as yet the word "synthetist" had not been added to the exhibition's title.

11 Vincent to Theo van Gogh, 9 June 1889, no. 779 in Gogh 2009.

12 Thalie Rapetti (Rapetti 2007, 64 n 165) refers to this article.

13 Merlhès 1995, 30.

14 The word "Christ" is crossed out.

15 Reference to Charles Laval and Meyer de Haan who are with Gauguin in Brittany at the time of writing. None of these three artists could have seen the Volpini exhibition at this date. De Haan made a visit to Paris in August specifically to see the Volpini exhibition.

16 No. 13B in Cooper 1983, 92–99.

17 Theo to Vincent van Gogh, 16 June 1889, no. 781 in Gogh 2009. Later in this letter Theo states that Gauguin left Paris for Pont-Aven a fortnight earlier.

18 Ibid., Vincent to Theo van Gogh, c. 18 June 1889, no. 782.

19 This seems to be a damning by inference of Schuffenecker.

20 Unpublished, this section is reproduced in the sale catalogue of 18 December 1985 of the Parisian firm Ader, Picard, Tajan.

21 Presumably this hastily produced sketch was Aux Roches noires, the drawing used to illustrate the Volpini exhibition catalogue; the catalogue illustrations by the various artists involved also appeared in Le Moderniste.

22 Neither this recriminatory letter to Bernard with its laconic list of urgent demands nor Bernard's wounded reply are known. However their tone and content can be inferred from the placating letter Gauguin wrote to Bernard shortly after.

23 This is a reference to the short-lived journal Le Fifre in which Forain published satirical drawings.

24 No. CVIII in Malingue 1946, 196–97, misdated July 1890.

25 No. 14 in Cooper 1983, 101.

26 Paul Sérusier to Maurice Denis, Jour de Venus 1889, in Sérusier 1950, 39–41.

27 Mentioned in his letter of August to Bernard in which he also acknowledges receipt of Le Moderniste, issue no. 14 (27 July), containing the first part of Bernard's article. No. LXXXIV in Malingue 1946, 163.

28 Vincent to Theo van Gogh, no. 797 in Gogh 2009; no. 16 in Cooper 1983, 119.

29 First published in Dorra 1955, 259–60. The date of this letter can be approximated from its contents. Bernard says he has spent two months in Paris (presumably June and July) looking at the Exposition Universelle and is now in Saint-Briac. The letter begins by quoting Gauguin's last letter, written in August, back at him. No. LXXXIV in Malingue 1946, 162–63.

30 No. LXXXVII in Malingue 1946, 166–68, dated early September 1889

31 Jansen 2007, 361–65.

32 Letter cited by Rewald 1956, 265.

33 No. XCVII in Malingue 1946, 180, misdated December 1889.

34 Reference to Aurier's review of art at the Salon, "La Peinture à l'Exposition," in *La Pléiade* (September 1889): 102–4, and to *Le Moderniste*.

35 No. LXXXVI in Malingue 1946, 164–65, where it was dated 1 September 1889; original in Louvre, Cabinet des dessins, RF 28885.

36 Gauguin to Theo van Gogh, between late August and 21 September, nos. 16, 18, 19, 20 in Cooper 1983, 116–19, 126–45.

37 No. XC in Malingue 1946, 170; original in Louvre, Cabinet des dessin, RF 28873. Wildenstein 2002 (2: 416) proposed a dating of 19–20 October.

38 Testified by a letter of Vincent Van Gogh to Bernard, c. 8 October 1889, no. 21 in Jansen 2007, 326.

39 *Paul Sérusier*, 64.

40 Gauguin to Bernard, October 1889, no. LXXXIX in Malingue 1946, 169.

41 Written c. 26 November 1889, no. 22 in Jansen 2007, 336 ff.

42 According to Brincourt 1890, 244. Added to this figure were the many nonpaying visitors.

43 No. XCV in Malingue 1946, 178.

44 No. LXXXII in ibid., 158–61, misdated end of June 1889.

45 Merlhès 1995, 73.

46 Unpublished, omitted from Segalen 1930 and Joly-Segalen 1950; original letter consulted in Institut Néerlandais, Paris.

47 These remarks, so dismissive of Schuffenecker's misguided attitude to exhibiting, seem to hark back to the time of the Volpini exhibition.

48 Published in Segalen 1930, 149–50; original letter consulted in Institut Néerlandais, Paris.

49 Despite what he said about Schuffenecker, Gauguin clearly valued the opportunities offered by world's fairs to interest a new, broader foreign audience in his works.

50 We are grateful to Clément Siberchicot for providing the exact reference to this illustration, first illustrated in Merlhès 1995.

51 This promised follow-up article never appeared.

52 Articles partially reprinted in Guérin 1974, 47–52. Translated by Eleanor Levieux in Guérin 1996, 28–32, 34–36.

53 We are much indebted to Clément Siberchicot for making this text available.

54 Contrary to what Retté thought, only one of the pictures he describes was by Gauguin. The works can be identified as *Les Palmes* by Laval; *Ramasseuses de Varech, Yport* by Schuffenecker; either *Falaises, Yport* or *Rochers, Yport* by Schuffenecker; *Les Mangos, Martinique* by Gauguin.

55 This review in a Dutch architectural journal was discovered by Agnieszka Juszczak.

56 Partially reprinted in Guérin 1996, 34–36.

57 In fact three Monets were shown. See chapter one (Thomson) in this catalogue.

58 Translated in part in Prather and Stuckey 1987, 130–31.

59 Either this was a misprint or Denis got the date of Dujardin's article wrong. It was actually published in March 1888.

60 Reprinted in Denis 1920, 199–210.

61 Rotonchamp 1925, 65–68.

62 Reprinted in Denis 1920, 262–78.

An Exegesis of the Volpini Exhibition (pp. 215–25)
Belinda Thomson

1 For Gauguin, the two "W." numbers refer, respectively, to the 1964 and 2002 editions of the catalogue raisonné of his paintings published by the Wildenstein Institute, Paris. For full details, see Works Cited. In most cases the identifications tally with those in the 2002 catalogue. For the letter from Gauguin to Schuffenecker listing his planned exhibits, see Chronology, pp. 194–96.

2 Probably the work described by Gauguin to Schuffenecker as "The Breton Women (1 standing, 1 lying on the ground)."

3 Probably the work Gauguin described to Schuffenecker as "The Arles landscape that you have, with bushes?" No. 38, *Landscape from Arles,* is the painting Gauguin described in the same letter as "The Arles farmhouses at Van Gogh's."

4 While this identification is by no means certain, the catalogue's *Portrait, Arles* is not likely *Portrait of Madame Roulin,* 1888 (W. 298/327, oil on canvas, 49 × 62.5 cm, Saint Louis Art Museum), because of that painting's provenance with the Roulin family until 1895.

5 In his letter to Schuffenecker, Gauguin lists "The big Breton [painting?] with the little boy (no. 30 canvas)." If one assumes he omitted the word "painting" or "landscpe" after "big," this painting could be identified as *Swineherd.*

6 The standard reference work on Schuffenecker's paintings is Grossvogel 2000, although it omits several of the works illustrated here.

7 Corresponds to Schuffenecker's illustration in the Volpini catalogue and to the Jeanniot illustration.

8 Suggested by Clément Siberchicot.

9 Suggested by Clément Siberchicot.

10 Identified by Clément Siberchicot from the asymmetrical portrait in the Jeanniot illustration.

11 For the Bernard identifications, we are indebted to the suggestions made in Welsh-Ovcharov 1981. See also Luthi 1982.

12 If this is the painting exhibited in the Volpini show, the ownership ascribed to Madame Berthe must be assumed to be a subterfuge since Gauguin owned the painting.

13 The proposal that the large Breton manor house seen in this painting, and in no. 76, represents the so-called Château de Kerlaouen is based on its inscription "au copain Moret." In 1888 Henry Moret rented a studio from the Pont-Aven harbor master, René-Jean Kerluen, which became a meeting place for the Gauguin circle of artists. This house was on the road to Concarneau. See *Henry Moret,* 7.

14 Identifiable from the Jeanniot illustration (cat. 48, frontispiece and p. 67).

15 Exhibited in *Les Amis de Van Gogh,* Institut Néerlandais (Paris, 1960), no. 14, Coll. Williame, Chateauroux.

16 See note 13.

17 For Anquetin, see *Anquetin*.

18 According to Welsh-Ovcharov 1981, 239.

19 Cats. 4 and 5 are possibly identifiable with these two equine studies, visible in a photograph of Anquetin's studio taken around 1891–92; *Anquetin,* Doc. 4, p. 14. Photo Bogomila Welsh-Ovcharov. Their approximate dimensions appear to be 40 × 50 cm.

20 Described in Jules Antoine, "Impressionistes et synthétistes," *Art et Critique,* no. 24 (9 November 1889): 370: "oeuvre de peintre, simplement, . . . j'aime mieux ça" (simply the work of a painter, . . . I like that better). See Chronology, pp. 208–9.

21 For the Laval identifications, we are indebted to Siberchicot 2007.

22 Formerly attributed to Gauguin: Wildenstein 1964 (W. 220, S. 6) (illustration from Charles Estienne, *Gauguin*); for attribution to Laval, see Pope 1983, 244–48.

23 Suggested by Clément Siberchicot.

24 Presumably a late entry since the canvas is dated "14 juin 1889." For de Monfreid, see Pessay-Lux and Lepage 2003.

Works Cited

1889 La Tour Eiffel
1889 La Tour Eiffel et l'Exposition Universelle. Exh. cat., Musée d'Orsay. Paris: Editions de la Réunion des Musées Nationaux, 1989.

Andersen 1967
Andersen, Wayne V. "Gauguin and a Peruvian Mummy." *Burlington Magazine* 109, no. 769 (April 1967): 238–42.

Anquetin
Anquetin: La Passion d'être Peintre. Catalogue by Frédéric Destremau. Paris: Brame & Lorenceau, 1991.

Antoine 1889
Antoine, Jules. *Art et Critique* (9 November 1889): 370.

Antreasian and Adams 1971
Antreasian, Garo Z., and Clinton Adams. *The Tamarind Book of Lithography.* New York: Abrams, 1971.

Aurier 1889
Aurier, Albert. "La Peinture à l'Exposition." *La Pléiade* (1889): 102–4.

Baas 1983
Baas, Jacqueline. "The Origins of l'Estampe Originale." *Bulletin of the University of Michigan Museums of Art and Archaeology* 5 (1983): 12–27.

Bailly-Herzberg 1972
Bailly-Herzberg, Janine. *L'Eau-forte de peintre au dix-neuvième siècle: la société des aquafortistes, 1862–1867.* 2 vols. Paris: Léonce Laget, 1972.

Bailly-Herzberg 1980
Bailly-Herzberg, Janine. *Correspondance de Pissarro, 1865–1885.* Paris: Presses Universitaires de France, 1980.

Becker 1998
Becker, Christoph, ed., *Paul Gauguin: Tahiti.* Exh. cat., Staatsgalerie Stuttgart. Ostfildern-Ruit: G. Hatje, 1998.

Bernard 1889
Bernard, Émile. "Au Palais des Beaux-Arts." *Le Moderniste,* no. 14 (27 July 1889).

Bernard 1939
Bernard, Émile. "Souvenirs inédits sur l'artiste peintre Paul Gauguin et ses compagnons lors de leur séjour à Pont-Aven et au Pouldu." *L'Orient* (1939): 13–15.

Bodelsen 1964
Bodelsen, Merete. *Gauguin's Ceramics: A Study in the Development of His Art.* London: Faber and Faber, 1964.

Bower 2002
Bower, Peter. "Blues and Browns and Drabs: The Evolution of Colored Papers." In Harriet K. Stratis and Britt Salvesen, ed. *The Broad Spectrum,* 42–48. London: Archetype Publications, 2002.

Boyle-Turner 1986
Boyle-Turner, Caroline. *The Prints of the Pont-Aven School: Gauguin and His Circle in Brittany.* Exh. cat., Smithsonian Institution Traveling Exhibition Service. Washington, 1986. Rev. ed. *Gauguin and the School of Pont-Aven: Prints and Paintings.*

Brettell 1988
Brettell, Richard, et al. *The Art of Paul Gauguin.* Exh. cat., National Gallery of At and tour. Washington, 1988.

Brettell and Fonsmark 2005
Brettell, Richard R., and Anne-Birgitte Fonsmark. *Gauguin and Impressionism.* Exh. cat., Ordrupgaard, Copenhagen, and Kimbell Art Museum. New Haven: Yale University Press, 2005.

Brincourt 1890
Brincourt, Maurice. *L'Exposition Universelle de 1889.* Paris: Firmin-Didot, 1890.

Burty 1861
Burty, Philippe. "La Gravure et la lithographie." *Gazette des Beaux-Arts,* 1st per., 11 (1861): 177.

Cahn 2004
Cahn, Isabelle. "Noa Noa: The Voyage de Tahiti." In Shackelford and Frèches-Thory 2004.

Cailler 1954
Cailler, Pierre, ed. *Lettres de Paul Gauguin à Emile Bernard.* Geneva: Pierre Cailler, 1954.

Cariou 2003
Cariou, André. *L'Aventure de Pont-Aven et Gauguin.* Exh. cat., Musée du Luxembourg, Paris, and Musée des Beaux-Arts, Quimper. Milan: Skira, 2003.

Cate 2000
Cate, Phillip Dennis, et al. *Prints Abound: Paris in the 1890s.* Exh. cat., National Gallery of Art. Washington/London: National Gallery of Art/Lund Humphries, 2000.

Clair 2006
Clair, Jean. *Melancholie. Genie und Wahnsinn in der Kunst.* Ostfildern: Hatje Cantz, 2006. Exh. cat., Galeries Nationales du Grand Palais and tour.

Cooper 1983
Cooper, Douglas. *Paul Gauguin: 45 Lettres à Vincent, Théo and Jo Van Gogh.* s'Gravenhage/Lausanne: Staatsuitgeverij/La Bibliothèque des Arts, 1983.

Croft 2003
Croft, Paul. *Plate Lithography.* London: A & C Black, 2003.

De la Faille 1970
De la Faille, J. B. *The Works of Vincent van Gogh. His Paintings and Drawings.* Amsterdam: Meulenhoff International, 1970. First published in 1928 as *L'oeuvre de Vincent van Gogh: catalogue raisonne;* 2d ed. published in 1939 as *Vincent van Gogh.*

Delouche 1988
Delouche, Denise. *Les Peintres et le Paysan Breton.* Baillé, France: URSA/Le Chasse-marée, 1988.

Delouche 1996
Delouche, Denise. *Gauguin et la Bretagne.* Paris: Éditions Apogée, 1996.

Denis 1920
Denis, Maurice. *Theories, 1890–1910. Du symbolisme et de Gauguin vers un nouvel ordre classique.* 4th ed. Paris: Bibliothèque de l'Occident, 1920. Originally published in 1912.

Dorra 1955
Dorra, Henri. "Emile Bernard et Paul Gauguin." *Gazette des Beaux-Arts,* 6th per., 45 (April 1955): 227–46.

Dorra 1978
Dorra, Henri. "Gauguin's Dramatic Arles Themes." *Art Journal* 38 (Fall 1978): 12–17.

Dorra 2007
Dorra, Henri. *The Symbolism of Paul Gauguin. Erotica, Exotica, and the Great Dilemas of Humanity.* Berkeley: University of California Press, 2007.

Druick 1979
Druick, Douglas W. "The Lithographs of Henri Fantin-Latour: Their Place within the Context of His Oeuvre and of His Critical Reputation." Ph.D. diss., Yale University, 1979.

Druick 1994
Druick, Douglas W., et al. *Odilon Redon: Prince of Dreams 1840–1916.* Exh. cat, Art Institue of Chicago and tour. New York: Abrams, 1994.

Druick and Zegers 1991
Druick, Douglas, and Peter Zegers. "Le Kampong et la pagode." In *Gauguin: Actes du colloque, Musée d'Orsay, 1989.* Paris: La Documentation Française, 1991.

Druick and Zegers 2001
Druick, Douglas W., and Peter Kort Zegers. *Van Gogh and Gauguin: The Studio of the South.* Exh. cat., Art Institue of Chicago and Van Gogh Museum. New York/London: Thames and Hudson, 2001.

Dumas 1998
Dumas, Ann, et al. *The Private Collection of Edgar Degas.* Exh. cat., Metropolitan Museum of Art. New York, 1998.

Eisenman 2007
Eisenman, Stephen F., ed. *Paul Gauguin: Artist of Myth and Dream.* Milan: Skira, 2007.

Emile Bernard 1868–1941
Emile Bernard 1868–1941. Rétrospective. Paris: Fondation Mona Bismarck, 1991.

Erfurt 1901
Erfurt, Julius. *The Dyeing of Paper Pulp: A Practical Treatise for the Use of Papermakers, Paperstainers, Students and Others,* ed. and trans. Julius Hübner. 2d ed. London: Scott Greenwood, 1901.

L'Estampe Originale
L'Estampe Originale: Artistic Printmaking in France 1893–1895. Essays by Patricia Eckert Boyer and Phillip Dennis Cate. Exh. cat., Van Gogh Museum and tour. Zwolle/Amsterdam: Waanders/Van Gogh Museum, 1991.

L'Exposition universelle de 1889
L'Exposition universelle de 1889: Les Expositions de l'Etat au Champ de Mars et à l'Esplanade des Invalides. 2 vols. Paris: Imp. des Journaux Officiels, 1890.

Feller 1986
Feller, Robert L., ed. *Artists Pigments: A Handbook of Their History and Characteristics.* London/Washington: Cambridge University Press/National Gallery of Art, 1986.

Fénéon 1888
Fénéon, Félix. "Calendrier de septembre: Les Expositions: VII. Aux vitrines dans la rue—chez M. Van Gogh." *La Revue indépendante* (May 1888): 382.

Fénéon 1889
Fénéon, Félix. "Autre groupe impressionniste." *La Cravache,* no. 437 (6 July 1889).

Fénéon 1948
Fénéon, Félix. "Les Peintres-graveurs." *La Cravache* (2 February 1889). Repr. in Jean Paulhan, ed., *Les Oeuvres de Félix Fénéon.* Paris: Gallimard, 1948.

Fénéon 1970
Fénéon, Félix. *Oeuvres plus que complètes.* 2 vols. Geneva: Droz, 1970.

Field 1968
Field, Richard. "Gauguin's Noa Noa Suite." *Burlington Magazine* 110, no. 786 (September 1968): 500–11.

Fisher 1985
Fisher, Jay McKean. *The Prints of Edouard Manet*. Exh. cat., International Exhibitions Foundation. Washington, 1985.

Flâneur 1889
Flâneur, Luc le [Albert Aurier]. "En Quête des Choses d'Art." *Le Moderniste*, no. 7 (18 May 1889): 55.

Fleming 1991
Fleming, Gordon H. *James Abbott McNeill Whistler, A Life*. New York: St. Martin's Press, 1991.

Frébault 1956
Frébault, E., et al. "Inventaire des biens de Gauguin." *Gazette des Beaux-Arts*, 6th per., 47 (January–April 1956): 201–4.

Frey 1994
Frey, Julia Bloch. *Toulouse-Lautrec. A Life*. London: Weidenfeld and Nicolson, 1994.

Gauguin 1894
Gauguin, Paul. "Natures mortes." *Essais d'art libre* (January 1894): 273.

Gauguin 1919
Gauguin, Paul. *Noa Noa*, trans. O. F. Theis. New York: N. L. Brown, 1919.

Gauguin 1929
Gauguin, Paul. *Noa-Noa. Édition définitive*. Paris: Les Éditions G. Crès et Cie, 1929.

Gauguin 1936
Gauguin, Paul. *Intimate Journals*, trans. Van Wyck Brooks. New York: Crown, 1936.

Gauguin 1950
Gauguin, Paul. *Lettres à Daniel de Monfreid précédés d'un hommage à Gauguin par Victor Segalen*, ed. Annie Joly-Segalen. Paris: G. Falaize, 1950.

Gauguin—Les XX et la Libre Esthétique
Gauguin—Les XX et la Libre Esthétique. Exh. cat., Musée d'Art Moderne et d'Art Contemporain de la Ville de Liège. Liège, 1994.

Gilmour 1988
Gilmour, Pat, ed. *Lasting Impressions: Lithography as Art*. Philadelphia: University of Pennsylvania Press, 1988.

Gogh 2000
Gogh, Vincent van. *The Complete Letters of Vincent Van Gogh*. 3rd ed. 3 vols. Boston: Little, Brown, 2000.

Gogh 2009
Gogh, Vincent van. *The Letters. The Complete, Illustrated and Annotated Edition*, ed. Leo Jansen et al. Amsterdam/The Hague/London: Van Gogh Museum/Huygens Institute/Thames and Hudson, 2009.

Goodman 1914
Goodman, Joseph. *Practical Modern Metalithography*. Letchworth, Herts., Eng.: Garden City Press, 1914.

Gray 1963
Gray, Christopher. *Sculpture and Ceramics of Paul Gauguin*. Baltimore: Johns Hopkins Press, 1963.

Grossvogel 2000
Grossvogel, Jill-Elyse. *Claude-Emile Schuffenecker: Catalogue raisonné*. Vol. 1. San Francisco: Alan Wofsy Fine Art, 2000.

Guérin 1927
Guérin, Marcel. *L'Oeuvre gravé de Gauguin*. 2 vols. Paris: H. Floury, 1927.

Guérin 1974
Guérin, Daniel, ed. *Gauguin: Oviri, écrits d'un sauvage*. Paris, 1974.

Guérin 1996
Guérin, Daniel, ed. *The Writings of a Savage*, trans. Eleanor Levieux. New York: Da Capo Press, 1996.

Halperin 1988
Halperin, Joan Ungersma. *Félix Fénéon: Aesthete and Anarchist in Fin-de-siècle Paris*. New Haven/London: Yale University Press, 1988.

Hauptman 2005
Hauptman, Jodi. *Beyond the Visible: The Art of Odilon Redon*. Exh. cat., Museum of Modern Art. New York, 2005.

Henry Moret
Henry Moret: Un Paysagiste de l'Ecole de Pont Aven. Exh. cat. Musée des Beaux-Arts, Quimper, 1998.

Hoog 1987
Hoog, Michel. *Paul Gauguin: Life and Work*. New York: Rizzoli, 1987.

Homburg 2001
Homburg, Cornelia. *Vincent van Gogh and the Painters of the Petit Boulevard*. Exh. cat., Saint Louis Art Museum and tour. St. Louis, 2001.

Hullmandel 1833
Hullmandel, Charles Joseph. *The Art of Drawing on Stone*. London: Longman, 1833.

Huyghe 1952
Huyghe, René. *Le Carnet de Paul Gauguin*. 2 vols. Paris: Quatre Chemins-Editart, 1952.

Isaacson 1889
J.-J. Isaacson. *De Portefeuille*, 10 August 1889, 233.

Jansen 2007
Jansen, Leo, et al. *Vincent Van Gogh, Painted with Words: The Letters to Émile Bernard*. Exh. cat., Morgan Library and Museum, New York. New York: Rizzoli, 2007.

Jeanniot 1933
Jeanniot, G. [Pierre-Georges]. "Souvenirs sur Degas." *Revue universelle* 55, no. 14 (15 October 1933).

Jirat-Wasiutynski 1978
Jirat-Wasiutynski, Vojtech. *Paul Gauguin in the Context of Symbolism*. New York: Garland, 1978.

Jirat-Wasiutynski and Newton 2000
Jirat-Wasiutynski, Vojtech, and H. Travers Newton Jr. *Technique and Meaning in the Paintings of Paul Gauguin*. Cambridge: Cambridge University Press, 2000.

Johnson 1977
Johnson, William McAllister. *French Lithography: The Restoration Salons, 1817–1824*. Kingston, Ont.: Agnes Etherington Art Center, 1977.

Kahn 1889
Kahn, Gustave. "L'Art français à l'Exposition." *La Vogue* 2, August 1889.

Kornfeld 1988
Kornfeld, Eberhard W., Elizabeth Mongan, and Harold Joachim.

Paul Gauguin: Catalogue Raisonné of His Prints. Bern: Galerie Kornfeld, 1988.

Kushel 1999
Kushel, Dan. "Radiographic Methods Used in the Recording of Structure and Watermarks in Historic Papers." In Franklin W. Robinson and Sheldon Peck. *Fresh Woods and Pastures: Seventeenth-century Dutch Landscape Drawings from the Peck Collection*. Exh. cat., Ackland Art Museum and tour. Chapel Hill, 1999.

Leard 1992
Leard, Lindsay. "The Société des Peintres-Graveurs: Printmaking, 1889–1897." Ph.D. diss., Columbia University, 1992.

Leclercq 1895
Leclercq, Julien. "Exposition Paul Gauguin." *Mercure de France*, no. 13 (1895): 121.

Lecomte 1926
Lecomte, Georges. *Guillaumin*. Paris: Bernheim Jeune, 1926.

Leroi 1886
Leroi, Paul. "Salon de 1886." *L'Art* 41 (1886): 36.

Lethève and Gardey 1967
Lethève, Jacques, and Françoise Gardey. *Inventaire du fonds français après 1800*. Vol. 14. Paris: Bibliothèque Nationale, 1967.

Luthi 1982
Luthi, Jean-Jacques. *Emile Bernard: Catalogue raisonné de l'oeuvre peint*. Paris: Editions Side, 1982.

Mainardi 1993
Mainardi, Patricia. *The End of the Salon: Art and the State in the Early Third Republic*. Cambridge: Cambridge University Press, 1993.

Malingue 1946
Malingue, Maurice, ed. *Lettres de Gauguin à sa femme et à ses amis*. Paris: Editions Grasset & Fasquelle, 1946.

Malingue 2003
Malingue, Maurice, ed. *Paul Gauguin, Letters to His Wife and Friends*, trans. Henry J. Stenning. Boston: MFA Publications, 2003.

Maurer 1998
Maurer, Naomi E. *The Pursuit of Spiritual Wisdom: The Thought and Art of Vincent van Gogh and Paul Gauguin*. Madison/London: Fairleigh Dickinson University Press/Associated University Presses in association with the Minneapolis Institute of Arts, 1998.

Melot 1980
Melot, Michel. *Graphic Art of the Pre-Impressionists*, trans. Robert Erich Wolf. New York: Abrams, 1980.

Melot 1996
Melot, Michel. *The Impressionist Print*, trans. Caroline Beamish. New Haven: Yale University Press, 1996.

Merlhès 1984
Merlhès, Victor. *Correspondance de Paul Gauguin: Documents Témoignages*. Paris: Fondation Singer-Polignac, 1984.

Merlhès 1989
Merlhès, Victor, ed. *Paul Gauguin et Vincent van Gogh, 1887–1888: Lettres retrouvées, sources ignorée*. Papeete, Tahiti: Avant et Après, 1989.

Merlhès 1995
Merlhès, Victor, ed. *De Bretagne en Polynésie: Paul Gauguin. Pages Inédites*. Papeete, Tahiti: Avant et Après, 1995.

Mirbeau 1889
Mirbeau, Octave. "Impressions d'un visiteur." *Le Figaro*, 10 June 1889, 1.

Mirbeau 2005
Mirbeau, Octave. *Correspondence générale*, ed. Pierre Michel. Vol. 2. Lausanne: L'Âge d'Homme, 2005.

Morane 2000
Morane, Daniel. *Emile Bernard, Catalogue raisonné de l'oeuvre gravé*. Exh. cat., Musée de Pont-Aven. Pont-Aven, 2000.

Ory 1989
Ory, Pascal. *La Mémoire des Siècles: L'Expo Universelle*. Brussels/Paris: Ed. Complexe/Presses Universitaires de France, 1989.

Painterly Print
The Painterly Print: Monotypes from the Seventeenth to the Twentieth Century. Exh. cat., Metropolitan Museum of Art and tour. New York, 1980.

Paul Sérusier
Paul Sérusier, 1864–1927. Exh. cat., Musée des Jacobins. Morlaix, France, 1987.

Pessay-Lux and Lepage 2003
Pessay-Lux, Aude, and Jean Lepage. *Georges-Daniel de Monfreid 1856–1929: le confident de Gauguin*. Exh. cat., Musée des Beaux-Arts et de la Dentelle d'Alençon and Musée d'Art et d'Histoire de Narbonne. Paris: Somogy, 2003.

Pickvance 1970
Pickvance, Ronald. *The Drawings of Gauguin*. London/New York/Sydney/Toronto: Paul Hamlyn, 1970.

Poe 1966
Poe, Edgar Allan. *Complete Stories and Poems*. Garden City: Doubleday, 1966.

Pollock 1993
Pollock, Griselda. *Avant-Garde Gambits, 1888–1893: Gender and the Color of Art History*. Walter Neurath Memorial Lecture, London, 1992. New York: Thames and Hudson, 1993.

Pope 1983
Pope, Karen Kristine Rechnitzer. *Gauguin and Martinique*. Ann Arbor: University Microfilms International, 1983.

Porro 1992
Porro, René. *Claude-Emile Schuffenecker, 1851–1934*. Combeau-Fontaine, France: Art Conseil, 1992.

Porzio 1982
Porzio, Domenico, ed. *Lithography: 200 Years of Art, History, and Technique*, trans. Geoffrey Culverwell. New York: Abrams, 1982.

Prather and Stuckey 1987
Prather, Marla, and Charles F. Stuckey. *Gauguin: A Retrospective*. New York, Hugh Lauter Levin Associates, 1987.

Proust 1892
Proust, Antonin. *L'Art sous la République*. Paris, 1892.

Rapetti 2002
Rapetti, Rodolphe. "L'Invention du symbolisme: Paul Gauguin, Emile Bernard, G.-Albert Aurier." In *Symbole in der Kunst*. St. Ingbert: Röhrig Universitätsverlag, 2002.

Rapetti 2007
Rapetti, Thalie, ed. *Chroniques d'art 1887–1904: Jean Lorrain*. Paris: H. Champion, 2007.

Rappard-Boon 1991
Rappard-Boon, Charlotte van, et al. *Catalogue of the Van Gogh Museum's Collection of Japanese Prints*. Amsterdam/Zwolle: Van Gogh Museum/Waanders, 1991. Rev. ed. *Japanese Prints. Catalogue of the Van Gogh Museum's Collection*. Amsterdam/Zwolle: Van Gogh Museum/Waanders, 2006.

Rapport Général
Rapport Général de L'Exposition de 1889. 10 vols. Paris, 1891.

Redon 1923
Redon, Odilon. *Lettres d'Odilon Redon 1878–1916*. Brussels/Paris: G. Van Oest, 1923.

Redon and Bacou 1960
Redon, Ari, and Roseline Bacou. *Lettres de Gauguin, Gide, Huysmans, Jammes, Mallarmé, Verhaeren à Odilon Redon*. Paris: J. Corti, 1960.

Reed and Shapiro 1984
Reed, Sue Welsh, and Barbara Stern Shapiro. *Edgar Degas, the Painter as Printmaker*. Exh. cat., Museum of Fine Arts, Boston, and tour. Boston, 1984.

Renié 1994
Renié, Pierre-Lin. "Goupil et Cie à l'ère industrielle. La photographie appliquée à la reproduction des oeuvres d'art." In Hélène Lafont-Couturier. *État des lieux*, 89–114. Bordeaux 1994.

Rewald 1943
Rewald, John, ed. *Paul Gauguin: Letters to Ambroise Vollard and André Fontainas*. San Francisco: Grabhorn Press, 1943.

Rewald 1958
Rewald, John. *Gauguin Drawings*. New York/London: Thomas Yoseloff, 1958.

Rewald 1973
Rewald, John. "Theo van Gogh, Goupil and the Impressionists." *Gazette des Beaux-Arts*, 6th per., 81 (January–February 1973): 1–108.

Rewald 1978
Rewald, John. *Post-Impressionism: From Van Gogh to Gauguin*. 3rd ed., rev. New York/Boston: Museum of Modern Art/New York Graphic Society, 1978. First published 1956.

Roberts 1924
Roberts, John R. *The Dyeing of Paper*. Wilmington, Del.: E. I. du Pont de Nemours & Co., 1924.

Roos 1999
Roos, Jane Mayo, et. al., *Stéphane Mallarmé: A Painter's Poet*. New York: Hunter College of the City University of New York, 1999.

Rotonchamp 1925
Rotonchamp, Jean de. *Paul Gauguin, 1848–1903*. Rev. ed. Paris: Crès, 1925. Originally published in 1906.

Segalen 1930
Segalen, Victor, ed. *Lettres de Gauguin à Georges Daniel de Monfreid*. Paris, 1930.

Seguin 1903
Seguin, Armand. "Paul Gauguin." *L'Occident* (1903): 165.

Sérusier 1950
Sérusier, Paul. *ABC de la peinture, suivi d'une Correspondence inédite recueillie par Mme P. Sérusier*. Paris: Floury, 1950.

Shackelford and Frèches-Thory 2004
Shackelford, George T. M., and Claire Frèches-Thory. *Gauguin: Tahiti*. Boston: MFA Publications, 2004.

Sheon 2000
Sheon, Aaron. "Theo van Gogh, Publisher: the Monticelli Album." *Van Gogh Museum Journal* (2000): 52–61.

Siberchicot 2007
Siberchicot, Clément. "Charles Laval (1861–1894). Les ateliers parisiens, la Martinique, l'école de Pont-Aven." M.A. thesis, Université Paris X, 2007.

Simpson 1999
Simpson, Juliet. *Aurier, Symbolism and the Visual Arts*. Bern: Peter Lang, 1999.

Stein and Karshan 1970
Stein, Donna M., and Donald H. Karshan. *L'Estampe originale: A Catalogue Raisonné*. Exh. cat. New York: Museum of Graphic Art, 1970.

Stevens 1990
Stevens, MaryAnne. *Emile Bernard 1868–1941: A Pioneer of Modern Art*. Exh. cat., Städtische Kunsthalle Mannheim and Van Gogh Museum, Amsterdam. Zwolle: Waanders, 1990.

Stolwijk 2000
Stolwijk, Chris. "An Art Dealer in the Making: Theo van Gogh in The Hague." *Van Gogh Museum Journal* (2000): 18–27.

Stolwijk and Thomson 1999
Stolwijk, Chris, and Richard Thomson. *Theo van Gogh 1857–1891: kunsthandelaar, verzamelaar en broer van Vincent*. Exh. cat., Van Gogh Museum and Musée d'Orsay. Amsterdam/Zwolle: Van Gogh Museum/Waanders, 1999. English ed. *Theo van Gogh 1857–1891: Art Dealer, Collector and Brother of Vincent*. Amsterdam/Zwolle: Van Gogh Museum/Waanders, 1999.

Thomson 1993
Thomson, Belinda, ed. *Gauguin by Himself*, trans. Belinda Thomson and Andrew Wilson. Boston: Little, Brown, 1993.

Thomson 2005
Thomson, Belinda. *Gauguin's Vision*. Exh. cat., National Galleries of Scotland. Edinburgh, 2005.

Twyman 1970
Twyman, Michael. *Lithography 1800–1850*. London: Oxford University Press, 1970.

Van Rappard-Boon 2006
Van Rappard-Boon, Charlotte, et al. *Japanese Prints. Catalogue of the Van Gogh Museum's Collection*. Rev. ed. Amsterdam/Zwolle: Van Gogh Museum/Waanders, 2006.

Walter 1978
Walter, Elisabeth. "Le Seigneur Roy." *Bulletin des amis du musée de Rennes*, no. 2, "Spécial Pont-Aven" (Summer 1978): 61–72.

Weisberg 1971
Weisberg, Gabriel P. *The Etching Renaissance in France: 1850–1880*. Exh. cat., Utah Museum of Fine Arts and tour. Salt Lake City, 1971.

Welsh-Ovcharov 1981
Welsh-Ovcharov, Bogomila. *Vincent van Gogh and the Birth of Cloisonism*. Exh. cat., Art Gallery of Ontario and Van Gogh Museum. Toronto, 1981.

Wildenstein 1964
Wildenstein, George. *Gauguin*. Paris: Beaux-Arts, 1964.

Wildenstein 2001
Wildenstein, Daniel. *Gauguin, Premier Itinéraire d'un sauvage, catalogue de l'oeuvre peint, 1873–1888.* 2 vols. Contributions by Sylvie Crussard and Martine Heudron. Milan/Paris: Skira/ Wildenstein Institute, 2001.

Wildenstein 2002
Wildenstein, Daniel. *Gauguin: A Savage in the Making: Catalogue Raisonné of the Paintings, 1873–1888.* Trans. Chris Miller. 2 vols. Milan/London: Skira Editore/Thames & Hudson, 2002.

Zafran 2001
Zafran, Eric M., ed. *Gauguin's Nirvana. Painters at Le Pouldu 1889–90.* Exh. cat., Wadsworth Atheneum Museum of Art. New Haven/Hartford: Yale University Press/ Wadsworth Atheneum Museum of Art, 2001.

Archives Cited

Archives de Paris

Van Gogh Family Archives, Van Gogh Museum, Amsterdam

Vollard Archives, Bibliothèque Centrale des Musées Nationaux, Paris

Checklist of the Exhibition

Note to the Reader

This checklist is organized alphabetically by artist; the works are listed chronologically and, when there are multiple works in a given year, in alphabetical order by title. For works by Paul Gauguin, titles follow those given in the catalogues raisonnés, unless the lender specified a different form. The numbers in parentheses after the dates refer to these catalogues raisonnés: Bodleson (1964; ceramics), Cooper (1983; letters to Vincent, Theo, and Jo van Gogh), Gray (1963; sculpture, including ceramics), Guérin (1927; prints), Kornfeld (1988; prints), Pickvance (1970; drawings), Rewald (1958; drawings), and Wildenstein (1964/2002; paintings). Complete citations for these publications are listed by author in Works Cited.

Louis Anquetin (French 1861–1932). *Avenue de Clichy,* 1887, oil on canvas, 69 × 53 cm. Wadsworth Atheneum Museum of Art, Hartford, The Ella Gallup Sumner and Mary Catlin Sumner Collection Fund, 1966.7. (Cat. 51, p. 73)

Émile Bernard (French 1868–1941). *Woman with Geese* (*La Gardeuse d'Oies*), c. 1886, watercolor on glass, 13 × 18 cm. Musée Départemental Maurice Denis "Le Prieuré," Saint-Germain-en-Laye, PMD 979.3.1. Amsterdam only. (Cat. 73, p. 133)

Émile Bernard. *Quai de Clichy,* 1887, oil on canvas, 39 × 59 cm. Musée Départemental Maurice Denis "Le Prieuré," Dépôt Musée d'Orsay, Paris, D-PMD 1989-17. (Cat. 45, p. 64)

Émile Bernard. *Breton Women with Seaweed* (*Bretonnes au Goémon*), 1888, gouache and charcoal on cardboard, 27.8 × 41.2 cm. Musée Départemental Maurice Denis "Le Prieuré," Saint-Germain-en-Laye, PMD 987.5.1. Cleveland only. (Cat. 79, p. 142)

Émile Bernard. *Lane in Brittany* (*Le Chemin au Bretagne*), 1888, pen and ink and watercolor, 30.7 × 20.2 cm. Van Gogh Museum, Amsterdam (Vincent van Gogh Foundation), d 646/V 1962. (Cat. 76, p. 137)

Émile Bernard. *Portrait of Marcel Amillet,* 1888, oil on canvas, 41 × 33 cm. Private collection, Paris. (Cat. 46, p. 65)

Émile Bernard. *La Promenade,* 1888, hand-colored zincograph, 20 × 23.5 cm. Van Gogh Museum, Amsterdam, p 2359 S/2003. (Cat. 93, p. 163)

Émile Bernard. *Washing* (*La Lessive*), 1888, hand-colored zincograph, 10.9 × 39.3 cm. Van Gogh Museum, Amsterdam (Vincent van Gogh Foundation), p 1373 V/2000. (Cat. 89, p. 157)

Émile Bernard. *Les Bretonneries: The Harvesters* (*Les Moissonneurs*), 1889, zincograph, 24.3 × 29.9 cm (image). The Cleveland Museum of Art, Purchase from the J. H. Wade Fund, 2005.180.2.b. (Cat. 59, p. 102)

Émile Bernard. *Les Bretonneries: The Harvesters* (*Les Moissonneurs*), 1889, hand-colored zincograph, 23.8 × 29.8 cm (image), 41.3 × 54 cm (sheet). Indianapolis Museum of Art, Gift of Samuel Josefowitz in tribute to Bret Waller and Ellen Lee, 1998.203. Amsterdam only. (Cat. 60, p. 102)

Émile Bernard. *Les Bretonneries: Return from the Pilgrimage* (*Le Retour du Pardon*), 1889, zincograph, 31.7 × 25 cm (image). The Cleveland Museum of Art, Purchase from the J. H. Wade Fund, 2005.180.1.b. (Cat. 55, p. 100)

Émile Bernard. *Les Bretonneries: Return from the Pilgrimage* (*Le Retour du Pardon*), 1889, hand-colored zincograph, 33 × 25 cm. Van Gogh Museum, Amsterdam, p 484 M/1984. (Cat. 56, p. 100)

Émile Bernard. *Les Bretonneries: Title Page* (*Page de Titre*), 1889, zincograph, 31.5 × 24.8 cm (image). The Cleveland Museum of Art, Purchase from the J. H. Wade Fund, 2005.180.1.a. (Cat. 54, p. 99)

Émile Bernard. *Les Bretonneries: Wedding in Brittany* (*La Noce en Bretagne*), 1889, zincograph, 24.2 × 29.9 cm (image). The Cleveland Museum of Art, Purchase from the J. H. Wade Fund, 2005.180.3.b. (Cat. 61, p. 103)

Émile Bernard. *Les Bretonneries: Woman with Pigs* (*Femmes au Porcs*), 1889, hand-colored zincograph, 24.8 × 31.1 cm (image), 41.3 × 54 cm (sheet). Indianapolis Museum of Art, Gift of Samuel Josefowitz in tribute to Bret Waller and Ellen Lee, 1998.199. Cleveland only. (Cat. 63, p. 104)

Émile Bernard. *Les Bretonneries: Women Hanging Laundry* (*Femmes Étendant du Linge*), 1889, hand-colored zincograph, 24.8 × 31.1 cm (image), 41.3 × 54 cm (sheet). Indianapolis Museum of Art, Gift of Samuel Josefowitz in tribute to Bret Waller and Ellen Lee, 1998.200. Cleveland only. (Cat. 62, p. 103)

Émile Bernard. *Les Bretonneries: Women Making Haystacks* (*Bretonnes Faisant les Foins*), 1889, zincograph, 25.8 × 33 cm (image). The Cleveland Museum of Art, Purchase from the J. H. Wade Fund, 2005.180.3.a. (Cat. 57, p. 101)

Émile Bernard. *Les Bretonneries: Women Making Haystacks* (*Femmes Faisant les Foins*), 1889, hand-colored zincograph, 24.8 × 32.8 cm (image), 41.3 × 54 cm (sheet). Indianapolis Museum of Art, Gift of Samuel Josefowitz in tribute to Bret Waller and Ellen Lee, 1998.202. Amsterdam only. (Cat. 58, p. 101)

Émile Bernard. *Caricature of Paul Gauguin,* 1889, pen and ink and watercolor, 20 × 15.5 cm. William Kelly Simpson, New York. (Cat. 102, p. 178)

Louis Béroud (French, 1852–1930). *The Central Dome at the Exposition Universelle of 1889* (*Le dôme central à l'Exposition Universelle de 1889*), 1889, oil on canvas, 198 × 164.5 cm. Musée Carnavalet—Histoire de Paris, P 2314. Amsterdam only. Cat. 24, p. 37)

Jules Breton (French, 1827–1906). *The Shepherd's Star* (*L'Etoile du Berger*), 1887, oil on canvas, 102.8 × 78.7 cm. Toledo Museum of Art, Gift of Arthur J. Secor, 1922.41. (Cat. 27, p. 40)

Pascal Dagnan-Bouveret (French, 1852–1929). *The Pardon in Brittany* (*La Pardon en Bretagne*), 1886, oil on canvas, 114.6 × 84.8 cm. The Metropolitan Museum of Art, New York, Gift of George F. Baker, 1931 (31.132.34). (Cat. 26, p. 39)

Henri Fantin-Latour (French 1836–1904). *Tannhäuser,* 1886, oil on canvas, 86.4 × 103.3 cm. The Cleveland Museum of Art, Gift of Mr. and Mrs. J. H. Wade, 1916.1038. (Cat. 28, p. 41)

Paul Gauguin (French 1848–1903). *Vase Decorated with Breton Scenes* (*Vase Décoré de Scènes Bretonnes*), 1886–87 (Gray 45), glazed stoneware, h. 29.5 cm. Musées Royaux d'Art et d'Histoire, Brussels, 6756. Amsterdam only. (Cat. 77, p. 138)

Paul Gauguin. *Bather Fan* (*Baignade [II]*), 1887 (W. 216 [1964]), pastel, crayon, gouache, and wash with graphite, 11.5 × 40.5 cm. The Kelton Foundation, Santa Monica. (Cat. 70, p. 129)

Paul Gauguin. *Fruit Picking* or *Mangoes* (*La Cueillette des Fruits* or *Aux Mangos*), 1887 (W. 224/250), oil on canvas, 86 × 116 cm. Van Gogh Museum, Amsterdam (Vincent van Gogh Foundation), s 221 V/1962. Amsterdam only. (Cat. 38, p. 55)

Paul Gauguin. *Head of a Woman, Martinique,* 1887 (Pickvance plate III), chalk and pastel, 36 × 26 cm. Van Gogh Museum, Amsterdam (Vincent van Gogh Foundation), d 664 V/1962. (Cat. 52, p. 78)

Paul Gauguin. *Riverside* (*Au Bord de la Rivière*), 1887 (W. 222/252), oil on canvas, 54 × 65 cm. Van Gogh Museum, Amsterdam (Vincent van Gogh Foundation), s 220 V/1962. Amsterdam only. (Cat. 81, p. 145)

Paul Gauguin. *Bowl with a Bathing Girl* (*Compotier à la Baigneuse*), 1887–88 (Bodelson 41; Gray 50), red-brown stoneware, 29 × 29 cm. Mrs. Arthur M. Sackler. (Cat. 68, p. 126)

Paul Gauguin. *Vase with the Figure of a Girl Bathing under Trees* (*Vase Décoré avec une Baigneuse*), 1887–88 (Bodelson 58; Gray 51), reddish-brown stoneware with brown glaze and gold trim, 19 × 12.8 cm. The Kelton Foundation, Santa Monica. (Cat. 69, p. 128)

Paul Gauguin. *The Arlésiennes (Mistral)* (*Les Arlésiennes [Mistral]*), 1888 (W. 300/329), oil on jute, 73 × 92 cm. The Art Institute of Chicago, Mr. and Mrs. Lewis Larned Coburn Memorial Collection, 1934.391. (Cat. 91, p. 159)

Paul Gauguin. *Breton Girls Dancing, Pont-Aven* (*La Ronde des Petites Bretonnes*), 1888 (W. 251/296), oil on canvas, 73 × 92.7 cm. National Gallery of Art, Washington, Collection of Mr. and Mrs. Paul Mellon, 1983.1.19. (Cat. 36, p. 52)

Paul Gauguin. *Human Misery* (*Misères Humaines*), 1888 (W. 304/317), oil on canvas, 73.5 × 92.5 cm. Ordrupgaard, Charlottenlund, Denmark, 223 WH. Amsterdam only. (Cat. 39, p. 56)

Paul Gauguin. *Landscape from Arles* (*Près d'Arles*), 1888 (W. 309/323), oil on canvas, 72.5 × 92 cm. Nationalmuseum, Stockholm, NM 1735. (Cat. 34, p. 50)

Paul Gauguin. *Landscape from Pont-Aven Brittany* (*Paysage à Pont-Aven, Bretagne*), 1888 (W. 258/273), oil on canvas, 90.5 × 71 cm. Ny Carlsberg Glyptotek, Copenhagen, SMK 3142. (Cat. 35, p. 51)

Paul Gauguin. *The Laundresses* (*Les Laveuses à Arles*), 1888 (W. 303/325), oil on canvas, 74 × 92 cm. Museo de Bellas Artes, Bilbao, 81/18. (Cat. 87, p. 155)

Paul Gauguin. *Self-Portrait* (*Les Misérables*), 1888 (W. 239/309), oil on canvas, 45 × 55 cm. Van Gogh Museum, Amsterdam (Vincent van Gogh Foundation), s 224 V/1962. Amsterdam only. (Cat. 65, p. 121)

Paul Gauguin. *Study for "Breton Girls Dancing, Pont-Aven"* (*Study for "La Ronde des Petites Bretonnes"*), 1888 (not in Rewald or Pickvance), pastel and charcoal, with watercolor and gouache, on cream-colored paper 58.6 × 41.9 cm. Thaw Collection, The Pierpont Morgan Library, New York, EVT 213. Amsterdam only. (Cat. 74, p. 134)

Paul Gauguin. *Study for "Breton Girls Dancing, Pont-Aven"* (*Study for "La Ronde des Petites Bretonnes"*), 1888 (Pickvance plate IV), brush and watercolor over charcoal and pastel, 24 × 41 cm (irregularly shaped). Van Gogh Museum, Amsterdam (Vincent van Gogh Foundation), d 663 V/1963. (Cat. 53, p. 81)

Paul Gauguin. *Study for "Woman with Pigs"* or *The Heat of the Day,* 1888 (Pickvance plate 26; related to W. 301/320), watercolor, 26 × 40 cm. Van Gogh Museum, Amsterdam (Vincent van Gogh Foundation), d 682 V/1962. (Cat. 71, p. 130)

Paul Gauguin. *Young Wrestlers* (*Les Jeunes Lutteurs*), 1888 (W. 273/298), oil on canvas, 93 × 73 cm. Private collection. Cleveland only. (Cat. 37, p. 53)

Paul Gauguin. *Jugs in Stoneware* (*Pots en grès Chaplet*), c. 1888 (Rewald 23; Pickvance 23), gouache, watercolor, and charcoal on Japanese paper, 31.8 × 41.6 cm. Frances Lehman Loeb Art Center, Vassar College, Poughkeepsie, Bequest of Sarah Hamlin Stern class of 1938 in memory of her husband, Henry Root Stern Jr. 1994.2.1. (Cat. 66, p. 123)

Paul Gauguin. *The Bathing Place* (*La Baignade*), 1889 (not in Rewald or Pickvance, but this heretofore unpublished work will be included in a forthcoming volume of the catalogue raisonné of the works by Paul Gauguin being prepared by the Wildenstein Institute as confirmed by correspondence from Joseph Bilbao of 4 February 2009), gouache, watercolor, pastel, and gold paint on green wove paper mounted on panel, 34.5 × 45 cm. Private collection. (Cat. 97, p. 171)

Paul Gauguin. *Breton Eve* (*Ève Bretonne I*), 1889 (W. 333; Rewald 22; Pickvance plate VI), watercolor and pastel, 33.7 × 31.1 cm. McNay Art Museum, San Antonio, Bequest of Marion Koogler McNay, 1950.45. Cleveland only. (Cat. 40, p. 57)

Paul Gauguin. *Breton Girl Spinning* (*Jeune Bretonne au rouet*), 1889 (W. 329), oil on plaster (mural), 116 × 58 cm. Van Gogh Museum, Amsterdam, s 513 S/2006. (Cat. 99, p. 174)

Paul Gauguin. *In the Waves* (*Dans les Vagues*), 1889 (W. 336), oil on canvas, 92 × 72 cm. The Cleveland Museum of Art, Gift of Mr. and Mrs. William Powell Jones, 1978.63. (Cat. 43, p. 61)

Paul Gauguin. *Still Life with Quimper Pitcher* (*Nature morte avec une cruche de Quimper*), 1889 (not in Wildenstein, but accepted by the Wildenstein Institute's Gauguin commission as confirmed by correspondence from Sylvie Crussard of 25 May 1990), oil on canvas, mounted on board, 34.3 × 42 cm. University of California, Berkeley Art Museum and Pacific Film Archive, Anonymous Gift, 1990.11. (Cat. 96, p. 170)

Paul Gauguin. *Volpini Suite: Breton Bathers* (*Baigneuses Bretonnes*), 1889 (Guérin 3; Kornfeld 4A.b), zincograph, 23.5 × 20 cm (image), 49.9 × 65 cm (sheet). The Cleveland Museum of Art, Dudley P. Allen Fund, 1954.55.3. Cleveland only. (Cat. 13, p. 18)

Paul Gauguin. *Volpini Suite: Breton Bathers* (*Baigneuses Bretonnes*), 1889 (Guérin 3; Kornfeld 4A.b), zincograph, 23.5 × 20 cm (image), 50.3 × 65 cm (sheet). Van Gogh Museum, Amsterdam (Vincent van Gogh Foundation), p 2437d V/2004. Amsterdam only. (Cat. 2, p. 14)

Paul Gauguin. *Volpini Suite: Breton Bathers* (*Baigneuses Bretonnes*), 1889 (Guérin 3; Kornfeld 4 A.a), hand-colored zincograph, 24.5 × 20 cm (image), 49.9 × 33.2 cm (sheet). Museum of Fine Arts, Boston, Bequest of W. G. Russell Allen, 60.306. (Cat. 67, p. 125)

Paul Gauguin. *Volpini Suite: Breton Women by a Gate* (*Bretonnes à la Barrière*), 1889 (Guérin 4; Kornfeld 8A), zincograph, 16 × 21.5 cm (image), 50 × 65 cm (sheet). The Cleveland Museum of Art, Dudley P. Allen Fund, 1954.55.4. Cleveland only. (Cat. 17, p. 22)

Paul Gauguin. *Volpini Suite: Breton Women by a Gate* (*Bretonnes à la Barrière*), 1889 (Guérin 4; Kornfeld 8A), zincograph, 16 × 21.5 cm (image), 50.3 × 65 cm (sheet). Van Gogh Museum, Amsterdam (Vincent van Gogh Foundation), p 2437h V/2004. Amsterdam only. (Cat. 6, p. 15)

Paul Gauguin. *Volpini Suite: Breton Women by a Gate* (*Bretonnes à la Barrière*), 1889 (Guérin 4, Kornfeld 8, hand-colored impression unrecorded); hand-colored zincograph,

27 × 31.5 cm (sheet). Private collection, New York. (Cat. 75, p. 136)

Paul Gauguin. *Volpini Suite: Design for a Plate: Leda and the Swan* (*Projet d'Assiette: Léda et le Cygne*), 1889 (Guérin 1; Kornfeld 1A.a), zincograph, 20.2 × 20.3 cm (image), 29.9 × 25.7 cm (sheet). The Cleveland Museum of Art, Dudley P. Allen Fund, 1954.55.1. (Cat. 12, p. 17)

Paul Gauguin. *Volpini Suite: Design for a Plate: Leda and the Swan* (*Projet d'Assiette: Léda et le Cygne*), 1889 (Guérin 1; Kornfeld 1A.a), hand-colored zincograph, 30.1 × 25.9 cm (image), 67 × 103.4 cm (support). Van Gogh Museum, Amsterdam (Vincent van Gogh Foundation), p 2437a V/2004. (Cat. 1, pp. 14, 122)

Paul Gauguin. *Volpini Suite: Dramas of the Sea* (*Les Drames de la Mer*), 1889 (Guérin 8; Kornfeld 3A), zincograph, 17.2 × 27.4 cm (image), 49.7 × 64.9 cm (sheet). The Cleveland Museum of Art, Dudley P. Allen Fund, 1954.55.8. Cleveland only. (Cat. 15, p. 20)

Paul Gauguin. *Volpini Suite: Dramas of the Sea* (*Les Drames de la Mer*), 1889 (Guérin 8; Kornfeld 3A), zincograph, 17.2 × 27.4 cm (image), 50.2 × 65 cm (sheet). Van Gogh Museum, Amsterdam (Vincent van Gogh Foundation), p 2437c V/2004. Amsterdam only. (Cat. 4, p. 14)

Paul Gauguin. *Volpini Suite: Dramas of the Sea* (*Les Drames de la Mer*), 1889 (Guérin 8; Kornfeld 3, hand-colored impression unrecorded), hand-colored zincograph, 18.5 × 27.5 cm (image), 31.6 × 48.5 cm (sheet). Van Gogh Museum, Amsterdam (Vincent van Gogh Foundation), p 2438 V/2004. (Cat. 78a, p. 141)

Paul Gauguin. *Volpini Suite: Dramas of the Sea: Brittany* (*Les Drames de la Mer, Bretagne*), 1889 (Guérin 7; Kornfeld 2A.b), zincograph, 16.6 × 22.6 cm (image), 49.8 × 64.8 cm (sheet). The Cleveland Museum of Art, Dudley P. Allen Fund, 1954.55.7. Cleveland only. (Cat. 16, p. 21)

Paul Gauguin. *Volpini Suite: Dramas of the Sea: Brittany* (*Les Drames de la Mer, Bretagne*), 1889 (Guérin 7; Kornfeld 2A.b), zincograph, 16.6 × 22.6 cm (image), 50.3 × 65 cm (sheet). Van Gogh Museum, Amsterdam (Vincent van Gogh Foundation), p 2437b V/2004. Amsterdam only. (Cat. 5, p. 14)

Paul Gauguin. *Volpini Suite: The Dramas of the Sea: Brittany* (*Les Drames de la mer, Bretagne*), 1889 (Guérin 7; Kornfeld 2, this hand-colored impression unrecorded), hand-colored zincograph, 16.8 × 21.2 cm (image). Albright-Knox Art Gallery, Buffalo, Gift of the ACG Trust 1970, P1970:1.24. (Cat. 78, p. 140)

Paul Gauguin. *Volpini Suite: The Grasshoppers and the Ants* (*Les Cigales et les Fourmis*), 1889 (Guérin 10; Kornfeld 5A.b), zincograph, 20.4 × 26.2 cm (image), 50 × 64.9 cm (sheet). The Cleveland Museum of Art, Dudley P. Allen Fund, 1954.55.10. Cleveland only. (Cat. 19, p. 24)

Paul Gauguin. *Volpini Suite: The Grasshoppers and the Ants* (*Les Cigales et les Fourmis*), 1889 (Guérin 10; Kornfeld 5A.b), zincograph, 20.4 × 26.2 cm (image), 50.3 × 65 cm (sheet). Van Gogh Museum, Amsterdam (Vincent van Gogh Foundation), p 2437e V/2004. Amsterdam only. (Cat. 8, p. 15)

Paul Gauguin. *Volpini Suite: The Grasshoppers and the Ants* (*Les Cigales et les Fourmis*), 1889 (Guérin 10; Kornfeld 5A.a), hand-colored zincograph, 19.3 × 26.7 cm (image). Collection of Irene and Howard Stein. (Cat. 82, p. 147)

Paul Gauguin. *Volpini Suite: Human Misery* (*Misères Humaines*), 1889 (Guérin 5; Kornfeld 11A.b) zincograph, 28.4 × 23.3 cm (image), 49.7 × 64.9 cm (sheet). The Cleveland Museum of Art, Dudley P. Allen Fund, 1954.55.5. Cleveland only. (Cat. 18, p. 23)

Paul Gauguin. *Volpini Suite: Human Misery* (*Misères Humaines*), 1889 (Guérin 5; Kornfeld 11A.b) zincograph, 28.4 × 23.3 cm (image), 50.3 × 65 (sheet). Van Gogh Museum, Amsterdam (Vincent van Gogh Foundation), p 2437k V/2004. Amsterdam only. (Cat. 7, p. 15)

Paul Gauguin. *Volpini Suite: Human Misery* (*Misères Humaines*), 1889 (Guérin 5; Kornfeld 11A.a), hand-colored zincograph, 27.9 × 22.6 cm. Collection of Jill and Michael Wilson. (Cat. 84, p. 151)

Paul Gauguin. *Volpini Suite: Joys of Brittany* (*Joies de Bretagne*), 1889 (Guérin 2; Kornfeld 7A.b), zincograph, 20.2 × 24.1 cm (image), 49.8 × 64.8 cm (sheet). The Cleveland Museum of Art, Dudley P. Allen Fund, 1954.55.2. Cleveland only. (Cat. 14, p. 19)

Paul Gauguin. *Volpini Suite: Joys of Brittany* (*Joies de Bretagne*), 1889 (Guérin 2; Kornfeld 7A.b), zincograph, 20.2 × 24.1 cm (image), 50.3 × 65 cm (sheet). Van Gogh Museum, Amsterdam (Vincent van Gogh Foundation), p 2437g V/2004. Amsterdam only. (Cat. 3, p. 14)

Paul Gauguin. *Volpini Suite: Joys of Brittany* (*Joies de Bretagne*), 1889 (Guérin 2: Kornfeld 7A.a), hand-colored zincograph, 20 × 24.1 cm (image), 30.2 × 30.8 cm (sheet). Museum of Fine Arts, Boston, Bequest of W. G. Russell Allen, 60.304. (Cat. 72, p. 132)

Paul Gauguin. *Volpini Suite: Laundresses* (*Les Laveuses*), 1889 (Guérin 6; Kornfeld 10A.b), zincograph, 20.3 × 26.1 cm (image), 50 × 65 cm (sheet). The Cleveland Museum of Art, Dudley P. Allen Fund, 1954.55.6. (Cat. 21, p. 26)

Paul Gauguin. *Volpini Suite: Laundresses* (*Les Laveuses*), 1889 (Guérin 6; Kornfeld 10A.b), zincograph, 20.3 × 26.1 cm (image), 50.3 × 65 cm (sheet). Van Gogh Museum, Amsterdam (Vincent van Gogh Foundation), p 2437j V/2004. Amsterdam only. (Cat. 10, p. 15)

Paul Gauguin. *Volpini Suite: Laundresses* (*Les Laveuses*), 1889 (Guérin 6; Kornfeld 10 A.a), hand-colored zincograph, 21 × 26 cm (image), 30.5 × 35.3 cm (sheet). Museum of Fine Arts, Boston, Bequest of W. G. Russell Allen, 60.310. Cleveland only. (Cat. 86, p. 154)

Paul Gauguin. *Volpini Suite: Martinique Pastorals* (*Pastorales Martinique*), 1889 (Guérin 9; Kornfeld 6A) zincograph, 17.6 × 22.3 cm (image), 49.8 × 64.7 cm (sheet). The Cleveland Museum of Art, Dudley P. Allen Fund, 1954.55.9. Cleveland only. (Cat. 20, p. 25)

Paul Gauguin. *Volpini Suite: Martinique Pastorals* (*Pastorales Martinique*), 1889 (Guérin 9; Kornfeld 6A) zincograph, 17.6 × 22.3 cm (image), 50.2 × 65 cm (sheet). Van Gogh Museum, Amsterdam (Vincent van Gogh Foundation), p 2437f V/2004. Amsterdam only. (Cat. 9, p. 15)

Paul Gauguin. *Volpini Suite: Old Women of Arles* (*Les Vieilles Filles [Arles]*), 1889 (Guérin 11; Kornfeld 9A.b), zincograph, 19.2 × 20.9 cm (image), 49.8 × 64.8 cm (sheet). The Cleveland Museum of Art, Dudley P. Allen Fund, 1954.55.11. Cleveland only. (Cat. 22, p. 27)

Paul Gauguin. *Volpini Suite: Old Women of Arles* (*Les Vieilles Filles [Arles]*), 1889 (Guérin 11; Kornfeld 9A.b), zincograph, 19.2 × 20.9 cm (image), 50.3 × 65 cm (sheet). Van Gogh Museum, Amsterdam (Vincent van Gogh Foundation), p 2437i V/2004. Amsterdam only. (Cat. 11, p. 15)

Paul Gauguin. *Volpini Suite: Old Women of Arles* (*Les Vieilles Filles [Arles]*), 1889 (Guérin 11; Kornfeld 9A.a), hand-colored zincograph, 19.1 × 21.6 cm. Collection of Jill and Michael Wilson. (Cat. 90, p. 158)

Paul Gauguin. *Self-Portrait*, 1889–90 (W. 297), oil on canvas, 46 × 37 cm. Pushkin State Museum of Fine Arts, Moscow, 3264. (Cat. 98, p. 172)

Paul Gauguin. *Self-Portrait*, 1889–90 (Rewald 26), water-color brush pen and ink on paper, 15.2 × 20 cm. The Triton Foundation, The Netherlands. (Cat. 103, p. 179)

Paul Gauguin. *Be Mysterious* (*Soyez Mystérieuses*), 1890 (Gray 87), polychrome woodcarving, 73 × 95 × 0.5 cm. Musée d'Orsay, Paris, RF 3405. (Cat. 94, p. 167)

Paul Gauguin. *Lust* (*La Luxure*), 1890 (Gray 88), polychrome woodcarving, 70 × 14.7 × 11.7 cm. J. F. Willumsens Museum, Frederikssund, Denmark, G.S. 14. (Cat. 100, p. 175)

Paul Gauguin. *The Ondines*, c. 1890 (Gray 75), polychrome woodcarving, 16.5 × 56.5 cm. Private collection, courtesy Barbara Divver Fine Art. (Cat. 95, p. 168)

Paul Gauguin. *Still Life with Fruit and Spices* (*Pommes et Piments*), 1892 (W. 495), oil on canvas, 31.7 × 66 cm. Private collection, Japan. (Cat. 105, p. 182)

Paul Gauguin. *There Is the Temple* (*Parahi te marae*), 1892 (Rewald 64; Pickvance plate XIV), watercolor over graphite on Japanese paper, 18.5 × 22.9 cm. Fogg Art Museum, Harvard University Art Museums, Cambridge, Bequest of Marian H. Phinney, 1962.42. (Cat. 101, p. 176)

Paul Gauguin. *What News?* (*Parau Api*), 1892 (W. 466), oil on canvas, 67 × 91 cm. Staatliche Kunstsammlungen Dresden, Gemäldegalerie Neue Meister, 2610. Amsterdam only. (Cat. 104, p. 180)

Paul Gauguin. *Portrait of Louis Roy*, 1893 or earlier (W. 317), oil on canvas, 40.5 × 32.5 cm. Private collection, New York. (Cat. 31, p. 46)

Paul Gauguin. *Noa Noa: The Devil Speaks* (*Mahna No Varua Ino*) (recto); *Volpini Suite: Laundresses* (*Les Laveuses*) (verso), 1893–94 (Guérin 32; Kornfeld 19/I), woodcut (recto); zincograph (verso) on yellow paper, 20.2 × 31.8 cm (sheet). The Cleveland Museum of Art, The Jane B. Tripp Charitable Lead Annuity Trust, 2008.149.a–b. (Cat. 108, p. 186)

Paul Gauguin. *Noa Noa: Offerings of Gratitude* (*Maruru*), 1893–94 (Guérin 24; Kornfeld 22/I), woodcut on pink paper, 20.3 × 35.5 cm (image), 20.6 × 36 cm (sheet). The Cleveland Museum of Art, Gift of The Print Club of Cleveland, 1925.987. (Cat. 107, p. 185)

Paul Gauguin. *Noa Noa: Women at the River* (*Auti Te Pape*), 1893–94 (Guérin 96; Kornfeld 16/II/D/b), printed by Pola Gauguin in 1921, woodcut, 20.3 × 35.6 cm. The Cleveland Museum of Art, Dudley P. Allen Fund, 1929.878.4. (Cat. 109, p. 187)

Paul Gauguin. *Young Christian Girl* (*Bretonne en Prière*), 1894 (W. 518), oil on canvas, 65.2 × 46.7 cm. Sterling and Francine Clark Art Institute, Williamstown, acquired in honor of Harding F. Bancroft, Institute Trustee 1970–1987; President 1977–1987, 1986.22. (Cat. 106, p. 183)

Paul Gauguin. *At the Black Rocks* (*Aux Roches Noires*), 1898–99 (Guérin 71; Kornfeld 52, state II/III), woodcut, 10.3 × 18.2 cm. National Gallery of Art, Washington, Rosenwald Collection, 1952.8.233. (Cat. 111, p. 191)

Paul Gauguin. *Human Misery* (*Misères Humaines*), 1898–99 (Guérin 69; Kornfeld 49), woodcut on transparent laid tissue paper, 19.4 × 29.8 cm (block), 22.9 × 30.2 cm (sheet). The Metropolitan Museum of Art, New York, The

Elisha Whittelsey Collection, The Elisha Whittelsey Fund, 1952 (52.608.1). (Cat. 110, p. 190)

Vincent van Gogh (Dutch 1853–1890). *Sorrow,* 1882, lithograph, 39.2 × 29.2 cm. Van Gogh Museum, Amsterdam (Vincent van Gogh Foundation), p2 V/1962. (Cat. 85, p. 152)

Vincent van Gogh. *Sketch of a Memory of the Garden in Etten,* 1888, pen and ink, from letter no. 725/W9, 21.1 × 26.9 cm (folded sheet). Van Gogh Museum, Amsterdam (Vincent van Gogh Foundation), b 709 V/1962. (Cat. 92, p. 160)

Vincent van Gogh. *Washstands at the Canal "La Roubine du Roi,"* 1888, ink on paper, 31.8 × 24.4 cm. Kröller-Müller Museum, Otterlo, The Netherlands, KM 112.856. (Cat. 88, p. 156)

Kuniyoshi Utagawa (Japanese, 1797–1861). *The Sacrifice of Yojibei,* 1849–53, color woodcut, 36.2 × 25.5 cm. Van Gogh Museum, Amsterdam (Vincent van Gogh Foundation), n 436 V/1962, n 437 V/1962, n 438 V/1962. (Cat. 80, p. 143)

Charles Laval (French 1862–1894). *Landscape Martinique* (*Paysage Martinique*), 1887, oil on canvas, 59.7 × 73.1 cm. Van Gogh Museum, Amsterdam (Vincent van Gogh Foundation), s 378 V/1982. (Cat. 83, p. 148).

Charles Laval. *Bathers* (*Baigneuses*), 1888, oil on canvas, 46 × 55 cm. Kunsthalle Bremen, Germany, 1177-1976/2. (Cat. 47, p. 66)

Charles Laval. *Going to Market, Brittany* (*Allant au Marché, Bretagne*), 1888, oil on canvas, 37.5 × 46 cm. Indianapolis Museum of Art, Samuel Josefowitz Collection of the School of Pont-Aven through the generosity of Lilly Endowment Inc., the Josefowitz Family, Mr. and Mrs. James M. Cornelius, Mr. and Mrs. Leonard J. Betley, Lori and Dan Efroymson, and other Friends of the Museum, 1998.178. (Cat. 50, p. 69)

Édouard Manet (French, 1832–1883). *Portrait of Antonin Proust,* 1880, oil on canvas, 129.5 × 95.9 cm. Toledo Museum of Art, Gift of Edward Drummond Libbey, 1925.108. (Cat. 25, p. 38)

Georges-Daniel de Monfreid (French 1856–1929). *Self-Portrait,* 1889, oil on canvas, 63 × 48 cm. Private collection, Paris. (Cat. 32, p. 47)

Émile Renouf (French, 1845–1894). *The Widow of the Island of Sein* (*La Veuve de l'île de Sein*), 1880, oil on canvas, 260 × 170 cm. Musée des Beaux-Arts, Quimper, 55-48. (Cat. 30, p. 43)

Alfred-Philippe Roll (French,1846–1919). *Portrait of Adolphe Alphand,* 1889, oil on canvas, 159 × 127.5 cm. Petit Palais, Musée des Beaux-Arts de la Ville de Paris, PPP00112. Cleveland only. (Cat. 23, p. 32)

Émile Schuffenecker (French 1851–1934). *Still Life with Bowl of Fruit* (*Nature Morte avec Bol et Fruits*), 1886, oil on canvas, 65 × 54 cm. Kröller-Müller Museum, Otterlo, The Netherlands, KM 104.191. (Cat. 44, p. 63)

Émile Schuffenecker. *Rocks at Yport* (*Rochers à Yport*), 1889, oil on canvas, 81.5 × 59.5 cm. Musée Centre-des-Arts, Fécamp, D.07. (Cat. 41, p. 59)

Émile Schuffenecker. *Seaweed Gatherers, Yport* (*Ramasseuses de Varech, Yport*), 1889, charcoal, 29.2 × 22.7 cm. Private collection. (Cat. 49, p. 67)

Documentary Material

Émile Renouf, *The Widow of the Island of Sein,* 1880, wood engraving, 21.8 × 17.9 cm, from *L'Exposition de Paris* (Paris, 1889), 2: 185, Van Gogh Museum (Library), Amsterdam. (Cat. 29, p. 42)

Poster for the Exhibition at the Café des Arts, 1889, lithograph, 28 × 39.7 cm. Pennsylvania State University Libraries, Rare Books and Manuscripts Special Collections, BRH-13. (Cat. 33, p. 49)

P.-G. Jeanniot (French, 1848–1934), *Le Cafe Volpini à l'Exposition Universelle,* in M. Montégut, "La Musique dans les cafés," in F. G. Dumas and L. de Fourcaud, *Revue de L'Exposition Universelle de 1889* (1889), 1: 225, bound book. Rijksmuseum Amsterdam, B/scholen/1248a–b. (Cat. 48, frontispiece and p. 67)

Paul Gauguin to Vincent van Gogh, c. 20 January 1889, letter no. 737 in Gogh 2009, 17 × 22.9 cm. Van Gogh Museum, Amsterdam (Vincent van Gogh Foundation), b 856 V/1962. (Cat. 112, p. 195)

Catalogue de l'Exposition de Peintures du Groupe Impressionniste et Synthétiste (Paris, 1889), bound book. Van Gogh Museum (Library), Amsterdam, bvg 2968 BVG. (Cat. 42, pp. 60, 215)

Émile Zola, *Les Romanciers Naturalistes* (Paris: G. Charpentier, 1881), bound book with yellow cover. Private collection, Cleveland. (Cat. 64, p. 115)

Invitation [to the Volpini exhibition] (*Carton d'invitation*), 1889, relief printed with letterpress, 13.6 × 21.1 cm. Musée Départemental Maurice Denis "Le Prieuré," Saint-Germain-en-Laye, Ms 12681. (Cat. 113, p. 197)

Comparative Illustrations

Fig. 1. Bird's-eye view of the 1889 Paris Exposition Universelle, from Brincourt, *L'Exposition Universelle de 1889* (Paris, 1890)

Fig. 2. Georges Garen, *The Lighting of the Eiffel Tower during the Exposition Universelle of 1889,* print, 52 × 34 cm, Musée d'Orsay

Fig. 3. Pavilion of Annam and Tonkin at the 1889 Paris Exposition Universelle, from *1889, La Tour Eiffel et L'Exposition Universelle* (Paris: Musée d'Orsay, 1989)

Fig. 4. Tonkinoise *pousse-pousse,* from Brincourt, *L'Exposition Universelle de 1889* (Paris, 1890).

Fig. 5. La Rue du Caire, 1889, Bibliothèque Nationale de France, Paris.

Fig. 6. Palais des Beaux-Arts at the 1889 Paris Exposition Universelle, courtesy Roger-Viollet

Fig. 7. Ground plan of Champ de Mars galleries, from François Guillaume Dumas, *Exposition Universelle de 1889: Catalogue Illustré des Beaux-Arts* (Lille, 1889).

Fig. 8. Restaurant row at the 1889 Paris Exposition Universelle, from Brincourt, *L'Exposition Universelle de 1889* (Paris, 1890)

Fig. 9. Maison de la Presse, from *L'Exposition de Paris* (Paris, 1889), 1: 41, Van Gogh Museum (Library), Amsterdam

Fig. 10. Grand Café poster with presumed portrait photograph of Monsieur Volpini, from *L'Armorial de l'industrie* (Saint-Germain-en-Laye: Musée Départemental Maurice Denis "Le Prieuré," 1889)

Fig. 11. Émile Friant, *The Wrestlers,* 1889, oil on canvas, 180 × 112 cm, Musée Fabre, Montpellier

Fig. 12. Paul Gauguin, *Farmhouse, Near Arles,* 1888 (W. 310/324), oil on canvas, 73 × 92 cm, private collection

Fig. 13. Paul Gauguin, *Vision of the Sermon,* 1888 (W. 245/308), oil on canvas, 72.2 × 91 cm, National Gallery of Scotland, Edinburgh, purchased 1925

Fig. 14. Émile Bernard, *Female Bathers,* 1888, panel, location unknown

Fig. 15. Émile Bernard, *Woman with Geese,* 1887, oil on canvas, 41 × 23 cm, Private Collection

Fig. 16. Émile Schuffenecker, *Portrait of Émile Bernard,* c. 1889, oil on wood, 83.3 × 77.5 cm, The Museum of Fine Arts, Houston, Gift of Mrs. Audrey Jones Beck

Fig. 17. Émile Bernard, *The Harvest,* 1888, oil on canvas, 56 × 45 cm, Musée d'Orsay, Paris

Fig. 18. *Princess Dolgorouky and Her Gypsy Orchestra,* from *Paris, les expositions universelles de 1835 à 1937* (Paris, 2004)

Fig. 19. Charles Laval, *Scene in Martinique,* 1889, pen and ink and crayon heightened with watercolor, affixed to gray-blue paper, 14.5 × 22 cm, private collection

Fig. 20. Paul Gauguin, *The Haymakers,* 1889, from *Catalogue de l'Exposition de Peintures du Groupe Impressionniste et Synthétiste* (Paris, 1889), Van Gogh Museum, Amsterdam (see cat. 42, p. 215)

Fig. 21. Paul Gauguin, *Spring at Lézaven,* 1888 (W. 249/279), oil on canvas, 70 × 92 cm, private collection

Fig. 22. Jacob Meyer de Haan, *Portrait of Theo van Gogh,* 1889, Van Gogh Museum, Amsterdam (Vincent van Gogh Foundation)

Fig. 23. Paul Gauguin, *Vincent van Gogh Painting Sunflowers,* 1888 (W. 296/326), oil on canvas, 73 × 91 cm, Van Gogh Museum, Amsterdam (Vincent van Gogh Foundation)

Fig. 24. Paul Gauguin, *The Moulin du Bois d'Amour Bathing Place,* 1886 (W. 221/272), oil on canvas, 60 × 73 cm, Museum of Art, Hiroshima, Japan

Fig. 25. Paul Gauguin, *Vase "Atahualpa,"* 1887–88 (not in Gray), stoneware, H. 23 cm, private collection

Fig. 26. Paul Gauguin, *Two Bathers,* 1887 (W. 215/241), oil on canvas, 87.5 × 70 cm, Museo Nacional de Bellas Artes, Buenos Aires

Fig. 27. Paul Gauguin, *Conversation (Tropics),* 1887 (W. 227/251), oil on canvas, 61 × 76 cm, private collection

Fig. 28. Paul Gauguin, *Breton Women Chatting,* 1886 (W. 201/237), oil on canvas, 72 × 91 cm, Neue Pinakothek, Munich

Fig. 29. Paul Gauguin, *Night Café,* 1888 (W. 305/318), oil on canvas, 72 × 92 cm, Pushkin State Museum of Fine Art, Moscow

Fig. 30. Paul Gauguin, *Yellow Christ,* 1889 (W. 327), oil on canvas, 92.1 × 73.4 cm, Albright-Knox Art Gallery, Buffalo, General Purchase Funds, 1946

Fig. 31. Paul Gauguin, *La Belle Angèle,* 1889 (W. 315), oil on canvas, 92 × 73 cm, Musée d'Orsay, Paris

Fig. 32. Paul Gauguin, *Be in Love and You Will Be Happy,* 1889 (Gray 76), polychrome woodcarving, 97 × 75 cm, Museum of Fine Arts, Boston, Arthur Tracy Cabot Fund

Fig. 33. Camille Corot, *Souvenir of Italy,* from the portfolio *Twelve Sketches,* 1871, lithograph, 31.8 × 57.2 cm (sheet), The Metropolitan Museum of Art, Harris Brisbane Dick Fund, 1932, 32.34.9

Fig. 34. Édouard Manet, *The Raven: Open Here I Flung the Shutter (The Window),* 1875, lithograph 54.2 × 35 cm (sheet), The Metropolitan Museum of Art, New York, Harris Brisbane Dick Fund, 1924, 24.30.27 (4)

Fig. 35. Henri Fantin-Latour, *Immortalité,* from Adolphe Julien's *Richard Wagner, sa vie et ses oeuvres,* 1886, lithograph, 22.9 × 14.8 cm, The Cleveland Museum of Art, Gift of Ralph King 1921.57

Fig. 36. Odilon Redon, *La Mort,* from *À Gustave Flaubert: Tentation de Saint-Antoine,* 1889, lithograph, 30.3 × 21.5 cm, Kröller-Müller Museum, Otterlo, The Netherlands

Fig. 37. Edgar Degas, *Nude Woman at the Door of Her Room,* 1879, lithograph, 16.1 × 11.9 cm, Rijksmuseum Amsterdam

Fig. 38. Paul Gauguin, *Carnet Huyghe,* p. 217, graphite and charcoal on lined ledger paper, 17 × 10.5 cm, The Israel Museum, Jerusalem, Gift of Sam Salz, New York, through America-Israel Cultural Foundation, B72.0043

Fig. 39. *Plan of Paris* (detail), showing the Left Bank of Paris with the addresses mentioned in Gauguin's sketchbook, from W. J. Rolfe, *A Satchel Guide for the Vacation Tourist in Europe* (Boston/New York: Houghton, Mifflin, and Co., 1901)

Fig. 40. Paul Gauguin, detail, *Breton Bathers* (Cleveland Museum of Art, cat. 2, p. 14) showing crayon line underdrawing

Fig. 41. Paul Gauguin, detail, *Dramas of the Sea: Brittany* (Cleveland Museum of Art, cat. 16, p. 21) showing tusche line,

tusche washes (dilute/textured gray and solid black passages), and dry tusche work in the figure's face and cap

Fig. 42. Paul Gauguin, detail, *Old Women of Arles* (Cleveland Museum of Art, cat. 22, p. 27) showing dry brush work with trailing brushstroke and plate grain

Fig. 43. Paul Gauguin, detail, *Joys of Brittany* (Cleveland Museum of Art, cat. 14, p. 19) showing pitted texture called *peau de crapaud*

Fig. 44. Inside the Essonnes paper mill, c. 1888–90, Île de France, near Paris, showing the pulp in a Hollander beater

Fig. 45. In this image captured with scanning electron microscopy, the bright white spots represent submicron particles composed of lead chromate. Complementary analysis with elemental dispersive spectrometry, spectrum illustrated below, shows the correlating peaks for lead and chromium and confirms the presence of chrome yellow.

Fig. 46. Félix Buhot, *Japonisme: Dix Eaux-Fortes, Title Page,* 1885, etching on yellow paper, 26.1 × 17.8 cm, Spencer Museum of Art, University of Kansas, Museum Purchase 1989.0015.1

Fig. 47. Émile Lévy, *Mes Transformations,* 1873, lithograph on yellow wove paper, 80 × 60 cm, Bibliothèque Nationale de France, Paris

Fig. 48. Vincent van Gogh, *Sunflowers,* 1888, oil on canvas, 95 × 73 cm, Van Gogh Museum, Amsterdam (Vincent van Gogh Foundation)

Fig. 49. Paul Gauguin, *Carnet Huyghe,* p. 223, graphite and charcoal on lined ledger paper, 17 × 10.5 cm, The Israel Museum, Jerusalem, Gift of Sam Salz, New York, through America-Israel Cultural Foundation, B72.0043

Fig. 50. Paul Gauguin, *Leda and the Swan,* 1887–88 (Gray 63), unglazed stoneware, decorated with slip, H. 20 cm, private collection

Fig. 51. Paul Gauguin, detail, *Volpini Suite: Breton Bathers* (Cleveland Museum of Art, cat. 13, p. 18)

Fig. 52. Paul Gauguin, *Breton Bather,* 1886–87 (Pickvance plate 16; Rewald 13), charcoal and pastel, with brush and brown ink, squared in graphite, on laid paper, 58.8 × 35.8 cm (irregular), The Art Institute of Chicago, Gift of Mrs. Charles B. Goodspeed, 1946.292

Fig. 53. Paul Gauguin, *Breton Girl,* 1886 (Pickvance plate II; Rewald 10), charcoal and pastel on paper, 48 × 32 cm, Glasgow Museums, The Burrell Collection

Fig. 54. Paul Gauguin, *Breton Women at the Turn,* 1888 (W. 252/271), oil on canvas, 91 × 72 cm, Ny Carlsberg, Glyptothek, Copenhagen

Fig. 55. Paul Gauguin, *Cowherd, Bellangenet Beach,* 1886 (W. 206/234), oil on canvas, 75 × 112 cm, private collection

Fig. 56. Paul Gauguin, *Young Boy,* date unknown, location unknown

Fig. 57. Paul Gauguin, *Les Alyscamps,* 1888 (W. 307/314), oil on canvas, 92 × 73 cm, Musée d'Orsay, Paris

Fig. 58. Paul Gauguin, *By the Sea,* 1892 (W. 463), oil on canvas, 68 × 92 cm, National Gallery of Art, Washington, Chester Dale Collection

Index of Names

Published on the occasion of the exhibition

Paul Gauguin: Paris, 1889
The Cleveland Museum of Art, 4 October 2009–18 January 2010

Van Gogh Museum, Amsterdam, 19 February–6 June 2010, under the title *Paul Gauguin: The Breakthrough into Modernity*

The exhibition was organized by The Cleveland Museum of Art and the Van Gogh Museum. The exhibition is supported by an indemnity from the Federal Council on the Arts and the Humanities.
The exhibition is made possible through major support provided by the Malcolm E. Kenney Special Exhibitions Fund. The supporting corporate sponsor of the exhibition is KeyBank. The Cleveland Museum of Art gratefully acknowledges the citizens of Cuyahoga County for their support through Cuyahoga Arts and Culture. The Ohio Arts Council helps fund the museum with state tax dollars to encourage economic growth, educational excellence, and cultural enrichment for all Ohioans.

Editing: Barbara Bradley, with Laurence Channing
Translation: Michael Hoyle (text by Agnieszka Juszczak); Diane Webb (text by Chris Stolwijk)
Editorial advice: Edwin Becker; Marije Vellekoop, Van Gogh Museum; Heather Lemonedes,
 The Cleveland Museum of Art
Coordination: Suzanne Bogman, Van Gogh Museum; Laurence Channing,
 The Cleveland Museum of Art
Image research: Geri Klazema, Van Gogh Museum
Editorial office: Simone Albiez, Hatje Cantz
Design and typesetting: hackenschuh com. design, Stuttgart
 Christina Hackenschuh, Markus Braun
Production: Stefanie Langner, Hatje Cantz
Typeface: Concorde, Univers
Reproductions: Repromayer GmbH, Reutlingen
Paper: LuxoSamtoffset, 135 g/m^2, Munken Print White, 150 g/m^2
Printing: Dr. Cantz'sche Druckerei, Ostfildern
Binding: Conzella Verlagsbuchbinderei, Urban Meister GmbH, Aschheim-Dornach/Munich

Published by
Hatje Cantz Verlag
Zeppelinstrasse 32
73760 Ostfildern
Germany
Tel. +49 711 4405-200
Fax +49 711 4405-220
www.hatjecantz.com

Hatje Cantz books are available internationally at selected bookstores. For more information about our distribution partners, please visit our homepage at www.hatjecantz.com.

Library of Congress Control Number: 2009928940

ISBN: 978-0-940717-60-2 (The Cleveland Museum of Art, hard cover with jacket)
ISBN: 978-1-935-294-00-9 (The Cleveland Museum of Art, soft cover)
ISBN: 978-90-79310-13-5 (Van Gogh Museum, soft cover)
ISBN: 978-3-7757-2427-2 (Hatje Cantz, trade edition)
ISBN: 978-3-7757-2533-0 (Dutch; Hatje Cantz)
ISBN: 978-2-7427-8695-4 (French; Actes Sud)
ISBN: 978-3-7757-2426-5 (German; Hatje Cantz)

Printed in Germany

www.clevelandart.org
www.vangoghmuseum.com